SOURCES AND DOCUMENTS IN THE
HISTORY OF ART SERIES

H. W. Janson, Editor

Andrea Mantegna, The Madonna of Victory. *Louvre, Paris. (Photo Alinari)*

Italian Art

1400–1500

SOURCES and DOCUMENTS

Creighton E. Gilbert

Jacob Gould Schurman Professor
of the History of Art
Cornell University

PRENTICE-HALL, INC.
Englewood Cliffs, New Jersey 07632

Library of Congress Cataloging in Publication Data

Main entry under title:
Italian art, 1400–1500.

(Sources and documents in the history of art series)
Principal contents made up of writings translated
from the original French, Italian, or Latin.
Bibliography: p.
Includes index.
1. Art, Italian—Addresses, essays, lectures.
2. Art, Renaissance—Early Renaissance—Italy—
Addresses, essays, lectures. I. Gilbert, Creighton.
II. Series.
N6915.I78 709'.45 79–11069
ISBN 0–13–507947–0

© 1980 by Prentice-Hall, Inc., *Englewood Cliffs, N.J. 07632*

Printed in the United States of America

10 9 8 7 6 5 4 3 2

PRENTICE-HALL INTERNATIONAL, INC., *London*
PRENTICE-HALL OF AUSTRALIA PTY. LIMITED, *Sydney*
PRENTICE-HALL OF CANADA, LTD., *Toronto*
PRENTICE-HALL OF INDIA PRIVATE LIMITED, *New Delhi*
PRENTICE-HALL OF JAPAN, INC., *Tokyo*
PRENTICE-HALL OF SOUTHEAST ASIA PTE. LTD., *Singapore*
WHITEHALL BOOKS LIMITED, *Wellington, New Zealand*

To

ALLAN H. GILBERT

in emulation

Contents

Preface *xiii*

Introduction *xv*

1. The Artist Speaking Informally *1*

 Ghiberti at Work *3*

 Jacopo della Quercia Defines the Real Artist *4*

 Domenico Veneziano Prepares to Move to Florence *4*

 Matteo de' Pasti Checks the Specifications *6*

 Fra Filippo Lippi Duns the Patron *7*

 Benozzo Gozzoli's Patron Asks for Revision in His Work *8*

 Cossa Claims Better Pay for a More Outstanding Artist *9*

 An Engraver in Dispute with Mantegna
 (Simone di Ardizoni) *10*

 Mantegna Offers Technical Options *11*

 Mantegna Writes Home from a Trip *12*

 Mantegna in His Last Days *14*

 Francesco Mantegna's Political Cartoon *14*

 Giancristoforo Romano Abandons Some Marbles
 for Some Others *15*

 Antoniazzo Romano's Preliminaries for a Fresco *16*

 Antonio del Pollaiuolo Remembers His Youth *17*

2. The Artist in Formal Records *19*

 A Contract to Paint a Ceiling and a Wall
 (Martino di Bartolomeo and Spinello Aretino) *21*

 Subsidy for the Education of Artists (Domenico de' Cori) *22*

 The Fistfight in Gentile da Fabriano's Yard
 (Jacopo Bellini) *23*

 Donatello's Bookkeeping, 1427 *25*

 A Work by Donatello Is Rejected *26*

 Jacobello del Fiore's Property Is Auctioned *27*

Jacopo Bellini in a Partnership Agreement
(with Donato Bragadin) *29*

A Dispute over the Price of Sculpture (Andrea di Lazzaro) *29*

Neri di Bicci Contracts with an Apprentice
(Cosimo Rosselli) *30*

Mantegna's Hand Can Be Recognized *31*

Cosimo Tura as a Pattern Maker *32*

A Training Course for a Young Painter (with Squarcione) *33*

A Defaulting Patron and Mino da Fiesole *34*

Jacopo Bellini's Sketchbooks *35*

Taddeo Crivelli Illuminates a Manuscript *36*

Matteo di Giovanni Receives Elaborate Instructions *38*

Verrocchio Prepares His Will *40*

Foppa's Municipal Appointment *41*

Benedetto da Maiano's Worldly Goods and Chattels *42*

3. The Artist as Book Author *49*

Alberti on Painting, 1435 *51*

Ghiberti's Second Commentary *75*

Filarete Explains the Figurative Arts *88*

Piero della Francesca on How to Do Perspective *91*

Giovanni Santi Rates the Artists *94*

Giusto d'Andrea's Early Career *100*

A Painter Comes to Rome to See the Sights ("The Milanese
Perspectivist") *101*

4. The Patron Speaking *105*

The City Council of Florence Legislates Sculpture *107*

Pierre Salmon Writes to the Duke of Berri, January 1408 *107*

Francesco Datini's Executors Watching
the Painters' Work *108*

The Marquis of Ferrara Gives a Medal *109*

Giovanni de' Medici Buying a Flemish Tapestry *110*

Giovanni Rucellai's Taste *110*

Symbolic Images Planned by a Patron for a Belt and Its
Buckle (Marco Parenti) *112*

The Priests of Pistoia Decide to Have an Altarpiece *114*

Donatello Gives His Doctor a Bronze Madonna *116*

Alessandra Strozzi Has Pictures in the House *117*

The Marquis of Mantua and His Jewelry Designer
(Cristoforo Geremia) *118*

The Duke and Duchess of Milan and Rogier van der
Weyden *120*

The Duke of Milan in Love with a Portrait *121*

The Duke of Milan's Most Personal Frescoes *122*

The Ducal Agent Arranges for Tura to Inspect a Picture *123*

The Duke of Milan Gives Bonifacio Bembo
a Job of Restoration *124*

The Duke of Milan Gets Competitive Bids for Frescoes *124*

The Duke of Milan Objects to Diverse Hands *125*

The Pistoia Committee Argue over a Monument *126*

Lorenzo de' Medici's Criteria for Paintings *128*

The Rulers of Mantua and Mantegna, Their Painter *129*

The Madonna of Victory Planned *133*

The Madonna of Victory Installed *135*

Piero de' Medici Acquires a Cimabue *136*

From the Medici Inventory *137*

The Duke of Milan Has Florentine Painters Recommended
to Him *138*

The Ambassador to Innsbruck Reports on Portraits
(Ambrogio de Predis) *139*

The Marquis of Mantua Seeks Portrayals of Cities
(Gentile and Giovanni Bellini) *140*

The Duke of Ferrara Finds a New Court Painter
(Boccaccio Boccaccino) *141*

The Duke's Mistress and Her Portrait by Leonardo
da Vinci *142*

5. The Clergy Speaking *143*

Cardinal Dominici on Paintings and Painters *145*

San Bernardino Preaches about Sienese Paintings *146*

Saint Antonino on the Ethics of Painting *147*

Fra Domenico Corella Shows the Church Treasures, 1469 *148*

Fra Giovanni Caroli Boasts of His Convent, 1479 *152*

Friar Felix Schmitt's Tour of Venice, 1483 *153*

Savonarola on Painting *155*

6. The Literary People Speaking *161*

B. Uberto Decembrio Remembers a Boy Painter
(Michelino da Besozzo) *163*

Gasparino Barzizza on the Education of Apprentice
Painters *163*

Leonardo Bruni's Rejected Program *163*

Bruni Reproves Elaborate Tombs (by Michelozzo) *165*

Poggio Bracciolini Collects Ancient Sculpture *167*

The Repartee of Donatello and Others *170*

Guarino Arranges a Program for Paintings *171*

Two Poets on Pisanello (Lionardo Dati and Ulisse) *173*

A Scientific Writer on Light and Perception
(Giovanni da Fontana) *174*

A Survey of Leading Artists and What Makes Them Leaders
(Bartholomeus Facius) *175*

Local Pride in a Fresco by Gentile da Fabriano
(Ubertino Posculo) *178*

Mantegna's Field Trip to Collect Classical Antiquities *179*

Etruscan Finds in 1466, Reported by Antonio da Sarzana *181*

A Poet of Florentine Statistics (Benedetto Dei) *181*

A Humanist Asserts that the Moderns Can Equal the Ancients
(Alamanno Rinuccini) *185*

Images from Innermost Philosophy (Valturius) *186*

A Trompe l'Oeil Still Life Painting (Zovenzonio on
Marco Zoppo) *186*

Indecision about Commissioning a Portrait from Tura
(Tito Vespasiano Strozzi) *187*

A Rhetorician Admires Inlaid Wood (Matteo Colacio) *188*

A Humanist Praises a Cassone Painter (Ugolino Verino on
Apollonio di Giovanni) *190*

Landino on Florentine Painting and Sculpture *191*

The Best Florentine Artists in 1488 (Ugolino Verino) *192*

Making Fun of the Venetian Masters (Strazzola on Gentile
Bellini and Others) *193*

Manetti's Lives of Florentine Artists *195*

How Mantegna Knew How to Present an Allegory
(Battista Fiera) *197*

A Visit to a Fresco Cycle (Michelangelo di Cristofano on the
Campo Santo of Pisa) *197*

7. Diarists and Chroniclers *201*

The Sienese Chronicle and the City Fountain (Jacopo della
Quercia) *203*

Marco Rustichi Sees the Sights of Pisa, 1425 *203*

Chronicle of the New Dominican Convent of San Marco,
Florence (Fra Giuliano Lapaccini) *204*

Ciriaco d'Ancona in Search of Greek Antiquities *206*

Michele Savonarola on the Fine Men of Padua *208*

Playing Cards for the Duke of Milan (P. C. Decembrio) *210*

Niccolò della Tuccia's Portrait Intrudes in Sacred
Images *211*

Pope Pius II Describes a Procession and Its Adornments *213*

Gentile Bellini's Trip to Constantinople (Marino Sanudo and
Others) *216*

Luca Landucci on the Passing Scene in Florence *216*

Niccolò dell' Arca's Strange Personality (Fra
Girolamo Borselli) *217*

Botticelli, His Brother, and Savonarola *218*

Index *220*

Preface

The writings about art from the period of the Early Renaissance, which make up the principal contents of this book, have all been expressly translated by me from the original Latin, Italian, or French. Most have never been translated before. In the introductory sentences preceding each text I include a bibliographical reference to its publication in the original language. Many of these publications are a century old or more, simply because the writings have long been overlooked. I hope others will be persuaded, as I have been, that they are of outstanding value nevertheless. Some of the writings have been published many times, and for these the reference given is to the edition most likely to be available to the reader, usually the most recent. In many cases that is not the one I used in preparing the translation.

The aim has been to make these texts, as nearly as possible, the equivalent of the originals in usability for the reader, carrying no less suggestion of the circumstances surrounding the works of art than they would for the reader of the original language version. Therefore, rather than providing any literary smoothness, I have reflected the amateur and sometimes awkward expression of the authors. On the other hand, usability required translating not only into another language but into modern terms, and I have avoided archaism. Sometimes in the process problems arise which have no good solution, and one small example will illustrate these. Many titles and respectful forms of address to people occur which are obsolete. One of these, *ser,* usually designates a man who was a *notaio,* similar to notary in etymology but less so in meaning, and more similar to the specialized lawyers called solicitors in Britain. To translate this word either as notary or as solicitor seemed not good. Hence *ser,* which is always a prefix to someone's name, is rendered lawyer, producing a phrase like our colloquial "lawyer Smith." There would perhaps be equal merit in leaving it untranslated, on the two grounds that there is precedent for doing so among good older translations of Italian texts, and that the reader's need here is little more than to know that a title of respect is meant. That would avoid a translation whose accuracy cannot be defended. Yet the pleasant outcome of such a debate seems to be that both choices do what is needed, and I trust that this may be found true of the work as a whole.

C. E. G.

Introduction

A CENTURY OF ARTIST-AUTHORS

When it comes to sources and documents in the history of art, Italy of the fifteenth century can claim to be unique, in that its greatest artists so commonly wrote whole books about art that it seems to be a pattern. One might think of Piero della Francesca, today the most widely admired painter of that age; or Leonardo da Vinci, the most extraordinary genius of the period in the arts as a whole. (Because he lived well into the sixteenth century, Leonardo's writing appears in the volume in this series on Italy 1500–1600.) Or one might cite Leon Battista Alberti, universally considered one of the two best architects of the century; or the sculptor Lorenzo Ghiberti, second only to the non-writing Donatello. Nothing like this occurred in any other place or time. To appreciate its import, imagine how it would be if in the Baroque period Bernini, Velasquez, and Rembrandt had each written a book, or if Impressionism had been explained in a treatise by Monet, or Cubism in one by Picasso.

Of course, artists in all periods have always written letters, diaries, memoranda, and the like—the kind of writing commonly done by non-professional writers—and the fifteenth century is no exception. But the only other age partially comparable to the fifteenth century is the twentieth, when there is a pattern of writing books on art among great architects—Wright, Le Corbusier, Gropius—but not other artists. Apart from that case, we only find individual major artists as book authors from time to time, such as Dürer in the early sixteenth century, when no other instances appear. Dürer's books on art confirm the artist-author pattern of the fifteenth century in Italy, for it was typical of him, and not of his contemporaries, to want to do everything that the Italians just before him had done, especially what might make art more intellectual and more dignified.

To be sure, one could argue against this characterization of the fifteenth century by pointing out a qualifying factor in every one of the cases mentioned. Leonardo never finished his books. Alberti's book on painting (the one included here) was written not by a professional painter of even minor rank, but by an amateur who was later to become an architect. Ghiberti's *Commentaries* began as an ordinary personal

notebook of precepts and memories for his family, similar to those kept by many merchants and others in his time. Piero's book on perspective consists largely of exercises that are barely readable. And yet each of these qualifications is different, and each book does exemplify the pattern in all the ways except one, passing the tests which might seem to disqualify each other one. Hence this does appear to be a special characteristic of this century, though every example is in some respect eccentric, as is natural in an innovative development. It is an unrecognized element of a tendency of the age which is well recognized as a whole, that at the time artists were first becoming strongly aware that what they were doing was art, in a sense of the word not much different from our own.

ALBERTI'S BOOK ON PAINTING

Of the books which manifest this growing awareness, Alberti's *On Painting* is by far the most remarkable, and therefore receives the most space in this anthology. It has a claim to be the only book of any age that is the manifesto of a great artistic movement composed by one of the founders. Even though the author was not a painter, he certainly was a real member of the Florentine group of founding fathers of the kind of art that was to be a constituent thread in all Western painting for centuries. If not his conversations with the others about the theories and methods recorded in the book, then his experiments with perspective would have given him such a role quite literally, since such things were integral to the studio practice of the innovative artists. Its rich applicability to the art of its time has been widely understood; it can serve as guide, as key, as reminder of what we may have missed in the artists' aims. But this density of its usefulness can create a problem for us in this anthology. If it were to receive a commentary drawing attention to its usefulness in the same proportion as is given to the other selections here, there would be no room in the book for anything else. So it has been given a mere token introduction, no longer than those given briefer or less crucial writings. There are two excuses that can be offered for this decision to skimp on Alberti. One is that many commentaries on his work already exist (which is not the case for most of the other writers). Kenneth Clark's *Leon Battista on Painting*, 1944, is a good place to start. To be sure, it is not quite fair to tell the reader he must go elsewhere. But there is a second, more rational excuse. The reader, it is assumed, is not using this book by itself to meet the art of the Italian Renaissance for the first time; it would be a very one-sided way to go about it. He can, therefore, bring his awareness of such artists as Masaccio and Donatello, Alberti's favorites, to bear upon Alberti's statements, and in that process will, I think, gain a great many clues illu-

minating their art. Most of the selections in this book are not similar to Alberti in this respect. They often point to qualities of the age that we would never expect from our usual approach, ones which need the emphasis provided by the selections and by a short reinforcing commentary. What Alberti says might, rather, be identified with *the* classic approach to the artists of his time.

OTHER WRITINGS BY ARTISTS

The writings of artists, with which we start, are the most numerous texts to concern us, taking up half the book. They have been subdivided according to the kind of writing being done. First the letters and other informal writings are collected in one group, with the thought that they will cast light on each other—for instance, on the conventions of letter-writing which might seem strange today—and thus reduce the need for explanations. In the same way a second group consists of formal legal writings. With these it seemed reasonable to include some documents not actually written by artists, such as contracts to which they were a party. Little space altogether has been given to contracts, however, even though they survive in greater quantity perhaps than any other kind of writing represented in the book. Like legal documents of our time, they are immensely repetitious, and the small variations which they do show may tempt us to treat them as more meaningful than we should, for it is quite probably only the different habits of the lawyers that make one patron seem to have been more suspicious and another more exacting of the artist. The reader who would like more variants can find some thirty such contracts of this century, along with other official documents, translated in a recent collection of texts about patronage.[1] After reading a great many contracts and selecting one particularly complete sample illustrating the norm, it seemed more interesting to ask: What happened when some of the standard escape clauses in them actually had reason to be invoked? Suppose the patron actually exercised his option to reject the work because he found it of poor quality, or suppose he couldn't pay when the artist finished? Many art historians have wondered about this sort of thing. Answers on these points have indeed always been available, but the records in question have been looked at only as details in the documentation of the specific artist, not from this broader aspect. Cases have been chosen showing Donatello subjected to quality rejection and Mino da Fiesole with a moneyless patron.

[1] D. S. Chambers, ed., *Artists and Patrons in the Italian Renaissance* (University of SC Press, 1971). Rab Hatfield, in a review in *The Art Bulletin*, vol. 55 (1973), 630–31, has called attention to the fact that not all the renderings are reliable.

THE ART PUBLIC

The second half of the book documents what the art of this age meant to its original public. Some of the world-famous people of the time are among the writers—Lorenzo the Magnificent, Savonarola, St. Bernardino. Others are people famous or powerful in their time, though not so often remembered—St. Antonino; Guarino, the founder of long-adopted educational methods; Poggio Bracciolini, the most typical of humanists. It is worth emphasizing that people of this age did not spend their time dwelling on art, though for us that is so much its greatest achievement that we are tempted to think of them doing so. An artist's name appears just once in Poggio's hundreds of letters, for instance, and in all the other cases short passages have to be drawn from vast mines of material.

PATRONS' INSTRUCTIONS

Among the writings by non-artists, we examine first those of the patrons because of this group's strong influence on the making of the works of art. How closely did patrons control the works of art they ordered? Current studies often postulate that they did so in detail, often with the help of a learned humanist or theologian who created a "program" for a particular work. This approach by many scholars is a justifiable reaction against an earlier one, according to which past artists expressed themselves as freely as do modern uncommissioned artists. And it goes hand in hand with a related concept, that the works often contain several layers of meaning, in part detectable only through our analytical studies. Since it is agreed that the artists would scarcely create such symbolisms, the hypothesis of the patron's or his agent's detailed supervision seems needed as an explanation for the presence of complex symbolism in the works. The whole approach has the appeal of suggesting a strong link between the works of art and the prevailing concepts of the society.

PAINTERS WITHOUT INSTRUCTIONS

Yet actual information about how patrons and consumers behaved in the period offers hardly any support for this reconstruction of events. To be sure, the fragmentary survival of all data means that we must be cautious in claiming what we do not find did not happen (as we must also in the opposite claim). But we can to some extent compensate for the scanty information by finding cases which extend from the single

instance to general habits. Notable among these are negative reports, in which people complain about the way things are. And theologians in the fifteenth century and earlier complained about what painters were doing to symbolic religious subjects. At the beginning of the fourteenth century, we find a priest called William the Englishman angry that paintings in churches ignored the Bible in favor of centaurs and monkeys, the fault, he says, of the criminal presumptuousness of the painters (*nefanda pictorum presumptio.*) [2] As early as the twelfth century similar imagery had led to a much more famous complaint by St. Bernard, who said it was out of place in monasteries because it distracted the monks from their meditation.[3] It is thus plain that it did not have an added symbolic meaning, as far as those two priestly observers knew.

In our period we will find the Dominican Schmitt shocked in the same way by a pagan Hercules in a church; he knew of no Christian references it might have, and in fact was bothered because simple people might think it had (see p. 153). Again, like William, in our period St. Antonino called the frivolous inclusion of dogs and rabbits in church paintings sinful behavior by the painter—not by the patron. It was no different in 1574, when the Inquisition brought Paolo Veronese to trial for including secular amusements in a sacred picture.[4] His famous reply, that such was a painter's accepted license, should by now not surprise us. These churchmen, then, thought the selectors of these motifs were the painters, and they should have known. No doubt the use of such motifs was encouraged because it was seen that they pleased the patrons—less austere churchmen; St. Bernard in fact rebuked churchmen for being willing to spend money on such things.

But perhaps patrons or their theologians did direct at least the religious components of such pictures. Not so, according to St. Antonino, who called it a *painter's* sin that the Nativity and other subjects were rendered in traditional ways which he thought not proper. In 1390 we have a vivid account of the choice of a religious theme by a painter, in a case when he and the patron were in different towns, so that letters record what otherwise would have been arranged orally.[5] (Most of them were written by the patron's business agent in the painter's town.) The patron wanted a picture of Our Lord but, his agent points out, didn't

[2] For the whole text, see M. R. James, "Pictor in Carmine," *Archaeologia,* vol. 94 (1951), 141ff.

[3] For the whole text, see C. Davis-Weyer, *Early Medieval Art: Sources and Documents* (Prentice-Hall, 1971), 168–70. See also the analysis by Meyer Schapiro, "On the Aesthetic Attitude in Romanesque Art," in his *Selected Papers: Romanesque Art,* 1977, 1–28.

[4] For the whole text, see R. Klein and H. Zerner, *Italian Art, 1500–1600: Sources and Documents* (Prentice-Hall, 1966), 129–32.

[5] For the whole correspondence, see R. Piattoli, "Un mercante del trecento e gli artisti del tempo suo," *Rivista d'Arte,* vol. 2 (1929), 228–33.

specify a Christ on the cross or anything else. The painter recommended a Christ in the tomb, and the patron then explained that his concern was simply to have pious figures which would induce thoughts of heaven. But when the picture was not begun on time, he cancelled the order angrily, saying, "The painter doesn't know how to think up (*trovare*) devout figures." He calmed down, the Christ was painted, and then the patron was asked which saints he would like. He gave a long list, which the painter then called unreasonable, saying, "He wants the whole procession," and it was settled that "we [agent and painter] will put in the ones that suit best."

It is not that patrons were vague or unsure of themselves in general; they were very firm about other matters in which presumably they did want the painters to follow rules. Three general areas show such strict control consistently: measurements, quality of materials (sometimes including the extent to which the master must personally do the work), and the subject, in the simple sense of title, of a painting. This last often included a list of saints or other persons, but not any more specific detail such as gestures or new attributes, elements in which modern studies find clues to symbolic levels of meaning. When in rare cases such details were included (see Matteo di Giovanni's contract, p. 38) there were also clues as to why, and the reasons had nothing to do with levels of symbolism. Matteo di Giovanni's is one unusually detailed contract; another, at the opposite extreme, specifies in 1461 that Benozzo Gozzoli is to paint saints "in their usual costume" or "with the proper usual decoration," or "with all their standard decorations." [6] He is to follow what was habitual in his experience, just like the painters of whom Antonino had disapproved a few years before. Although it might be objected, despite this double witness, that the unusualness of this contract clause is a signal that such unsupervised painting of attributes was atypical, this doubt seems to disappear when we consider that, if lack of patrons' specifications *was* normal, it would have been normal, too, for the contracts to be silent on that subject, as in fact they are; thus, almost unanimous silence on the point is no argument against its normality. If, on the other hand, patrons' instructions had been the norm, on such a positive requirement it would be strange to find the contracts consistently silent. (The rare record in Benozzo's contract of the conventional procedure probably reflects a particular lawyer's wordiness.)

It really is not so odd that the artists were left to go ahead, since

[6] The document is printed in *Rivista d'Arte,* vol. 2 (1904), p. 10. In three allusions, the same point is made in slightly different terms: St. John is to be dressed in his due usual (*debito usato*) costume; St. Jerome is to be shown with his due usual decoration (*ornamento*), and St. Francis with every habitual (*consueto*) decoration around him.

their experience of the usual ways of painting each religious image made them more expert specialists than the verbally oriented theologian. It is sometimes argued to the contrary that the artist was uneducated in the symbolic meanings of religious images. But doubt is cast on that assumption by the—unnoticed—list of Benedetto da Maiano's books, (p. 42) a shelfful corresponding rather nicely to those which art historians use today as clues to those symbols. And Benedetto was one of the less sophisticated sculptors of his age. It is right to stress that the Renaissance artist doing a commission was not in a modern artist's free situation, but emphasis on that fact can sweep us too far along to some unhistorical corollaries. For if, on that same principle, we compare him instead with the modern artist who does work on commission—the architect or the advertising artist—we see the similarities: the latter also receives firm orders about materials, measurements, and general theme or function, but the client decidedly wants the artist—that is why he pays him—to work out the visual means of articulating the client's purposes, which come in all degrees of vagueness or complexity. Such a person hardly seems different from the painter's client in 1390. When the architect of today has prepared a sketch with the client's wants in mind, of course the client asks for changes, and the architect counterproposes. A similar discussion in 1410 about a painter's sketch (p. 108) is on record.

There was certainly a range of instructions from precise to vague, and some painters were even allowed to paint whatever subject they pleased. In a famous case just after 1500 it was diplomatically made clear to the Marchioness of Mantua, Isabella d'Este, that Giovanni Bellini, whom she had asked to paint a certain subject, was used to having his own way. She must have wanted to have a Bellini (regardless of subject) more than she wanted a picture on her proposed theme (by any other artist), for she dropped her planned subject, "leaving the labor of the poetic invention" to him (see p. 141). In earlier Mantuan court commissions we already see the same freedom, even when the patron's suggestion had been less special than Isabella's. Thus, in 1480 (p. 132) the Marquis explained to a neighboring Duchess that Mantegna would not paint the portrait she wanted, adding that "as a rule" the best artists have their own notions and we must be content with what they will give us; the generalized form of the remark is of special interest. The marquis was willing to take not only his painter's but also his jewelry designer's project on the artist's terms (p. 118).

Nor was this the earliest generation to defer to the artist in this manner. In 1406 the Sienese painter Taddeo di Bartolo, no innovator, was asked by a civic committee to paint their chapel with figures and ornament it in a way that seemed good to him. If that was an experiment, it must have turned out well, for he was rehired the next year to destroy some old paintings and produce some that seemed to him more

appropriate (*ut sibi melius videbitur convenire*).[7] Many years later, the
painter Perugino, as would hardly have been expected, was asked by
some magistrates to paint Mary and four named saints and above these,
after removing an older image, either a pietà or another appropriate
figure of his choice (*ad electionem praefati Mag. Petri*).[8] The Sienese and
Perugian committees were not avant-garde connoisseurs, and so we seem
forced to accept that such documented behavior was conventional. It
should be pointed out, however, that these cases both involved a techni-
cal problem—fitting an image into a surface of special shape—one reason
why the painter's knowledge might have been especially respected. Other
contracts similarly allowed him to vary the number of figures named in
them, if there was not room, or to change full-length to half-length
figures. But in Perugino's case we see that this had become the basis for
giving him a choice of the religious iconography too. In still another
variation of this kind, the artist might be given specified saints for his
main field but freedom of choice in the margins, as in the contract with
the miniaturist whose "animals and other inventions" were required to
meet the approval only of other artists, although the patron had to
approve the figures (p. 36).

That split system may also explain the fairly frequent contracts in
which the themes of the main field of an altarpiece were specified but
those of the predella left to be settled later. Those clauses have been
claimed to be indications of the patrons' close supervision (in the absence
of any more direct evidence for that), on the hypothesis that detailed
instructions would have been provided orally. Yet it seems implausible
that, if patrons had wanted to supervise this area with special care, they
should have let it fall outside the agreement which had contractual
force. Thus, it is perhaps more likely that, as a minor area, it was treated
as we have seen the miniaturist's borders were, as an element given
precisely the lesser attention that the contract's words reflect. The
analogy for this hypothesis provided by the miniaturist's contract cer-
tainly cannot be countered by any analogies of the contrary idea.

PAINTERS WITH INSTRUCTIONS

How then has the idea been maintained that patrons did keep
close control of artists' images? There are documented cases of their
doing so, like those we have seen of "painter's choices" at the opposite
end of the range. It seems possible to provide a *complete* list of the
known full and partial such cases for the fifteenth century.

[7] For the whole text, see G. Milanesi, *Documenti per la storia dell'arte
senese,* reprinted, 1969, vol. 2, pp. 27–28.

[8] For the whole text, see F. Canuti, *Pietro Perugino,* Siena, Diana vol. 2
(1931), 175.

(1) Bruni's program for Ghiberti's Doors of Paradise, p. 163, which lists only titles of themes, but says that he would like to give more detailed symbolic meanings orally; (2) Matteo de' Pasti's request to his patron for details to include in his Petrarch illustrations, p. 6; (3) Guarino's program for a series of Muses, p. 171; (4) the reliefs of the Tempio Malatestiano, Rimini, whose unknown program is known to have been given by the patron, p. 186; (5) Matteo Parenti's program for a belt buckle, p. 112; (6) the astrological fresco cycle at Schifanoia, in Ferrara, which matches texts in astrological sources, and is known to have been supervised by a learned courtier; (7) the reliefs in Bartolomeo Scala's courtyard, in Florence, whose iconography matches writings by the patron himself; and (8) Mantegna's Madonna of Victory, p. 133, for which two programs written by a priest exist.

These cases group themselves into clear types, with some unexpected results. Two (Schifanoia and Scala) should apparently be dropped from the list, since no programming (i.e., instructions about internal details to make a point of symbolism, within the general topics) can be seen to have been involved. Both cycles use only one text throughout, including its preestablished symbolic meaning, and thus in no way differ from the commissioning of a set of Biblical frescoes, except that the texts are less well known (which may affect our analysis too much). All the patron did, as far as the results show, was point to the text and, in the second case, pick passages to be illustrated.

Of the six remaining programs, three (Bruni, Guarino, Madonna of Victory) were wholly or partly rejected when the works were made, as we luckily know from their survival. (Thus, by assuming as we do in the case of lost works that a program planned was a program carried out, we probably overestimated the program's weight.) Bruni's was not used at all, Guarino's was used for some of the paintings, and Mantegna followed one of the two offered programs but added more elements in the foreground, tending to leave the programmed ones like unfunctioning appendices. What is surprising is that just these three of our six programs, and no others, were prepared by a humanist or theologian, not the patron in person. Such "agent" programs, then, seem to have had poor chances, to say the least.

Of the remaining three, given by patrons, we know two only slightly. In Rimini we know the patron assigned the program but not what it was—again, it might have been an instruction to use just one book. Of Matteo de Pasti's, we know only one detail: a query as to whether the allegorical figure's attendants should be male or female. We thus have left just one case from the century in which we have fairly well-rounded knowledge of detailed instructions given by a patron. This rarity may justify our treating this procedure as one end of a range of possibilities, since our instances of artists' freedom actually are more

frequent and give evidence of having been typical of others. The well-rounded case shows a particular way of giving instructions, rather more simple-minded than we might have expected. On Marco Parenti's belt buckle, the units of the symbolic message were well-established (if sometimes rare) images, such as a family coat of arms, and usually were included here unchanged but grouped in a new way with other images, to add up to the new symbolic message of the series as a whole. This principle has assisted in a scholar's decoding of what is very probably a similar case, the frescoes on the walls of the Sistine Chapel (all the images in common point to the various supreme roles of the pope), but in the case of the belt buckle, as the editor of that text noted, the patron's invention was so arbitrary that a viewer of the buckle never could have interpreted it correctly. Such a case, where we know the answer, may make us hesitant in accepting proposed interpretations based on the imagery only.

We can test this point when an original code is found for imagery (previously the theme of one or more interpretations.) This happened with the Scala reliefs, and the finder of the text rightly noted that the solution was "somewhat disappointing. Instead of representing complicated initiation rites as might appear, they are merely clumsy illustrations of some moralizing apologues." [9] The intellectual elementariness of the original meanings indeed tends to be underestimated by modern interpreters. There are *no* cases among our known ones, even among the rejected ones of the humanists, of double symbolism such as have been suggested—for example, that Piero della Francesca's Arezzo frescoes have a liturgical reference and at the same time propagandize for a crusade against the Turks. That interpreters without the code should arrive at more elaborate readings than the codes had is understandable, since the former are forced to assemble their hypotheses from scattered sources, whereas the code had squeezed all these into a harmony.

The belt buckle program seems then to be the sole solid evidence for what has been called common in the century—an oddly minute base for a large superstructure of research studies. The commonness also appears dubious when it is seen that writers who want to support it do so by regularly turning to just the same example or two, introducing them with the heading "for instance". These are the Bruni program (with or without the qualification that it was rejected) and the instructions that Isabella d'Este gave to artists just after 1500. These latter, indeed very detailed, ought to be balanced by the similarly rare and active evidence in the same papers for artists' resisting such instructions. It seems possible that the two procedures may be related—that is, that

[9] A. Parronchi, "The Language of Humanism and the Language of Sculpture," *Journal of the Warburg and Courtauld Institutes,* vol. 27 (1964), 125.

this unusual articulation by artists of not wanting to be told details was produced precisely by an unusual patron's wanting to tell them things, as an architect sometimes encounters such an unusual client today. For we cannot deny that the case of Isabella was unusual and not commonplace, unless we appeal to possible lost evidence. On this view, the suggestion that detailed instructions and artist's freedom are both rare ends of a long range would be further supported.

The idea that such instructions in the fifteenth century were common is also based on their genuine commonness in other periods, particularly the sixteenth century (when, however, evidence for artists' spontaneity is also more abundant). Thus, texts of the late sixteenth century on symbolism, especially Ripa's *Iconology,* have often actually been applied to fifteenth-century images, on the ground that earlier similar texts were merely lost. However, the interesting pattern in which, from about 1525, books were increasingly written on symbolic imagery (emblems, handbooks on the symbolic meaning of classical mythology, and the like), subjects which had not been themes of books in the preceding century and a half, may instead suggest that the difference between the periods was real.

We are not likely to discover many more examples of fifteenth-century programs beyond the eight mentioned above, which have received intensive study. Of the illustrations cited, all except Matteo de' Pasti's one-line query about the male or female attendants have been the subject of individual analysis in articles or chapters of books, and those six that are treated in contemporary texts are all represented in this anthology.[10] They are thus given a weight far out of proportion to their part in the records of the age, all the more so in contrast to the absence of any similar articles dwelling on the evidence at the opposite end of the range, such as the letter saying that we must "as a rule" take from Mantegna and leading painters like him what they give us, or on the similar texts about Taddeo di Bartolo, Cristoforo di Geremia, or Perugino, discussed here in relation to this question for the first time. It is thus more likely that more of the latter sort, as they have been less hunted, may continue to emerge.

Besides such direct reports refuting the idea of patrons' detailed supervision, particularly of symbolic meanings, there are many other indirectly related situations to suggest this lack of supervision: the agent

[10] The two not represented in this book have been studied by A. Warburg, "Italienische Kunst und internationale Astrologie im Palazzo Schifanoia in Ferrara," in his *Gesammelte Schriften,* Leipzig, Teubner vol. 2 (1932), 459–81, and A. Parronchi, in the article cited in the preceding footnote. Studies pertaining to the programs represented in this book, apart from Matteo de' Pasti's, which has not been analyzed, are cited at the head of each text. Also of interest is C. Mitchell, "The Imagery of the Tempio Malatestiano," *Studi romagnoli,* vol. 2 (1951), 77–90.

Fruosino's buying a tapestry for the Medici when only the title had been specified; Brunelleschi and Marco Zoppo painting for themselves, doing technical experiments; the purchase of paintings by persons other than the original patron, such as Alessandra Strozzi; the free hand given by a duke to Bonifacio Bembo in the motifs in the frescoes of the ducal castle; the three "complete" criteria for good paintings proposed by Lorenzo the Magnificent, in which symbol-carrying is absent; Benozzo Gozzoli's readiness to argue back when for once a patron did offer a detailed criticism; the collector Rucellai's pride in the particular artists represented in his collection, whom he lists without naming of the subjects of his works by them; the report in the chronicle of Viterbo that a painter chose to include in a fresco the portrait of a local person who was not the patron; and other instances already cited, such as St. Antonino's complaints of the sinful painters.

Vast quantities of fifteenth-century paintings no doubt merely followed the tradition of older paintings with the same themes, like the saint "with the usual decoration." But when the theme was novel, many pictures perhaps were worked out in a way intermediate between the two extremes discussed above. The middle ground may be recorded in Fiera's report of what his friend Mantegna did when the pope ordered an allegory of Justice from him. That the pope did not tell him how to paint it is clear from Mantegna's next step, which was to ask "philosophers" how she should look. This scenario conforms neatly with Alberti's long recommendation to the painter to cultivate poets because they could be helpful with subjects. In this way learned allusion could indeed enter in (its presence has been taken as a leading proof of patron's instructions, but this pattern of the artist seeking ideas would account for it equally well) while at the same time the painter could make adjustments, choosing from the several proposals made to him the most pictorial one, as Mantegna did in this case. The patron, more plausibly than in the other hypothesis, would be concerned only with the effective result, not with the details of the means. In this case, too, we would understand how artists like Ghiberti might produce learned images and yet simultaneously claim to have been left to their own devices; there is now no contradiction between that claim and the presence of learned symbols. Further, it makes it understandable why humanists like Bruni might feel it natural to volunteer their suggestions, while at the same time these might not be used (just as later Pietro Aretino volunteered one for Michelangelo's Last Judgment which was also rejected). When the humanist sent his suggestion to the patron—thus making it more likely to survive in our archives—he may have expected it to have a better chance of being executed, but we have seen that the contrary happened. Such a pattern of behavior, then, seems to be an improved

reconstruction of the relations among artist, patron, literary man, and churchman, the chief figures of our interacting group.

CLERICAL AND LITERARY MATTERS

After the patrons, the other groups of writers on art present fewer questions to detain us. It may at first be surprising that there are so few religious writers. Indeed, when we recall that most surviving quattrocento painting is for churches, these texts seem very sparse in proportion. There may be no more to discover, if we can infer from the fact that a number of these have only recently been brought to attention in relation to the art of this time. A large proportion of the quotations in this book from San Bernardino, Corella, and Schmitt, though long since published in the collected works of these writers, are "new" to the world of art history. Those of Dominici and Antonino are relatively recent finds. But what may better explain the rarity of these writings is the unexpected fact that they lean heavily toward one group of the clergy of this age, those who were austere reformers of their orders. Besides Savonarola, both Dominici and Antonino belonged to the reformist branch of the Dominicans, and Bernardino to the same section of the Franciscans. Reformers of this sort were actually a very small fraction of the clergy, most of whom were content with less strict requirements for themselves. Happily, we can see one example of writing by a more ordinary "fat priest," Caroli, and what he says is indeed far from austere. It seems that it was the reformers—the energetic clergy and the leading edge of religious articulation in their time—who did most of the writing. Their writings are few partly because they themselves were few in number. Moreover, as our texts show, they were not entirely in favor of art at all. They found it useful—in a rather low-level way—but did not give it much emphasis; indeed, one of the reasons why the paragraphs included in this book have only recently been found is that they are sparse allusions among thousands of pages devoted to quite different matters.

When we turn to literary men, and then to chroniclers, the special interests of each group are again, it is hoped, brought into sharp focus by assembling the quotations from each. Yet it is apparent that these, too, were people for whom art was a far from central interest. When we read their incidental remarks on it, we are, to be sure, often rewarded by sudden small illuminations about things never otherwise recorded, ranging from finding the phenomenon of the child prodigy in one of our earlier texts to that of the eccentric artist in one of the last. In general, we can see what role the work of art played in the wider world

when we look at it with this perspective, distant relatively to those considered above. All together, these and the preceding texts must of course suffer from the limitations of the evidence. They are scattered truths, showing what things about art people chose to write down, and only such of those as have survived and then been found. But they can make a good claim to be truths. They must be put together by the reader using his own awareness of the works of art and the full range of his resources in the continuing effort toward full understanding.

I

The Artist
Speaking
Informally

Ghiberti at Work

Lorenzo Ghiberti (1378–1455), while engaged all his life with the great bronze doors of the Florence Baptistery, gladly did other jobs on the side. In Siena he was asked to do two of the six bronze panels for a new baptismal font, and was treated there as a great man, honored with dinners, and evidently awed the artists, who borrowed his notebook of birds. Indeed the novelty of a bronze-covered font may well be due to his persuasive campaigning for that medium. When he did not meet the deadline, he was asked about it by a Sienese goldsmith who was doing another of the panels. Ghiberti delivered the panels soon after this. Original text in R. Krautheimer, Lorenzo Ghiberti, 1956, 399–400.

To the prudent and honorable man Giovanni Turini, goldsmith, in Siena.

In Jesus' name

Honorable friend, etc. I got your letter of April 14, which I read as one from a dear and faithful friend. Besides that, about your being in good health [word missing] glory. Also about your good will to me, which you have always had; that is, if necessary you would help me polish one of these scenes, you say you would do it willingly, and I know you are only speaking as a good friend, and God bless you for that for me. Know, dear friend, the scenes are nearly finished, the one is in the hands of Giuliano son of lawyer Andrea, I have the other, and they will be finished by the date I promised master Bartolomeo. And they would have been finished long since, were it not for the ingratitude of those who were my co-workers in the past, from whom I've received not just one injury, but many. With God's grace I am out of their hands, for which I always praise God, taking into account what freedom I now feel I have.

I have decided to stay completely without associates and want to be master in my shop and receive every friend of mine with good and cheerful hospitality. I thank you for your perfect good will toward me, and give my warmest greetings to master Bartolomeo.

I also beg you warmly, if you can manage it somehow, to get me back the sheets with birds that I lent to Goro. I know it will be no bother to you to ask master Domenico the wood carver to send them back, because I hear that they and everything that was in Goro's hands has wound up in the hands of master Domenico. And also greet him from me, and master Francesco da Valdambrino, and if there is anything I can do here, I am always at your service. That's all I had to say. Christ keep you in peace. Done on April 16, 1425.

By your Lorenzo di Bartolo, goldsmith in Florence, your dear friend.

Jacopo della Quercia Defines the Real Artist

Although this book does not include architects, the praise here given to two otherwise not very notable ones by the great Sienese sculptor Jacopo della Quercia (ca. 1374–1438) probably reveals primarily his own feelings of what was important for artists. To be sure, he would not ask a sculptor to renounce the chisel, and probably exaggerates here for vigor, but he would see hand work as secondary to designing. He is writing from Bologna. Original text in J. Beck, Jacopo della Quercia e il Portale di S. Petronio a Bologna, 1970, 103.

The honorable and noble knight master Bartolomeo di Giovanni Ciechi, administrator of the church of Siena, Siena.

In the name of God, 1428, July 4

The honorable and noble knight, preliminary greetings etc. By your messenger I have received two letters of yours, one dealing with the question of a master for the building and construction you have to get done on the Loggia of St. Paul, telling me of a Sienese master adequate for the work, who must be in this region. For your information, the master, who is known to me, is called master Giovanni da Siena. He is at Ferrara with the marquis, and is planning a very large and strong castle within the city, and is given 300 ducats a year and expenses for eight, as I know for certain; how much he would come there for I can't say, and he is not a master with a trowel in his hand, but a planner and deviser (*ingegnere*).

And it is true there is another master here in Bologna, who is called Fioravante, who has done a very beautiful palace, extremely rich, for the Cardinal Legate, and he did the castle of Braccio in Perugia, and is bright, and fits in with unusual things better than the other, as far as the idea of things goes, and also uses the trowel little, or any other hand labor, but knows how to have his work done very well. I have spoken to him, and think he would go down there, if your Reverences wish, and he knows what I am writing to you about him. . . .

By your servant, Jacopo del maestro Piero in Bologna.

Domenico Veneziano Prepares to Move to Florence

In a generation of great Florentine painters—the list is not exhausted by those mentioned here, but also included Paolo Uccello—one outsider, trained in north Italy, immigrated and was able to compete equally. Domenico was well prepared diplomatically and knew the artistic situation, as we see in his letter to the leading patron in Florence, whom he addresses more obsequiously than Florentines did, perhaps be-

4

cause in north Italy he was familiar with feudal lords. The letter is a unique report of a phase of this very creative period. It is also quite suitably the very first record of the existence of Domenico Veneziano (about 1400–1461). Original text in G. Gaye, Carteggio Inedito d'Artisti, *1839, Vol. 1, 136–37.*

To the honorable and generous man Piero di Cosimo de' Medici of Florence, his honored superior, in Ferrara.

Honorable and generous Sir. After the due salutations. I inform you that by God's grace I am well, and I wish to see you well and happy. Many many times I have asked about you, and have never learned anything, except that I asked Manno Donati, who told me you were in Ferrara, and in excellent health. I was greatly relieved, and having first learned where you were, I would have written you for my comfort and duty. Considering that my low condition does not deserve to write to your nobility, only the perfect and good love I have for you and all your people gives me the daring to write, considering how duty-bound I am to do so.

Just now I have heard that Cosimo [de' Medici, Piero's father] has decided to have an altarpiece made, in other words painted, and wants a magnificent work, which pleases me very much. And it would please me more if through your generosity I could paint it. And if that happens, I am in hopes with God's help to do marvelous things, although there are good masters like Fra Filippo and Fra Giovanni [Angelico] who have much work to do. Fra Filippo in particular has a panel going to Santo Spirito which he won't finish in five years working day and night, it's so big. But however that may be, my great good will to serve you makes me presume to offer myself. And in case I should do less well than anyone at all, I wish to be obligated to any merited punishment, and to provide any test sample needed, doing honor to everyone. And if the work were so large that Cosimo decided to give it to several masters, or else more to one than to another, I beg you as far as a servant may beg a master that you may be pleased to enlist your strength favorably and helpfully to me in arranging that I have some little part of it. For if you knew how I long to do some famous work, and specially for you, you would be favorable to me, I'm certain we won't be wanting in that. I beg you to do anything possible, and I promise you my work will bring you honor.

Nothing else at the moment, except that if I can do anything for you here, command me as your servant, and I hope you won't dislike giving me a reply, and above all inform me of your health, which I desire above all things, and Christ prosper you and fulfill all your desires.

By your most faithful servant Domenico da Venezia painter, commending himself to you, in Perugia, 1438, first of April.

Matteo de' Pasti Checks the Specifications

This is the earliest life record of Matteo (ca. 1420–ca. 1467), an artist endlessly busy in many media—miniature painting, making medals (his most notable area), and, as a builder, executing the plans of Alberti in Rimini. There we also find him lending to the Venetian ambassador his copy of Ciriaco d'Ancona's archeological notebooks. Through all phases of his career, the constants are that he is following orders, is attached to lords' courts, and shows learned curiosity. At this date deluxe illustrations in manuscripts of Petrarch's allegorical poem, the Triumphs, *were just beginning to be made, and notoriously did not follow the text. Thus we see Matteo asking for details (about the content of the painting but not for technical details; he simply informs his patron about that aspect). The query is of special interest, since many historians think that such detailed instructions by patrons were common in the period. This letter shows exactly what was involved, yet it is also notable that it is almost the only such document of its time. Original text in* Il Buonarroti, *Series 2, Vol. 4, 1869, 78–79.*

Most honored and respected master. Venice, 1441, 24th of . . .
I hereby inform you that since I have been in Venice I have learned something that couldn't be more appropriate for your work. It is ground gold, which I paint like any other color, and with it I have started to enrich it so that you have never seen the like. The greens are all touched with the ground gold, and on the ladies I have done thousands of little embroideries. I therefore beg you urgently to send me your notion of the others so that I can visualize them, and if you like I will send you these. So command me to do as you please, since I am ready to obey you in whatever you like. And I beg you to excuse me for what I have done, for you know I was under pressure. So complete it as you wish, and if you like it send me word to do the one of Fame, for I have the concept, except that I don't know whether you want the seated woman in a short gown or in a mantle, as I would like. For the rest I know all that is to go into it, that is, the chariot drawn by four elephants. And I don't know if you want shieldbearers and girls behind, or famous men of the past, so tell me all of it and I will do a fine thing that will make you glad.

And excuse me for everything, and just one of these I am doing now will be worth more than all those done before. So as a favor give me an answer, and be so kind as to let me have something to see, so that then you will see something you never saw in the world before, finished with the ground gold as this will be. My compliments.

Your least servant, Matteo de' Pasti.

Fra Filippo Lippi Duns the Patron

Many documents reflect the vast energy used by artists to collect money and by patrons to collect promised work. Much of it is dull, though it may include information valuable for us.

In the case of this painting another letter from an agent to the patron reports trying to get Filippo to finish, while two more from the patron (the younger son of Cosimo de' Medici) to the King of Naples mention giving the painting to him. Florence was known for the best paintings, as another city might be for silks or swords, so they could serve as diplomatic gifts.

As a sample of this frequent type, Fra Filippo's letter is selected because, mixing obeisance and familiarity, competence and chatter, it exceptionally evokes his individuality best known from Vasari's biography. Original text in G. Gaye, Carteggio inedito, *1839, Vol. 1, 175–76.*

To the nobleman Giovanni di Cosimo de' Medici
Mary Virgin
Dearest superior, etc. I did what you required of me about the panel painting, and set everything to rights. The Saint Michael is so thoroughly finished, that I went to see Bartolommeo Martelli about his armor, which is silver and gold, also the rest of his costume, he said that he would speak with ser Francesco about the gold and what was called for, and I should follow your wishes in everything, and he reproved me greatly, showing I was in the wrong toward you. Well, Giovanni, I am here entirely to be a slave to you, and I will get the work done. I have had fourteen florins from you, and I wrote you the expenses would be thirty, and that that's how things stand, because it's beautiful in its frame, I beg you for God's sake to assign Bartolommeo Martelli as the contractor for this work, and if I need anything to take care of the work, I can go to him and he will see to it, I will do him honor. And I have told him that between you and me he should be my agent, and he says he is willing, and wants to do it, so long as I make haste, and also wants me to write you, and that if you think it good do it, and I will stick to it. For I have no more gold, nor money for the one who is applying it. I beg you not to have to stop, it's three days I have done nothing, and I'm waiting for you.

Also, if you think that for all my expenses, like the thirty florins above, which includes each and every item, all completed, you might give me sixty broad florins, for the wood, gold, applying it, and painting, and as already mentioned Bartolommeo can be what I said, I will have it all finished, to be less bother to you, by the end of August 20 for my part, and Bartolommeo can be my security. And if the expenditure is not so much, I will go along with what it is. And so that you can be well informed I send you the drawing, how it is made in wood, the height and

the breadth*, and for love of you I don't want to take more than a hundred florins from you for labor, I renounce any more. I beg you answer, for I'm dying here, and would like to leave, and if it was presuming to have written you, pardon me, and I will always do, more sometimes and less sometimes, what pleases your reverence. Farewell, July 20, 1457. Frate Filippo, Painter in Florence.

Benozzo Gozzoli's Patron Asks for Revision in His Work

The Medici Chapel frescoes of the Journey of the Magi, the theme of this letter, were the one prominent work of Benozzo Gozzoli (1420– 1497); otherwise he worked in small towns. Here the patron, Piero de' Medici (who even in his father's lifetime seems to have handled all relations with painters) is seen making a minute criticism and wants a change. This is the best document of such a demand by a client and has been cited to show the low status of artists; however, it should be added that the painter did not make the change when asked, but argued back. And the criticized angel seems to be there still, if one can determine which figure it is. (So says the one modern observer who seems to have looked for it.) This also seems the implication of the parallel letter about it from the patron's agent to his master; he says the angels "in my opinion don't look bad, and he will leave them that way until you come back." It would appear that in further discussion the painter won. Original text in G. Gaye, Carteggio inedito, *1839, Vol. 1, 191–92.*

Lord Piero di Cosimo de' Medici, Careggi. July 10, 1459.

This morning I had a letter from your lordship through Roberto Martelli. And I learned you thought the seraphs I had done were not suitable. I made one in a corner among some clouds, of which nothing is to be seen but some wing points, and it is so hidden, and the clouds cover it in such a way, that it doesn't create any bad effect, but rather adds beauty. And that is next to the column. I made one on the other side of the altar, also hidden in the same way. Roberto Martelli saw them and said it was nothing to make a fuss over. Nevertheless, I will do whatever you order, two clouds will wipe them out. I would have come to talk to you, but this morning I began to apply the azure, and it can't be left; it's very hot, and the glue could go bad at any moment. I think in another week I will have finished this level, I think you will want to see it before I remove the scaffolding.

And I also learned you had ordered Roberto Martelli to give me what was necessary; I had him give me two florins and they will do for

* Below: a quick sketch, marked "five feet high, six feet wide."

now. I keep on working as much as I can, what I do not do will be left through not knowing. God knows I have nothing on my mind that weighs on me more than this, and I am constantly looking for methods, so I can do something I can satisfy you with, at least in large part. Nothing else for now. I commend myself to your lordship. Your servant,

Benozzo di Lese, painter in Florence.

Cossa Claims Better Pay for a More Outstanding Artist

This letter documents an early Renaissance transition. The patron, the Duke of Ferrara, paid all his artists the same, by the square foot. He was in an older tradition which bracketed painters with other craftsmen in an anonymity that might still apply today to a skilled plasterer or the like. Cossa wants more because he has an individual reputation and a name. The almost feudal north Italian courts were old-fashioned about this compared to merchant cities like Florence. In them an individual entrepreneur could succeed in this way with painting as he might in a silk shop; the rise of the artist's individuality was indeed a function of a capitalist value system. Even in Ferrara a rare artist might be famous, such as Pisanello, who is praised by poets in epigrams. After Cossa lost his appeal, he left and had a brilliant career (with poets' praises) in Bologna, but the frescoes for the Duke of Ferrara, in the summer pavilion at Schifanoia, remain his greatest work. Original text in E. Ruhmer, Cossa, 1959, 48–49.

Most illustrious Prince and Excellent Lord my most particular Lord: I recently petitioned your lordship along with the other painters about the payment for the room at Schifanoia, to which your lordship answered that the account was persistent. Illustrious prince, I do not wish to be the one to annoy Pellegrino de Prisciano and others, and so I have made up my mind to turn to your lordship alone, because you may feel, or it may have been said to you, that there are some who can be happy or are overpaid with a wage of ten pennies. And to recall my petition to you, I am Francesco del Cossa, who have made by myself the three wall sections toward the anteroom. And so, illustrious lord, if your lordship wished to give me no more than ten pennies per foot, and even though I would lose forty to fifty ducats, since I have to live by my hands all the time, I would be happy and well set, but since there are other circumstances, it makes me feel pain and grief within me. Especially considering that I, when after all I have begun to have a little of a name, should be treated and judged and compared to the sorriest assistant in Ferrara. And that my having studied, and I study all the time, should not at this point have a little more reward, and especially from your lord-

ship, than a person gets who had avoided such study. Surely, illustrious lord, it could not be that I would not feel grief and pain. And because my work proves what I have done, and I have used gold and good colors, if they were of the same value as those who have gone ahead without such labors it would seem strange to me, and I say this, lord, because I have done almost the whole work in fresco, which is a complex and good type of work, and this is known to all the masters of the art. All the same, illustrious lord, I put myself at your lordship's feet, and I pray you, if your objection should be to say: I don't want to do it for thee because I would have to do it for the others, my lord, your lordship could always say that the appraisals were this way. And if your lordship doesn't want to follow the appraisals, I pray your lordship may wish to give me, if not all that I perhaps would be entitled to, then whatever part you may feel in your grace and kindness, and I will accept it as a gracious gift, and will so proclaim it. My compliments to your illustrious lordship. Ferrara, March 25, 1470.

[Annotated by the Duke:] Let him be content with the fee that was set, for it was set for those chosen for the individual fields.

An Engraver in Dispute with Mantegna

In reading this letter by an otherwise unknown writer, one may first be struck by the extreme vehemence of Mantegna's actions. Though it does not seem reflected in his art, it is on record in his life in violent arguments with his neighbors and others about property. This dispute seems to be about artistic property. Since many known works of Zoan Andrea, the other engraver mentioned, are based on Mantegna designs, it seems likely that we have here a very early case of an artist's trying to prevent his work from being copied; this may have been in order to dissociate his reputation from second-class work (not likely, since Zoan Andrea signed the engravings which he did after compositions by Mantegna) or to ensure that he earned something from the sales (a concern foreshadowing the modern problems of piracy and copyright). It is an aspect of the emergence of the modern artist whose career is heavily dependent on his originality, in contrast with the medieval preference for anonymous repetition (including German engraving in Mantegna's time, intended to be copied as much as possible).
The Marquis of Mantua gave Simon a safe conduct to tell his story, but after that the records stop. Original text in P. Kristeller, Andrea Mantegna, Berlin, 1902, 530.

The most illustrious and excellent lord, Lord Lodovico Marquis of Mantua etc., my most especial lord, Mantua.

I make bold to inform your lordship of how I have been treated in your city, and to let you know my name is Simone di Ardizoni from Reggio, painter and engraver with the burin. When I came to Mantua Andrea Mantegna made me big offers, presenting himself as my friend. And since I had long since been a friend of Zoan Andrea, painter in Mantua, and he told me when we were talking that he had been robbed of prints, drawings, and medals, he moved me to pity that he had been so badly treated. I said I would do these prints over, and I worked for him about four months. When the devilish Andrea Mantegna found out I was doing these prints over, he sent a Florentine to threaten me, saying I would pay for it. And besides that, one evening I was assaulted by the nephew of Carlo de Moltone and more than ten armed men, Zoan Andrea and I, and left to die, and this I can prove. And again, to keep the work from continuing, A. M. found some ruffians to do his bidding and they accused me to the criminal court of being a sodomite, and the one who accused me is named Zoano Luca of Novara, the notary who has the accusation is a relative of Carlo Moltone. Being a foreigner, I had perforce to flee, and I am now in Verona to finish these prints. [He appeals for justice] for I believe I have gone to forty cities and nothing was ever said against my good name, only now Andrea Mantegna with his arrogance and rule of Mantua, and if your lordship does not restrain him he would be the cause of great scandals arising, and I humbly commend myself to your lordship.

15th [September 1475] Simone de Regio

Mantegna Offers Technical Options

The twenty-five surviving letters of Andrea Mantegna (1431–1506) are more numerous than those of any other artist of his time or earlier. They are all addressed to his patrons, for the most part the marquises of Mantua, and their survival is of course due to the relative permanence of state archives. Yet since other court artists have not left such records, Mantegna's letters may be thought of as an aspect of his personality, that of an especially intellectual and systematic artist.

In the first letter chosen here, we see him cooling the marquis's pressure for speed, and in the process telling us about his working habits. (Several paintings by Mantegna on thin canvas, otherwise a rarity in Italy, survive.) Other sources suggest that he preferred to avoid small-scale work and portraits, and since the latter were basic to court art at the time, their rarity in his work suggests a notable freedom in getting his way. (See p. 132 on his avoidance of portraits, and p. 139 on the dominance of portraits at the court of Milan.) Original text in P. Kristeller, Andrea Mantegna, *Berlin, 1902, 534.*

Most illustrious and excellent my lord, after the compliments due, I inform your excellency that, as you wish these portraits done, I do not understand, since your excellency wants them so quickly, in what manner they are to be done, in a drawing only, or in color, on panel or on canvas, and what size. If your lordship wants to ship them far away, they should be done on thin canvas so that they can be wrapped around a little pole. Further, as your excellency knows, one cannot do something well from life if one has no arrangements for seeing it! Your excellencies are out of the territory. I will await the instructions you wish to give, I will wait to hear, and to have either little panels or little canvases so I can begin the portraits. My compliments to your illustrious lordship. July 6, 1477 Your excellency's follower Andrea Mant.

Mantegna Writes Home from a Trip

Most of Mantegna's letters are money complaints, and so is this one in part, but it is unique in also showing why he was good company. At fifty-eight, at the peak of his career, he was lent by his marquis (who made him a knight to boot) to the pope, who had begged for him to do some work. The frescoed chapel he did was intentionally destroyed in a later remodeling of the Vatican, in the Age of Enlightenment. His account of the Turkish prince who was the pope's prisoner has been discounted because of exaggeration, but it is the only vivid source we have about this exotic figure, who was obviously fascinating to all, and recalls the paintings of Turkish people by Carpaccio and Gentile Bellini. Original text in P. Kristeller, Andrea Mantegna, *Berlin, 1902, 546–47.*

Most illustrious and excellent my lord, after the cordial compliments. The fame of the illustrious House of Gonzaga fills all Italy, especially here in Rome, in connection with the honors done and received by your lordship. So I rejoice and congratulate you eternally, shouting loud Gonzaga, Gonzaga, Turk, Turk, Mark, Mark.* And also hoping, or rather being certain, that your excellency will prove no less than all the lords of that house. And God lend me life to see you, as I wish with all my heart. At present I am happy, and regard that as a good beginning, hoping for a good middle and a very good end. With my few attainments, as a member of your excellency's household I do you honor with all the powers of my weak wits. And, for love of your excellency, I am well regarded by His Holiness and all the court. It is true I have nothing but expenses, and have never had any other recompense, not even a trifle, nor

* The Marquis was nicknamed "The Turk" and was general of the armed forces of Venice, whose patron saint is Mark.

would I ask for one, since my aim is to serve your lordship. And so I pray you not to forget your Andrea Mantegna, and not let him lose his salary, granted me so many years ago by that illustrious house, for things could not go well if I had nothing either here or there. So my Lord, I put it to you strongly that it is needed.

Of my situation and concerns I believe your excellency is informed. The work is a big one for one man alone who would have honor, most of all in Rome where there are so many worthy judges. And so, as with Barbary horses, the first gets the ribbon, and I must get it finally, if God wills. So again I commend myself to your excellency.

The Sultan's brother is here in his Holiness's palace, very well watched. His Holiness gives him a lot of diversions of various kinds, hunts, singing, instruments, and so on. He often comes to eat here in the new palace where I am painting, and has good manners of the Barbary kind. He has a certain proud majesty, and never takes off his cap to the pope, and since he doesn't, so by the same token nobody takes off his cap to him. He eats five times a day and sleeps just as many, and before meals drinks water, with sugar in it for his monkey. After eating, he plays the drinking-glass trumpet [drinks heavily], and when he does that he drops all formality, he is dry inside, not just like wheat or barley but like a Venetian keg. He has one eye that is a trifle twisted, and often keeps it shut. When he opens it, he has something of our Fra Raffaele, he acts the great man when he has nothing. His way of walking is like an elephant. His people praise him greatly, they say especially that he rides well. That may be, I have never seen him take stirrup or try anything. He is an extremely cruel man, he killed four men over there, and according to what they say, they didn't die for four hours. One day recently he hit his interpreter many blows, so severely that they had to carry him to the river to revive him. You would imagine Bacchus visits him often. In short, he is feared by his people. He takes little heed of all about, like one who does not understand and has little judgment. He lives his own way, he sleeps dressed. He gives audience sitting tailor-fashion, with crossed legs. On his hat he wears thirty thousand yards of Lodi cloth, and a pair of hose so wide that they make him take a set pose in them and he can't be seen, and the whole company is struck dumb. When I see him I will immediately send your excellency a drawing. I would send it now, but I haven't quite got it yet, because sometimes he looks one way, sometimes another, like a man in love, so I can't get it from memory. In short, he has a fearful face, especially when Bacchus visits him. I won't bore your excellency any more with this joking and familiar writing of mine. Again I commend myself to you, and pardon me if I am taking liberties.

The New Palace of the Pope, June 15, 1489. Your underservant, Andrea Mantegna.

Mantegna in His Last Days

Writing to Isabella d'Este, Marchioness of Mantua, that remarkable patron of artists and planner of elaborate projects for her surroundings, Mantegna is still seeking money. He had reason, for his patrons often were behind with his salary, and in this case Isabella answered that she would make the purchase but could offer only a down payment. As he offers to sell her his most notable possession, the ancient Roman head of Faustina, the pathos is increased when we realize that this is his last preserved letter and that he died later in the same year. It may well be that he was thinking of how to allocate his possessions, and thought his heirs would not dispose so well of this treasured centerpiece in his collection. Original text in P. Kristeller, Andrea Mantegna, Berlin, 1902, 577.

My most illustrious lady. After humble and heartfelt compliments. As I find myself a bit improved at present, by God's mercy, even though I don't have all parts of my body back to their former state, I have not lessened that small quantity of talent God gave me. It is at your excellency's command, and I have almost finished drawing your excellency's story of Comus, which I will continue when my imaginative faculty helps me. My most illustrious lady, I commend myself to you, because for many months I have not been able to secure a penny. I find myself in need especially at present, since I was hoping things would not be thus and I find myself overwhelmed. This is because, after I bought a house for 340 ducats to be paid in three installments, to keep from wandering here and there, the installment date is passed, so I am being pressed by my creditor, and as your excellency knows it cannot be sold or mortgaged. And I have other debts too, quite a lot, and it came into my head that the best way I could help myself was with my dearest possessions, since I have often been asked, by various persons at various times, to sell my dear ancient Faustina of marble. And through necessity, which causes many things to be done, I wished to write your excellency because, having to let it go, I would rather you have it than any other lord or lady in the world. The price for it is 100 ducats, which I could have had several times from notable persons. Please do let me know your excellency's intention, and I send infinite compliments.

Mantua, 13th, 1506 [month omitted]. Andrea Mantegna, your servant.

Francesco Mantegna's Political Cartoon

Andrea Mantegna's two sons were both named for his patron marquises of Mantua and he hoped they would be artists, with very modest results. Here Francesco points out what we might not otherwise have

guessed to have existed in this period, an attack on a political enemy through caricature of his looks. The King of France had just invaded Italy, and the marquis led the army opposing him. The crudity of the caricature recalls that at this date Richard III of England was mocked as a hunchback. Such imagery implies realistic portraiture as the base with which it makes a contrast, and so can only arise in an age which, like the Renaissance, has developed such portraiture. At this time Leonardo was making drawings of deformed faces, the subject of much debate as to whether they are caricatures or records of actual afflictions. Original text in P. Kristeller, Andrea Mantegna, Berlin, 1902, 555–56.

To the most illustrious and unconquerable prince and lord, Lord Francesco de Gonzaga Marquis of Mantua, his most liege lord, etc.

Most illustrious and unconquerable prince and my most particular lord, etc. Since I have heard from some people about the most serene king of France's appearance, and how greatly deformed it is, with the large eyes popping out, and faulty in the large aquiline misshapen nose, with few thin hairs on his head, the amazement of the image of such a little hunchbacked man made me have a dream about it. Whereupon, when I got up, what I quickly did I send to your excellency, to whom I constantly commend myself. And I pray that, if you please, I may stay and work at Marmirolo, if you deign to give me enough to live on and serve your lordship until the map of the world is done. And then, if you do not want to give or provide anything for me I will always consider myself satisfied with your excellency, to whom I commend myself again.

Mantua, October 12, 1494. Your servant Franciscus Mantinius.

Giancristoforo Romano Abandons Some Marbles for Some Others

This letter to Isabella D'Este, like Antoniazzo's below, instructs a patron how to do preparatory work when the artist is at a distance and cannot do it as usual, and thus reveals working method. The wariness in choosing marble helps to explain why, for instance, Michelangelo spent such a long time at the quarries. Perhaps even more revealing is the description of what degree of responsibility is given to unsupervised assistants. The participation of assistants is constantly studied in the art of this period, and proposals are offered, but rarely with evidence. The validity of this evidence is not reduced by the fact that the sculptor did not do Isabella's bust. Original text in Archivio Storico dell' Arte, Vol. 1, 1888, 52–53.

To the most illustrious and excellent lady, my honored Lady the Marchioness of Mantua

Illustrious and excellent my honored Lady. This morning the Lord young marquis let me know that he had had letters from the most illustrious lord Lodovico, determining that I should come to your ladyship to do the portrait of your ladyship, and charged me to begin the trip and come to you. And since I have the work for the young marquis on my hands unfinished, I answered him that it was not possible that I should leave at present, until certain marbles have arrived that I expect; when these have arrived, I will leave the drawing with my workers. Thus no time will be lost and I come to satisfy your ladyship. And so he was in agreement that I should come at once when these marbles have been delivered.

In the meantime your ladyship can send to Venice and have two pieces of marble shipped, which should be just three feet long and two wide, and one and a half thick, each of them, because if one should be no good, the other can be taken. And it should be bought by a man who understands the nature of these marbles, and they should be white, and not be burnt and not have any hairline cracks, or black veins. And as soon as these marbles have arrived, your ladyship can have a line sent to master young marquis, and I will come flying right away, and in the meantime give the orders for this work of the young marquis so as to lose no time in satisfying your ladyship, to whom I commend myself always.

Milan, July 1, 1491. Your servant, Giancristoforo Romano.

Antoniazzo Romano's Preliminaries for a Fresco

The time which was allotted by artists for phases of projects is often the subject of elaborate guesses. This letter is a rare record of what went on, which we owe to the patron's distance and his inexperience. Venice as a source for the best colors is on record elsewhere, as is the patron's obligation to pay separately for them and scaffoldings. Scaffolding along a single wall may come as a surprise. Seasonal interruption of fresco painting during cold weather, insufficiently understood though well established (see p. 109 for a reference in 1410), is seen to be unnecessary in a castle hall, which of course had fireplaces. Suspension in December and January of work in a church, such as on the outdoor fresco here, is recorded in 1530 in the diary of the painter Pontormo. Antoniazzo's outdoor frescoes survive today, in poor condition, in the Castle of the Orsini family at Bracciano. The patron, Virginio Orsini, was the head of this powerful old feudal family. Original text in L. Borsari, Il Castello di Bracciano, 1893, 23 ff.

My most illustrious lord: the other day master Francesco came to see me, to tell me he was back from Venice because he had bought all the

colors your most illustrious lordship had ordered him to buy. And he urged me strongly to come to begin the work. I answered him that I was very ready, and wanted nothing night and day but to come and see your illustrious lordship.

So I send word to say, may it please you to have a scaffolding made at the arch [at the castle gate] and another in the room, covering one wall of the room complete. Since I am held back by the present great cold and ice, the plaster and the work I would do on the arch would freeze, and your illustrious lordship would not be served by me very well. So I decided during the freezing period to work and paint in the room, and when nice weather comes and the plaster could not freeze, to work on the arch, and give the arch the priority when weather permits. So, now that your lordship has heard the specifications, I beg you may be pleased to hurry the scaffolding in the above-mentioned places as soon as possible, and when they are done, if you will be so good as to send me a short note, I will come at once with my crew of workmen, because, if the scaffolding were not made, all my workmen that I would bring with me would lose time, and I would incur no little damage. Nothing further, except my compliments to your most illustrious lordship, whom God ever preserve in prosperity and happiness. Farewell.

Rome, Jan. 1, 1491. Your very humble servant, Antoniatus painter.

Antonio del Pollaiuolo Remembers His Youth

This is the only surviving letter of the great painter and sculptor Pollaiuolo (1431–1498). Though he alludes to a new project—not otherwise known to us—his concern, like ours in reading, is more with his past achievements. The Hercules paintings, surviving in a small version, are his most brilliant early work, while his tomb of Pope Sixtus IV first established the tradition of extreme elaboration and luxury that became standard thereafter in papal tombs. Its success led to his doing the tomb of the next pope, in process at the time of writing. The real theme of the letter is his confidence that his patrons prize his work and he can base his behavior on that fact. He was indeed a grand old man who could look back on his ever-rising success with contentment. The letter is written to the same Virginio Orsini addressed by Antoniazzo in the preceding letter. Original text in M. Cruttwell, Antonio Pollaiuolo, 1907, 256–57.

July 13, 1494. My most illustrious and generous lord, I take the liberty, feeling assured of your graciousness, since chance has not allowed me to talk to you. A proposal was made to me orally by Mister Agnolo the doctor, when I was at Ostia; he said on your behalf that your lordship would like to have a head of your lordship in bronze, life-size. I

answered at once that I would do it with pleasure, and so I repeat that I will come to stay two days at Bracciano, and will make a rendering of you in a drawing. Then I will return to Rome and do it in bronze. But I would have liked it better to do you complete on a big horse, and I would make you immortal. We can do the head first, then we will think of the whole.

Your lordship's highness, I will leave on Monday, which will be July 14, and go to Tuscany, taking along two bronze figures, and I want to go to my property which is fifteen miles from Florence. On account of the epidemic it has been established that people coming from Rome cannot go closer to Florence than twenty miles. I would like your lordship to [write] on my behalf to Piero de' Medici, if he would be agreeable to my having permission to go to my property, between Poggio a Caiano and the city of Pistoia. I think he will agree readily, because he knows I have always been attached to his family, and just think, it is thirty-four years since I did those labors of Hercules that are in the great room of his house, which my brother and I did between us. I know you must have seen them.

[A request to press one master Manfredi, in Orsini's service, to repay a small debt owed to Pollaiuolo's nephew.] I beg you to pardon me if I take liberties with your lordship, out of my great affection, and hearing that my work pleased you in the tomb of Pope Sixtus.

Your servant Antonio del Pollaiuolo in Rome.

2

The Artist

in

Formal Records

A Contract to Paint a Ceiling and a Wall

It is sensible to paint a room from the top down, and knowing this routine helps to settle dates of series of frescoes. But to assume the practice never varied ignores glaring exceptions from Cimabue to Michelangelo. The following documents interestingly prove the norm (which like many norms was usually not put on record), because they contract with two artists at once and specify that the ceiling painter is to work first. The wall painter, obviously more favorably treated, received money soon after he had begun and before the ceiling painter got his due (a warning to us not to link payment dates to work dates). The contract is also evidence on the extent to which patrons gave instructions about subjects and iconography. The vault painter's promise to have his figures follow the form of an older vault does not involve such instructions, as we might assume from such a clause, were it not for the survival of both vaults (he painted virtues, the older vault had angels). The same presumably applies to instructions to the wall painter to follow the form which will be assigned to him. However, he is to follow a paper in one specific scene, which in fact has a different imagery from his standard repertory compositions. Thus, instructions are needed in the exceptional instance. The documents are a notary's record of the agreement. Original text in G. Milanesi, Documenti per la storia dell'arte senese, *1854, Vol. 1, 30–32.*

1407, June 18. Assignment of the painting of the New Room (of the City Hall of Siena).

Master Martino, painter, son of the late Bartolomeo, hired out to paint all four vaults of the New Room of the Palace of the Lord Priors, down to the moldings at the end of the said vaults, in good and suitable colors, with as many figures as are painted in the other four vaults of the chapel of the palace, and like them in workmanship, manner, and form, and all expenses for colors and everything else being master Martino's, except the plaster and scaffoldings, which are to be at the cost of the city of Siena, and not of the said master Martino, and with the condition that he does not have to put gold on the panels, but instead of gold can put tin, and for all this he is to have from the city of Siena forty-four Sienese gold florins. And he promised to have done the whole work and have it finished by the end of February next.

Master Spinello son of Luca, painter of Arezzo, hired out himself and his labor to paint all the rest of the said New Room, which he promised and is obligated to paint with such figures and stories, and in the manner and form in which he will be directed by those in whom the authority lies or with whom it may lie. And he promised to be at work continuously in the said painting, and to have [blank] his son with him,

until they are fully completed. And he must do these paintings with all expenses for colors, scaffolding, and everything else at the cost of the city of Siena, so that they shall furnish nothing but their persons only. And between the two of them they are to have a salary each month of fifteen gold florins, and to begin this work on the first of March next at the latest; they are not bound before then. And besides the said salary, they are to have, for both, the costs of leading their lives comfortably morning and evening, at the expense of the city. More about the conditions and hiring is on record in the hand of me the below-named notary. [Later documents:] April 4, 1408: The administrator of the chamber may lend to master Spinello, who is painting the New Room, twenty gold florins from the money allocated for doing this painting.

April 29: The administrator pays to master Martino the painter son of Bartolomeo, forty-four florins due him for the painting done by him on the vaults of the New Room.

July 11: It was decided that master Spinello the painter should paint the story of the naval battle of the Venetians with the Emperor Frederick as it is set forth in that paper which Betto di Benedetto made available.

Subsidy for the Education of Artists

It is generally assumed that in the fifteenth century, the training of artists was by apprenticeship, and that during the next century this system was gradually replaced by the academy with an employed teacher. The different pattern seen here is not easy to understand. It is generally supposed that apprentices were exploited and thus profitable to masters. Why then did the master who speaks here not seek them on his own, claiming instead that he could not afford them? If it was because he had so little work that he could not keep apprentices occupied, why would the city be willing to pay him to teach them? Perhaps the city hoped such an investment of a little money in the very high skill of this artist would be repaid by firmly attaching a skilled craft specialty to the city, bringing in jobs. It is not merely disguised charity to a local man past his prime (in 1438 the same system was arranged with a tapestry weaver of German origin), nor is it limited to rare minor arts (the painter Vincenzo Foppa made a similar arrangement with the city of Brescia in 1489). In any case, the pupils, if only because the masters were responsible for them even when not busy with commissions, evidently would have more instruction and less labor than usual for apprentices, and thereby suggest a transition to the later academy. Original text in G. Milanesi, Documenti per la storia dell'arte senese, 1854, Vol. 2, 103–104.

Siena, May 13, 1421.
Lords and potent master priors and Captain of the People of the

City of Siena, it is reverently brought before you by your least servant, the master of woodwork Domenico di Niccolo, who is making the choir of your palace, that it has been said to him many many times by some of the honored citizens of our city and others too, that considering the grace God has given him in carving and inlaying, as is known to all, he would do well for his own honor and the city's good to have an apprentice with him who would see and learn from his skill. And in truth, my lords, although he always answered that if he could he would willingly do it and teach everyone what he knew, he has been reviled and poked fun at by some of these citizens, who say: he is behaving like all the rest, he doesn't want anyone else to know his craft. And since he has been reviled in this way through no fault of his own, because this happens through lack of possibility rather than lack of will, he decided to have recourse to your lordships, especially since, as is known to all, he is not the sort who can hide his powers from anybody, rather it would be a particular pleasure to him to be able to share it and teach the gift God has granted him, if it were possible to sustain such a burden. But since it is known to your lordships that he is your poor servant, and his family is unprofitable and a cost, as girls are, and they know that to keep apprentices to learn, they ask for thirty and forty florins each a year, and he could not sustain such a burden. Nevertheless if he were aided, he offers himself to your lordships as willing to keep two or three apprentices with him, and teach them what he knows of his craft, and he wishes to be bound to this if your lordships may please to provide him with a little salary so that your servant can support himself and maintain himself. [A final paragraph reiterates the above.]

1421, May 13, it was decided by the priors and the captain of the people to put it to the council of the people, with this limitation and condition, that the said master Domenico have from the tax office annually as a salary 200 pounds tax free, on condition that he continuously keep two or three youths to teach them the said art, as he offers, and that they be of the city and commune of Siena. [On the same day it was approved by the Council.]

The Fistfight in Gentile da Fabriano's Yard

This document is a vivid corrective of any thought that vandalism or juvenile delinquency is a growth of modern conditions; a distinguished temporary resident in Renaissance Florence also had to cope with it. The great Gentile da Fabriano (about 1375–1427) was then working on his famous altarpiece of the Adoration of the Magi, which he signed and dated May 1423. It is debated whether or not the assistant involved is his famous pupil Jacopo Bellini, who soon after named his own son Gentile. Jacopo's father's name is different here, but that could be a common

mistake. A more serious argument against identifying the assistant with Bellini is the report here that after the fight Jacopo happened to sign up as a sailor, not likely for a professional painter like Bellini; however, we may suspect that this was not quite true, and that he was actually escaping until the excitement died down. Since it is not as likely that Gentile had two loyal assistants named Jacopo of Venice, the identification with Bellini is usually considered probable. Original text in A. Venturi, editor, Le vite scritte da Vasari, Vol. 1, Gentile da Fabriano, 1896, 11–12.

Minutes of the Florence City Council, April 3, 1425.

It is respectfully set forth before your noble and potent lordships, the lord priors and bannerman of justice of the people and city of Florence, on behalf of Jacopo son of Piero, painter of Venice, that under the name of Jacopo of Venice, employee and pupil of master Gentile of Fabriano, painter, living in the parish of S. Maria degli Ughi of Florence in the house and dwelling of the said master Gentile, on September 2, 1423, he was condemned by Romano dei Benvenuti of Gubbio, then chief judge of Florence, in the sum of 450 lire to be given to the city treasurer, and one-quarter more if not paid in one month from the date of sentence. And this proceeded from the fact, as told in the verdict, that the said Jacopo, intending to commit the offense named below, armed with a certain wooden stick, an object suitable for committing the offense, hurtfully and deliberately assaulted Bernardo the son of lawyer Silvestro the son of master Tommaso notary and citizen of Florence, of the parish of S. Trinita, and wielding the said stick several times, struck the said Bernardo one blow on the left arm, not drawing blood, against the wish of the said Bernardo, as set forth and written, with other things, in the said verdict, by lawyer Antonio son of Francesco of Gubbio, public notary, and then the notary for crimes of the said judge.

And that, whatever may be said in the verdict, the truth was that, when the said Bernardo with certain others threw stones into a certain courtyard of the said master Gentile, where there were certain sculptures and paintings of the highest importance, Jacopo, on instruction of the said master Gentile, remonstrated with the said Bernardo, saying: "Thou art certainly doing an ugly thing to be throwing, since thou'rt as big as a man now." Angered by those words, Bernardo shouted many insulting and ridiculing words at him, offering to fight with him. And Jacopo, impatient with the treatment, answered yes, and so they fought each other with their fists, with their hands empty, and no other type of blow took place. And Jacopo, thinking no condemnation could result from the mentioned things he had done, went on your ships in the service of your city. And the said Silvester, seeing the said Jacopo was away, denounced him to the said judge, who was an associate of his, and easily believed what

he said, and against all justice condemned the said Jacopo unknowing of the inquiry and unable to defend himself. And after a while when the ships returned to your port, still knowing nothing of the said condemnation, he freely returned to this your happy city. And a few days after he had returned in this way he was seized. And then on October 24, 1424, he was ordered to be jailed. . . . And that on November 24 he made peace with the above Bernardo, as appears in the attached notarial document. . . . And that he is extremely poor, and sees no way to be relieved of his misery unless by the mercy of your lordships . . . wherefore he has decided to beg for the following grace as an alms . . . wherefore he petitions that on the coming Easter Day the said Jacopo may be presented at the church of St. John the Baptist, and in the usual manner be led with bare head with a torch in his hand at the usual hour with trumpets going before, and so through the method of offering obtain absolution and freedom from prison. [Petition approved on April 2, and passed by the public assembly by a vote of 202 to 5.]

Donatello's Bookkeeping, 1427

A new tax law in Florence in 1427 required every family head (except the very poor) to write a declaration of his property, debts and credits, and family status, including the ages of everyone in his household. (There were deductions for aged and children.) It provides us with a unique basis for assembling information about all the people of one city in that period, since the entire file still exists. For individuals, such as artists, it tells us a great many things, beginning with birth dates, which prior to this are generally unknown.

Besides other insights, Donatello's return records two works for which he was the creditor, including the famous bronze relief of The Banquet of Herod for the overseers of the Cathedral of Siena. He had evidently taken over this commission from the procrastinating Jacopo della Quercia and so owes him a part of the fee. Donatello's partner, Michelozzo, prepared the declaration, and their tomb of Pope John XXIII appears on his. (An English translation of Masaccio's declaration in this same year is available in L. Berti, Masaccio, 1967, pp. 36–37; a condensation of Ghiberti's is in R. Krautheimer, Ghiberti, 1970, p. 410.) Original text in Rivista d'Arte, Vol. 19, 1937, 186ff.

July 11, 1427, before you, the lords officials of the tax of the people and city of Florence, this is the property and obligations of Donato son of Niccolo son of Betto, carver, assessed in the Santo Spirito quarter, in the ward of the Shell, as owing 1 florin, 10 shillings, 2 pence. Without any property except a few household goods for personal and family use.

I practice my art together in partnership with Michelozzo di Bartolommeo, with no capital, except 30 florins worth of various tools and equipment for this art.

And from this partnership and shop I gain my property and in the manner that is shown in the declaration of the property of the said Michelozzo, in the San Giovanni quarter, in the ward of the Dragon, under the name of Leonardo di Bartolommeo and brothers. Also, I am owed by the Cathedral administrator of Siena 180 florins on account of a narrative scene in bronze, which I did for him some time ago. Also, from the convent and monks of Ognissanti I am owed on account of a bronze half figure of Saint Rossore, on which no bargain has been set. I believe I will get more than 30 florins from it.

I have the following family in my house:

Donato, aged 40

Madonna Orsa, my mother, 80

Madonna Tita, my sister, a widow without dowry, 45

Giuliano, son of Madonna Tita, crippled, 18

I rent a house from Guglielmo Adimari, on the Corso degli Adimari, in the parish of St. Cristoforo. I pay 15 florins a year.

CREDITORS

To Master Jacopo di Piero, carver, of Siena, on account of that narrative scene for the Siena Administration, as shown, 48 florins.

To Giovanni Turini, goldsmith of Siena, for time he took on that scene, 10 florins.

To the Cathedral Administration of Siena, 25 florins for gilding that scene, at their request.

To Sandro Mantellini, 35 florins, as shown in his book.

To Guglielmo Adimari, 30 florins for two years back rent on the house I live in.

To Giovanni di Jacopo degli Strozzi, 15 florins for a figure of Saint Rossore he cast for me several times in his kiln, and other things.

To various people for various reasons, small sums, 15 florins.

To debt to the city of Florence for old assessments from '11 to '24, and for all of a new assessment, 1 florin.

I Michele di Bartolomeo, goldsmith, have done this writing at the request of the said Donato.

A Work by Donatello Is Rejected

Since artists' contracts routinely contained an escape clause, allowing the patron to reject work not to his satisfaction, it is natural to wonder what might have happened if it had been invoked. It is rare to

find such an action recorded, and it is more surprising that it happened to Donatello, at the height of his career in 1434. The record tells how it was done, but not why (that would be too much to hope). Many possibilities can be ruled out: the clients did get along with the artist (they hired him again later), they were not reducing the scale of the project (they at once hired another sculptor to do the same job), nor is it likely they were annoyed if the work was done by the hand of one of the master's associates (their substitute sculptor was of similarly lesser fame). The possibility that it was an actual aesthetic dislike is supported by the fact that the work by Donatello most comparable to this lost work, the doors for the sacristy of San Lorenzo in Florence (also bronze, also reliefs, of about this time, and with imagery of just about the same scale) is precisely the one work by Donatello that drew strong negative criticism in its time, from Filarete and others. The fact that the clients did give Donatello some money might reflect either disagreement in the committee or worry that their rejection might be hard to justify if Donatello made difficulties. Original text in G. Milanesi, Documenti per la storia dell'arte senese, *1854, Vol. 2, 159ff.*

Deliberations of the Administrator and Counselors of the Cathedral of Siena, August 18, 1434.

The aforesaid administrator and counselors, except Andrea, being duly assembled etc., there appeared before them Pagno di Lapo, assistant of Donato di Niccolo of Florence, and requested on behalf of the said Donato the settling of the accounts of the money that the said Donato has had from the said Administration and of the jobs he has done for the said Administration, which settling is reasonable and owing. [The first item is to balance his advances received, 738 pounds 11 shillings, against work delivered, for 720 pounds.]

And since Donato, after this is subtracted, remains obligated to the extent of 18 pounds, 11 shillings, and considering that the said Donato made a little door for the said font also of gilt bronze, which did not turn out the way the administrator and counselors liked, and wishing to be reasonable with the said Donato and not make him suffer all the damage, which seems right and proper, so that he will not have lost all his time and labor, they formally decided that the said Chamberlain should pay from the money of the Administration without prejudice 38 pounds 11 shillings, in which sum should be included the said 18 pounds 11 shillings owed by Donato to the Administration as the balance of the sum mentioned, and that the said door be freely made over to the said Donato. And the said Bartolomeo, the Administrator, gave and consigned the door to the said Pagno di Lapo, who received it for the said Donato, in the presence of the notary and undersigned witnesses etc.

Jacobello del Fiore's Property Is Auctioned

Since auction lists are ephemeral pamphlets, the survival of any from 1439 is remarkable, and that it should be of the estate of the leading painter of Venice is more interesting still. Understandably, it is hard in a list with no context to understand many of the words for special kinds of objects, and the system of the sale, divided into a startling number of days. Only a fraction of the list has even been published, and here a small selection of the most interesting items is translated. Of course it is not the equivalent of an inventory of an estate (see one of these on p. 42) but of specially valuable objects likely to attract buyers. As such, it may modify ideas on the living standards of artists, for Jacobello, the most successful painter of his city, clearly surrounded himself with pleasant things. Original text in P. Paoletti, Raccolta di documenti, *1894, 6.*

First sale, November 8, 1439
 one easel, tin
 one parrot cage
 one red curtain, with gold
 one overcoat
Second sale, November 11
 one panel with Our Lady
 one clock
 one square candlestick with eagles in relief
Fourth sale, November 30
 one vermilion shawl, embroidered
Fifth sale, December 6
 one panel in relief with Our Lady
 Master Jacopo Bellini, one intarsia panel
Sixth auction, December 30
 one chest
 one panel
 one head of St. Anthony
Seventh sale, December 31
 one glass cup
 one enamel
 one porcelain goblet
 one mosaic panel
. . . April 24, 1440
 one porcelain goblet
 one basin, silvered
 one glass mirror

Jacopo Bellini in a Partnership Agreement

Partnerships among painters were frequent. To the modern reader the limited duration may be surprising, but this characterizes economic life generally in this period; there was no such thing as an immortal corporation. The purpose of partnerships was not necessarily to save on costs (the partners often maintained separate workshops) or to have an older, successful painter take on a younger one (these two painters seem to have had similar status). Like some medical partnerships today, the main idea seems to have been that when one partner was too busy for new commissions, he could direct them to the other and still receive income. But the benefits were uncertain, as suggested by the fact that this partnership was canceled before it went into effect. Original text in P. Paoletti, Raccolta di documenti, 1894, 7.

1440, September 24. Master Donato, son of the late lawyer Giovanni Bragadin, of the district of San Giovanni, of the first part, and Master Jacopo Bellini, son of the late lawyer Niccolo Bellini, of the district of San Geminiamo, of the second part, contracted and made a society and mutual compact as to all and every painting of whatever sort and condition that they might make or obtain in their shops, of any sort, that is, here in Venice as also everywhere outside Venice, so that whatever they earn from painting and from money derived from painting here in Venice and elsewhere is to be divided equally between them without exception except for works that they shall obtain outside Venice. And this association is to last five years from October 1.

A Dispute over the Price of Sculpture

It is routine for contracts to provide for arbitration of the price of work, but records of such arbitration are very rare. This one survives because the patron family's representative was a friar and thus the papers were kept in the church's archive. The complexity and seriousness of the matter were affected by the death of the artist whom the family had picked, who had subcontracted the narrative relief panels on it to another one. This second artist, the adopted son of Brunelleschi, failed to live up to people's expectations generally. Yet because such subcontracting is not well understood, it is usually stated that the work as a whole, the pulpit of the great Dominican church of S. Maria Novella in Florence, is by him, and not by its actual designer, whose early death made him still more obscure. (Similarly, in the baptismal font of Siena, narrative panels

by Ghiberti, Donatello, and others—cited above, pp. 3, 25—went into a framework designed by another sculptor.) The seriousness of the negotiation emerges also from the fact that the two arbitrators chosen by the parties, both carvers, simply selected other experts, and that these included the famous sculptors Antonio Rossellino and Desiderio da Settignano. Original text in Rivista d'Arte, *Vol. 3, 1905, 81–82.*

In the name of God, February 5, 1453 [1452 in the Florentine calendar]. To those to whom this writing may come, be it known that Giovanni del Ticcia, stonecarver, assigned to Andrea di Lazzaro, carver, to carve and make four little narrative scenes, with figures, buildings, foliage, and other decorations pertaining to the four said scenes, of marble, with the agreement of myself, Fra Andrea Rucellai, as spokesman for the Rucellai family. And since the said Giovanni del Ticcia said to me, Fra Andrea Rucellai, that the said Andrea di Lazzaro would do these scenes for us to our satisfaction, they were assigned with my concurrence. Now the said Giovanni di Ticcia is dead, and I Fra Andrea Rucellai and Andrea di Lazzaro who has carved the scenes are in disagreement about the price of the scenes. So we transfer all argument and questions and the price to be paid for the marble scenes and all the decoration to Giuliano di Nofri and Bartolo d'Antonio, stonecarvers, both agreeing. And I Fra Andrea Rucellai promise to abide by what will be decided, and likewise Andrea di Lazzaro promises to abide by it, and we wish that their responsibility last through the month of February.

[Both sign and add confirmation of the agreement.]

The above scenes were evaluated on February 26, by agreement of the said Giuliano and Bartolo, at the following sums, by the following masters:

Antonio di Matteo, stonecarver, resident in the Proconsolo [street], estimated them at 25 pounds each.

Desiderio di Bartolomeo estimated them at 22 pounds each.

Giovanni di Pierone stonecarver estimated them at 24 pounds each.

[Bartolo signs to witness that these were the estimates made.]

Neri di Bicci Contracts with an Apprentice

The unique, though partial, preservation of the account books of Neri di Bicci, a minor Florentine painter, is revealing not so much for individual items as for its long cumulation of examples of average patterns of artists' practice—the amount of time taken to paint an altarpiece, the relations of sizes to prices, etc.—which it is risky (but usual) to deduce from single examples. An isolated item of great interest in Neri's book is his record of agreement with an apprentice, almost unique. Un-

fortunately, not even this tells us what apprentices actually did (the usual tag about color grinding seems to be fanciful) but instead, like later hiring contracts, records the pay and hours, the things both were anxious to have on record. We learn incidentally that it was the second contract; the first one three years earlier, when the pupil was fourteen, doubtless provided for much less pay, as in the later case of the thirteen-year-old Michelangelo, who got six florins for the first year. When Neri's pupil left him and broke the contract, he was seventeen, the earliest age at which painters often become independent masters (Uccello, Mantegna, and Raphael are notable instances.) Original text in Neri di Bicci, Le Ricordanze, *1976, 51–52.*

March 1, 1456 [1455 in the Florentine calendar]. I record that on the above day I, Neri di Bicci, hired as a disciple in the art of painting Cosimo di Lorenzo, for a year beginning on the same day and ending on the same day in 1457, with these agreements and procedures, that the said Cosimo must come to the shop at all times and hours that I wish, day or night, and on holidays when necessary, to apply himself to working without any time off, and if he takes any time off, he is required to make it up. And I Neri must give the said Cosimo for his salary in the said year 18 florins, paying him every three months, and this was agreed with the said Cosimo on the above day in my house and so I have made this record at his desire and with this agreement.

[Postscript:] Cosimo left me and went to Rome on October 4, 1456, he had been with me seven months and four days at 6 pounds the month, for a total of 42 pounds 4 shillings.

March 1, 1456. I record that on this day I settled accounts with Cosimo di Lorenzo, my disciple, for the three years he has been with me in the past, and each and every thing we had to arrange with each other. There is a balance to give of 45 pounds 2 shillings as appears on this account in my notebook C, on page 141, and in Notebook D, on page 18 there is five pounds two shillings.

Mantegna's Hand Can Be Recognized

Mantegna first arranged to paint only a part of the fresco cycle in the Ovetari chapel of the Eremitani church in Padua, his first masterpiece, but his part increased when one of the other painters died; there was then a lawsuit as to how much he was owed, from which this testimony is taken. Many readers may be surprised to find at so early a date consciousness of the artist's unique hand, a style recognizable by other professionals. This text may be the first record of a stylistic attribution of a painting. For that to happen is a phase of the general emergence

of the idea that a work of art is above all else an instance of its maker's creative activity, a basic assumption today. Like later attributions, this one is notably linked to a money value, and is qualified with a comment that sometimes attribution is not easy (as when one artist finishes another artist's work). Original text in Istituto Veneto di Scienze Lettere e Arti, Atti, *Vol. 87, 1927–28, Part 2, 1185.*

Monday, February 14, 1457. Master Pietro da Milano, painter, inhabitant of Padua, a witness produced by Bartolomeo Franco of Verona, lawyer, on behalf of master Andrea Mantegna, painter, in the suit he has with master Giovanni da Verona, lawyer of the honorable lady Imperatrice da Ovetari. He was called and sworn, interrogated and examined by Michele da Campesio, special assistant. . . .

Questioned on the fifth item of the first form, the preceding items being omitted voluntarily, he answered that he knows this much, to wit, that about a month ago it may be, master Andrea, the one in question, took the said witness to the chapel of Lady Imperatrice, and showed the said witness both the part involving master Niccolo Pizzolo and the part involving master Andrea, which parts were totally complete, and master Andrea said to the said witness that he had completed certain works that remained unfinished at the death of master Niccolo, which works are now finished, as this witness saw. But whether they were completed by the selfsame master Andrea or not, he said he did not know in any other way than what master Andrea told him.

Interrogated on the first item of the second form, he answered that he knows this much, to wit, that he, the witness, saw both the scene of the Assumption of the Blessed Virgin Mary, which is behind the altarpiece, and the scene of St. James, and those scenes were finished in an honorable and worthy way. And, as the said witness saw from those paintings, those scenes and paintings are by the hand of the said Master Andrea. And he said that he, the said witness, knows paintings by the hand of the said Master Andrea well, not that he the witness saw him painting them, but out of long experience, which he has in this art of painting, he knows that these paintings are by the hand of the said master Andrea. And that, among painters, it is always known by whose hand any painting is, especially when it is by the hand of any established master.

Cosimo Tura as a Pattern Maker

These documents show, with unusual vividness, a common situation in which court painters are responsible for much more than painting pictures. We often pass over such phases of their lives because we surmise that this other work was done only by assistants, and this too

restricted view of ours is complicated by the change in the romantic period, when we began to give far more value to the single artist's individual touch. It is likely that Tura took some direct part, for instance, in painting the duke's horse trappings "with gold, silver, ultramarine and other fine colors." But the general situation in which "Tura and Associates" delivered work to the client survives today with architects and lawyers, from whom we understand—without even thinking of it as an issue—that we are obtaining a blended product. Original text in Jahrbuch der preussischen Kunstsammlungen, *Vol. 9, 1888, 6–7.*

From Ducal Account books, Ferrara, 1457.

Gregorio da Gasperino, paper seller, is to be paid for six sheets of royal-size paper, which Cosimo the painter had for painting devices for the design from which the seat-back covers of Master Levino the tapestry weaver are to be executed.

M. Johannes de Romeo, Alberto Dolcetto, and Company are to have 2 pounds 12 shillings 6 pence, by February 9, for 42 feet of German cloth 2 feet wide, at 2 shillings 6 pence the two-feet, which Marco and Giacomo Gaiardo cut off, to make a model 4-1/2 feet long, on which Cosimo the painter is to paint various coats of arms, devices in natural colors, and other verdure, as the design from which seat backs are to be made by the hand of the master who is to come to work in Ferrara.

Master Cosimo, painter in Ferrara, is to have on May 18, 24 pounds 6 shillings, which Galeotto has calculated as his fee for work and materials for painting a model for a design for making tapestry seat backs, 20 feet long and 4 feet wide, on which he has painted pavilions, under which are the duke's arms, and four devices of his lordship, namely paradise, the unicorn, the baptism, and the cedar, done in full color, and on the rest of the field various animals and greenery, to be used by a French master who is to come here to make these seat backs.

A Training Course for a Young Painter

Francesco Squarcione (1397–1468) of Padua is unusual in that he was better known for his teaching than for his paintings, which are few and old fashioned. Many casual references to his studio props—casts, drawings, medals—do not add up to a coherent picture. He evidently emphasized ancient Roman models, certainly influencing his pupil Mantegna, although he did not originate but only continued a Paduan fascination with the classical. Long before him artists and writers of this region had (in a way that seems to be unclassical) incorporated bits of ancient culture in their work in an informal and even picturesque way. Squarcione's relationships with his pupils during more than forty years were complex: he adopted some as his sons and was sued by others. By

1446 when Michele Savonarola alludes to Padua as a training center for young painters, he no doubt is referring to this "school," which constitutes a transitional stage from apprenticeship to academy. We observed another such transition in Siena above. In this document, annexed to a contract with a pupil's father, he wrote down what he would do, and what he had no doubt been doing for decades. It is our only good evidence about painter's training at the time. Certainly it is atypical (what causes things to be recorded is that they are atypical), and was not an apprenticeship: it was too short, and the boy had no doubt been apprenticed to his father, a painter too. Here he was to get an extra short course in some advanced specialties. But the emphasis on geometry and the nude certainly reflects what was considered important to learn. Original text in Nuovo Archivio Veneto, *Series 2, Vol. 15, 1908, 292ff.*

October 30, 1467, Padua

Be it known and clear to whoever may read this writing that master Guzon, painter, has agreed with master Francesco Squarzon, painter, that the latter is to teach the former's son, Francesco, and namely the principle of a plane with lines drawn according to my method, and to put figures on the said plane, one here and one there, in various places on the said plane, and place objects, namely a chair, bench, or house, and get him to understand these things, and teach him to understand a man's head in foreshortening by isometric rendering, that is, of a perfect square underneath in foreshortening, and teach him the system of a naked body, measured in front and behind, and to put eyes, nose, mouth and ears in a man's head at the right measured places, and teach him all these things item by item as far as I am able and as far as the said Francesco will be able to learn, and as far as my knowledge and basic principles will go, and always keep him with paper in his hand to provide him with a model, one after another, with various figures in lead white, and correct these models for him, and correct his mistakes so far as I can and he is capable, and this is agreed by both sides for four months from now, and he is to give me half a ducat every month as my fee . . . [detailed payment provisions, including food provided] and if he should damage any drawing of mine the said Guzon is required to pay me its full worth, etc. And I Francesco Squarcione wrote this with my own hand.

A Defaulting Patron and Mino da Fiesole

Contracts are routinely followed by delivery, but what happened when a patron could not pay? The prominent Florentine Dietisalvi Neroni failed in a coup d'etat against the Medici government and was

exiled (though he remained rich), leaving the sculptor Mino da Fiesole (1428–1484) with a marble relief altarpiece on his hands, designed for Neroni's chapel in San Lorenzo. The monks of the Badia church, for whom Mino was doing a major work at the time, advanced him the money that Neroni owed him, taking the altarpiece as security. Although this was subject to being redeemed, it is still in the Badia today, with the Badia coat of arms a bit awkwardly carved on it, and built into a side wall with no particular function. Besides showing one of the ways contracts could work out and showing the work of art as a commodity, this also warns us of pitfalls in interpreting religious images. Since without this document one would have every reason to consider the Badia the original and intended site of the work, the inclusion of St. Lawrence (the patron of San Lorenzo) could easily be the theme of a rational attempt to explain its suitability. The actual reason for the presence there of the altarpiece in the Badia could never have been guessed. Thus, we must allow for monks' taking into their church, and even paying money for, images that were entirely without symbolic focus in it—in short, for the frequent caprices of history. Original text in Rivista d'Arte, Vol. 2, 1904, 41–42.

In the name of God Amen. In the year of our redeemer's incarnation 1470, September 13, in Florence, in the Piazza della Signoria, in the parish of San Piero Scheraggio, in the presence of . . . witnesses. . . .

Antonio, son of the late Michele da Rabatta, Florentine citizen, attorney, in the name of the attorney of the creditors of Master Dietisalvi son of Dietisalvi, Florentine citizen, having heard a certain judgment by the Court of Eight, by which they decided and gave permission to the monks of the Badia of Florence to take on deposit a panel of white stone, on which are carved the Virgin Mary with her son on her arm, St. Leonard and St. Lawrence with two little angels, which panel was made by Mino the son of Giovanni, sculptor, on order of Master Dietisalvi son of Dietisalvi, and to lend 32 large florins on its security, which the said Mino said was the balance due him, with this condition, that if at any time Antonio da Rabatta [and two others] attorneys of the creditors of the said Master Dietisalvi wish to get the said panel back, that the said monks are required to give back the same, receiving in return the said 32 florins. . . .

Jacopo Bellini's Sketchbooks

This extract from his widow's will, famous because the sketchbooks still survive, shows how they remained useful through generations. Original text in P. Paoletti, Raccolta di documenti, *1894, 11.*

1471, November 25. Anna, widow of Master Jacopo Bellini, Venetian painter, sound of mind and intellect but weak of body and lying in bed. I bequeath to my son Gentile all works of plaster, marble and relief, drawn pictures and all books of drawings and all else pertaining to the pictorial art and to painting, which belonged to the said late Master Jacopo Bellini my husband. [All other property was divided equally between Gentile and her other son Niccolo.]

Taddeo Crivelli Illuminates a Manuscript

The first book printed in Venice (and, with scattered exceptions, in Italy) dates from 1470. Manuscript books continued for a few years to be produced as before, and this commission to illustrate a set of music books for the great church of San Petronio in Bologna is a late example of a long tradition. Such documents are rare, but as Taddeo's illustrations themselves reflect medieval practice in their choices, sizes, and hierarchy of groups, we may well think the system shown in the commission does so too. The clause about the borders with animals and other forms is of a different kind. The clear meaning of the word "invention" may help us to understand this word in other texts on works of art which have been baffling. And the exceptional absence of dictation of specific subjects in this area, where only approval by other artists is required, may suggest the context in which artists long before had created marginal images rather distinct from their sacred neighbors—drolleries in Gothic manuscripts, misericords in choir stalls, even the Romanesque capitals that a great twelfth-century abbot found so unsacred—all of which have been found difficult to explain. Original text in L. Frati, I corali della Basilica di S. Petronio in Bologna, *1896, 84–86.*

In the time of the Pontificate of the most holy Father in Christ, our Father and Lord, Sixtus, by divine providence Pope, the Fourth.

The Lord knight Galeazzo, son of the famous and respected doctor of laws Ludovico Marescotti dei Calvi, citizen of Bologna, one of the board members of the building of the church of San Petronio of Bologna, and principal officer and treasurer of the building, under authority of its rules, in his own name and that of his colleagues [their names given], assigned and gave the below-named work and volumes of songbooks for masses for the whole year, which the said Galeazzo has had written for the use of the building by master Paul [last name blank] and Henry Fearless of Germany, to be illuminated by master Taddeo of Ferrara, miniature painter, now living in the parish of St. Cecelia, who is present and accepts the conditions:

First, the said master Taddeo promised Lord Galeazzo, acting on

behalf of the others mentioned, to paint well and properly the said songbooks, and to make the below-named forms or types of letters, with good and fine colors, with ultramarine and ground gold, in the judgment of a good man and good masters in this art and mystery. To wit, first, letters at the beginnings of each of the said volumes of the said songbooks, eleven or thereabouts, he must illustrate with figures appropriate to the said opening texts, and with beautiful foliage around the page, with a figure of San Petronio or another saint, or arms of Bologna or other arms at the judgment of Lord Galeazzo, on the lower part of the page. And with animals, winged children, birds, and other beautiful inventions, to the judgment of a good man and good master expert in this art.

Next, letters in other places, not the beginnings, about ten or twelve as may be, where the most important stories occur, with beautiful foliage on three sides, that is, opposite the binding and at the top and bottom, and other stories if it should please Lord Galeazzo and the other officials, with no change in price. And the names of these stories to be made by the said Master Taddeo are the Annunciation, the Nativity, the Three Magi, the Resurrection, the Holy Ghost, the Ascension, Corpus Christi, the Assumption, and the Feast of San Petronio, and all others that fall at the beginnings as noted.

And the said Master Taddeo promised to do all the above for 3 pounds 5 shillings per letter.

Second, letters in which there are less important stories, he promised to do with fine colors only opposite the binding, as far as the writing extends, i.e., from the first to the second line, and the names of these stories are the Birth of the Virgin, her Purification, the Massacre of the Innocents, Quadrigesima Sunday, Holy Saturday, i.e., He has Risen, He is not here, the Circumcision, the Conversion of St. Paul, except those at the beginnings, which must be special as indicated above. And all these for two pounds each.

Third, letters with half figures of saints, namely Stephen, John the Evangelist, Sylvester, the Twelve Apostles, Lawrence, John the Baptist, Peter and Paul, James and Philip, Lucy, Catherine, Mary Magdalene, the four doctors of the church, Dominic, and Francis. All these for one pound each.

Fourth, letters for Sundays, feasts, and other saints' days without figures, seven shillings each.

In return, Lord Galeazzo promised to pay master Taddeo all these sums for all the letters, and at the rate indicated, from volume to volume or from letter to letter as master Taddeo wishes. And at present to give him fourteen pounds in advance. Done in Bologna, in the residence of the officials of the building, in the presence of master Henry Fearless of Germany, living in Bologna in the parish of San Procolo [and

other witnesses]. And today the officials assigned to Master Taddeo the volume of the said songbook with Pentecost, twenty-nine gatherings. 1478, February 10.

Matteo di Giovanni Receives Elaborate Instructions

Among hundreds of fifteenth-century contracts for paintings that survive, this one is typical in that it emphasizes the concerns of the patron that are always present and are often the only points insisted on. These are size, materials, and time, the critical factors in contracts for other types of work too. But this one has been selected to represent contracts in this book since, exceptionally, it is also insistent on details of the images. An active school of historians holds that patrons regularly gave instructions of that sort, and so this type of document warrants study. Because it is so rare, such instructions are often thought to have been furnished separately, and that certainly happened, yet there are reasons to think not often (i.e., not one example of the hypothesized type survives, only a few references to extra instructions to come later—as in this contract—and such instructions would lack contractual force). The puzzle of why such instructions (to whatever extent they existed) do not appear in contracts may be tackled by observing why they do appear in the exceptional case here—the patrons wanted an exceptional image. In particular, being Germans, they wanted the story of the Magi shown in the German way, and so had to explain it to Matteo—in the contract. Absence of instructions then, may suggest that painters were expected to show things in the usual way, as a few contracts actually say they were, and as most fifteenth-century images do. Original text in G. Milanesi, Documenti per la storia dell'arte senese, *1854, Vol 2, 364–66.*

Anno Domini 1478, November 30. Antonio da Spezia and Peter Paul of Germany, bakers, inhabitants of the city of Siena, in the street of the Maidens, administrators, as they affirm, elected and deputed for the purpose mentioned below by the Society of St. Barbara [patron saint of Germans] which meets in the church of San Domenico in Siena, for the purpose of renting the meeting room and for the work on the painting, in their own personal names ordered and commissioned Matteo di Giovanni, painter of Siena, here present, to make and paint with his own hand an altarpiece for the chapel of St. Barbara already mentioned, situated in the church of San Domenico, with such figures, height and width, and agreements, manners, and arrangements and length of time noted below, and described in the common language. [The text changes here from Latin to Italian.]

First, the said panel is to be as rich and as big, and as large in each

dimension, as the panel that Jacopo di Mariano Borghesi had made, at the altar of the third of the new chapels on the right in San Domenico aforesaid, as one goes toward the high altar. With this addition, that the lunette above the said altarpiece must be at least one-quarter higher than the one the said Jacopo had made. Item, in the middle of the aforementioned panel the figure of St. Barbara is to be painted, sitting in a golden chair and dressed in a robe of crimson brocade. Item, in the said panel shall be painted two angels flying, showing that they are holding the crown over the head of St. Barbara. Item, on one side of St. Barbara, that is on the right, should be painted the figure of St. Catherine the German [sic; St. Catherine of Alexandria is represented] and on the left the figure of St. Mary Magdalene. Item, in the lunette of the said panel there should be and is to be represented the story of the three Magi, who come from three different roads, and at the end of the three roads these Magi meet together, and go to offer at the Nativity, with the understanding that the Nativity is to be represented with the Virgin Mary, and her Son, Joseph, the ox and the ass, the way it is customary to do this Nativity. Item, that in the columns of the said panel are to be painted four saints per column, who will be named to the said master Matteo. Item, that in the middle of the predella* is to be painted a crucified Christ with the figure of our Lady on one side and St. John on the other, and on either side of this Crucified are to be painted two stories of St. Barbara, and at the foot of the columns of the predella two coats of arms, one on each column, as will be explained to master Matteo. Item, that the said master Matteo has to have this panel of wood made to the measurements mentioned, at his own expense, and have it painted and adorned with fine gold, and with all the colors, richly, according to the judgment of every good master, like the one of Jacopo Borghesi, and have it set on the altar at his own expense, in eight months from now, without any variance.

[Latin resumes] And all these things for the price of ninety florins, at four pounds the florin, in Sienese money, to be paid to the said master Matteo in this way and at these times, to wit, 25 florins at the present time, another 25 florins at Easter next, 20 florins on the feast of the Holy Ghost next, and the balance, to wit another 20 florins, at the end of the time, and when the said master has completed the painting in every degree of finish, and placed it on the said altar. Done at Siena, in the hall of the notaries' guild, in the presence of [two] bakers of Germany, inhabitants of Siena, witnesses. After which, in the same place, Master John son of the late Frederick, of Germany, at present cook of our lords the Lords of Siena, and Master John son of the late George of Germany,

* The painting of the predella appears not to have been executed. It was usual at the time to paint small scenes on the predella, the horizontal beam which was the base supporting the altarpiece.

embroiderer, and inhabitant of Siena, promised the said master Matteo to guarantee that the said clients paid the said sums.

Verrocchio Prepares His Will

As a typical example of many wills, this one contains some provisions (notably the religious ones) which are standard and do not bear on the writer's personality. Then as now, some wills are more revealing than others, and the more revealing, like this one, tend to be those whose writers did not leave widows and therefore are seen making more decisions about their inheritances. Yet it was also quite typical, contrary to modern patterns, that Verrocchio never married. If we check the five pioneers of the Florentine Renaissance named by Alberti in 1435, plus Alberti himself, only one of the six ever married. The one quite unusual element in Verrocchio's will is his effort to bequeath his commission for the Colleoni monument, which failed. Original text in M. Cruttwell, Verrocchio, 1904, 240–42.

In the name of God, amen. In the year since the incarnation of our Lord Jesus Christ the thousandth four-hundred eighty-eighth, the twenty-eighth of June. Since there is equality for all in dying, and any point in life may be the hour of death, therefore I, master Andrea, son of the late Michele Verrocchio of Florence, sculptor, inhabitant of Venice in the San Marciliano district, in good health of mind by the grace of our Lord Jesus Christ, but weak of body, have called to my side Francesco Malipede, notary of Venice, and instructed him to write this my will, and that after my death he should fulfill and corroborate it with the necessary and opportune clauses and additions according to the style and custom of the city of Venice.

And first, I constitute the executor of this my will Lorenzo [di Credi] son of Andrea de Oderich, Florentine painter.

I will my body to be buried in the cemetery of S. Maria dell' Orto, if I die in Venice, or where my executor may decide, who is to spend for my funeral from my estate what seems right to him.

Item, I wish to have masses of St. Mary and St. Gregory celebrated for my soul.

Questioned by the notary whether I wish to leave anything from my estate to the hospitals of Christ of the Pietà, St. Mary of Nazareth, and St. Mary of Mercy, I replied no.

Item, any and all things that the said executor has obtained from any of my debtors and whatever of mine he has administered up to the present day I freely give over to him.

Item, I leave to the said executor Lorenzo all bronze, tin, porphyry,

and furniture and furnishings of my house, which are all in Florence, and also a pair of bellows.

Item, I leave to him all furnishings, clothing, bed, and all other furniture of mine that I have in Venice. And the aforesaid I leave to him with the following condition and requirements, first, that he bear the costs of my burial and funeral, and have the said masses celebrated.

Item, that he must give ten ducats to Zenobio, married to a niece of mine, he is a cloth weaver. Item, he must give my niece Ginevra, wife of Giovanni the cooper, ten ducats. Item, he must give to Giusto my servant all that he is owed in salary, and in addition a payment of five ducats.

Item, I leave to Tommaso my brother two houses, that is, all the houses I have in Florence, in the S. Ambrogio district.

Item, I leave to the said Tommaso all moneys I have and may obtain from the Bureau of Commerce of Florence for any reason and cause, from which money I order that he provide dowries for his daughters.

Item, I order that the said Tommaso my brother cannot sell, mortgage, or in any way alienate the houses that I left to him above, but my will is that the houses go from heirs to male heirs, and if there are no males, the houses must go to the nearest females equally and in equal portions. The rest of my goods, rights, and shares present and future, wherever located, I give and leave to the said Lorenzo, my executor.

Item, I leave the work on the horse begun by me to him to be finished, if it please the illustrious doge of Venice, and I humbly beg the government of the Venetians that it may see fit to allow the said Lorenzo to complete the said work, since he is qualified.

Further, I give and confer to the said executor and residuary legatee full powers as my executor to manage, control, and appear in every judgment, to defend, seek, obtain, and receive money, things, and goods due to me . . . and everything needful and opportune for the above. If anyone should attempt to oppose this my will, he must pay my executor five pounds as a penalty.

[Signed by three witnesses and the notary.]

Foppa's Municipal Appointment

The admirable and insufficiently remembered painter Vincenzo Foppa (about 1430–1515), born in the middle-sized town of Brescia, had a successful career in Milan but in later life returned home with the encouragement shown in this record. Civic pride was no doubt involved, and perhaps some influence. Such an appointment seems, strictly speaking, unique, but it has a number of partial analogies in the stipends for dukes' court painters and for the city painter of Venice (responsible for

portraits of new doges) and the subsidies for taking pupils in Siena. As in other cases, we can observe trends in this period marked by very flexible variants rather than firm rules. This salary was confirmed but in 1499 withdrawn by a vote of 65 to 18. Original text in C. Ffoulkes and R. Majocchi, Vincenzo Foppa, *1909, 324.*

Brescia, meeting of the Special Council, December 18, 1489. On behalf of Master Vincenzo, the most excellent painter, our fellow citizen, having read his elegant petition with the rich information in it, presented by the noble citizens Lord Johanne Cristoforo de Cazago and Lord Emanuel de Lanis, containing in effect the following:

Since the art of painting is the best among the other arts, and especially honorable, and in itself has no little grace, as is also true of the art of architecture, and as the painting which he has done in many cities and places amply testifies, and since he desires to repatriate with his family and exercise the art of painting and architecture while he lives, to teach and instruct the young devoted to this art, our community ought to deign to provide him with a suitable annual stipend of fifty ducats, so that by means of it he can sustain himself and his family and decorate our city, especially in public buildings, with worthy paintings.

It was voted without opposition that Master Vincenzo be given an annual stipend by our commune of a hundred pounds, while he resides and paints in the city of Brescia, which salary shall last at the pleasure of this commune and as pleases the general council.

Benedetto da Maiano's Worldly Goods and Chattels

Inventories taken at the deaths of various fifteenth-century artists survive; the one of the Sienese painter Neroccio lists 270 items, almost all individual items of furniture and utensils. This inventory of the prominent Florentine sculptor Benedetto da Maiano (ca. 1442–1497) is the most revealing about the living and working environment of an artist, though it has never been appreciated from this viewpoint. Indeed it has been assumed that no information of the type survived. Printed only in two locally issued publications which are not referred to in the most used and up-to-date bibliographies on Benedetto, it has been exploited only for its lines citing works of sculpture that survive, in the common pattern which regards attribution as the prime utility of documents. To be sure, this use has been of great value; the unfinished Coronation relief in the National Museum of Sculpture, Florence, was supposed, before it was linked with this inventory, to be a work of a century earlier, so little are we in tune with unfinished form in this period.

We owe the inventory to the care of the executor, the painter

Cosimo Rosselli, whom we met as an apprentice. Along with a vivid and not too minute list of household goods, it happily provides an extremely rare case (along with that of Leonardo da Vinci) of a list of an artist's books. Some of them are secular, but most are the religious books known to us as the main bases of religious art of that time, new evidence on the problem of the extent of the artist's role in designing these works. The wood and stone shops may surprise us most because of the very large number of works simultaneously unfinished. This suggests many employees, a pattern perhaps more usual with sculptors than with painters. Original text in L. Cendali, Giuliano e Benedetto da Majano, *1922, 178–86.*

1498, April 25, Florence, notarial record. This is the inventory of the movable goods now to be found in the room in which the late Benedetto son of Leonardo da Maiano, sculptor, lived, and in which he died, which is made at the request of Mrs. Elizabeth, formerly the wife of the said Benedetto, as guardian of the sons and heirs of the said late Benedetto, and she does so with the consent of Benedetto son of Salvi de' Marocchi, her legal guardian. . . .

One wooden bed, measuring ten feet, covered with nutwood and inlaid, with its chests around it, and with bolster, mattress, pillow filled with good feathers, two coverlets, and white bed linen, blanket, and a red curtain, and a tester on top.

A small bed of nutwood, inlaid, with a chest, with a blue mattress full of wool, and a white blanket

Two chests of nutwood, inlaid, each with two locks

A large chest to hold cloth, of pine, with pilasters, and a nutwood cornice, and other ornaments

A chest covered with nutwood and inlay

A tabernacle of our Lady, half relief, with a bronze candelabrum

A rack, with a viol to play on, and other trifles

A crucifix in relief above the chest

A baby, in wood relief, with a red cloth dress

IN BENEDETTO'S WRITING ROOM

A Bible, in the common tongue, with a leather cover

A book of the saints, in the common tongue, large and beautiful, bound in a leather cover

A history of Florence, in the common tongue, bound with a leather cover

A book of miracles of Our Lady, bound with a leather cover

A death of St. Jerome, bound with a leather cover

A little book of the virtues and vices, quarto, similarly bound

A little book bound in wood, quarto, the life of Alexander

A book of St. Bernard bound in wood with leather cover

A Dante bound in wood with leather cover

A little book, quarto, wood covered with leather, of lauds

A book, bound in wood, of Gospels and Epistles, all in type except one

IN GIULIANO'S WRITING ROOM

A little book, quarto, bound in wood with leather cover

A Book De Vita Patrum, bound in wood with green leather cover

Two large books, bound in wood with green leather cover, of the first and third Decades of Livy

A large book, extra sheets, bound in wood with red leather cover, the Bible in the common tongue

A folio book bound in wood with yellow leather cover, an anthology of the Bible

A similar book bound in wood with red leather cover, anthology of the Bible

A little book of the Flowers of Virtue, bound in wood, quarto, covered in red chamois skin

A little book in quarto, bound in wood, composed by Mister Bastiano Palvini

A large book bound in wood written in ink, called Imperial

A book with Bologna-size pages, covered in wood with red leather, of the first book [missing word] Cristoforo Landino

A dialogue of St. Gregory, bound in wood covered in red chamois

A little book, quarto, the Little Flowers of St. Francis, bound in wood

A large book of a hundred tales, bound in wood with green leather cover

A large book, in wood with red chamois cover, of the fourth Decade of Livy

A book bound in wood with red chamois cover, Altobello and the Paladins [a poem about the wars of Charlemagne]

A quarto book bound in wood, Blessed Antonino, Omnia mortalium Cura

A book in manuscript, the Gospels, ordinary pages, bound in wood

IN THE DOWNSTAIRS CHAMBER

A bedstead measuring nine feet, simple, with low chests inlaid and covered with nutwood

An Our Lady, terra cotta, in a carved round frame

A figure in full relief, terra cotta, two feet high, above the bed.

* * *

1497, BOOK OF CREDITORS AND DEBTORS, INCOME AND OUTGO, records of the executor Cosimo di Lorenzo Rosselli, painter

Benedetto died May 24, 1497, the will read to the executors on that day. Mrs. Elizabeth took the guardianship on July 11. There remained in the house of the said Benedetto his son Giovanni, aged 10, Giuliano, aged 6, Anton Maria, aged 2, Lena, Leonarda, and Caterina, all six his children, also Mrs. Lena and Mrs. Fioretta his sisters-in-law and Mrs. Elizabeth his wife, and Menica, servant.

REAL AND PERSONAL PROPERTY

A farm in the Ponzano district, a place called the Olive, with household goods and animals and related property, it is worked by Lapo di Martino Bricci on a half share, rented by Benedetto on August 1, 1491 to the said Lapo's father

A house in the via San Gallo with furnishings

Mrs. Lena, mistress of her own room

The same for Mrs. Fioretta

The same for Mrs. Elizabeth

The main room, furnished

The cellar, with all sorts of barrels

The kitchen, with all sorts of furnishings

Bed for the servant, bed on the ground floor for guests

A shop on the ground floor with figures of clay, wood, and glazed, all in the charge of Mrs. Elizabeth, guardian

A house in the via dei Balestrieri at the Pazzi Corner, rented to Bartolommeo, painter, for 74 pounds a year, as recorded on page 143 of the same account book

A house begun to be built on the via di Ventura near the Servi church, with a notice for rent on it. It was rented on October 13, 1498 for 18 florins, as recorded on page 146

Cash in three bags, eight hundred nine gold florins, and 49 pounds 6 shillings 8 pence, which we leave with Mrs. Elizabeth, guardian, today May 27, 1497

A credit in seven percent funds of 301 florins 9 shillings 5 pence, in the book marked G, page 652, in the name of Benedetto. This credit was put in the names of Giuliano, Giovanni and Anton Maria on April 9, 1498, in Book H, page 652

A credit in seven percent funds, Book D page 514, 383 florins 6 shillings in the name of Mrs. Fioretta

A shop in the via de' Servi, place called the Castellaccio, used for sculpture, renting for 3 gold florins, consigned to Leonardo di Chimenti del Tasso with everything listed below, with the obligation to maintain and return them: two chests and a half of things in these shops for woodwork and sculpture, signed by Leonardo with his own hand, and Chimenti his father, and checked by them November 5, 1497. Later, May 10, 1500, rented to Giovan Francesco Rustichi, page 146

The woodworking shop, where some of these things were, they had rented from the nuns of Monticello, page 143

Record of a settlement with Lorenzo da Montauto, in which the said Lorenzo remains creditor of 3 florins, page 7

Mrs. Fioretta received her dowry back, 500 florins, April 19, 1498, 386 large florins, and renounced her claim on the Funds, page 10

Acknowledgment of the dowry of Mrs. Alessandra di Giovanni 540 florins August 16, 1494

Inventory and delivery of the executors to Mrs. Elizabeth of the furnishings of the house in via San Gallo, written on page 112, notarized by ser Giovanni, April 25, 1498

Benedetto on May 9, 1492 created two dowries for his two daughters, 22 large florins each, for Lena and Leonarda. Lena died.

INVENTORY OF WORKS FOUND IN THE SHOP OF BENEDETTO
(done when it was handed over to Leonardo del Tasso)

In the woodworking shop we find these things, to wit:

1 piece, rough hewn, of the Duke, about six feet high

1 bishop, finished, six feet

1 performer, rough hewn, six feet

1 Don Federigo, rough hewn, 3 feet
1 musician, finished, five feet
1 piece of frieze with architrave, finished, over six feet
1 cornice belonging to the above frieze, a piece of five feet, finished
1 piece of the pavilion for the royal gate, that is of Naples
1 half figure of God Father, two feet high, almost finished
1 base, two feet long, a foot and a half wide, almost finished consigned
 to Betto Buglioni for 30 florins

Marbles outside the woodworking shop, not worked up:

1 angel, rough hewn, consigned May 7, 1499 for 850 pounds
1 head, rough hewn, consigned the same day for 690 pounds
1 figure, rough hewn, two feet high, a foot wide, consigned the same day
 for 340 pounds
1 piece of a pilaster, four feet, consigned for 355 pounds
1 piece of a pilaster, two feet high, one foot wide, consigned May 7, 1499
 for 380 pounds
1 piece of an arch, four feet, one foot wide, consigned to Leonardo
 August 16, 1498 for 400 pounds
1 similar piece, two feet, consigned on the 7th as above for 220 pounds
1 figure, two feet, consigned on the same day for 310 pounds

Now we will start on the Castellacio, and first

1 tomb cover, consigned on the 7th as above for 500 pounds
1 half circle, four feet, consigned on the same day for 730 pounds
1 piece five feet, one foot thick, two feet wide, consigned July 3 for 2800
 pounds
1 section of arm, two feet, one foot thick, consigned for 400 pounds
 [and sixteen similar pieces]

These are the things that are in the marble shop, that is, where the
marble is worked.

1 roundel, one foot
1 St. Sebastian, almost finished, four and a half feet
1 Virgin Mary, rough hewn, five feet
1 figure belonging to the royal gate
1 of six feet
1 king with a bishop, five feet
1 . . . anello, finished
2 pieces with four trumpets, finished
1 other trumpet, alone
1 roundel, rough hewn, of Our Lady, two feet
2 pieces of fluted pilasters in four sections, seven feet high, finished
1 piece of cornice, six feet
 [and twenty-five more similar items]
 Figures in terra cotta, and first
1 Our Lady in terra cotta with the Child, three feet; it is consigned for
 sale to the abbot of San Frediano in Pisa, as noted in this book page 6
1 St. Paul, similar
2 angels, kneeling, half relief, two feet
 Heads, with the bust, portrayed from life

2 heads of Giotto, without bust
1 little frieze with a festoon, a foot wide, three feet long
1 Virgin Mary seated, one and a half feet
1 roundel in plaster, of Our Lady seated
4 evangelists in roundels, one and a half feet
4 scenes of the model of the Santa Croce pulpit
2 little angels, not baked, one and a half feet
1 concave half relief, two feet
1 model of the Santa Croce pulpit
1 model of the Salviati tomb
6 brackets
1 piece of an arch of stone
1 St. John the Evangelist, terra cotta, three feet
1 St. John the Baptist, similar, both consigned for sale to the Abbot of San Frediano in Pisa
1 Virgin Mary seated, one and a half feet
1 head of Giovanni Serristori
Objects in wood, and first
1 Crucifix, two feet, in the hands of Cosimo the painter
1 of a foot and half, in the hands of Cosimo the painter
4 Crucifixes, two between eight inches and a foot, one consigned to Simone del Pollaiuolo on November 10 for 1 large florin, one foot high, and one of eight inches consigned to a monk of the Badia on February 15, 1497, 1 large florin
1 Crucifix of boxwood, four inches, sold to Lorenzo di Credi January 27, 1498, one large florin
[The inventory of tools follows.]

3

The Artist
as
Book Author

Alberti on Painting, 1435

The essay On Painting *by Leon Battista Alberti (1404–1472) is often printed as a separate book. These editions justifiably tend to have commentaries longer than the text. To have room for other sources, comment must be reduced here to a few pointers. The three parts suggest the author's emphases but do not exhaust them. The first book is today often emphasized most, partly because it explains linear perspective, a new invention, and so seems to offer an easy explanation of the Renaissance, treating it as a definite technical advance. However, it should be noticed that in it Alberti gives as much space to light and shade and that he calls this book only a foundation. The second, the longest, tells us that the heart of painting is not its space but its story. Yet the author's interest is less in meanings than in the way the human body can express them. And indeed, the most effective gift of Florence to Western art up to the nineteenth century is this approach, regarding most major painting as drama or as a critical moment in the interrelationship of a few very real human beings. The third book is on the artist, reminding us of the Renaissance interest in the part that the artist's personality plays in art.*

The reader's best approach may be to seek likenesses between what is in the book and what is in the painting of its time, and Masaccio offers the best choices for this. This is true first of all in large general factors, such as his dramatic composition, his great reliance on lighting (sometimes overlooked to emphasize his space, just as Alberti's is), and his authority in perspective. They appear also in specifics—for example, his almost invisible outline drawing, his buildings parallel to the front plane, squared drawing used to check bodily proportions, or the sharp features of old women. Other Albertian ideas seem to find later fruition, as in Leonardo's fascination with deformed faces and Botticelli's rendering of some of the figurations Alberti suggests. Alberti's book may claim to be the only full program for a major movement in art written at the time when it was getting started, not to mention that its author was a remarkable writer and also has some claim to be called one of the artists of the movement.

Because he was breaking new ground and seeking language for it, Alberti is often moved to state a point several times. By omitting some of these, it has been possible to present the entire matter of the book. Original text in many editions; standard are those of L. Mallè for Alberti's Italian version (Florence, 1950) and C. Grayson for the Latin (1972).

To Filippo son of lawyer Brunellesco, Leon Battista Alberti. I used to feel baffled, and sorry as well, that so many excellent and godlike arts and sciences, which from history and from their products we see

were so widespread in the talented times of old, are now so lacking, and almost lost altogether: Painters, sculptors, architects, musicians, geometricians, rhetoricians, augurs, and the like very noble and wonderful intellects, are rarely to be found nowadays and little to be praised. And so I supposed that it was as I heard it to be from many, that Nature, mistress of things, grown old and weak, just as she no longer produces giants, so too with talents, of the sort that in her younger and more glorious days she produced so profusely and wonderfully. However, after I was brought back to this our native city, so much more graced than others, from the long exile in which we Alberti have grown old, I recognized in many, but first in you, Filippo, and in that Donato, our very dear friend, and in the others, Nencio [Lorenzo Ghiberti] and Luca and Masaccio, the existence of talent not to be ranked below anyone at all who was ancient and famous in these arts. And so I came to see that the ability to attain praise for any gifts whatever is found in our hard work and persistence no less than in the kindness of nature and the times. I acknowledge to you that if it was less difficult for those ancients, with their abundance of teachers and models, to rise in the knowledge of those supreme arts and sciences which are so laborious for us today, by that token our fame should be the greater, if we find arts and sciences never heard of and not seen, with no tutors and no examples. Whoever would be so hard or so envious as not to praise Pippo the architect, seeing so large a building here, raised above the skies, broad enough to cover all the Tuscan peoples with its shadow, done without any aid of centering or mass of timber, a feat of workmanship, if I judge rightly, which, as in our own time it was unbelievable that it could be done, so among the ancients it was perhaps not known either in theory or practice. But your praises and the gifts of our Donato, and the others whom I admire so much for their ways of doing things, can better be told elsewhere. In the meantime, do you persevere in discovering things, as you do daily, by which your miraculous talent achieves fame forever, and if you have some leisure time it would please me to have you review this little book of mine on painting, which I did into Italian in your name. You will see three books; the first is all mathematical, and lets this delightful and noble art grow from its roots in nature. The second book puts the art in the artist's hand, distinguishing its parts and showing everything. The third teaches the artist how he can attain, and must, perfect skill and knowledge, and in what, concerning painting as a whole. May it please you then to read me attentively, and if you think something should be changed, correct me. There never was a writer so learned that his erudite friends were not exceedingly useful to him, and I would wish to be altered by you first of all, so as not to be sniped at by detractors.

Book One

In writing on painting, in these very brief commentaries, we shall first, in order for our statements to be quite clear, take the things that belong to our topic from the mathematicians, and having become as well acquainted with it as our talents permit we will present painting from the first principles of nature. But in all our talk, I strongly urge you to consider me not as a mathematician but as a painter writing about these things. The former measure the forms of things with their understanding alone, leaving out anything material. We, desiring to have things set up to be seen, will therefore use a more down-to-earth inspiration, as the expression goes, and will be fully content if our readers somehow or other understand this material, which certainly is difficult and as far as I know has never been described. So I ask that what we say be interpreted as being by a painter only.

[Definitions, condensed: a *point* is whatever can be seen but is indivisible; a *line* is two or more points; a *surface* is two or more lines. All surfaces have two permanent characteristics, a *body* and an *edge,* both of which can be of several types: bodies can be *plane, concave,* or *convex;* edges may form *triangles, circles,* and other shapes. Surfaces may also have two nonpermanent characteristics, changing their *place* and their *lighting.*]

Let us consider place first and then lighting, and inquire in what way the qualities on the surface may seem changed because of them. This belongs to the power of seeing, since when the location changes, things seem to be larger, or to have another kind of edge or color, those all being things we measure by seeing. Let us seek the rules about these things, beginning with the opinion held by learned men that we measure surfaces with certain rays which assist seeing, called visual for that reason, which can bring the form of things seen to our awareness. And we may imagine the rays to be like very fine threads, tied at one end like a bundle, very tight, inside the eye where the sense of sight resides, and from there, like a trunk made of rays, that knot stretches its twigs very straight and very fine as far as the opposite surface. [Various rays hit the edges and all parts of the surface.] Some come from the whole body of the surface as far as the eye, and these have their duties, for they fill the pyramid, of which we will speak at the proper time, with the colors and gleaming lights with which the surface shines, and these are called middle rays. One of the visual rays is called centric. This, when it reaches the surface, makes equal and right angles all around itself.

[The outermost rays measure the size of the surface like a pair of compasses.] Hence it is said that in seeing we make a triangle, whose base

is the quantity seen, and the sides are the rays that stretch from the points on that quantity to the eye.

Here are some rules: the more acute the angle in the eye is, the smaller the seen quantity will appear. This explains the reason why a very distant quantity will seem no greater than a point. And although this is so, there are some surfaces and quantities of which a larger part is seen farther away and a smaller nearby; the sphere is an example. So quantities seem greater or less according to the distance. And anyone who has fully appreciated that point will understand, I think, how when the interval changes, the rays to the edge of the surface will become the rays to the middle of the surface and vice versa, and will understand how in the latter case the quantity will seem smaller, and in the former case, larger. So I often give my friends this rule, the more rays, the larger the seen thing appears, and vice versa.

And the outermost rays, going all round the surface and touching each other, enclose the surface like bars of a cage, and make what is called the visual pyramid. [Another definition of the pyramid.]

Next we must speak of the middle rays, the great number inside the pyramid, and these are like the chameleon, for from where they touch the surface, all the way to the eye, they take on the color and light at the surface, whatever it is, so that anywhere you might break them you would find them colored and lighted the same way. And thus one sees that they weaken with long distance. I think the reason is that they go through the air loaded with light and color, and the air, damp and heavy, weakens the loaded rays, whence we get the rule: the greater the distance, the darker the color. [The centric ray again described, as the shortest.]

Hence the distance and position of the centric ray is very important for certainty of seeing. A third thing that makes the surface seem varied is the way light is received. In the same light, one sees that convex and concave surfaces are in the one case light and the other dark, and though the distance and position of the centric ray be unchanged, if you place the light somewhere else the part that had been light becomes dark and vice versa, and if there were several lights around you would see, depending on their number and strength, various spots of bright and dark. This point reminds me to speak of colors and also lights.

It seems plain to me that colors are varied by lights, since every color seems in shadow different from what it is in the bright light. Shadow makes the color dark and light makes brightness where it hits. [The theory of vision.] Let us speak as a painter.

I would say that mixing of colors produces an infinity of other colors, but the true colors are only four, like the elements, from which many many other species arise. The color of fire is red, of air blue, of water green and of earth gray. The other colors, like jasper and porphyry,

are mixes of these, and colors produce species by adding dark and light, black and white, and are almost numberless. We see leaves losing their green bit by bit until they become colorless. So too air near the horizon is often a whitish vapor that fades little by little. And among roses, we see some that are a strong purple, others like young girls' cheeks, still others like ivory. The earth too produces its types of colors in terms of white and black.

Thus the mixing of white, or of black, does not change the kinds of colors but makes subtypes. One sees colors being altered by shadows, when the shadow increases the color becomes fuller, when the light increases it becomes more open and bright. The painter may then well be persuaded that white and black are not true colors, but modifications of the other colors, for the painter has no means besides white to show the ultimate shine of lights, and likewise only black to show the depths. Besides, you will never find white or black that is not beneath one of those four colors.

Turning to lights, some are from the stars, like the sun and moon or that other beautiful star Venus, and others are from fires, but these differ greatly among themselves. Light from stars produces a shadow equal to the body, but fire makes a larger one. Shadow is what is left when light rays are interrupted; the interrupted rays either return whence they came or turn elsewhere. You see the latter when, after reaching the surface of the water, they cut the beams of the house. On reflections more could be said, which pertains to those "Miracles of Painting" that many associates of mine saw me do formerly, in Rome; here it will suffice to say that these bent rays carry with them the color they find on the surface, so you will find someone who is walking on the grass in the sun look green in the face. [A repetition of the above follows, in summary.]

Now since in a single glance one sees many surfaces, not just one, let us explore how we see many combined together. You saw that each surface has its pyramid, colors, and lights. But since bodies are covered by surfaces, all the surfaces of a body as we see them will compose one pyramid, pregnant with as many smaller pyramids as the onlooker can see surfaces. But here someone will say, "What use is it to the painter to explore all this?" Let every painter consider himself a good master to the extent that he understands proportions and connections of surfaces, which very few know, and when they are asked what they are trying to do on that surface they are painting, they will tell you anything at all sooner than what you asked. Hence I beg studious painters not to be ashamed to hear us; it was never foolish to learn from anyone at all something useful to know.

And they should know that they should circumscribe the surface with lines, and when they fill the areas so drawn with colors, they need seek nothing but to present the forms of the things seen on this surface

no otherwise than as if it were a pane of transparent glass, so that the visual pyramid might pass through it, given a certain distance, with certain lights and a certain central position, into the air and its other locations. That this is so every painter shows when he places himself far off from what he is painting, as if he were instinctively looking for the point and angle of the pyramid from which he knows the painted things can be viewed best.

But as we see that the painter aims to represent various surfaces contained in the visual pyramid on a single surface, of a wall or a panel, it behooves him to slice through this visual pyramid at some point, so that he can render the lines and colors similarly in painting. Painting is therefore nothing but the cutting of a pyramid, according to a set distance, once the center is established and the lights arranged, in a certain surface with lines and colors executed with proper craftsmanship. [We must then study what makes up this cross-section, and then we can understand the surfaces at the base of the pyramid.]

Some surfaces are flat on the ground, like pavements and floors and any others on a plane parallel to those; others stand on end, like walls and others lined up with walls. [Parallel planes are defined.] Lined-up surfaces are those that a single straight line will touch at like points, such as the faces of flat piers in a portico. [We must therefore add such lines to our presentation of rays.] To this add the theory of mathematicians, proving that if a straight line cuts two sides of a triangle, making a smaller triangle, and is also parallel to the side of the larger triangle, then the smaller triangle is proportional to the larger one; that is what the mathematicians say. But we have to speak more broadly, and understand what proportional is. Triangles are called proportional when their sides and angles are so related that if one of the sides is twice the length of the base, and the other side three times the base, all other larger or smaller triangles having a similar set of relations will be proportional to the first one. To understand this better we will use an analogy. A small man is proportional to a big one, since the same proportion of hand to foot and foot to other parts of the body was found in Evander as it was in Hercules, whom Aulus Gellius conjectured to have been bigger than other men, nor was Hercules' body of a different proportion from the members of the giant Antaeus. And the same is true of the triangles. And if I am well understood in this, I will propound with the mathematicians what applies to us, that all intersections of any triangle, so long as they are parallel to the base, make new triangles proportional to the large one. . . . And, as I said, a part of the visual triangle are the rays . . . so it is manifest that every intersection of the visual pyramid parallel to the surface which is seen will be proportional to that seen surface.

We have spoken of surfaces proportional to the intersection, that

is, parallel to the painted surface, but since many surfaces are not parallel, these must be carefully investigated so that the whole theory of intersection may be shown. It would be a long, difficult and obscure matter here to follow everything with the rules of the mathematicians, so we will continue speaking only as painters.

We will speak of nonparallel quantities very briefly, and when those have been understood, we will easily recognize nonparallel surfaces. Some nonparallel quantities are lined up with the visual rays, others are parallel to some visual rays. The former produce no triangle and are not between any rays, and so occupy no space on the intersection. As for those parallel to rays, the wider the angle between the base and one of the rays, the less space that quantity will occupy in the intersection. When as often happens a quantity is parallel to the intersection, it has no effect on the painting, but those not parallel to the intersection will modify it the more, the wider one of the angles is at the base.

And to this we should add the opinion of the learned that if, by God's will, the heavens, stars, seas, and mountains and all bodies became half their size, nothing would seem smaller to us. For large, small, long, short, high, low, wide, narrow, light, dark, bright, shadowed, and all things that are called accidental because they can be added to and removed from things, are known only by comparison. Virgil said Aeneas looked over every man's shoulder, but beside Polyphemus he would have seemed a runt. [Other examples.] Ivory and silver are white, which, placed beside a swan, or snow, would seem dim. Hence in painting, things seem brilliant when there is a good proportion between black and white, as there is from bright to shadowy in things. [Further definition of comparison.] And I think that among other ancients the painter Timanthes enjoyed this power of comparison, when he painted a giant Cyclops asleep, and some little satyrs measuring his thumb, which made the sleeping figure seem very big indeed.

Up to now we have talked of the power of vision, and of the intersection, but now besides knowing what it is we must show the painter how to paint it. I will omit everything except what I do when I paint. I first draw a rectangle of right angles, where I am to paint, which I treat just like an open window through which I might look at what will be painted there, and then I decide how large I want the people in my picture, and I divide the length of a man of this size into three, which is proportionate to a two-foot measurement [a *braccio*], since a normal man measures almost six feet. And I mark these two-foot units on the bottom line of my rectangle, as many of them as it will take, and this line is for me proportional to the horizontal quantity I originally saw. Then inside the rectangle, where I like, I mark a point which will be where the middle ray hits, and I call it the midpoint. This should not be higher above the bottom line than a man I would paint there, so that the viewer

and the things seen will appear to be on a level with each other. Then I draw straight lines from the midpoint to the divisions already marked in the bottom line. These lines will show how each transverse quantity might change from the one before almost to infinity. Some would draw a horizontal line parallel to the bottom line, and divide the distance between them into three parts . . . but this is a false method, because the first line is placed at random, so that even if the rest follow rationally, they don't know where the peak of the visual pyramid ought to be, and the midpoint may be higher or lower than the height of a painted man. And note that nothing will ever seem real if there is not a certain distance from which it is seen, but, of this we will give the theory if we ever write about those demonstrations which, when we did them, our friends seeing and marveling called miracles.

So I found this the best way, as I said, fixing the midpoint, and then I draw lines to points on the bottom line. As for the transverse quantities, to show how one follows after the other I do as follows: I take a little space and in it draw a straight line similar to the bottom line and divide it similarly, then above it I put a point, straight above one end of it, as high as the midpoint is above the bottom line, and thence I draw lines to each point in the first line. Then I fix the distance I want from the eye to the painting, and so draw a perpendicular line cutting every line it finds, and the places where I find all my parallels to be drawn, that is, the squares of the pavement in the painting; and the test of whether they are rightly done is if one straight line will make a diagonal through all the rectangles drawn in the painting.

When I have done this, I draw a horizontal straight line in the painting, parallel to the lower ones, passing through the midpoint, as a boundary that can be passed only by quantities higher than the observer's eye. As a result, men painted standing on the last paving block of the painting are smaller than the others, which nature shows us is

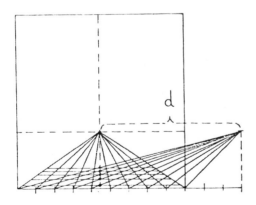

Alberti's system for determining equidistant receding parallels (based on A. Parronchi's drawing in Paragone, *no. 145, 1962)*

just. In temples we see the heads of men almost all at the same height, but the feet of those farther off correspond almost to the knees of those nearby. But this system of dividing the pavement belongs to the part we will call "Composition" later on, and I fear may not be understood since it is new material and so briefly explained.

[Some will understand easily, others not at all.] Here I only spoke of the first rudiments of the art, the first foundations for painting well. In what follows will be shown how the painter can follow with his hand what he has learned in his mind.

Book Two

But since this learning may perhaps seem tiring to the young, I think I should show why painting is worth taking up all our effort and study. Painting has a divine power, not just because, as is said of friendship, it makes absent ones present, but it makes the dead seem to live, after centuries, so that they are recognized with pleasure and the artist is admired. Plutarch says that one of Alexander's generals, Cassander, trembled because he saw Alexander's face. [Other examples.] And since painting represents the gods, as they are adored by the nations, it was always a great gift to mortals, for in this way painting helps to tie us to the gods and to keep our minds filled with religion. They say Phidias made a Jove, in Aulis, whose beauty reinforced the received religion. And . . . even gold worked into paintings is valued at much more than gold, and that vile metal lead, when figures are made in it, by Phidias or Praxiteles, will be considered more precious than silver. The painter Zeuxis took to giving his works, since, as he said, they could not be bought. And he felt that no praise could satisfy one who, in modeling and painting living creatures, was behaving like a god.

Thus painting has this praise, that any master painter will see his works loved, and will feel himself judged almost another god . . . and all smiths, and sculptors, every shop and every art rule themselves by the painter's rules and art . . . whatever beauty you find in things you may say comes from painting. Thus I used to say among my friends, following the poet's line, that the inventor of painting was that Narcissus, who was changed into a flower. The whole story fits, if painting is the flower of every art, for what can you call painting but embracing, with art, that surface of the water?

Quintillian said that ancient painters used to circumscribe shadows in the sun, and this art grew from that. [More on the origins of painting.] But we are not retelling histories like Pliny, but constructing an art of painting again. [The ancients are said to have written on painting.]

[Prices of ancient paintings; painting by noblemen and emperors.] Painting and sculpture are certainly akin, and nourished by the same

genius, but I always put the genius of the painter first, because he works with something more difficult. [High honor of painting in antiquity.] And I decidedly consider it a good touchstone of perfect intelligence to love painting, though it does also happen that this art is liked by the uneducated as well as the educated, something that hardly happens in any other art. Indeed, nature herself seems to love to paint, as we see in cracks of marbles where she often paints centaurs and bearded kings. Thus, if painting is a fine and ancient adornment, worthy of free men, and welcome to the educated and the uneducated, I strongly urge young students to give painting as much study as is allowed.

Painting is divided into three parts, which we have taken from nature. Since painting tries to show things that are seen, we should note how things are seen. When we see something, we first say it occupies a place. Here, marking this place, the painter will call the forming of an edge with a line "circumscription." After that, looking again, we recognize many surfaces of the seen body fitting together, and here the artist, marking them in their places, will say he is doing "composition." Finally, we determine the qualities and colors of the surfaces more precisely, and when we represent these, since every difference derives from lights, we can rightly call it "reception of lights." [The three are summarized.]

First we will speak of circumscription, which draws the border all around in a painting. [An ancient master of this technique.] One must take great care that it be done in very thin lines, that almost escape being seen. [Two ancient masters.] If it is made with a too visible line, it will seem not a margin but a cleft. On this, therefore, I insist they should work hard. No composition or reception of light can be praised where there is not good circumscription too, and it is not rare for a good circumscription alone, that is, a good drawing, to be very welcome in itself. Hence this should be a main effort, and for that in my opinion nothing is more useful than the veil, which I among my friends call the intersection. It is a very fine veil, with thin threads, colored as you please, marked off with thicker threads in as many parallels as you like, which I place between the eye and the thing seen, so that the visual pyramid may penetrate the fineness of the veil. It is of no little utility to you, first because it always presents you with the same unmoved surface, on which, once you have established the limits, you always find the true apex of the pyramid, which would be very difficult without the intersection. And you know how hard it is to render something which does not remain the same, so that painted things are easier to copy than sculptured ones, and you know how when you change the distance and the midpoint whatever you see seems greatly altered. So the veil will help not a little, being always the same. Its other utility is that you can easily establish the limits of edges and surfaces. So on one parallel you will see the forehead, on another the nose, or another the cheeks, below that the chin, and the

same way everything in its place; thus you will see similar parallels on the panel or the wall, and will place everything just right. Finally, the veil will help you a great deal in learning to paint when you see in it round and projecting things, and so with judgment and experience you will find our veil very useful.

Nor will I listen to those who say that they are unsuitable for painters to use because, though they help, afterwards you cannot get on without them. I do not think that infinite labor is demanded from painters, simply painting that seems three-dimensional, and like what it represents, which I think cannot be done without use of the veil. So let them use it, and if they like to try their skill without it, let them first note the boundaries of things within the parallels of the veil, or always, as they look, imagine a transverse line cut by another perpendicular where that boundary is established. But since it is not unusual for inexpert painters not to know the edges of surfaces, for instance in men's faces, where they cannot tell where the forehead ends and the temples begin, they should be shown how to recognize this. And this nature shows. We often see how each plane surface presents itself in its lines, lights and shades, and so too we see convex and concave surfaces divided as it were in many almost square surfaces, with diverse bright and shadowy spots; thus each part with its bright and dark is to be read as several surfaces. But if a single surface begins shadowy and little by little grows brighter, then the middle point between them should be marked by the thinnest of lines, so that the color system there will not be left in doubt.

It remains to mention the aspect of circumscription which relates to composition; so we must know what composition is in painting. I call composition the system in painting that puts the parts together in a painted work. The painter's greatest work is the narrative; the narrative is made up of bodies, the bodies of members, the members of surfaces. And if circumscription is simply a way of marking the edges of surfaces, while some surfaces are small, such as animals, others are very large, such as buildings or colossi. For the small ones, the previous instructions with the veil are fully adequate, but new systems are needed for the larger ones.

Here we must recall what we said above, in the Rudiments, about surfaces, rays, the pyramid and the intersection, also about lines parallel to it, and the midpoint and its line. Upon the pavement, with its orthogonal and transverse lines, we build walls and other surfaces that are horizontal. First I begin with the bases, mark the width and length of the walls in their transversals, and follow nature in that no right-angled three-dimensional body can be seen from more than two adjacent sides at once. I adhere to that, and begin with the nearest buildings, especially those parallel to the intersection, and mark their length and width in the transversals, taking as many of them as I want to have the building

to extend two-foot lengths. To find the midpoint between two transversals I find where their diameters intersect. And so I draw the foundations just as I like. Then I mark the height by a not very difficult method, for I know the height contains a proportion, beginning at its base up to the centric line, and continuing above it in the same way. So if you want the distance up to the centric line to be the height of a man, that will be six feet, and so if you want your wall twenty-four feet high, you will go three times as much above the center line as you had gone to the floor from the centric line. With these methods we can draw all the surfaces that have angles.

It remains to say how circles are drawn. Circular surfaces are derived from angular ones. I draw a rectangle, and divide its sides in parts, in the way I divided the bottom line of the painting before, and then I draw lines from each to the one opposite, so that the rectangle is divided into many small ones. Then I draw a circle the size I want, making the lines of the little squares and of the circle intersect, and these points I mark on the transversals of the pavement in my painting. Since it would be a great labor to divide the circle into a great many parts, I stop after about eight and guide the curved line from point to point by my wits. Would it not be speedier to take it from a shadow? Certainly, if the body making the shadow were just in the middle.

Thus we have finished circumscription, that is, how to draw, and composition remains, the system in painting for putting together things seen in a painting. A painter's greatest work is not a colossus, but the narrative; a narrative returns greater praise for skill than any colossus. As a part of the narrative is the bodies, part of the bodies the members, and part of the members the surfaces, hence the first parts of painting are the surfaces. It is from composing surfaces that there arises that grace in bodies which is called beauty. You will see some faces with some of their surfaces large and some small, some projecting and some receding, like an old woman's face, and this is very ugly to see. But when a face has its surfaces related in such a way as to take soft and pleasant lights and shadows, without any sharp projecting corners, we will call it lovely and delicate. In this matter of composition of surfaces, grace and beauty of things is much sought after. [It is to be achieved by closely following nature, and using the veil.] And when we want to put into practice what we have learned from nature, the first thing is to draw our lines to certain points, as we noted.

Next to members. One must first take care that all the members go together, and they will when, in size, purpose, type, color, and other similar things, they correspond to the same beauty. For if in a painting the head was very large and the breast small, a hand wide and a foot swollen, and the body distended, the composition would certainly be ugly to see. So one must maintain a certain ratio in the size of the members,

and in this coordination first take into account each bone, then the various muscles, then dress it in its skin. Here it might be objected that I had said before that nothing pertains to the painter that he cannot see. That shows a good memory, but just as to dress a man he is first drawn naked, and then surrounded with cloths, so we cover him with flesh so that it will not be hard to understand where each muscle is underneath. And since nature has established measurements within us, which are very useful to know, let studious painters take this work from nature, and hold on to it after working to acquire it. One reminder, to take one member of a creature with which to measure the others. Vitruvius, the architect, measured the height of a man by the foot, I would consider it more worthy to measure the other members by the head.

[Summary repetition.] Then make sure that each member does its own function. A runner should not move his hands any less than his feet, but a philosopher speaking should show modesty rather than skill in fencing. In Rome they praise a story in which the dead Meleager, being carried, weighs down those who carry his weight, and he seems dead in every one of his members, everything hangs down, hands, fingers, and head. Everything hangs loosely, which helps to suggest a dead body, certainly a very difficult thing, and anyone who can make believe that every member is useless is a very good artist. In every painting, then, make sure that every member does its office so that nothing is left over without function. The members of the dead should be dead down to the nails, and every smallest part of the living should be living. A body is called alive when it has a certain movement while stationary; it is called dead when the members can no longer support the functions of life, movement and feeling. So the painter desiring to express life in something will make every part in motion. But in every movement he will maintain grace and gentleness; those movements are particularly attractive and lively that move upward through the air.

We also said that in composing members a particular type was needed, and it would be absurd if Helen's or Iphigenia's hands were old and gnarled, or if Nestor had a soft breast or a thin neck and Ganymede a head of curly hair or the thighs of a porter, or if Milo, the strongest of all, had a thin small build. And again, in a figure with a fresh creamy complexion it would be silly to have the arms shriveled and thin. [Another example and a summary.] The members should also all correspond in color, thus if someone has a pink, bright, charming face, he should not have an ugly dirty breast or other members. [Summary.] And besides all this, everything should match in dignity; it would not be suitable to dress Venus or Athena in a camp follower's cap, or Mars or Jove in a woman's dress. When the ancients painted Castor and Pollux, they were careful to make them look like brothers, but one showed his fighter's nature, the other his agility. [Another ancient example.]

Next comes the composing of bodies, in which all the painter's skill and praise is found, and here some of the things said about the composing of members also apply. The bodies should match each other in the scene in size and in actions. When the centaurs are painted fighting after the banquet, it would be inept for one in the middle of the tumult to be sleeping off his wine. And it would be a fault if one were larger than another seen at the same distance, or if dogs were the size of horses, or if, as I often see, there was a man in a building as if he were enclosed in a box, barely fitting it when seated. Thus let all bodies in size and function conform to what is being done in the scene.

The story that you can praise and admire will be the one that presents itself so enriched and attractive in its delights that it will hold anyone who sees it, educated or uneducated, with pleasure and emotion. The first thing that pleases in a scene comes from the abundance and variety of things; just as in eating and in music novelty and abundance please by being different from the old familiar things, so the soul delights in all abundance and variety, and it is the same in painting. I would call a scene abundant that mixes, in their places, old, young, children, women, girls, infants, chickens, puppies, birds, horses, sheep, buildings, landscapes, and all such things. [Summary.] But I would wish this abundance to be graced with a certain moderation in variety, and marked with dignity and modesty. I condemn those painters who want to seem abundant by leaving no empty space, and so strew a loose confusion, not a composition, so that the story does not seem to be doing something worthwhile, but to be enveloped in tumult. Perhaps if one wants great dignity in a scene, one would like solitude. In princes, few words lend majesty, when they give instructions, and so in a scene a certain suitable number of bodies brings out no little dignity. I don't like solitude in a scene, yet I don't praise an undignified abundance. But in all stories variety is charming, and especially attractive are those in which the poses differ greatly. So some bodies should stand straight up and show their whole faces, with hands held high and fingers graceful, resting on one foot. Others should have faces turning away, arms dangling, feet close together, and everyone his own action and bending of limbs, some sitting, some kneeling, some lying down. And if it is proper, some should be nude and other partly nude and partly dressed, but always observing modesty and decency. The parts of the body that are ugly to see and others that are ungraceful should be covered with cloth or a leaf or a hand. The ancients painted Antigonus only from the side in which he did not have an eye missing. [Other examples.]

[Summary] and thus an effort should be made to keep any figures from having the same gesture or pose as another. Then too, a scene will touch our minds when the people painted in it express their emotions a great deal. It is an effect of nature, than whom nothing is more capable

of things like itself, that we weep with those who weep and laugh with those who laugh and mourn with those who mourn. But we recognize these emotions from motions. We see how someone who is saddened, because care presses on him and thoughts besiege him, stands with his powers and feelings almost in a daze, holding himself sluggish and inert, his limbs pale and scarcely supported. In one who is melancholy, you'll see the head hanging down, the neck loose, all the limbs drooping as if weak and neglected; in the angry man, since anger kindles the mind, the eyes and face will swell up with fury and heat up in color, and every limb fling itself as impetuously as in madness. Happy and witty men have free motions and certain attractive turns. They say Aristides the Theban knew these movements very well. . . .

So painters need to know all the movements of the body very well, as they can be learned from nature, though it is hard to imitate the many emotions of the soul. Who would suppose without trying it out that it is so difficult when one wants to paint a laughing face to keep from making it more tearful than happy? And then who, without a great deal of study, could represent faces in which mouth, chin, eyes, cheeks, forehead, and brows all match a single laughing or crying face? Hence they should be learned from nature, and one should always follow very vigorous things that make the person seeing them think of more than he sees. But since we are telling some things about these movements, which we partly worked out in our head and partly learned from nature, I think, first of all, all the bodies should move in terms of the theme of the story. And I like to have someone in the scene guide and show us what is being done, or call us with his hand to look, or warn us not to go there, with angry eyes and troubled face, or show some danger, or wonder, or invite you to laugh with them, or cry. And thus, whatever the painted people do among themselves or with you, it all adds to the enrichment or the instruction of the scene. [An example from ancient art.] Praise goes to the "Ship," painted in Rome, in which our Tuscan painter, Giotto, set eleven disciples, all trembling with fear, seeing one of their number walking over the water, for he showed each one revealing a certain indication of a troubled mind with his face and gestures, so that each one had different movements and states of mind. But let us go through this passage on movements very briefly.

Some motions of the mind are called feelings, such as pain, joy and fear, desire and the like. There are movements of the body, in which bodies move in various ways, increasing, diminishing, getting sick or well, and moving from place to place. But we painters, who wish to show the emotions of the mind through the motions of the body, refer to movement in space only. Whatever moves from its place can take seven routes: upward, downward, right, left, to the front or to the back, and in a circle. I want to see all these motions in painting; let there be some bodies

leaning out toward us, some this way and some that, and let some parts of a single body present themselves to the watcher either retreating or rising or falling. But since some of these movements are beyond all reason, I would like to speak of some things I have picked up from nature about poses and motions, to make it clear what moderation we ought to use. Notice how a man, in every pose he takes, establishes his body so that all of it supports his head, the heaviest member, and if he has his weight on one foot, it is always perpendicularly under the head, like the base of a column. And almost invariably in a standing person the head turns the same way the foot points. Head movements are almost always, I observe, such that they have some part of the body to hold it up, the weight of the head being so great, or else he stretches out one member like the arm of a scale to compensate for the weight of the head, and we see how any-body carrying a weight in an outstretched arm, placing his foot like the needle of a balance, uses all the rest of his body as a counterweight to it. I also have the impression that in raising one's head, no one shows his face higher than where he sees the middle of the sky, nor to the side more than where the chin touches the shoulder. At the waist, you almost never twist so far that the point of the shoulder is above the umbilicus. Leg and arm movements are very free, but I would not want them to conceal any noble and respectable part of the body. And I see that, in nature, the hands are almost never lifted over the head, nor the elbows over the shoulder, nor the foot over the knee, nor is there more space between the two feet than the length of a foot. And notice how when one hand is stretched upward, that whole side of the body follows it, all the way to the foot, so that even the sole of the foot lifts off the ground.

A diligent artist will note many such things for himself by himself, and perhaps the things I spoke of are so obvious that they seem super-fluous to mention. But since I see mistakes being made in them, by not a few, I thought I should not pass them by. One encounters those who think they will be praised for presenting movements that go too far, and ar-ranging for the front and back of a figure to show at the same time, be-cause they have heard that images throwing all their limbs about seem very lifelike, so they make them seem fencers and mountebanks, with no dignity in the painting, and thus they are not only without all grace and sweetness, but show besides that the artist's mind was too nervous and violent.

It suits paintings for motions to be soft and attractive, relating to what is being done. Let young girls' movements be airy and full of sim-plicity, with more gentleness than strength, even though Homer, whom Zeuxis followed, liked a heavy form even in women. Let young boys have light and cheerful movements, with a certain show of spirit and potential. Men should have movements graced with more firmness, with nice-look-ing and well-composed stances. Old people should have weak motions

and stances, supporting themselves not only on both feet but with their hands. And thus, each one should, with dignity, express through the motions of his body the emotions of the soul that you want, and the greatest disturbances to the mind should match the greatest motions of the limbs. And this pattern of common motions can be seen in all living creatures. It's inappropriate to give a plowing ox the motions you would give to Bucephalos, Alexander's bold horse. [Other examples and summary.] That will do on the motions of living creatures; now, since inanimate things also move in all the same ways we mentioned above, we will therefore speak of them.

It is pleasing to see some motion in hair, manes, branches, leaves, and clothing. I particularly enjoy seeing the seven motions I mentioned in hair; it can swing in a circle as if trying to form a knot, wave in the air like flames, some of it can weave into the rest like a snake, part extending this way, part that way. Branches, too, twist upward sometimes and downward sometimes, now inward, now outward, or upon themselves like ropes. So do folds, and folds arise the way branches do from a tree trunk. Thus all the motions should be employed, so that no part of a cloth will be left blank without movement. But, as I have often repeated, the motions should be moderate and gentle, so as to present grace to the viewer rather than amazement at the effort. But if we want the cloth to be in motion, as cloth by nature is heavy and keeps falling to the ground, it is a good idea to put the face of the north or west wind blowing among the clouds in the painting, so that the cloth will flutter. And from this follows the graceful effect of bodies caught in the wind on one side, so that they show a good part of the bare body, and on the other the cloth flung by the gentle wind will fly through the air, and in this fluttering the painter must watch out not to unfurl any cloth against the wind. [Summary of instructions to the painter.]

It remains to speak of the receiving of light. In the Rudiments, above, we showed adequately how lights have the power of varying colors, when we taught how a single color can be constant and yet alter its appearance according to the light and shade that it receives. And we said that white and black express dark and light for the painter, all other colors being as it were raw material for the painter to which he can add more or less shadow or light. And so, leaving out the rest, here we need only say how the painter should use his white and black. [What ancient painters did.] There is surely no doubt that abundance and variety of colors are a great help to the grace and praise of painting. But I would like the instructed to believe that the entire highest work and art consists in knowing how to use black and white, and it is wise to give all one's study and diligence to knowing well how to use the two of them, because light and shade make things seem to be three-dimensional. [Examples from the ancients.] I will almost never judge anyone to be a

middling good painter who does not understand what power certain lights and shadows have in every surface. To the instructed and the uninstructed I say, I will praise those faces that seem to issue forth from the panel as if they were sculpture, and condemn those that have no art except in the drawing perhaps. I would want a good drawing for a good composition to be well colored. So let them first study about lights and shadows, and notice how the brightest surface is the one that the rays of light hit, and how that same color becomes dark where the power of light is absent. And they should notice that always opposite the light there is corresponding shadow on the other side, so that there is never in any body a lighted part without there being another darkened part.

But when it comes to imitating brightness with white and darkness with black, I warn them to be very careful in getting to know individual surfaces, and how much each is covered with light or shadow. You will grasp this by yourself from nature, and when you are well acquainted with them, then you will begin to put on the white where it is needed, very sparingly, and immediately on the other hand black where it is needed, for through this balancing of white with black one can see very well how things form relief, and so little by little, still sparingly, you will continue adding more black and more white until it is enough. And the mirror will be a good judge for recognizing this, and I don't know how it happens that well-painted things are very attractive in the mirror, an astonishing thing, while every fault of painting shows up in the mirror as a deformity.

Here are some things we have learned from nature: take care that color is uniform over a plane surface as a whole; in concave and convex surfaces the color will vary, here bright, there dark, elsewhere a middle tone. This shift takes in silly painters, who, as I said, if they had drawn the edges rightly, would have found it easy to apply the light. This is what they would do: first they would cover the surface all the way to the edge with whatever black or white was needed, as light as dew, then after that another and another, so that where there was more light there would be more white on the area, and where light was lacking the white would fade away like smoke, and contrariwise with black. But remember never to make any surface so white that it could not be made still whiter. Even if you dressed in the brightest garments, you should stop well short of ultimate whiteness. The painter has nothing but white to show the extreme shine of a highly polished sword, and only black to show the deepest night. And arranging white near black has the power that vases will seem to be of silver, gold, or glass, and although painted will seem to gleam. And hence a painter who uses black and white immoderately is to be condemned. I would be glad if white were sold to painters at a higher price than the most precious gems. [Variations on the same point.] And though they err in distributing them, one who uses much black is

less to be reproved than one who does not stretch out his white. Nature makes you hate dark and ghastly things more from day to day, and the more your hand becomes refined in charming grace. Certainly nature causes us to love open and bright things, so all the more the road should be closed that leads more easily to error.

Having spoken about white and black, we will speak of the other colors, not as Vitruvius does about the origin of the best pigments, but of how colors well-ground are to be used in painting. [An ancient painter's lost book on color.] So we who, if there was something written earlier, have drawn this art from underground, or, if it never was written, have drawn it from heaven, will proceed by our wits as we have so far. I would like painting to show all kinds, and each of their species, with much joy and grace to look upon. There will be grace when one color is very different from the one nearest it, so if you paint Diana leading her chorus, let one nymph wear green, a second white, a third russet, a fourth crocus-yellow, and so on, with different colors so that the bright are always next to different darks. When there is such contrast, the beauty of the colors stands out more charmingly, and there is a certain friendship among colors, such that one attached to the other gives them dignity and grace. Russet next to green and sky-blue bring each other out and do each other honor. White produces pleasure not only next to gray or yellow, but near almost all of them. Dark colors placed between bright ones have a certain dignity, and likewise the bright ones fit well between the dark.

Some use much gold in their scenes, which they think evokes majesty; I do not praise it. Even though one were painting Virgil's Dido, who had a golden quiver, golden hair tied with a gold ribbon, and a purple dress belted with gold, her horses' reins and everything else gold, I would not want gold used at all, for there is more admiration and praise for the painter in imitating golden rays with colors. And besides, surfaces with gold on a flat panel may shine when they should be dark and look black when they ought to be bright. To be sure, I would not object to other carpentered framing ornaments added to painting, like carved columns, bases, capitals and cornices, even if they were of the purest and heaviest gold. On the contrary, a perfect scene deserves ornaments of precious gems.

[The topics of Book Two are summarized.]

Book Three

But there remain other things, useful in making a painter entirely praiseworthy, and I think I should not omit them in these commentaries. I will go over them very briefly.

The job of a painter, I would say, is to draw with lines and paint

with colors, on any wall or panel given him, surfaces that resemble any body that can be seen, so that at a fixed distance and from a fixed central position, they seem three-dimensional and with the bodies very like. The goal of painting, to bring the artist respect and good will and praise rather than wealth. And painters will attain this when their painting holds the observer's eye and mind, and how he can do this we explained above, speaking of composition and receiving of light. But I would like the painter, so as to be able to do all these things, to be a good man and learned in literature. And everyone knows how a man's goodness counts much more toward gaining him the good will of citizens than all his industry or art, and no one doubts that the good will of many helps the artist greatly toward both praise and earnings. For it often happens that the rich, moved more by good will than being impressed by someone's skill, sooner give employment to the good and modest man, casting aside another painter who is perhaps better in his art but not so well behaved. [Restatement of the same.]

I would like the painter to be well versed in all the liberal arts he can, but first I want him to know geometry. [An ancient authority.] Our Rudiments, which explain all of the complete and finished art of painting, will be understood easily by geometers, but those who are ignorant of geometry will not understand it or any other system of painting, and so I affirm that the painter needs to understand geometry.

And let them cultivate the enjoyment of poets and orators, for they have many adornments in common with painters, and abundant knowledge of many things; they will help a great deal toward composing the narrative well, whose every praise consists in the invention. How much it often has this power we see when a beautiful invention is attractive by itself, without the painting. We praise in reading it the description of the Calumny, as Lucian told it, which was painted by Apelles. I feel it is not irrelevant to our concern to tell it here, to warn painters where they should be watchful with respect to invention. This painting was of a man with extra large ears, beside whom stood two women, one on each side, one called Ignorance, the other Suspicion. Further off Calumny came, a woman beautiful to look at but she seemed scheming in her expression. In her right hand she held a lighted torch, with the other she was dragging by the hair a youth who was lifting his hands to heaven. And there was a pale, ugly, grimy man, with an evil look, who might remind you of one who had grown thin and sunburned from long labor in armies, he was the guide of Calumny, and was called Envy. And there were two other women, Calumny's companions, adjusting her clothing and ornaments, and one was called Insidiousness and the other Fraud. After these came Penitence, a woman dressed in funeral garb, who was tearing at herself, and after her followed a young girl, modest and retiring, called Truth. And if this tale gives pleasure in being told, think how

agreeable and attractive it would have been to see it painted by Apelles' hand.

It would also be a pleasure to see those three sisters whom Hesiod called Egle, Euphrosyne and Thalia, as they are painted taking each other by the hand and laughing, each in a loose, neat dress; they signified liberality because one of these sisters gives, the next receives, and the third returns the favor, steps that are required for any complete liberality. Thus we see how much praise inventions of this kind bring to the artist, and I therefore advise every painter to cultivate the friendship of poets, orators and others similarly versed in letters, whether they provide new inventions or help in composing a story beautifully, through whom they cannot but gain much praise and fame for their painting. Phidias, the most famous of painters, admitted that he had learned from the poet Homer to paint Jove with much divine majesty, and we too, more eager to learn than for pay, will learn from poets many many things useful to painting.

But it happens not seldom that those who are willing and eager to learn exhaust themselves when they don't know how to learn and only add to their labor; therefore we will state how one becomes instructed in this art. No one can doubt that the basis and beginning of this art, and every step toward becoming a master as well, is to be taken from nature, and the attainment of the art can be had with diligence, persistence, and study. I would like the young, whom I see starting out to apply themselves to painting, to do what I see in those learning to write: first they teach the form of each letter separately, which the ancients called elements, then they teach the syllables, and then they put together all the sounds, and one should learn to paint by the same system. [They should go from edges to surfaces to members.] And the differences among members are many and obvious. You will notice one person with a turned-up humped nose, another with nostrils like a monkey or pulled back open, another will show a drooping lower lip, others will be graced with tiny little thin lips, and so the painter should study everything that makes each member different, larger or smaller. And he should also notice how we can see that children's limbs are round, as if turned on a lathe, and soft, and in a more mature age they are sharp and angular. And so the attentive painter will come to know all these things from nature, and will persistently study how each one is. And in this investigation, he will always keep his eyes and his mind open; he will notice the lap of a person sitting, take note how softly the legs of a seated person hang, be aware of the whole body of a standing person, and will not miss the function and measurement of any part. And he will be pleased not only to render the likeness of all the parts, but also to add beauty to them, for in painting good looks are not only attractive but required. The ancient painter Demetrius failed to attain the highest praise, because he was much more

interested in making things like nature than good-looking. So it is helpful to take each praiseworthy part from all beautiful bodies, and one should work with study and labor to learn what is good-looking, and although this is difficult, because one finds complete beauty not in a single body but scattered and uncommon in many bodies, still one must search it out and learn to put one's full labor into it. It will happen, as it does with those who dare to undertake great things, that the small ones are easy, and there is nothing so hard that study and persistence cannot overcome it.

But in order not to lose labor and study, one must keep clear of the habit of some foolish people, who work by themselves to attain praise in painting for themselves, presuming on their talent, without any model in nature that they follow with their eyes and mind. Such people do not learn to paint well, but reinforce their own mistakes. Talents that are not expert authorities should stay away from that idea of beauties that the most experienced barely discern. Zeuxis, a particularly outstanding and experienced painter, in making a panel that he set up in public in the temple of Lucina in Crotona, did not insanely trust his own skill like every painter today, but, thinking that he could not find all the beauties he sought in one single body, since nature does not give them all to one, therefore chose five girls, the most beautiful of the youth of that land, to take from them all the beauties most praised in a woman. He was a wise painter, since he knew that when painters have no model in nature to follow, and want to attain the praise of beauty by their wits, they may easily fail to find the beauty they seek with such toil, and develop bad habits, which then they can never get rid of when they want to. But the one who accustoms himself to take all things from nature will develop such an experienced hand that whatever he does will always seem taken from the natural. One can appreciate just how much the painter needs to attempt this when a scene contains a face of some well-known and worthy man, since even though it may have other made-up faces that are much more perfect and attractive, yet that well-known face will draw all the eyes of the observers of the scene first, such is the power, we see, of what is drawn from nature. Hence we will always take what we want to paint from nature, and we will always pick the most beautiful things.

But take care not to do as many do who learn to draw on tiny little panels; I would have you practice drawing big things, almost equal to the size of what you are drawing, for in small drawings it is easy to hide large errors, and in large ones the smallest errors can be easily seen. Galen the physician writes that in his time he saw Phaeton, borne by four horses whose reins, forequarters and every foot could be seen distinctly, carved in a ring. But our painters should leave this praise for the gemcutters, and turn to larger fields of accomplishment; if you know how to paint a large figure well, you can easily form these minute things

well in a single stroke, but one who has got into the habit of these little trifles and baubles will very likely make mistakes in larger things.

Some repeat the figures of other painters, and seek praise for that [such as an ancient artist received]. But our painters will surely be mistaken if they do not realize that the painter was working to show you something that you can see in our veil, described above, as it was well and sweetly painted by nature herself. And if you still like to repeat the works of others, because they have more patience with you than living things, I would prefer to draw from a mediocre sculpture than an excellent painting, because you gain nothing from paintings except how to duplicate them, but from sculpture you learn how to duplicate them and also how to draw the lights. And for getting a sense of lights it helps to half-close the eye, and narrow your vision with your eyelashes, so that the lights may appear to touch each other as if they were painted on the intersecting plane. And it may be more useful to you to practice relief modeling than drawing. Sculpture, if I am not wrong, is more objective than painting, and it is hardly ever possible to paint something without knowing its relief, which is easier to ascertain by sculpting than by painting. And a supporting argument for this is that there have been some fair sculptors in almost every period, but there have been hardly any painters who were not completely inept and laughable.

But whatever you practice on, always have some choice and special model before you that you look at as you are drawing, and I consider that diligence combined with quickness is necessary in drawing it. Never apply your pencil or brush without having established in your mind first what you are going to do, and how you are going to carry it out, for it is certainly safer to correct mistakes with the mind than to scrape them off the painting. Then when we have become habituated to do nothing without planning first, we will turn out to be much faster painters than Asclepiodorus, whom they call the fastest of all ancient painters. And our wits, stimulated and heated by practice, become ready and swift to work, and a hand will be quick to follow when it is well guided by a firm method of the wits. And as for those who are lazy artists, they are lazy because they are slow and frightened in trying what they have not clarified in their minds. And while he turns about among those clouds of errors, like the blind man with his stick, he will try this way and that with his brush, while a well-informed man will never put his hand to his work unless it has been explored in his mind.

But since the story is the painter's supreme work, which must have abundance and choice of all things, we must know how to paint not only a man but also horses, dogs, and all other animals, and all other things worth seeing. This is called for to make our story abundant, which is a great thing, I acknowledge to you. And though the ancients did not often admit that anyone was even fair, not to mention excellent, in all

things, nevertheless I hold that we must try not to omit through negligence those things that draw praise when done and condemnation when neglected. [Many examples of specialist painters in antiquity.] Thus not every one had equal faculties, and nature gave each talent its own gift, yet we should not therefore be content to give up trying out of negligence anything that with further study we could do; nature's goods are to be cultivated with study and practice, and in that way to be increased day by day, and it would be wrong to overlook through negligence anything that might conduce to our praise.

And when we have a scene to paint, we should first think long to ourselves what would be the most beautiful way and arrangement for it, and execute our concepts and models of the entire story and each of its parts first, and call all our friends to advise us about this. In this way we will make an effort to have every part well thought out first, so that there will be nothing in the work about which we do not understand where and how it is to be done and located. And to be even more certain, we will mark our models with parallel lines, so that in the public work we will take every pose and location of things from our concepts, as if from private notes.

In working on the story, we will be quick enough, in combination with diligence, to avoid irritation or boredom in working, and we will evade the eagerness to finish things that makes us hurry the work. Sometimes it is good to intersperse the labor of working with mental recreation. It is not helpful to do as some do, undertaking a number of works, beginning this one today and that one tomorrow, thus leaving them unfinished, but to complete the work you undertake in its entirety. There was a man to whom Apelles answered, when he showed him a painting of his saying he did it that day, I wouldn't be surprised if you had done several more of the same kind. I have seen some painters and sculptors, and orators and poets too if there are any orators and poets in our age, apply themselves to some work with burning concentration, then when that ardor of their minds has cooled they leave the work in its rough beginnings, and apply themselves to new things with new passion. I thoroughly denounce men like that, for whoever would have what he does liked and accepted by those who come after must first think out what he has to do, and then make it complete with the greatest diligence. And it is not rare for diligence to be praised above talent, yet it is best to evade the severity of those who, wanting every fault removed from everything and each to be completely polished, will sooner see their works grow old and dirty in their hands than finished. The ancients condemned the painter Protogenes who did not know how to lift his hand from the panel. And deservedly so, for although it is good to extend all the skills we have, so that things may be done well with our best efforts, yet to want more than is possible for you in all things seems to me an act of an obstinate and eccentric man and not a diligent one.

So let a moderate diligence be given to things, and take advice from friends, and in painting be open to all comers and hear everyone. The painter's work aims to be agreeable to the whole population, so the judgment and opinion of the population should not be despised, so long as it is allowable to satisfy their opinions. They say Apelles heard whatever anyone condemned or praised, hidden behind the painting so that everyone could condemn him more freely and he could hear it more frankly. I would have our painters in the same way openly ask and hear from everyone what he thinks, and this will help him to gain favor. There is no one who does not consider it an honor to give his opinion on other people's work. And there is little doubt, besides, that the envious and contrary-minded harm a painter's reputation; the painter's praise in all cases was always open, and the things he has painted well are the witnesses to his praise. So let him hear everyone, and first think over everything thoroughly, and correct himself thoroughly, and when he has heard everyone he should believe the best informed.

These were the things I had to say about painting, and if they are convenient and useful to painters, I ask as a reward of my labors only that they paint my face in their stories, and thus show that they are grateful and that I was studious of the art. And if I satisfied their expectations less, let them not therefore abuse me, in that I had the courage to undertake such a large topic. And if my skill could not finish what it was praiseworthy to try, still, even the will in great and difficult deeds is generally praised. Perhaps someone else after me will correct the mistakes in my writing, and will be more helpful and useful to painters in this most worthy and outstanding art. . . . We, however, considered it a pleasure to have been the first to take this prize, to have had the courage to reduce to writing this most subtle and most noble art. . . . Those who follow, if someone comes who surpasses us in study and talent, will in my opinion make painting complete and perfect.

Ghiberti's Second Commentary

Florentine merchants, self-aware to a remarkable degree and great family men besides, from the fourteenth century on often wrote memoirs of their achievements to pass on to their descendants. Some of these extend into chronicles of civic events, and of these the more ambitious begin by copying previous chronicles. They may also tell of their predecessors in a family business. Ghiberti's Commentarii *are an artist's version of this form. In the first commentary, he copies texts about artists of the ancient world. The second one, whose largest section is an autobiography (the first by any artist), is introduced by a series of accounts of preceding Florentine artists. It is not quite the first such series, for around 1400 a set of biographies of famous Florentines had included a page on Giotto*

and his pupils. But it is the first survey of the history of Florentine art, useful, first of all, for its lists of works, often the earliest records of them, basic to our knowledge of the earlier artists. The survey of Giotto cites an amazing forty works, no doubt assembled over years (we know Ghiberti kept a diary), and our first allusions to some of the most important, such as the chapels at Santa Croce. Ghiberti is equally important in showing the attitude, which later led up to the writing of Vasari's Lives, *of artists conscious of being members of a tradition where their models were previous artists, an idea first seen in the Italian Renaissance. The second commentary is presented complete here, for the first time in English. The third commentary, on the science of optics, is almost all copied from medieval books and is not easy to understand today. Original text in several editions, the most accessible by O. Morisani, 1948, 32–47.*

Now at the time of the Emperor Constantine and Pope Sylvester the Christian faith arose. Idolatry was subject to great attack, such that all the statues and paintings were destroyed and broken which had been so noble, and of such ancient and perfect dignity, and so too, along with the statues and paintings, there were also destroyed the commentaries and books and outlines and rules that gave instructions in so worthy and noble an art. And then, to wipe out all ancient idolatrous customs, they decided that all the temples should be bare. At this time they ordered heavy punishment to anyone who would make any statues or paintings, and so the art of sculpture and of painting stopped, and all learning that had been produced in it. When the art was undone, the temples remained bare six hundred years or so. The Greeks [Byzantines] began the art of painting in a very weak way, and produced very rough work; to the same degree that the ancients had been expert, so in this age these were crude and rough. This was 382 Olympiads after the foundation of Rome [probably about A.D. 1140].

The art of painting began to arise in Etruria. In a village near the city of Florence, called Vespignano, a boy of marvelous genius was born. He was drawing a sheep from life, and the painter Cimabue, passing on the road to Bologna, saw the boy sitting on the ground and drawing a sheep on a flat rock. He was seized with admiration for the boy, who was so young and could do so well. And seeing he had his skill from nature, he asked the boy what his name was. He answered and said, I am called Giotto by name, my father is called Bondone and lives in this house close by. Cimabue went with Giotto to his father; he made a very fine appearance. He asked the father for the boy; the father was very poor. He handed the boy over to him and Cimabue took Giotto with him and he was Cimabue's pupil. He used the Greek manner, and in that manner he was very famous in Etruria. And Giotto grew great in the art of painting.

He brought in the new art, abandoning the rudeness of the Greeks,

and became dominant in Etruria in the finest way possible. And very fine works were produced, and especially in the city of Florence, and in many other places, and many pupils were taught on the level of the ancient Greeks. Giotto saw in art what no others added. He brought in natural art, and grace with it, not stepping outside the bounds. He was thoroughly expert in the whole art, he was the inventor and discoverer of much learning that had been buried some six hundred years. When nature wants to give anything, she gives it without stinting. He was fertile in everything; he worked on walls, in oil, on panel. In mosaic, he did the mosaic of the "Ship," at St. Peter's in Rome, and painted with his own hand the chapel and altarpiece of St. Peter in Rome. He painted the great hall of King Robert with famous men, in Naples, very well, and painted in the Castel dell'Ovo. He painted in the church of the Arena in Padua, it is all by his hand. There is a Glory of this World by his hand. In the Party Headquarters there is a scene of Christian Faith, and there were many other things in that building. In the church of Assisi of the Franciscan friars, he painted almost all the lower part. He painted at Santa Maria degli Angeli in Assisi. At Santa Maria della Minerva in Rome a crucifix and a panel painting.

The works that were painted by him in Florence. He painted in the Badia in Florence, in an arch over the entrance door, a half-length Our Lady with two figures at the sides, very finely, and he painted the main chapel and its altarpiece. At the Friars Minor, four chapels and four altarpieces. He painted very excellently in Padua at the Friars Minor. Very learnedly indeed, in the Humiliate friars in Florence, there was a chapel, a great crucifix and four panel paintings, done very excellently, in one the Death of Our Lady, with angels and twelve apostles and our Lord all around, done very perfectly. There is a very large panel with Our Lady sitting on a seat, with many angels around. Over the door to the cloister, a half-length Our Lady with her child in her arms. And at San Giorgio an altarpiece and a crucifix. At the Friars Preachers there is a crucifix and a most perfect panel painting by his hand, as well as much else. He painted for many lords. He painted in the Chief Officer's Residence [Palazzo del Podestà] in Florence; in it he did how the city was robbed, and the chapel of St. Mary Magdalene. Giotto deserved the greatest praise. He was worthy in the whole art, and in the art of sculpture too. The first stories on the building he built, the bell tower of Santa Reparata, were carved and drawn by his hand; in my time I saw preparatory designs of these stories drawn by his hand very finely. He was as expert in one phase as in the other. He is the one to whom all praise must be given, since so much learning derived and followed from him. Since one sees how nature extended all talent to him, he led the art to the greatest perfection. He produced many disciples of the greatest fame. The disciples were these.

Stefano was a very fine master. In the first cloister of the Augustinian friars of Florence he did three scenes. The first, a ship with twelve apostles, with the greatest turbulence of weather and a great storm, and how Our Lord appears to them walking on the water, and how St. Peter throws himself to the land from the ship, and great winds; this is very excellently done, with the greatest diligence. In the second is the Transfiguration. In the third is how Christ frees the woman possessed of the devil at the step of the temple, with twelve apostles and a great crowd watching; these scenes are carried out with the greatest art. And at the Dominicans, beside the door that leads to the cemetery, a St. Thomas Aquinas, very excellently done; this figure seems to be in relief, out from the wall, done with great diligence. This Stefano began a chapel, very excellently, he painted the altarpiece and the arch in front, where there are angels falling in various poses, and great foreshortenings, marvelously done. In the church at Assisi is a Glory begun by his hand, done with perfect and very great art, which would have made every noble spirit wonder at it if it had been finished. His works are marvelous, and done with great learning.

Taddeo Gaddi was a pupil of Giotto; he was of marvelous talent, he did very many chapels and very many frescoes; he was a very learned master, and did very many panels, finely made. For the Servite friars of Florence he did a most noble altarpiece of great skill, with many scenes and figures, a very excellent work, and it is a very large painting; I think few paintings better than this are to be found in our time. Among other things he made for the Franciscans a miracle of St. Francis about a boy falling from a balcony to earth, of the greatest perfection, and he showed how the boy is stretched on the ground, and how St. Francis revives him; this story was done with such learning and skill and such talent that I never in my time saw anything painted with such perfection. In it Giotto and Dante and the master who painted it, that is Taddeo, are drawn from life. In the same church, over the sacristy door, there was a Disputation of the Wise Men with Christ at the age of twelve; it was three-quarters destroyed to build a stone cornice there; clearly the art of painting quickly disappears.

Maso was a pupil of Giotto; few things by him are anything but very perfect. He introduced short cuts in the art of painting. His works in Florence are, at the friars of Saint Augustine in a chapel, [near] the door of the church, very perfect, the Descent of the Holy Spirit, it was of great perfection, and at the entrance of the city square [outside] this church is a tabernacle, an Our Lady with many figures around, done with marvelous art. He was very excellent. At the Friars Minor he did a chapel, in which are stories of St. Sylvester and the Emperor Constantine. He was most noble and very learned in both the arts. He carved in marble beautifully; there is an eight-foot figure on the bell tower. He

was a man of the greatest talent. He had many pupils, they were all most expert masters.

Bonamico was a most excellent master; he had his art from nature, and would not endure much labor in his works. He painted in the convent of Faenza nuns, quite marvelously, many stories, all finely painted by his hand. When he put his heart into his works he surpassed all the other masters. He was a most refined master, he colored very freshly. In Pisa he did very many works. In the Cemetery at Pisa he did very many stories. At San Paolo a Ripa d'Arno in Pisa he did stories of the Old Testament, and many stories of virgin saints. He was very ready in his art, and a very jolly man. He did very many works for very many lords, up to the Olympiad 408 [probably A.D. 1315]; he flourished in a fine way in Etruria; he did very many works in the city of Bologna. He was very learned in all the art. He painted in the Badia a Settimo stories of St. James and many other things. There was a large number of most excellent painters in the city of Florence, and of quite a few of them I have not told. I hold that in that time the art of painting flourished in Etruria more than in any other age, much more than it ever did in Greece either.

There was in Rome a master of that city, most learned among the other masters. He did a great deal of work; his name was Pietro Cavallini. In Rome we see at St. Peter's, inside, over the doors, four evangelists by his hand, more than life-size, and two figures, of St. Peter and St. Paul, very large figures most excellently done and with great relief, and there are also some more like this painted in the nave at the sides. But he retains a bit of the Old Greek style. He was a most noble master. He painted entirely with his own hand at Santa Cecelia in Trastevere, and the greater part of San Crisogono, and did mosaic scenes in Santa Maria in Trastevere very excellently, six scenes in the apse. I would venture to say I have never seen anything produced on a wall in that medium that was better. He painted in Rome in many places. He was very expert in that art. He painted the whole church of San Francesco; at San Paolo the mosaic front outside was his, and inside all the walls of the middle nave were painted with stories of the Old Testament, and the chapter house was finely painted all by his hand.

Orcagna was a very noble master, especially expert in both media. He did the marble tabernacle of Or San Michele, it is a very excellent thing and quite unusual, done with the greatest diligence. He was a great architect, and did all the scenes of that work with his own hand. His own portrait, marvelously done, is carved on it by his own hand; the price of it was 86 thousand florins. He was a man of most unusual talent. He did the main chapel of Santa Maria Novella, and painted very many other things in that church, and three superb scenes at the Franciscan friars, done with the greatest art; also in that same church a chapel, and many other things painted by his hand. There are also two chapels painted by

him at Santa Maria dei Servi, and a refectory at the Augustinian friars. He had three brothers; one was Nardo, and at the Dominican friars he did the chapel with Hell, that the Strozzi family had done. In the Hell he followed just what Dante wrote; it is a very beautiful work, executed with great diligence. The second was also a painter, and the third was a sculptor who was not too good. There were in our city many other painters who could be mentioned as excellent, but I don't feel they should be grouped among these.

The city of Siena had most excellent and learned masters, among whom was Ambrogio Lorenzetti. He was a most famous and unusual master, and did very many works. He was most noble in composition; among his works at the Franciscan friars is a scene which is very large and excellently done, occupying the whole wall of a cloister. It is how a young man decided to become a monk, how he becomes one and his superior vests him, how, when he is a monk with the other monks, they eagerly ask permission from their superior to go to Asia to preach the Christian faith to the Saracens, and how the monks leave and go to the Sultan, how they start to preach the faith of Christ. As it turned out, they were seized and led before the Sultan, he ordered at once that they should be bound to a column and beaten with whips. At once they were tied, and two men began to beat the friars. The painting there shows how two had beaten them, and now have their whips in their hands as two others replace them, while the two rest with their hair damp, dripping with sweat, and full of anxiety and stress. The master's art seems a miracle to see, and there are also all the people looking, with their eyes fixed on the naked friars. There is the Sultan sitting in the Moorish manner, with varied apparel and garments, they look unquestionably alive when one sees them, and how the Sultan gives the decision that they are to be hanged from a tree. It is painted how they hang one of them to a tree, and it is very plain how all the people, there to look, are hearing the monk hanged on the tree preaching and speaking. How he commands the executioner to behead them. And there is how the monks are beheaded, with a great crowd watching, on foot and horse. There is the executioner with many armed men, and there are many men and women there, and when the monks are beheaded a dark storm starts up, with hail, lightning and thunder, and earthquakes; looking at it heaven and earth seem endangered, everyone seems to cover himself up in great fear, we see the men and women folding their clothing over their heads and the soldiers putting their shields on their heads, with the hail thick on the shields, it really seems that the hail is striking the shields with the astonishing winds. We see the trees bending to the ground, and some splitting, and everybody seems to be running off; we see the executioner falling under his horse, which kills him. Because of this very many people were baptized; for a painted story it seems a marvelous thing to me.

This was a most expert master, a man of great talent. He was a most noble craftsman, and was very expert in the theory of that art. On the front of the hospital he did the first two stories, the birth of the Virgin, and when she goes to the temple, very finely done. At the Augustinian friars he did the Chapter House, in the vault are painted the stories of the Credo. On the main wall are three stories, the first is about St. Catherine in a temple, and the tyrant is on high and how he questions her; it seems to be a feast day in that temple, many people are painted in and outside it. There are the priests at the altar, shown as they make a sacrifice. This scene is very full, and very excellently done. On the other side is how she disputes with the sages before the tyrant and how she seems to vanquish them. There is how a group of them seem to go into a library to seek out books to defeat her. In the center is Christ crucified, with the thieves, and armed men at the foot of the cross. In the palace of Siena, War and Peace are painted by his hand, you have what pertains to peace, and how goods go safe, with great safety, and how they leave it in the woods and how they come back for it. And the destructions that take place in wars are shown perfectly. And there is a cosmography, that is, the whole habitable globe. At that time the cosmography of Ptolemy was unknown, so it is no wonder if his is not perfect. And three paintings in the Cathedral by his hand, very perfect. And at Massa, a large painting and a chapel, at Volterra a noble painting by his hand, in Florence the chapter house of the Augustinians, in San Procolo in Florence a painting and a chapel. At La Scala, where the abandoned babies are kept, is an Annunciation most marvelously done.

Master Simone was a most noble painter, and very famous. The Sienese painters hold that he was the best, but to me Ambrogio Lorenzetti seemed much better, and far more learned than any of the others. To get back to Master Simone, by his hand there is in the City Hall, in the great room, an Our Lady with the Child in her arms and many other figures about, very marvelously painted, and in the same City Hall a very good panel, and on the front of the Hospital how Our Lady was married, and another of how she is visited by many women and girls, much enriched with architecture and figures. And in the Cathedral, two paintings by his hand; an enormous Coronation was begun over the Rome Gate, I saw it drawn in outline. Also, over the door of the Cathedral administration there is an Our Lady with the child in her arms and above a banner with angels flying holding it, and many other saints around, done with great diligence. And he was in Avignon at the time of the papal court, and did many works. Master Filippo worked with him, they say he was his brother; they were elegant masters and their paintings were made very thoroughly and very delicately finished; they did a very great quantity of paintings.

The Sienese masters painted in the city of Florence. One master,

who was called Barna, was excellent among all the others. There are two chapels at the Augustinian friars, with a great many stories. Among them is a youth going to be executed, going with terrible fear of death, a monk is with him comforting him, with many other figures. And the art used by this master in many other scenes is something to see; he was very expert in that art. At San Gimignano, many scenes of the Old Testament, and he worked a good deal at Cortona; he was very learned.

In Siena there was Duccio as well, who was most noble, he kept to the Greek style. The high altarpiece of the cathedral of Siena is by his hand; in the front is the Coronation of our Lady and in the back the New Testament. This painting was made most excellently and learnedly, it is a marvelous thing, and he was a most noble painter. Siena had very many painters, and abounded in wonderful talents. I leave out many so as not to overflow with too much talking.

Now let us speak of the sculptors who were in these times. There was Giovanni, son of Master Nicola. Master Giovanni made the pulpit of Pisa, the pulpit of Siena was by his hand and the pulpit of Pistoia. These works of master Giovanni are to be seen, and the fountain of Perugia. Master Andrea of Pisa was a very good sculptor, he did very many things in Pisa at Santa Maria a Ponte, in the Bell Tower of Florence he did the seven works of mercy, seven virtues, seven sciences and seven planets. By master Andrea there are also four carved figures each eight feet high. There are also carved there a great part of those who were called inventors of the arts; Giotto is said to have carved the first two. Andrea did a bronze door for the church of St. John the Baptist in which are carved the stories of the said St. John the Baptist, and a figure of St. Stephen, which was placed in the front of Santa Reparata on the bell tower side. These are the works that are available by this master. He was a very great sculptor, he was in the Olympiad 410 [probably A.D. 1330].

In Germany in the city of Cologne there was a very expert master of sculpture named Gusmin, he was of most excellent talent. He was with the Duke of Anjou, who had him do many works in gold. Among other works he did a gold panel, which he executed very finely, with every care and precision. He was perfect in his works, he was equal to the ancient Greek sculptors; he did the heads marvelously well, and all the nude parts, there was no other lack in him except that his statues were a little short. He was very fine and well versed and excellent in this art. I saw many figures cast from his. He had a very elegant air in his works, he was very learned. He saw the work he had done with such love and skill destroyed for the Duke's public requirements; he saw his labor had been vain, and cast himself to the ground on his knees, lifting his eyes and hands to heaven, and spoke, saying, O Lord, who governs the heaven and the earth and made all things, let me not in my ignorance follow any

but thee, have mercy on me. And immediately he went about dividing up what he had for love of the creator of all things. He went up on a mountain where there was a great hermitage, which he entered, and was a penitent as long as he lived. He was old and died in the time of Pope Martin. Some young men who were seeking to become expert in sculpture told me he was learned in both media, and how he had painted where he was living, he was learned and died in the Olympiad 438 [probably A.D. 1420]. He was a great draftsman and most teachable. The young men who wanted to learn went to visit him, and asked him; he received them very humbly, giving them wise instructions and showing them many measurements, and giving them many examples; he was quite perfect, with great humility he died in that hermitage, having been most excellent in his art and of most holy life.

We shall follow Theophrastus' maxim, supporting those who are well taught rather than those who put their faith in money; he who is well taught in all things is not alone nor a wanderer in the lands of others when he has lost familiar and necessary things and is in need of friends, being a citizen in every city and able to despise hardships of fortune without fear, never a prisoner in fortresses but only in bodily infirmity. And Epicurus, not differing, says that the wise set little store by fortune, and the greatest needful things are governed by thoughts of the mind and soul. So too said many philosophers, and no less did the poets, writing the ancient comedies in Greek and putting forth the same opinions in verse, such as Eucrates, Chyonides, Aristophanes, and especially Alexius said the Athenians must be praised, in that the laws of all the Greeks demand obedience of children, except that the Athenians demand it only for those children whom they are teaching professions. Whereas all gifts of fortune are given and as easily taken back, but disciplines attached to the mind never fail, but remain fixed to the very end of life. And thus I give greatest and infinite thanks to my parents, who, proving the law of the Athenians, were careful to teach me the art, and the one that cannot be tried without the discipline of letters, and faith in all teachings. Whereas therefore through parents' care and the learning of rules I have gone far in the subject of letters or learning in philology, and love the writing of commentaries, I have furnished my mind with these possessions, of which the final fruit is this, not to need any property or riches, and most of all to desire nothing. Some who judge these things lightly might think those are wise who abound in money; they have pursued this assertion, audaciously claiming that knowledge is added with riches. And I, O excellent reader, who am not a slave to money, gave my study for the art, which from boyhood I have always followed with great study and discipline. Since I have the first teachings, I have tried to inquire how nature proceeds in it and how I can get near her, how things seen reach the eye and how the power of vision works, and how visual

[word missing] works, and how visual things move, and how the theory of sculpture and painting ought to be pursued.

In my youth, in the year of Our Lord 1400, I left Florence because of both the bad air and the bad state of the country, with a fine painter whom the lord Malatesta of Pesaro had besought, who had us do a room, which we painted with the greatest diligence. My mind was largely directed to painting, on account of the works that the lord promised us, and also because the company I was with was always showing me the honor and advantage to be had from it. Nevertheless at that moment I was written to by my friends how the board of the temple of St. John the Baptist was sending for well-versed masters, of whom they wanted to see a test piece. A great many very well qualified masters came through all the lands of Italy to put themselves to this test and this battle. I asked leave of the lord and my associate. Sensing the situation, the lord gave me leave at once, and we were before the board of that temple, with the other sculptors together. Each one was given four bronze plates. As the demonstration, the board of the temple wanted each one to make a scene for the said door, and they chose that the scene should be the sacrifice of Isaac, and that each of the competitors should do the same scene. These tests were to be carried out in a year, and whoever won it should have the victory. The competitors were these: Filippo di ser Brunellesco, Simone da Colle, Niccolo D'Arezzo, Jacopo della Quercia from Siena, Francesco da Valdambrino, Nicolo Lamberti; we were six to take the test, a test which was a demonstration of a large part of the art of sculpture. The palm of victory was conceded to me by all the experts and by all those who took the test with me. The glory was conceded to me universally, without exception. Everyone felt I had gone beyond the others in that time, without a single exception, with a great consultation and examination by learned men. The board of the temple wanted to have their decision written by their own hand; they were very expert men, including painters and sculptors in gold and silver and marble. The judges were thirty-four, counting those of the city and the surrounding areas; the endorsement in my favor of the victory was given by all, and by the consuls and board and the whole body of the merchants' guild, which has the temple of St. John the Baptist in its charge. It was acknowledged as mine, and determined that I should do this bronze door for this temple, and I executed it with great diligence. And this is the first work; with the frame around it, it added up to about twenty-two thousand florins. In that door there are also twenty-eight squares; twenty have the stories of the New Testament and at the foot are four evangelists and four doctors of the church, with a great quantity of human heads around this work; it is carried out with great love, and diligently, with cornices and ivy leaves, and the posts with a great adornment of leaves of many sorts. The weight of the work was thirty-four thousand. It was carried out

with the greatest talent and discipline. At the same time the statue of Saint John the Baptist was made, which was eight feet high and over, it was installed in 1414, fine bronze.

By the city of Siena I was assigned two stories in the Baptistery, the story of how St. John baptizes Christ, the other when St. John is taken before Herod. In addition I made with my hand the statue of St. Matthew, nine feet, of bronze. I also did in bronze the tomb of messer Leonardo Dati, master general of the Dominican friars; he was a very learned man, whom I drew from life; the tomb is of slight relief, and has an epitaph at the feet. I also had the tombs of Ludovico degli Obizzi and Bartolomeo Valori carried out in marble, they are buried at the Friars Minor. In addition a bronze casket can be shown, at Santa Maria degli Angeli, where the Benedictine friars live; in that casket are the bones of three martyrs, Protus, Hyacinth and Nemesius. On the front side are sculptured two little angels, holding an olive garland in their hands, within which are written the letters of their names. At that time I mounted in gold a cornelian, the size of a nut in its hull, in which were carved three figures finely made by the hand of a most excellent ancient master. As a mount I did a dragon, with the wings a little open and the head lowered, the neck rises in the middle, the wings grasp the seal; the dragon, or snake as we would say, was between ivy leaves. Antique letters stating the name of Nero were carved by my hand around the figures, which I did with great diligence. The figures in this cornelian were an old man sitting on a rock, in a lion skin, and tied to a dry tree with his hands behind his back; at his feet was a child kneeling on one knee, and looking at a youth, who had a paper in his right hand and a zither in the left, it looked as if the child were asking the youth to teach him. These three figures were made for our three ages of life. They were certainly either by the hand of Pyrgoteles or Polyclitus; there were as perfect as anything I ever saw cut in hollow relief.

Pope Martin came to Florence and ordered from me a golden miter and the clasp of an episcopal robe. In the one I did eight half figures in gold, and in the clasp I did a figure of Our Lord blessing. Pope Eugene came to live in the city of Florence and he had me make a golden miter, which weighed, the gold of this miter, fifteen pounds, the stones weighed five and a half pounds. They were estimated by the jewelers of our city at thirty-eight thousand florins, there were rubies, sapphires, emeralds, and pearls. There were six pearls in that miter as big as walnuts. It was adorned with many figures and many decorations, and in front a throne with many little angels around and an Our Lord in the center, and on the back likewise an Our Lady with the same little angels around the throne; in golden circles the four evangelists, and there are very many little angels in the frieze that runs below; it is done with great magnificence. I took on from the board of the wool guild a bronze statue nine

feet high, they installed it in the oratory of Or San Michele, and this statue is made to be Saint Stephen the Martyr, which was made with great diligence, according to the rule with my works. The cathedral administrators ordered from me a tomb in bronze for the body of Saint Zenobius, seven feet wide, in which stories of this Saint Zenobius are sculptured. In the front part is how the child is brought back to life whose mother had left him to be cared for while she went on pilgrimage. And how the child, while the mother was journeying, died, and she on her return asks Saint Zenobius for him, and how he brings him back to life, and how another man was killed by a cart. There is also how he brings back to life one of the two servants Saint Ambrose sent him, who died in the mountains, and how the other one mourns his death, and Saint Zenobius said: Go, you're asleep, you will find him alive, and how he went, and found him alive. In the part at the back are six little angels, holding a garland of elm leaves, and inside this an epitaph carved in antique letters in honor of the saint.

I was commissioned to do the other door, that is, the third door of San Giovanni, in it I was given permission to carry it out in the way I thought would turn out most perfectly and most richly and most elaborately. I began this work in square panels, two and a half feet in size. These stories, filled with figures, were stories of the Old Testament, in which I tried every way to be faithful in seeking to imitate nature, as far as was possible for me, and with all the outlines I could produce, and with fine compositions rich with many figures. In some stories I put a hundred figures, in some more and in some less. I carried out this work with the greatest diligence and the greatest love. There were ten scenes, all with buildings in proportion as the eye gauges them, and so true that when one stands away from them they seem in three dimensions. They have very little relief, and on the floors one sees the nearer figures apparently bigger and those farther off apparently smaller, as reality demonstrates. And I followed through the whole work with those measurements. The stories are ten. The first is the creation of man and woman, and how they disobeyed the creator of all things. Besides, there is in that scene how they are expelled from paradise because of the sin committed; this includes four scenes, that is incidents. In the second panel is how Adam and Eve have the offspring Cain and Abel, little children. There is how they sacrifice, and Cain sacrificed the worst and poorest things he had, and Abel the best and most noble that he had; his sacrifice was most acceptable to God, and Cain's just the opposite. There is how Cain kills Abel out of envy; in the same panel Abel was guarding his animals and Cain was plowing the earth. Besides, there is how God appears to Cain, asking him for his brother whom he has killed; thus in each panel there are the incidents of four scenes. In the third panel is how Noah comes out of the ark, with his sons and daughters-in-law and wife, and all the

birds and animals, and there is how he makes a sacrifice with all his company. There is how he plants the vine and gets drunk and Ham his son jeers at him, and how the other two sons cover him up. In the fourth panel is how three angels appear to Abraham, and how he venerates one of them, and how the servants and the ass stay at the base of the mountain, and how he has stripped Isaac and intends to sacrifice him, and how the angel takes the knife from his hand and shows him the ram. In the fifth panel is how Esau and Jacob are born to Isaac, and how he sent Esau hunting, and how the mother instructs Jacob, and hands him the skin of the kid, and puts it around his neck and tells him to ask Isaac for the blessing. And how Isaac gropes for his neck and finds it hairy, and gives him the blessing. In the sixth panel is how Joseph is put in the well by his brothers, and how they sell him and how he is given to Pharaoh king of Egypt, and by means of the dream that revealed the famine that there was to be in Egypt Joseph found the remedy, and how all the lands and territories escaped it. And how he was greatly honored by Pharaoh. How Jacob sent his sons and Joseph recognized them, and how he told them to come again with their brother Benjamin, otherwise they would get no grain. They returned with Benjamin, he gave them a great banquet, and had the cup put in Benjamin's sack, and how it was found and brought before Joseph, and how he made himself known to his brothers. In the seventh panel is how Moses receives the tablets on the mountain, and how Joshua stayed half way up the mountain, and how the people stay at the foot of the mountain, all astonished. In the eighth panel is how Joshua went to Jericho, and the Jordan stood still, and he set up twelve tents, and how he went around Jericho sounding the trumpets, and at the end of seven days the walls fell and they took Jericho. In the ninth panel is how David kills Goliath and how the people of Israel smash the Philistines, and how he returns with the head of Goliath in his hand, and how the people come out toward him singing and playing, and saying, Saul has slain his thousands, and David has slain his tens of thousands [line quoted in Latin]. In the tenth panel is how the Queen of Sheba comes to visit Solomon with a great company; she is richly adorned and surrounded by many people. There are 24 figures in the frieze that is around these scenes, a head between one frieze and the next, making twenty-four. Carried out with the greatest study and discipline of my works, it is the most special work I have done, and it has been finished with every skill and proportion and talent. In the outer frieze, which is in the posts and lintel, there is an ornament of leaves and birds and little animals in a manner suitable to such a decoration. There is a bronze cornice as well. And there is as well on the inner side of the posts a decoration in low relief done with the greatest art, and the same at the foot on the sill; this decoration is of fine bronze.

But not to bore my readers, I will omit a great many works that I

carried out. I know one cannot find pleasure in this kind of thing. Nonetheless, I ask pardon of all the readers, and let them all have patience. In addition, I have done very great favors to many painters and sculptors and carvers in their works, I have made many preparatory models of wax and clay, and drawn a great many things for painters, and in addition I have provided the formulas for those who had to make large figures outside the natural scope, so as to carry them out with perfect proportions. In the façade of Santa Maria del Fiore, in the central round window, I designed the Assumption of the Virgin, and I designed the others at the sides. In the same church I designed many glass windows. In the tribune there are three round windows designed by my hand, one with Christ when he ascends to Heaven, one when he prays in the garden, one when he is brought to the temple. Few things have been done of any importance in our territory that were not designed and arranged by my hand. And especially in the building of the tribune we were coworkers, Filippo and I, for eighteen years at the same salary; and in that way we carried out that tribune. We will do a treatise on architecture, and discuss that subject. The second commentary is complete; let us turn to the third.

Filarete Explains the Figurative Arts

The minor Florentine sculptor and architect Antonio Filarete (born after 1400, active until 1464) settled in Milan and presented to his patron the duke a huge treatise, combining courtly flattery with an ideal rational plan, to show how he might build the perfect city. Eccentric rather than typical, the book has not been available in its entirety until quite recently. Ways of decorating the city with painting and sculpture are presented at the end (Books 23 and 24); these chiefly offer the right subjects for various buildings, as Alberti also did in his book on architecture. But some of Filarete's incidental comments either are revealing about attitudes of the time, rarely recorded but probably ordinary, or are surprising anticipations of ideas often assumed to have developed much later.

When he speaks of poses for figures as showing their personalities and the drama, he reinforces Alberti's emphasis on this main interest of artists at the time. That he takes all his examples from Donatello (probably including the St. Anthony, though he does not say so) is suggestive of that artist's dominant role in his time, as is also his dislike of one of Donatello's works, the San Lorenzo doors, in which he seems not to have been alone. His concern about distinguishing between ancient and modern costumes is reflected in paintings such as those on the walls of the Sistine Chapel. Filarete seems to be the first (apart from an allusion by Petrarch) to take up the paragone, *the argument over whether paint-*

ing or sculpture was superior, which obsessed the sixteenth century. The reasons given, however absurd for us, reflect the serious involvement with the change in the artist's status from craftsman to professional. So too does his concern about the decline of mosaic, the only one of the great medieval craft-oriented art media (also including stained glass, enamel, and ivory carving) to have played a large role in Italy. One might not have guessed that its loss would have been so consciously articulated in the early Renaissance. The final passage is perhaps the earliest description of life drawing, as well as of the jointed lay figure, and again calls attention to the significance of the pose. Original text in the edition of Filarete's Trattato di Architettura *by J. R. Spencer, 1965, folios 179r, 181r, 182v, 184r–v.*

. . . Thus the actions, manners, and poses and everything should match [the figures'] natures, ages, and types. Much difference and watchfulness is called for when you have a figure of a saint to do, or one of another habit, either as to costume or as to essence. Saints also should match their types, so that when you have a St. Anthony to do, he is not to be made timid, but alert, and likewise St. George, as Donatello did, which is truly a very good and perfect figure, it is a marble figure at Or San Michele in Florence, and so too if you have to do a St. Michael killing the devil he ought not to be timid; if you have a St. Francis to do, he should not be bold, but timid and devout, and St. Paul should be bold and strong, and so with judges and their poses, not like the above named, who did a bronze horse as a memorial to Gattamelata, so inappropriate that it has been little praised, for when you make a figure of somebody of our time, he is not to be put in ancient costume, but as his habit is. How would it seem if you wanted to do the Duke of Milan, and did him with a costume he didn't wear? It would not look right and it would not seem to be he. Likewise, in doing the figure of Caesar or Hannibal, and making them timid, and wearing the clothes usual today, and even if they were bold and alert, even so if they were done in the clothes of today they would not seem to be themselves, so they should be according to their essence and their type. If you have apostles to do, don't make them seem like fencers, as Donatello did in San Lorenzo in Florence, that is, in the sacristy in the bronze doors. The figures ought to be arranged in such a way that they present their essence, but not to want so much to show expertness as to fall into the mistake of unsuitability.

* * *

[Filarete:] . . . Thus, this turns out to be the one most worthy process that the hand does, painting. [The Duke:] I like that, and I would think what you say is right, I wasn't giving it too much thought; I was

under the impression that drawing and carving in marble or bronze or anything else was much worthier than painting, since someone carving a figure in marble might well happen to have a bit of the nose or some other element break off, as it can happen sometimes that a piece is knocked off, how can he repair the figure? But a painter can cover up with colors, and patch things up even if they were spoiled a thousand times, and so too anyone carving in the hollow, in cornelian or any other stone, must work mentally, and on the other hand it is not so with painting.

[Filarete:] Your lordship speaks truth, for carving in marble is a matter of great mastery. In the same way, as far as the eye's vision goes, and aiming to counterfeit those colors that nature makes, those [paintings] are great things too. For however good they are, the one [sculpture] always seems to be of the material they really are, but what is painted seems to be the actual thing. And many are taken in, believing the object to be real. And not only men but animals have been taken in by this power of colors, for we read that in ancient times there was painted in a certain place in Greece, I think Athens, a roof, which duplicated the real thing and resembled it so closely that crows often went to perch on that roof, and likewise an arbor where there were grapes, so that they say the birds were oftentimes taken in and went to peck at them, thinking they were real ones [further instances]. I too once, in the house of a Bolognese painter in Venice who invited me to take refreshment, and put some painted fruits in front of me, was really tempted to take one, but held back in time, for it wasn't, but indubitably seemed to be, so real that if there had been some actual ones there is no doubt people would have been taken in. And we read of Giotto that as a beginner he painted flies, and his master Cimabue was so taken in that he believed they were alive and started to chase them off with a rag. Whence, this is based on the knowledge of applying colors in the right places, and such miracles are not seen in sculpture.

* * *

[The Duke:] Tell me now, I have seen colors on a wall that looked like glass. [Filarete:] That is called mosaic, it is glass colored in a fire, and, as to how it is done, one must have the mosaic pieces made, but today it is little used. In the old days it was used a great deal, and was a worthwhile and beautiful thing. [The Duke:] Tell me why, then. [Filarete:] Because it was very costly in time, materials, and skill. [The Duke:] Do you know the method? [Filarete:] As mosaics are made in various colors, I would know how to do the gold, but this is not part of painting, masters of glass do it [repeated]. At Venice there is a kiln that makes it, but, to tell the truth, not the way it us ed to be in former days, since it has gone

out of use, and so they only have it nowadays at Venice, because there they decorate the church of St. Mark with it. . . . This art, as I say, is lost, for from Giotto on it was little used. He did it only in Rome, the "Ship" by his hand may be seen at St. Peter's. And one Pietro Cavallini, a Roman, who was a very good master, also worked in it in his time. . . .

* * *

There are various ways to learn to do them [costumes]. When you have some to do, have someone dress in the costume you want to do, if it is modern, and if it is ancient, do as I shall tell you. Have a little wooden figure, with jointed arms, legs, and neck, then make clothing of linen, in the style you like, as it if were for a living person, and dress it in this, in the pose that you want, so that it looks fitting. And if the cloth doesn't hang the way you want, take melted glue and wet it thoroughly over the whole figure, and then arrange the folds your own way, and let it dry, and they will stay in place, and then if you want to do it in another way, put it in hot water, and you can change it to another form, and draw from this the figures that you want. . . .

Piero della Francesca on How to Do Perspective

The fact that there is a book on perspective by Piero della Francesca (about 1420–1492) is fascinating, but it has to be admitted that it is discouraging to read. It consists almost entirely of specific exercises for drawing individual things correctly, divided into three parts on planes, solids, and complex objects (with emphasis on curved forms). Not only are no general systems offered from which the draftsman could extrapolate, but each exercise is presented step by step, often requiring a hundred or more individual instructions, typified by drawing a line from A to B, intersecting another line CD at point E, then drawing EF, etc. No conceptual framework is ever provided, and the book can enhance our understanding of Piero or his contemporaries only if it is studied in a much bigger series of cases than possible here. An unusually brief exercise is offered as an example, along with two introductory paragraphs, the first a close variant of Alberti's ideas. Original text in the edition of Piero's De Prospectiva Pingendi *by G. N. Fasola, 1942, 63–65, 70, 128–30.*

Book I

Painting contains within itself three main parts, which we may call drawing, calibration, and color. By drawing we mean the edges and borders that a thing contains within itself. Calibration we may call the placing of these edges and borders in their places proportioned to each

other. Color means applying the colors as they show themselves in the objects, light and dark as the objects vary. Of the three parts I plan to treat only calibration, which we may call perspective, mixing in some part of drawing, since without it one cannot in practice demonstrate perspective; we will leave out color, and treat that part that can be demonstrated with lines, angles, and proportions, speaking of points, lines, surfaces, and bodies. This part contains in itself five parts. The first is the eye, that is, seeing; the second the form of the thing seen; the third the distance from the eye to the thing seen; the fourth the lines that go from the end of the thing seen to the eye; the fifth is the term that is placed between the eye and the thing seen, where it is intended to place the things.

The first I said was the eye, of which I do not mean to treat except insofar as necessary to painting. Hence I say that the eye is the first part because within it all seen things present themselves with different angles; that is, when the things seen are equally distant from the eye, the larger object will present itself subtending an angle larger than the smaller one, and likewise, when the objects are equal but not equally distant from the eye, the nearer will show itself subtending a larger angle than the more remote, and these diversities signify the diminution of the objects. The second is the form of the object, for without that the mind could not judge nor the eye comprehend that object. The third is the distance from the eye to the object, because if there were no distance, the eye would be contiguous with the object and if the object were larger than the eye, it could not take it in. The fourth is the lines, which present themselves from the ends of the object to the eye, within which the eye receives and discerns them. The fifth is a term on which the eye marks things with its rays proportionately and can on it judge their measurements; if there were no term, one could not judge how much the objects diminished, and they could not be demonstrated. Besides this, it is necessary to be able to draw on the plane in their own form all the things that a man intends to make.

[Exercise 8:] If above a straight line divided into many parts, a second parallel line is drawn, and lines are drawn from the first to a single point, they will divide the parallel one in the same proportion as the first one.

Given the line BC, divided at points DEFG, draw another line parallel to it, HI, and from point A draw lines AB, AD, AE, AF, AG, and AC, which will cut HI at points KLMN. I say it is divided in the same proportion as the first line BC, because BD is to DE as HK is to KL, and EF is to FG as IM to MN, and FG to GC as MN to NI, and the triangle ABD is similar to the triangle AHK, as ADE to the triangle AKL, and AEF is similar to the triangle ALM, so they are proportional, and that same proportion found between AB and BC is found between

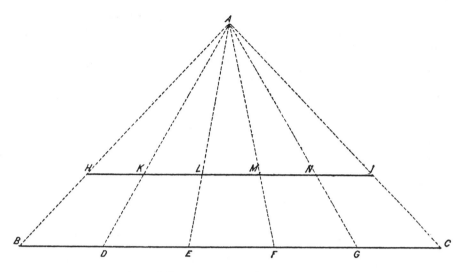

Piero della Francesca's eighth proposition
(as redrawn by C. Winterberg from the original)

AH and HI, and since the major bases are proportional, so are the minor bases, and the angles of the triangle ABD are similar to the angles of the triangle AHK, so they are proportional, as is shown by the twenty-first theorem of the sixth book of Euclid, and the same applies to the others, which was the claim.

Book III

Many painters condemn perspective, because they do not understand the power of the lines and the angles produced by it, with which every edge and line can be produced proportionally. Hence I feel I have to show how necessary this science is to painting. I say that the word perspective by its sound speaks of things seen from afar, represented in proportion in given terms, according to the degree of their distance, without which nothing can be correctly diminished. And since perspective is nothing but the showing of surfaces and bodies diminished or enlarged upon the plane, placed as the real objects present themselves on that plane, seen by the eye with different angles, and since in every quantity one part is always nearer to the eye than another, and the nearest always presents itself with a larger angle than the farther on the designated plane, and since the mind cannot judge their sizes by itself, that is, which is the nearer and which the farther, therefore I say perspective is needed, which as a true science discerns all the quantities proportionally, showing the diminution and enlargement of all quantities by the power of lines.

Following that, many ancient painters gained eternal praise, such as Aristomenes, Tasius, Policles, Apelles, Andron of Ephesus, Theo Magnes, Zeuxis, and many others. And although praise is given to many who are without perspective, it is given with false judgment by those who have no awareness of the potential of the art. And so, being zealous for the glory of the art and of our age, I have presumed to make so bold as to write this little segment of perspective pertaining to painting, doing it in three books as I said in the first. In the first I showed the diminutions of planes in many ways, and in the second the diminutions of cubes and various polyhedrons, placed perpendicularly on planes.

But since now in this third book I intend to treat of the diminution of bodies comprising various surfaces and placed in various ways, so, having to treat of more difficult bodies, I will take another route and method in their diminutions than in the past demonstrations, but the result will be one and the same, and whoever does the one is doing the other. But I will change the system for two reasons, the first because it is easier to demonstrate and understand, the second because of the great multitude of lines that would be required to make following the first method, so that the eye and the mind would be dazed among those lines, without which these bodies cannot be perfectly diminished, nor without great difficulty. So I will take this other method with which I can demonstrate the diminutions part by part, and in this method, as I said at the beginning of the first book, it is necessary to understand what a man wishes to make and know how to put it on the flat surface in its own form, [not in perspective] because, when they are placed in their own form, the power of the lines following the art of perspective will generate the diminished ones, the way they are represented on the terminal plane of the visual lines. So it is necessary to know how to make all the edges of what a man wants to make, according to measurements, and put it on the flat surface in its own form, of which method I will give the particulars in the demonstrations that will follow.

Giovanni Santi Rates the Artists

Raphael's father, the minor painter Giovanni Santi of Urbino (died 1494), wrote an immense chronicle in rhyming doggerel extolling the military activities of the Duke of Urbino; understandably, it is little read and is almost inaccessible in its single printed edition. In Chapter 91, he seizes the opportunity of the duke's state visit to Mantua to have him admire Mantegna's frescoes, and goes on to extol first Mantegna as the greatest living artist and then many others in a few lines. Unfortunately, his lines are usually quoted in books dealing with single artists, and only the single phrase on the particular artist is then cited, out of context.

This is understandable because for the first time in such surveys of approved painters, Santi concentrates on living and even young ones (following a brief list of older ones, mostly the same who had been chosen by such earlier writers as Fazio, see p. 175). Hence his words are often the earliest appreciations of the artists on record. His judgments were usually good as to which artists would later be most admired, which may surprise us if we think in terms of a pattern, normal in the nineteenth and twentieth centuries, of failure to recognize the best living artists. Before the nineteenth century, however, such choices usually were the same which posterity would confirm, essentially because artists and society had common aims. The quotation out of context inflates Giovanni's admiration for these artists by not noting how low he rates all of them in comparison with Mantegna. Indeed, at the time he wrote the center of painting was moving from Florence to the Venice area. His text is a good token of the changing status of the two places, especially if we recall that he was from a neutral location. In particular, his allusion to Piero della Francesca has been wrongly used by itself to suggest that Piero was widely influential at the time. It is worth noting that at the very site of Piero's greatest success, Urbino, he was merely on a list; in fact, outside his own area Piero was spoken of mainly as a respected expert on perspective technique rather than in connection with his paintings. But Santi's praise of Mantegna by categories—of drawing, invention, etc.—seems to be the first fully worked-out example of a type of art criticism dominant in the baroque period. His greater interest in Mantegna's drawing, foreshortening, and thematic invention than in his color and depth of space probably matches our own and is the most thorough example of the time of art criticism of one artist. Original text in the edition of Santi's Cronaca rimata *by Holtzinger, 1897, Book 22.*

Of the Duke's Departure from Urbino to go to Milan, and a Discussion of Painting.

> To Mantua then he turns, and out from thence
> The famous marquis came to honor him,
>
> .
>
> Then, looking at the site and at the beauty
> Of such a great land, and the ample court,
> He had the greatest pleasure in admiring
> The marvelous painting and the exalted art
> Of Andrea Mantegna's high and famous genius
> To whom Heaven opened wide its gates
> With gifts in excellent and worthy painting
> Which flourishes in our outstanding age.
> Far more than others, Andrea bears the banner

Of its great excellent authority.
 Wherefore the Duke, as a distinguished master
 Giving his attention to these paintings
Of the fine artist, with their great distinction,
 Praised them roundly, and again extolled them
 With words and with praises splendidly.
And certainly, nature endowed Andrea
 With such superior and worthy parts
 That I don't know how more could have been added.
For of all the several aspects of this art
 He possesses the full united body
 More than all men in Italy or elsewhere.
One finds sometimes indeed that some great men
 Excel in one, but as one takes good notice,
 And his works are good witness of it to us,
One sees that first of all he has a grasp
 Of great Drawing, which is the true foundation
 Of painting, then, second, in him comes
A glowing adornment of Invention
 Such that, if all imagination were
 Dead and extinct, as I perceive and feel,
They would be born again in him, so fertile
 For all who come and follow after him
 That they could be taught it with no trouble.
And no man ever took or used the brush
 Or other pencil, who was a clear successor
 Of ancient times, as he is, with such truth,
Nor with a greater beauty. And if it's not
 Going too far, he has surpassed them
 And gone beyond them all in that grace of his,
For which I put him before all of them.
 And then his diligence, his lovely color,
 With all his planes and various distances,
Movement in drawing, and he astonishes
 All who see and note his foreshortening,
 Which fools the eye and makes the art rejoice,
Perspective, which brings on in its train
 Arithmetic, also geometry,
 And great architecture turns to it.
With the most talent possible in man
 He glows and shines, expressing with great concepts
 So that I am left dazzled in my mind.
In sum, what many high intelligences
 Have demonstrated in most excellent painting
 Shines out in him with all its terms perfected,

Nor has he overlooked relief, with soft attractive
 Methods by which to show to sculpture too
 What heaven and good fortune gave to him.
Wherefore deservedly Nature in him
 May praise herself, and also he who advanced him
 To knightly rank because of his great painting.
An honest zeal and noble heart had moved him
 To cover up the ill fame of the moderns
 When their thoughts spurred them on to avarice.
Many things in the world can bring immortal
 Fame to a mortal, letters first of all,
 Which are founded in many solid bases,
But two, it seems, will raise a man to heights,
 In poetry or history we sing
 Of anyone who gains some admiration.
Sculpture, besides, and painting can preserve
 A mortal man present before us and
 True image of all noble family trees,
And of these two arts I will dare to say
 Of what and how great genius and hard work
 They are, spreading my wings to heaven.
And who is there who'd care to contradict
 That all the graphic arts, or arts of drawing,
 Do not bring every trade to flourish more;
Whoever has it counts more than another
 In his own trade, the farmer cannot keep
 His bounds or lines without it, and therefore
It is the greatest error of the moderns
 Not to bestow all praise and due honor
 On such a universal sharp great science.
Look at divine worship, without her
 It's no account, and architecture's subject
 To this instruction and unequaled source.
The more an officer is versed in drawing
 The better he can arrange his camp
 And better is enclosed in safe redoubt.
Returning to the high rank of this art,
 Read in the ancients to what rank and honor
 They raised each aspect of its excellence.
Pliny first gives his witness, full of fire,
 And there's Vitruvius' definition, and
 Great hearted Macedonian Eupompus',
Who held that every art in all the world
 Would lack its excellence, except for it.
 Our century is so destructive to it,

Ungrateful, evil, ignorant, and bad,
 That they would place this gift, bestowed on us
 By the high gods, among mechanical arts.
Who is there that could take Perspective's praise
 Away, the high science that goes
 Sharper than Geometry, and more apt.
The former gives each figure its own form,
 The latter transforms it by foreshortening,
 Something no other age of earth has seen.
And nowadays it gleams so perfectly
 That it transfers exactly on the drawing
 Just what our sense of sight had first observed.
Now this is called perspective science perhaps
 To say it does not show by reasoning
 From what great powers and clear sense it is born,
And though men cannot find an end to it,
 Yet it is an integral part of painting
 And new invention of our century,
And all who see or recognize the truth
 Will see some even greater difficulties
 In painting, and demanding greater skills.
Who will he be who'll ever imitate
 The ruby's shining bright transparent color,
 Or counterfeit the beauty of its splendor?
Who is he who can paint sun in the morning,
 Or paint the mirror that we see in waters
 With the leaves and the flowers near its border,
Who in the world was ever born so good
 That he could make a white lily, or fresh
 Rose of such beauty as to satisfy nature?
The hurdle is there, where everything's defeated,
 Nor can one bring up against the hurdle
 A case at law with a sufficient brief.
In sum, what painting does is to attempt
 To fool the eye, and make what's really flat
 Show to our sense that it is in the round,
And to pretend and show the human sense
 With bright pencil what nature shows to us
 Whether it is nearby or far away.
And in the marvelous and noble art
 So many have been famous in our age
 That they seem to make every other low.
At Bruges, among the others most was praised
 The great Jan, also his pupil Roger,
 And many gifted with great excellence,

So that in this high art and mystery
 They have been so excellent in coloring
 That often they have even outdone the life.
Then in this present age in Italy
 Gentile of Fabriano was distinguished,
 Giovanni of Fiesole, burning for the good,
And in medals and paintings Pisanello,
 Fra Filippo, likewise Pesellino,
 Domenico known as Il Veneziano,
Masaccio, Andrein, Paolo Uccello,
 Antonio and Piero, great as draftsmen,
 Piero della Francesca, who was older,
Two young ones, equal in their gifts and ages,
 Leonardo da Vinci and Perugino,
 That Piero from Pieve, godlike painter.
Ghirlandaio, younger Filippino,
 Sandro di Botticelli, and from Cortona
 Luca, so special in his gifts and spirit.
And now, leaving fair Etruscan land,
 Antonel of Messina, famous man,
 Giovan Bellino of the far-flung praise,
His brother Gentile, Cosimo their equal,
 Ercole too, and many I omit,
 But not Melozzo who's so dear to me,
Since in perspective he has made such strides.
 In sculpture, Donatello has high powers,
 As the bronze and the hard rock can show,
The lovely Desiderio, sweet and fair,
 Master Jacopo known as of the fountain,
 The good Vecchietta, Rosselin, and
Vittorio Ghiberti, the bright source
 Of inborn gentleness and humanness,
 Who is a bridge to painting and to sculpture,
Across which one may pass if one is deft,
 High Verrocchio and the Roman Andrew,
 So great in his composing, and with beauty,
Antonio Rizzo, who's so often mentioned,
 And for his low reliefs there is the famous
 Outstanding architect with his worthy locks,
Ambrogio of Milan, whose marvelous
 Foliage is so notable, so that he equals
 The ancients with their lively minds in that.
Now the works of those who painted or who carved,
 Or paint or carve, remain on view, and show
 To what a level they may rise in fame.

Who therefore will not be inflamed with rage
>Whose special talent this vile age will not
>Toss up as far as its deserts would draw it?
Among the Greeks, only nobles and gentles
>Were allowed into this bright exercise,
>Many philosophers would use the brush,
And since it is the gate and clear beginning
>To practice talents, it was made a law
>That fathers, as we still may read, should have
Their sons instructed in the graphic arts
>In their own house, and Scipio in Rome
>And Caesar, and many of the finest clans
Were versed in this, and knew its principles;
>And in our time the aged King René
>Painted better than many who are famous.
These things we have said with a sincere
>Feeling for painting, and to praise Andrea,
>The master who holds the sway in it,
So that he made the Duke of Urbino stop
>In stupefaction then, when first he saw
>His sweet paintings and exceptional art.

Giusto d'Andrea's Early Career

Among surviving record books of Florentine artists of this century, only two extend from business accounting to autobiographical memoirs: Ghiberti's and this one by Giusto d'Andrea (1440–1497). It is a unique view from the subordinated part of a workshop, giving the assistant painter's perceptions. His evidence as to what parts of a fresco cycle the assistant did is unique but has not been included in the many modern studies assigning parts in them to master and assistants on the basis of intuitions about quality. (Giusto's report suggests that the assistant did whole units rather than certain folds or hands.)

This text and one other fascinating fragment of Giusto's memoirs, about the expulsion of the Medici from Florence in 1494, were published in isolation over a century ago, unfortunately without noting the location of the manuscript, which has not been seen since; very likely its interest is not limited to these two passages. Giusto's work is obscure; of his life, we know further that he was a family head at fifteen, an orphan responsible for two younger brothers mentioned here. Original text in G. Gaye, Carteggio inedito, *1839, Vol. 1, 212.*

In 1458 I took a job staying with Neri di Bicci, painter, in his shop, for a salary of 30 florins for two years, and one pair of hose per year, the

first year twelve, the second eighteen, and the time was completed, and I said goodbye to all of them with good feelings and affection. When the said three years were over, and the time with Neri di Bicci, I then worked one year at home for my own account, did many works and earned well;* but still, to gain skill in the art and in my capacities, I went and hired out to Benozzo di Lese, painter, who was working and was an excellent master in fresco; the contract we made was that I was to work in a chapel in San Gimignano in the church of Sant'Agostino, and stay up there with him, and to pay me my expenses and nothing else, and to this I applied myself steadily for a considerable time, and I stayed up there three years including several trips, and I kept Andrea my brother there and had him study, and paid the friars that kept him, and Giovanni went to Rome, and to this very day I have among my papers the paper with the contract of the payment I gave the friars as we agreed. And in that chapel in Sant'Agostino there are by my hand all the female saints that are in the thickness of the main window, and the four apostles, two on each side, at the bottom, in the entrance arch of the chapel, and the greater part of the friezes next to the mouldings, and the first small scene of the ones in the vault, and in addition at that time I worked with him at Certaldo, at the tabernacle of the condemned prisoners, where there is a Christ being taken down from the cross, and that was the last work I worked on with him.

A Painter Comes to Rome to See the Sights

In the Renaissance pilgrims to Rome with religious concerns were joined by those with artistic ones, especially the artists themselves. (For one who was not an artist, see Rucellai, p. 110). Their records are chiefly drawings, and their interest is in ancient sculpture and architecture. The first artist to write about such a visit is the anonymous author of a poem, printed as a four-page pamphlet about 1500. He calls himself "the Milanese Perspectivist," which suggests that he might have been the great architect Bramante, a perspective expert, who came from Milan to Rome in 1500. However, Bramante was not a Milanese, and the naive language of the poem might rather suggest a less sophisticated associate. The cheerful mixture of modern works of art among the ancient ones is climaxed when the writer expresses the fancy that both ancient and more recent painters might have painted the grotesques, the then newly dis-

* The three years in this sentence contradict the two in the sentence before. Perhaps the explanation is that (a) there is some indication that the published text omitted something between the sentences, and (b) since Neri in his own account book records that when Giusto left he went to work for Fra Filippo Lippi, one could deduce that both employments together are being referred to as occupying three years. But this is only one possible explanation.

covered ornamental wall patterns in the ancient rooms which were being excavated and thought of as "grottoes." The writer's excitement about them, combined with his strict limitation otherwise to sculpture, confirms the point of Alberti and others that up to then no ancient painting had been visible. His account of the crawl into the caves with ham sandwiches and guide is a unique description of the conditions of viewing. The following excerpts include only a small fraction of the citations of ancient sculpture. The verse form, limping in the original, has been given up in this translation. Original text in Atti della R. Accademia dei Lincei, *Series 2, Vol. 3, 1876, Part 3, 49ff.*

. . . There are two great colossi, both together, with two men at their feet holding them in check, they are perfect and of the largest size. . . . In the Cardinal of Siena's house may be found three nude graces, and a nymph who seems as if she were drawing a great wind toward her. . . . And in the house of Cardinal Santa Croce, a nude holding a skinned goat, which is much talked of for being good. . . . The city councilors have in bronze a statue of the man that killed the robber Cacus that looks as if it were by him who made Adam. Nearby, within the range of the eye, a gypsy, showing more money lust than the ones Verrocchio made . . . and there are two columns, huge, of stone, which are threatening to fall down, if they fell they would make a great crash, one of Hadrian and one of Antoninus Pius, storied all over with battles, but we prefer the smaller one, it is two hundred feet of big thick carvings. . . .

There is a tomb, of molten material, of the great pope, fourth of his name [Sixtus IV], from Savona, like the one where the enemy of Darius reposed [Alexander the Great]. It is all bronze, and seems to thrust outward, adorned with virtues, muses, and sciences, crowned with praise, reward, and honor. At the top is the pastor himself, in glory like Phoebus' chariot, and he seems natural in its presence. Praxiteles and Scopas and Perseus would not have made it so fine. . . . And Antonio Pollaiuolo made the model, with every nerve and bone in the anatomy, as if Praxiteles had done it. . . . [the trophies of Marius] there are two trophy carvings, a good twenty feet in height, whence I have an unsated desire to draw them, swords, quivers, bows, shields, clubs, helmets, greaves, weapons, breastplates, and cuirasses. . . .

No heart is so hard it would not weep for the vast palaces and broken walls of Rome, triumphant when she ruled, now they are caves, destroyed grottoes with stucco in relief, some in color, by the hands of Cimabue, Apelles, Giotto. At every season they are full of painters, summer more than winter seems to freshen them, just as the name fresco suggests. They

go through the earth with belly bands, with bread and ham, fruit and wine, so as to be more bizarre when they are with the grotesques, and our guide Master Pinzino makes us bump our faces and eyes, looking to everybody like a chimney sweep, and makes us think we are seeing toads and frogs, owls, bats, breaking our backs and knees. . . .

4

The Patron
Speaking

The City Council of Florence Legislates Sculpture

The great statues by Donatello, Ghiberti, and others around the outside of the church of Or San Michele, each ordered by one of the guilds or trade associations, were rapidly produced after this law. More than fifty years before, it had been planned for the guilds to take part in the building, uniquely combining civic and ecclesiastical spaces, but most of the guilds did not act. A possible stimulus now was the penalty of assigning the spot if not used to some other guild; since places had been given to all the guilds officially classed as major and middle, such a reassignment would, to the shame of the rich defaulter, bring in one of the humbler minor guilds. Original text in Jahrbuch der preussischen Kunstsammlungen, *Vol. 21, 1900, 246.*

Resolution of April 20, 1406

For the completion of the decorations of the oratory of San Michele in Orto: they resolved . . . that whatever guild among the guilds of the city of Florence that has a place in the wall or columns of the oratory or palace of the Garden of San Michele on the exterior, is required to and must within the next ten years from now have made, in the place assigned to it, one figure or sculptured marble image, large and honorable, of that saint whose feast is celebrated by it each year. And that whatever such place in which, beyond the said time, the said figure or image was not placed, completed, and perfected, is understood to be taken from that guild, and priors of the guilds [City Council] can and shall assign any such place whatsoever to any other guild that does not have a place.

Pierre Salmon Writes to the Duke of Berri, January 1408

A royal counselor, a rich, upstart bourgeois and himself a patron of the Boucicaut Master, Salmon seizes the chance to do a favor to the king's brother. The artist whom he recommended, Domenico de' Cori, was indeed outstanding. He evidently did not go to France, but a number of artists made such trips, and we have here an exceptional picture of how that might happen. Original text in Gazette des Beaux-Arts, *Series 2, Vol. 38, 1888, 410–11.*

. . . [after reporting on other matters] And otherwise, my most dread lord, may it please you to know that in this city of Siena there is a worker in mosaic and also in marquetry pictures, so beautiful and well finished in various colors of wood that no man was ever a better worker than he is in this science. And since, my most dread lord, I know that you wish to see and have proper and pleasant things and the outstanding and

107

perfect workers in their art and science, I have offered to advance this worker money, and to provide him with a horse and have him brought to you at my expense, but I have not been able to get him to agree to anything for earlier than St. John's Day. . . .

Francesco Datini's Executors Watching the Painter's Work

A rare view of a patron's associates watching over the labors and behavior of artists is available here, in the case of an executor in one city forwarding his instructions to another, so that we have in writing what would usually be done orally. The letters come from the unique preserved business papers of the great merchant of Prato, Francesco Datini, the richest surviving records of commercial activity of this period. The commission was for frescoes on the outside of Datini's house; in the last letter, an additional job painting an altarpiece under the terms of Datini's will is being sought by one of the painters, Niccolò Gerini. The postscript refers to the technical fact that fresco painting needs to be avoided when the weather is freezing, and also to the fact that this need was little known, as indeed it still is today in studies calculating the dates of Renaissance artists' work. Besides these letters, several others deal with scheduling, bills, supplies, etc. of the project. Original texts in Rivista d'Arte, *Vol. 12, 1930, 118, 120, 124.*

From the executor in Florence to the others in Prato, October 15, 1410.

We have met with these painters, Mr. Torello, lawyer Lapo, and I, and after a great deal of talking we settled that they would draw a scene on a sheet and a drawing of how they want it, and on that as basis we will see whether we are in agreement.

Say to Arrigo, would he as a favor, since he has Francesco's physical features in his mind, please make a drawing of Francesco the way the slab should look that we are to have carved. He should be in his cloak, hood, and cap the way he wore them.

And in the same way, ask Piero the painter to do one too, and let me have them quickly, and send it.

* * *

November 21, 1410.

The painters have come, I am told, but it strikes me as a bad thing that Mrs. Margaret keeps them at her own table; it is not right or proper, such a thing is surely very odd, not to know what is fitting for three dependents. They are neither to get a wedding feast nor die of hunger,

but let them have bread and wine as is needful for them, and other things as you see fit, and Barzalone and Lionardo and the other office men are there, who know how they live. Get it done now, without having to make me worry over it, for I am the butt of everything and nobody else is, and it's not right.

* * *

January 6, 1411.

. . . Niccolò the painter will come to you tomorrow, I believe, and also the others for the roof. Niccolò has talked with me about the altarpiece for the nuns. He was told lawyer Lapo is handling it, and for my part I am agreeable to whatever Barzalone does and decides, so he should arrange with him.

Postscript: Niccolò will come to you, and since it is very cold, and freezing, don't let any figure painting be done or plastering on a wall, since it would freeze and the work would be ruined. He can do that work for fifty pounds for the nuns of San Niccolò, you can make an agreement with him. I wouldn't want him to do something that would be money wasted, and I say this on the word of someone who knows about it, who has told me that such work in this weather goes bad. I will mention it to him too, if I see him today.

The Marquis of Ferrara Gives a Medal

The great medals of Pisanello are well recognized as one of the most inventive and typical forms of Renaissance art. Surprisingly, since they must have had great interest for the rulers who were often portrayed in them, there is scarcely any evidence of attitudes toward them. Here, in the case of one of the few Pisanello medals portraying not a ruler but a court writer and humanist, we see it being used as a fee; such writers normally lived by offering their books as gifts to rulers and obtaining gifts in return. Original text in A. Venturi, editor, Le vite scritte da G. Vasari, *Vol. 1,* Gentile da Fabriano e il Pisanello, *1896, 58.*

Lionello d'Este to Pier Candido Decembrio, Ferrara, August 28, 1448.

Greetings to P. Candido. We have finally extracted from the hands of the painter Pisano the coin of your face, and we send it to you attached to the present letter, keeping one example, so that you may realize how much we are doing for you and yours. We commend the changes you made in your life of Duke Filippo. . . . Farewell.

Giovanni de' Medici Buying a Flemish Tapestry

Italian merchants might begin by buying a stock of Flemish wall hangings as luxury trade goods, but this could develop into collecting. A taste for such objects was rather old fashioned, since they would still have an international Gothic quality, just as the Medici family chapel frescoes by Benozzo Gozzoli still had, to a certain extent, ten years after this letter. We see here a pattern in which the patron fixes the size, the medium, and the general theme (though no iconographic details) of the work he is ordering—the same concrete specifications he would make in many other purchases. It recurs later, as in Mantegna's letter of 1477. Original text in Archivio Storico Italiano, Series 5, Vol. 25, 1900, 89.

Fruosino to Giovanni de' Medici, Bruges, June 22, 1448.

Respected Sir and Honored Superior. A few days ago I wrote and informed you how I had got here, by God's will, and then went to Antwerp to the fair, where I looked for what you had commissioned me to get, a tapestry cloth, and that I had found nothing I thought would meet your purpose, and told you what I had found, a wall covering with the story of Samson, very well executed but so large it would be a chore to stretch it in your big room, and so I didn't think that was what you wanted. Also I told you I didn't like the subject, because there was a great quantity of dead people in it, and I thought it was just the opposite of what one would want for a chamber, and besides, I thought it was too fine, for it would cost about seven hundred ducats. Besides, I told you there was another, with the tale of Narcissus, and I think the measurement would fit in with your aims, and if it had been worked a little more richly I would have taken it, which would have cost about a hundred and fifty ducats. There was and is nothing that would fit your needs because all those that want a better than average work have it done to order, and I therefore suggest to you, if you are not in too great a hurry, send me the measurements and the story or tale you want in it, and I'll have it made by the best master that can be found; you can just send me the measurement and the story you want.

Yours, Fruosino in Bruges.

Giovanni Rucellai's Taste

A rich and prominent merchant from a long established family, with the best connections (his son married Lorenzo il Magnifico's sister), Giovanni Rucellai (died 1481) was also the most outstanding Florentine patron of architecture after the Medici. He commissioned two major works of Alberti, his own house and the façade of his parish church of

Santa Maria Novella. His notebook, like many, was kept for the informa-
tion he thought his descendants should have. When he went as a pilgrim
to Rome, for the Holy Year 1450, we find him mixing religious motives
with those of an artistic tourist, admiring much architecture and a lesser
number of mosaics (from which the following selections come). His en-
thusiasm for the S. Costanza mosaic may be linked to the fact that it is less
Early Christian than classical and was the nearest thing anyone could see
to ancient paintings. This is in general the first record of "appreciation"
of Roman monuments, in the Renaissance sense.

Thus it is less surprising that Rucellai also gives us the very first in-
ventory of a private art collection which is clearly a "collection," not a
number of paintings owned for their nonaesthetic functions as religious
or historical images. He identifies his works by authorship only—as to-
day one would say "I own a Renoir"—thus showing that they were
primarily viewed and valued as examples of particular artists. Earlier
than this, some references to owning "a Giotto" can be tentatively identi-
fied, but not to owning a whole series of artists. Original text in A.
Perosa, editor, Giovanni Rucellai e il suo Zibaldone, *1960, pp. 67–76,*
23–24.

The Jubilee, which is held once every fifty years, means nothing but
the full remission of all your sins, if you go to Rome in that year and
stay fifteen days, and every day visit the four churches, St. Peter, St. Paul,
St. John Lateran, and Santa Maria Maggiore. . . .

Being in the city of Perugia in 1449 with my family, because of the
epidemic that was in our city of Florence, and the jubilee having begun,
I decided to go to Rome for the pardon, and in the name of God left
Perugia on February 10, 1449 [1450 by modern reckoning] in company
with the late lamented Lorenzo Strozzi my brother-in-law, and Domenico
Bartoli, my son-in-law. And we returned to Perugia on March 8, and
during the time we were in Rome, we followed this rule, that we
mounted horses in the morning and went to visit the four churches men-
tioned above, and then after lunch we mounted again and went seek-
ing and looking at all the ancient buildings and worthwhile things of
Rome, and in the evening, when we got back home, we made records, as
follows. . . .

. . . [At St. Peter's] also, on one wall of the said courtyard the ship
of the apostles, with the sail and mast, a very good thing, which is said
to be by the hand of Giotto.

. . . [At Santa Maria Maggiore] with a very beautiful mosaic at the
entrance of the main chapel and on the façade outside. . . .

. . . [At St. John Lateran] near St. John, a church . . . with very
beautiful mosaics with foliage, circles, and other fine things of porphyry,
granite, and marble.

. . . Near St. Agnese is a chapel of Santa Costanza, round, with double columns in pairs, with beautiful arches, and in the vault very beautiful mosaics with little figures to perfection, and with foliage and trees and many little winged creatures swimming in various ways, which is the most lovely, charming, and noble mosaic not only in Rome but the whole world, and around it in the corridor a vault, with a very nice mosaic in the vault with animals, birds, foliage, and other charming things.

Monte Giordano, where Cardinal Orsini lives, where there is a beautiful room storied with good figures. . . .*

* * *

Memorandum [written in the 1470s] that we have in our house many objects of sculpture and painting and wood inlay, by the hand of the best masters who have existed for a good while back, not only in Florence but in Italy as a whole; whose names are these, as follows

> master Domenico of Venice, painter
> Fra Filippo of the order . . . painter
> Giuliano da Maiano, woodworker, master of inlay work
> Antonio di Jacopo del Pollaiuolo, master of drawing
> Maso Finiguerra, goldsmith, master of drawing
> Andrea del Verrocchio, sculptor and painter
> Vittorio di Lorenzo [Ghiberti], carver
> Andreino del Castagno, known as of the Hanged Men, painter
> Paolo Uccello, painter
> Desiderio da Settignano and
> Giovanni di Bertino, masters of carving.

Symbolic Images Planned by a Patron for a Belt and Its Buckle

The Florentine silk merchant Marco Parenti served as business manager to Alberti and was son-in-law to Alessandra Strozzi (this was a small world, even when we include with the intellectuals of Florence the interested businessmen who gave part-time attention to these pursuits). He was also a patron of painting. Thus in the present case, even though he was not the patron but was the agent for his exiled brother-in-law, Filippo Strozzi (later the very rich builder of Palazzo Strozzi), it seems natural that he offers us the best single record in this century of a patron's inventing the iconography of any work. Indeed, it is apparently the sole explicit document of such practice. It is therefore interesting to underline some qualities of what Marco is doing, most of which were rightly pointed out when this letter was discovered and published a few

* A unique reference to modern paintings, frescoes by Masolino.

years ago: (1) The symbolic concept is a very elementary, signifying the message "To you, in Naples, from me," nothing more subtle; (2) the images chosen to translate this concept into a visual form are common-place ones, found in prints and similar sources of the time; (3) each such symbol is given just one role, no second layers of meaning; (4) despite this, the visual result would be quite impossible for any observer to de-code without the key; (5) there is no concern to keep the meaning hid-den; it is simply a matter of a diversion to draw a smile; (6) the whole program is the original fancy of the writer, without any specific reference to established set ideas, apart from the whole culture of his age; (7) its starting points are such unesoteric contexts as the recipient's family coat of arms and the traditional formulas of astronomy. Original text in Renaissance Quarterly, *Vol. 27, 1974, 293.*

From Marco Parenti, in Florence, February 10, 1451 [1450 Floren-tine style], to Filippo Strozzi in Naples.

I last wrote you on the 30th of last month, since then I have had two of yours, of the 22nd and the 29th. I am sending you, with God's blessing, your belt, by Battista's carter, it has been forever and a day in the making. I think you will like the leather piece, the silver, and the workmanship, and altogether I don't think it could have been better worked. I have had a fancy of my own sort worked upon it, as you see, and in order that you may understand it, I will tell it to you in full. Three things had to be made on it, one on the buckle and two on the tongue, which I had an idea should signify three other things. The first, you to whom I am sending it. The second the place to which I send it. The third, myself who am sending it. And to signify these things, there must be some sign as a similitude or symbol, and not knowing by what already established sign to mean you, I took your coat of arms, which are moons, in a symbol that means the moon. The ancient poets made up stories about the moon, which would be long to report. Among other ways, they symbolized the moon as a girl, or Goddess of hunting, with a bow in her hand and arrows and dogs, and dressed in fox skins, and a flame on her head with two little wings, which were I forget what, and this I had put on the buckle with a little moon between clouds under her feet, the better to be understood. And since the moon is a sign in Heaven, as can be seen, and the heavenly signs and their movements de-limit and govern us here below, it seemed to me that a device of mine would fit in well, which signifies time, symbolized by a circle. To tell you how a circle symbolizes time would be long, but the mathematicians symbolize it this way, because the heavens around us make a circle, the sun in 365 circuits around us returns whence it came, and that makes a year. The moon with 29 and a fraction around us marks a month, and thus through these revolutions and movements of the heavens and of

signs in a circle they make time, in which and with which time we connect and arrange all our doings and affairs, and so there is a motto that says UTI FERT RES, which means, that's the way it goes, to give to understand that matters and actions are to be accommodated to the times. And since the ancient philosophers said that the heavens were moved by separate substances, and our theologians say that they are moved by angels, which in substance comes to the same thing, therefore I put that angel in the middle, and there you have the second figure. The third is well known, that is, when you want to signify that you are in the Neapolitan Kingdom, you see a landscape, in which an armed king is reposing, to denote that in a kingdom the power of the king extends everywhere. So you have heard my fancy, and perhaps you will laugh about it. The silver weighed 2 ounces 15 denarii, and he wanted to be paid at the rate of 19 groats per ounce, I gave him, that is Facchino, 49 groats, which equals 84 shillings and 6 pence per florin or 3 florins 3 shillings 10 pence in gold. I don't want to charge you for the leather at all. I am planning to send you the two pieces of cloth, etc.

The Priests of Pistoia Decide to Have an Altarpiece

We are fairly well informed on how patrons behaved when approaching artists, but we have almost no evidence on the preceding stage, in which the patron made up his mind that he would commission a work, and what factors he was concerned about. We owe our exceptional luck in the present instance to the fact that the patron was a group, which had to discuss its ideas in verbal form, and moreover was a group of priests, so that they were perhaps even more articulate and systematic than others. What we find is very convincing, though it may come as a surprise. Looking at Renaissance altarpieces of this kind, we are prone today to find the patron's motivation in the message of religious exhortation, with levels of symbolism. In fact, however, these priests devoted relatively little emphasis to the subject matter, and their concerns are as ordinary and elementary as they are oddly disunified and assembled from a coalition of vested interests. What engrosses them in their meeting is to recognize various claims to pride; the broader context is a deep desire to get a work that would show off the group well, while also watching costs. Such emphases do indeed recur in the period in many contexts, such as in planning new churches and other buildings. Original text in Rivista d'Arte, *Vol. 2, 1904, 163.*

Records of the Society of the Most Holy Trinity, Pistoia, 1455. Christus. Here below I, the priest Piero, the current chamberlain, will write all the motions resulting through balloting in the Society of the Trinity. First; Noon, September 10, in the above year, in our church, in

its regular headquarters according to the usual procedures, divine office being first celebrated, and silence being commanded by order of the priors, they made a motion ordering everyone to sit down, and master Jacopo, the current high priest, one of the priors, with the consent of the venerable religious the priest Domenico di Simone, prior, colleague of the said master Jacopo, spoke, persuading the society that the most devout society of the Trinity was held in such honor and glory that, by divine providence and by the good and holy rules that had ever been observed therein, it had been increased daily in all those things that were proper to it, wherefore the said society might regard itself as at its peak, and higher than any situated in our land; still, it was true that it did seem to him that in one thing only the said society was not comfortable, and felt a great lack, and this was that the society was without an altarpiece, wherefore he, moved by this defect, under which the said society had long suffered, most humbly begged each of them and all of them together to do something about it.

This proposal was most welcome and acceptable to the company, and various and many suggestions were put forward on this matter in the said society, but all agreed that the said altarpiece ought to be made, but there were varying opinions about the expenditure. To one it seemed best to produce something middling and of small cost, others, considering the distinction of the place, were opposed to the small sum, and so as all discussed it together one wanted one thing and one another, with no agreement.

There rose to his feet the prudent religious the priest Bartolomeo Ferucci, bare-headed and most humbly offering his advice; he said he knew the distinction of the place, and also recalled that the society was in such a position that nothing required to be done for its honor, and so it seemed to him that, if the company wished to arrange for an altarpiece, it should not spend less than 150, or up to 200 florins, because it did not seem to him that they could have anything suitable to the place for less money. This motion being put to the body by consent of the priors, it was so decided, by 20 black beans to 17 white ones, that from 150 florins to 200 should be spent for the said altarpiece, not however slighting the usual items.

The same morning the matter was delegated to the venerable religious master Filippo di ser Giovanni, parish priest of S. Andrea, and to me, priest Piero son of lawyer Lando, currently chamberlain; this was decided by vote, on the advice of Mr. Jacopo, archpriest. It was also decided by vote, in order that the society might not suffer thereby, especially not in a spiritual way, so that it not be allowed to slip during this year, the said master Filippo and priest Piero the chamberlain should have power and instructions to sell at their pleasure for this altarpiece 350 minas [=25 pound units] of grain, and the money for which this grain should be sold should be given to the painter, in whatever manner

and form seems best to the said master Filippo and priest Piero, because it was agreed with the condition that the usual budget should not be reduced.

Further, because there was an argument in the society as to the chief figures in the altarpiece, it was ordered by agreement of all that in the middle there should be the Trinity, because it is our badge, and that there should be two saints on each side. It was ordered that one should be St. James the Greater, because he is the patron of our land, and the second San Zeno, the patron of the whole priesthood of Pistoia, and the third St. Jerome. And since the fourth was lacking I, priest Piero, humbly prayed the company that, seeing that I had a special devotion to the glorious saint Mr. Saint Mammas the Martyr, that they be willing that this figure be painted, and I would celebrate his feast every year in the said society, and for this feast leave in perpetuity six minas of grain in this form, to wit:

I priest Piero di ser Lando, currently chamberlain of the society, if the society of the Trinity were agreed that the glorious and devout saint Mammas was to be painted in the altarpiece of the company and was one of the four chief figures, agree to celebrate his holy feast every year myself during the month of August on the day I thought it should be held, that is, every year in our church, with two vespers and a sung mass, and then [more specifics of the arrangements]. This was voted also.*

Donatello Gives His Doctor a Bronze Madonna

Dr. Giovanni Chellini was really not a patron, though he acquired a work by a great artist. In fact, his way of saying who Donatello was, mentioning his biggest work, suggests that educated Florentines of the age could be more unsophisticated about art than is sometimes thought. Yet his awareness that he had received an amazing gift records, for the first time perhaps, one type of recognition of artists as more than ordinary people—a gift of a work from one of them is much more than the simple gift of a Madonna image. The bronze mentioned here (now in the Victoria and Albert Museum) was technically unique, as far as we know, in being usable as a mold for glass casts as well as for casts in other media. Some of the latter exist; since they obviously were not made after Chellini received the gift, we may observe that Donatello was somewhat thrifty, presenting as a gift what had served its purpose for him already. (That is, there is a link between the unique donation and the unique function of the object.) It reminds us of how Raphael gave an importunate duke a cartoon for a painting already executed; in both cases, there

* The altarpiece was duly commissioned from Pesellino and survives today in the National Gallery, London, with exactly the figures mentioned here.

is the further implication that the recipient was grateful to have a work by the master, its subject or other specifics being irrelevant. Yet Donatello's gift was nonetheless a special gesture; it also recalls the intense gratitude of some later artists to those who helped in their illnesses, from Michelangelo (who gave two marble figures—also useless to him—to the family who took him into their house when he was ill) to van Gogh painting the portrait of Dr. Gachet. Original text in H. W. Janson, Sixteen Studies, *1974, 109–16.*

From Dr. Chellini's notebook of accounts and memoranda.
I make note, August 27, 1456, while I was treating Donato, called Donatello, the remarkable and outstanding master in making figures in bronze, wood, and clay which is baked, and who made that big man which is on top of a chapel over the door of the Cathedral toward the Servites' Street, and also began another one, eighteen feet high, that he, out of courtesy and because it was merited by the treatment I had given him and was giving him for his illness, gave me a roundel as large as a plate, on which was sculptured the Virgin Mary with the child at her neck and two angels at each side, all in bronze, and on the other side scooped out so as to be able to cast molten glass in it, and it would then produce the same figures mentioned on the other side.

Alessandra Strozzi Has Pictures in the House

Writing by women in the period is rare, and so is writing by any patrons who were not wealthy. A normal political punishment of the period, exile, often left mothers of families to handle problems, and Alessandra Strozzi worked so well to recoup her family's fortune that her sons built the notable Strozzi palace. Here she shows an attitude toward paintings that combines pleasure and commercial considerations, and her two adjectives "devout" and "beautiful" show an awareness of both symbolic and aesthetic qualities independent of each other that we will see again in Fra Giovanni Caroli. Of the two subjects, the peacock (although otherwise unknown to us in the period), was evidently quite ordinary, like the well-known Magi theme, since the writer on the one hand thought it saleable, but on the other hand not for much. So this context requires us to expand our ideas about the range of themes of art at this date. Original text in the edition of her letters, 1877, 224.

Letter to her son Lorenzo in Bruges, 1460.

. . . The painted papers, or rather canvases, I got two months ago, and you have been notified in several of my letters, and I gave Jacopo his as you had asked me several times. He seemed to like it quite well, and made us great offers. The other I have at home. . . .

As to the two painted canvases, one is the Three Magi, offering gold to our Lord, and they are good figures. The other is a peacock, which seems very fine to me, and is enriched with other decorations. To me they seem beautiful; I will keep one, because, from what you in your letter say they cost, I don't know if here one would get three florins apiece, for they are small canvases. If I had a chance to sell them at a profit, I would sell them both. The Holy Face I will keep, for it is a devout figure and beautiful.

The Marquis of Mantua and His Jewelry Designer

Lordly patrons, even including Lorenzo il Magnifico, all probably paid more attention to jewelry than to paintings, but art historians have more often published their statements on the latter. Hence special interest attaches to this correspondence, in which the Marquis Ludovico Gonzaga instructs his agent in Rome about working with Cristoforo Geremia, a notable medalist, carver, and restorer of ancient works. It is especially vivid on the high status of the artist and his consequent independence in the designing details of his work. (Because of the length and complexity of the correspondence, quotations will be bridged by summaries paraphrasing the rest.) Original text in D. Heikamp, Il Tesoro di Lorenzo il Magnifico, *Vol. 2,* I Vasi, *1974, 75–77.*

[The Marquis had earlier arranged with another craftsman, who died, to carve a rock crystal into a shell-shaped salt cellar; Cristoforo was to finish this, design a golden base, and arrange with a goldsmith to execute it. The Marquis gave assurances that he would provide all the gold needed, concluding, on March 8, 1461:] We know that we cannot but be well served when it passes through his hands, and so we give no additional instructions, for we are sure none are needed. [Cristoforo replied, just before going on a trip from Rome, that he would need seven or eight ounces. On August 2, the Marquis wrote that, on further consideration] We cannot imagine where so much gold could go, and we have some doubts lest this turn out to be some great object, the opposite of what we wanted, so if Cristoforo comes back, tell him that we would be obliged, before he does anything more, for a look at the model of how it is going to come out, and you can send it to us. But don't give any sign that we want it for this reason, nor that we have written you anything about being surprised that he wants so much gold. But just indicate, as if it was your own idea, that we would enjoy seeing the model and how it is going to come out. And when we have seen it, we will tell you our intention.

[Since Cristoforo was still away, the agent simply shipped to Mantua

the crystal shell and] the lead model that Cristoforo Jeremia made, which for his part is not finished, but enough so that I think your lordship can understand what it would be like when finished. [The Marquis answered on September 27:]

. . . This evening we received by the Brescia courier the box you sent with the little crystal shell and the model made by Cristoforo Geremia. We were much pleased, believing that it will turn out a fine thing. . . . And we want you to tell Cristoforo that if he were not from Mantua we would not dare use this presumption, especially we who are not expert compared with a master as he is, but since he is from Mantua, as I said, we will not hold back our opinion, for we know he will not take it amiss. Having considered the feet of this shell, even though they are not finished perhaps, it seems on the basis of the model he did on another occasion that they ought to be more massive and solid, for these seem thinner in proportion than the others he made. And he should not worry about using more gold, for we have no concern about that, so long as they are beautiful; but he should not be blocked by this, since he understands the matter better than we do, from going ahead as he pleases and thinks best. We will see to his getting the gold, and we think 21-carat will do, for we have the means to get that. When you get hold of him, we would be glad if he could do this as soon as possible, for it will please us very much, and if he needs it with more carats, then we will send him enough more so he can do it.

[The agent replied on October 24 that Cristoforo had returned.]

. . . He thanks your highness for this memorandum, inferring from it that you hold him in great affection, and says that it seemed this way to you because it was unfinished, and if he were to finish it this same way you would be quite right, and in this sense you are right, but the fault was mine for sending it unfinished. Above those feet, he says, some wax goes, with a little column in the middle, and thus they will be so thick that you will think it a beautiful little object when your highness sees it, to whom he yields the mastery and whose pupil he declares himself, and feels he cannot be wrong in this for it will be manifest. Let your highness send the gold when it pleases you, for he will await it, and consider it a singular favor.

[On November 7 the agent acknowledged receipt of the gold and that Cristoforo found it to be more than enough. On December 9 the Marquis was urging speed, and went on,] Tell him we were talking through our hat, and that if he hadn't been from Mantua as he is, we wouldn't have dared to send him such a word, because we would judge that, being the master he is, he would have observed perfectly that we do not understand these matters, and being from Mantua we thought we could talk that way safely. [After the work was shipped on April 1, Cristoforo wrote himself on April 6 to "My Lord and sole benefactor,

with humble commendation," apologizing for taking so long, and add-ing,] I also send your Lordship four ancient heads reputed good by the experts. May your highness deign to wish to accept them such as they are, and I commend myself and mine to you. And if I hear your lord-ship takes pleasure in such things, I will make constant efforts to send others, and always to do whatever I know may gratify you and what your lordship commands. [On April 20 the Marquis replied, thanking him both for the salt cellar, which "couldn't have been done better," and for the ancient heads: he would like more, if a license may be had from the pope, who is said to have forbidden their export from Rome on pain of excommunication.]

Contrary to what is sometimes suggested about patrons' detailed supervision of their commissions (especially when a work is suggested as having a complex extraaesthetic message) it is clear that the marquis's deference to the artist is genuine. At first he wants his doubts concealed from him (perhaps also so as not to seem stingy about gold). Next he for-gets that doubt and presents, along with a new one, the conclusion that the artist is nevertheless not to be bound by it because he knows better. All this in no way contradicts a feudal social relationship of lord and worker. It might be compared to a modern case in which a leader in high society is at pains not to offend her chef (or gardener or dress designer) because he is known to be one of the few best and she needs the best to make the proper show. If he seems to do something peculiar, she may hint at a revision but is more pleased when her anxiety proves to have been a false alarm. In this game the chef has the role of a courtier, ex-claiming about her fine taste and understanding. He is at the top of his field because he understands the fashion, in which she is a leader of con-sumers and in which he is the planner, so that the particular forms of menus are his concepts, not hers. In 1480 the next Marquis of Mantua's remark about Mantegna, that one must take what the artist is willing to do, extends the pattern to a general rule.

The Duke and Duchess of Milan and Rogier van der Weyden

The two letters below document the only known case of an Italian painter's actually working as an assistant in a Flemish master's shop. (A third letter, of intermediate date, alludes to a perhaps temporary dispute between Rogier and the young Italian.) Since Zanetto's paintings do not survive, the situation must remain something of a mystery. He was not an apprentice, having already painted ducal portraits; his motive for the journey may have been a wish to learn the oil technique, just then

emerging in Italy. There was a general Italian openness to Flemish art: Flemish works were imported, or purchased when Italians visited the north or when Flemish painters came south. There were also Italian biographies of Rogier and of Jan van Eyck. No similar interest in Italian art was shown by the Flemish at this time. Original text in F. Malaguzzi-Valeri, Pittori Lombardi, *1902, 126–27.*

The Duke of Milan to the Lord Duke of Burgundy. Milan, December 26, 1460.

We have here a youth by the name of Zanetto, who is the bearer of this letter to your lordship, of singular talent in the art of painting, and devoted to the art, so that, hearing of the fame of Master William [sic] who lives in your lordship's domains or thereabouts, and who is said to have the greatest knowledge of those skills, he made up his mind, with our permission, to go to learn something from him. Therefore the said Zanetto, whom we love not a little for his good qualities, we commend to your lordship. . . .

* * *

The Duchess of Milan to Master Rogier of Tournay, painter in Brussels, Milan, 1463.

Hearing of your fame and qualifications, we decided formerly to send our master Zanetto to you to learn something in the art of painting. And on his return, he recounted to us how willingly and lovingly you had treated him and taken him on, and what thoroughness and attention you had shown, on our behalf, in demonstrating to him freely all the things you knew about in your special trade. The which, having become aware of the result as well, we are pleased to make our own, and thank you very much.

The Duke of Milan Falls in Love with a Portrait

Artists sent on missions to paint their masters' potential brides included Jan van Eyck and Holbein; this was a standard function for a work of art in the period. The exciting effect of this one on the duke may seem something more to be expected in fiction (as in The Magic Flute), *and also magical, for it implies that the painting was conceived of as totally identical with the sitter, not less or more because of being an image: the "beauty" he reacts to is that of the lady. Although this may seem bizarre, it has its parallel in our modern ability to adore photographs—as of film actresses, for example in the story of how the Prince of Monaco fell in love with Grace Kelly's pictures—without thinking about the retouching or other alterations in the image. By such analogies we*

may perhaps better understand the Renaissance public's approach to painting, as a versatile and active tool of living. Original text in F. Malaguzzi-Valeri, Pittori lombardi, *1902, 110.*

The Duke of Milan to his mother, from Vigevano, March 6, 1468.

Most illustrious lady mother, I remember that I wrote to your excellency before, since I had sent master Zanetto the painter to France, to bring me the portrait from life of the illustrious lady Bona of Savoy who is already, if I may say so, my wife, that when he would bring it if I thought it ugly I would send it to show to your ladyship, but if beautiful, the contrary. And just today master Zanetto has returned and brought me the picture of the same, who seems to me not only beautiful, but very beautiful. To fulfill the arrangement with your ladyship, I do not plan to send it to you, because I want it for myself, and you will surely be glad to excuse me. My compliments.

<div align="right">Your son and servant, Galeazzo Maria Sforza</div>

The Duke of Milan's Most Personal Frescoes

These instructions make vivid an aspect of Renaissance painting that hardly survives at all, and so help in redressing the balance with better known religious imagery. One fifteenth-century fresco of girls playing ball survives in a grand house in Milan, but we would not have guessed that the figures are individual portraits of the family, even less that the favorite servants are given equal weight. Such images in castles showing the lord's own daily life go back to fourteenth-century hunting scenes, but this one has become even more casual (and illustrates a set of patron's instructions that go into detail yet indicate no symbolic level of meaning). Frescoes that mirror the very people who look at them may throw light on the context of Mantegna's court frescoes of his marquis with family and courtiers, and the special feeling for painting a horse anticipates a later generation of castle frescoes in Mantua, in Giulio Romano's work. Original text in Archivio storico lombardo, *Vol. 3, 1879, 547, 553.*

Order according to which our most illustrious lord wishes the rooms in the Castle of Pavia to be painted and repainted, June 22, 1469. . . . [Among others] in the little room where the ladies eat [are to be painted] her most illustrious ladyship, the most illustrious lady Isabella playing *ballone* or *poma* with her ladies in waiting, or at *trionfi* or *pelluco* [all various ball games] and Virgilio, Don Biasio, and Zohane Antonio the court fool should be in it, and the female dwarf is to be bringing picked mushrooms to my lady. In the tower room, their most

illustrious lordships, and my lady as a Turk, with the nurse, and the most illustrious Count of Pavia, and their lordships could be caressing him, and Novissa should be in it.

* * *

The Duke to the Castellan, from Abbiategrasso, March 27, 1470.

Whereas we wish to see a bay horse rendered, you will immediately have painted the horse on which the late most illustrious Duke Galeazzo is shown riding in the room at Pavia, the second from the end when you come from the red room, that is on our most illustrious consort's side, said horse with its saddle and accouterments in the color and action as it is, and when they are rendered, you will send them to us by the bearer.

The Ducal Agent Arranges for Tura to Inspect a Picture

This unique surviving record of a patron's sending his artist to look at an older work of art reveals two things. One is the rather peremptory treatment of artists by this duke, as illustrated in Cossa's letter to him. The other is the fame of Gentile da Fabriano, whose status fifty years after his death as one of the most admired painters of the century is sometimes not taken into consideration (see discussion of Facio). The work by Gentile that Tura was to see was a St. George and the Dragon, and he had himself just painted the same theme in Ferrara. It is thus tempting to reconstruct a conversation in which the duke might have told him he could still learn something about it from the older master. Original text in Jahrbuch der preussischen Kunstsammlungen, *Vol. 4, 1888, 14–15.*

To the Duke of Ferrara from Salutius Consandulus, in Brescia, November 1, 1469.

Most illustrious and notable prince, and my particular lord.

. . . Whenever your most illustrious lordship wants to send Cosme the painter to Brescia, you can send him, since the area is free of contagion and has been for the last three months. Since I happened to be showing certain jewels to the captain of the territory, who is the brother of the late Master Girolamo Barbarigo, and we were in the chapel of Gentile, I told him that your lordship wanted to send a good painter of his to see it; he assured me that he would be welcome and well received, and that he would want to enjoy it for three or four days. For he has heard of his fame. He shows the most cordial affection for your excellent and notable lordship, at whose feet I most humbly commend myself.

Your excellency's most devoted Salutius Consandulus

The Duke of Milan Gives Bonifacio Bembo a Job of Restoration

This letter serves to recall some aspects of the age not included in our standard image of it. We see restoration going on of frescoes at most a century old. And we see a leading court painter involved in "wallpaper" decoration, which, when preserved today in such castles as this of Pavia, is generally excluded from the class of works by leading painters, and so is little noticed. The text also illustrates that, within the general topic assigned, even so authoritarian a patron as the duke gave the artist choice of subject matter in painting his own residence. Original text in F. Malaguzzi-Valeri, Pittori lombardi, *1902, 110.*

The Duke of Milan to Bonifacio Bembo, from Vigevano, January 23, 1470.

To Master Bonifacio, painter. Dearly beloved, we have noted what our captain of the hunts, Carlo da Cremona, has told us about retouching our Chamber of the Rabbits there, and we are well pleased, and want you to retouch it where needed, and make the frieze under the white field, and some plants, millet in its several species, and such like greenery, with some birds, to wit pheasants, partridges, and quails, as you think best, and as you have discussed with the said Carlo.

The Duke of Milan Gets Competitive Bids for Frescoes

Although it is known that competitions among artists through samples were held in the period, it is not so often noted that they also competed as contractors, in a way that we can instantly recognize in the practice of our own time but think of as far from the concerns of artists. Original text in C. Ffoulkes and R. Majocchi, Vincenzo Foppa, *1909, 304–5.*

Bartolomeo Gadio to the Duke of Milan, Milan, June 27, 1474.

On St. John's Day I had a letter from your illustrious highness about the painting of the vault of that chapel of the Castle of Milan in which you said, among other things, that some painters had been to see you, among whom were some who wanted to take on the job of this painting for 200 ducats, some for 150, and some for 100, and since in the aforementioned letter your excellency instructed me to have all those painters come to me, and decide which would offer the best conditions for this work, I have had them come, and others as well. Among these the master Johanne Pietro da Corte, Melchior da Lampugnano, Stefano de Fideli, Gottardo de Scotti, and Pietro da Marchesi, as a team, offered to paint it for 175 ducats, and, as another team, master Bonifazio Bembo da

Cremona, Zanetto de Bugatti, and Vincenzio de Foppa offered to paint it for 160. Finally, the above-mentioned masters Johanne Pietro and associates offered to paint it for 150, doing it according to one of the drawings I am sending to your excellency by one of them, whichever you prefer with or without cherubim, with God Father dressed in ultramarine blue with rays of fine gold in relief, painting the said vault in blue, of the quality and fineness of the drawings, with fine gold stars in relief, and with twelve angels too on each side of the chapel, except on the window side where they say they can place only six, but will put more if they can fit them in, and for the 150 ducats they also have to make a border a foot wide, the color of the woodwork of the altarpiece, up to the ceiling, painted in the likeness of the altarpiece, and thus remove the old plastering of the vault and do it over at their own expense, and put the plaster on, with the beams, hooks, ironwork, and all needed to make the scaffolding, and so present it finished for the said price of 150 ducats. And since I found none willing to do it at a better price than they, I decided on them, if your illustrious lordship pleases, and if you are agreeable to this decision let me know, and decide which drawing of the two pleases you more, and, in short, let me know so that I can order it to be followed up, if you will send me back the drawing that you wish followed, to keep, so as to see when the work is finished if the blue is good and fine as promised. Those painters who, your excellency said, offered to paint it for a hundred ducats are not to be found, and in fact they all say they never spoke of a hundred ducats. But those that have the job must do it in such a way that it can be approved and perfect, and with good colors and everything right, and if your excellency wanted to eliminate something from one of the drawings the price would have to be reduced, or conversely increased if your excellency added anything.

<div style="text-align:right">My compliments, B. da Cremona</div>

The Duke of Milan Objects to Diverse Hands

After the assurance that experts could recognize the hand of acknowledged masters (see Mantegna) it is a little less surprising to see that a complaint can be made based on such recognition alone when several artists present different styles in one cycle. Nothing is alleged about one's being inferior or about an assistant's hand being visible, but the discrepancy itself is objectionable. Laymen at this time had perhaps a greater sensitivity to personal style than has been supposed by historians. This might help to explain why, for example, when the Brancacci Chapel was first painted in the 1420s, the two masters seemed free to differ, but in the second phase in the 1480s Filippino Lippi made a heroic effort to

blend his work with what had been done earlier, modifying his own style, a fact often noticed but not explained. But this area would need research. Original text in F. Wittgens, Vincenzo Foppa, *ca. 1950, 114.*

The Duke of Milan to the masters Bonifatio of Cremona, Vincenzo Foppa and Jacopino Zaynario, painters, from Pavia, August 23, 1476.

Mrs. Zacharina, widow of the late lord Augusto de Beccaria, has presented the enclosed petition, in which she complains that you and your associates did not take the care you were obligated to in painting the life of Christ in the church of St. James, outside this our city of Pavia, as is stated in full. Wherefore, since it seems decent that you should live up to what has been promised, we say to you and desire that you take care of it according to your obligation, by arranging that the painting is not done by so many hands as it would seem to be done, so as not to make the work unharmonious [*disforma*], but one of you should finish it, being obligated officially, as soon as possible, not however meaning by this to prejudice in any way the account of master Constantino,* to whom you may report this that we are writing; one of you, however, executing what is described above, so as to take care of and meet your obligation, and also for the beauty and honor of the church, as above, assuring you that our intention is that nothing herein should delay the work on the chapel of this our castle of Pavia, which work we wish to be finished very fast.

The Pistoia Committees Argue over a Monument

Memorials to notable citizens, voted by city fathers with public funds, are a category of works of art today, and long arguments in and outside official bodies continue to surround the choice of artists for them. In this case it was clever of one side to appeal to Lorenzo de' Medici, who combined political powers with a reputation for judging art; however, no reply by him is on record, and the opposite side, the more powerful city council, won, giving Verrocchio the commission. The special monument committee's choice, Piero del Pollaiuolo, is unknown as a sculptor, and one wonders whether they approached him in order to bypass Verrocchio's high demands and whether annoyance about those may have affected their pleasure in Piero's work. Yet they articulate their choice in terms of beauty, showing that isolation of the aesthetic component was customary. The whole story indicates that the famous competition over the Baptistery doors of Florence was not an isolated occurrence. Original text in M. Cruttwell, Verrocchio, *1904, 252–53.*

* A painter who was partner with Bonifacio and Foppa on another work, mentioned just below, in the Castle of Pavia.

The Overseers of the church of S. Jacopo, Pistoia, to Lorenzo de' Medici, our most special lord and benefactor, March 11, 1477.

After the due compliments, we must trouble your lordship about a matter that has arisen, and that is, that after the death of Monsignor of Tiano, of virtuous memory, our most beloved fellow citizen, it seemed that in memory of his most reverend lordship and because of the benefits this city had received from him, the community here ought to make this clear, and it was settled that through our council 1100 pounds should be spent for his tomb and memory, and they delegated us, being citizens, to have models made, and when they were made they should be presented to the council, and this council would choose which should be picked. Wherefore five models were presented to the council, among which was one by Andrea del Verrocchio, which was liked more than any other, and the council gave us the duty of negotiating with the said Andrea about the price. Which we did, and he asked 350 ducats, and when we realized his requirement we let him go and made no contract with him, because we had no authority to spend more than 1100 pounds.* Then, wishing that the work should be actually executed, we went back to the council, saying more money was needed for this work than 1100 pounds, if we wanted something worthy. The council, having heard the facts, reconsidered and gave us authority to spend what we thought we should for the said work, as long as it was beautiful, and assign it to the said Andrea or anyone else we wanted. Wherefore, hearing that Piero del Pollaiuolo was here, we went to him and asked him to make a model of this work, which he promised to do, and so we put off assigning the work. Now it has happened that our commissioners, to ensure that the work would be executed, have assigned it to the said Andrea with the said price and form, and we as obedient subjects would always be satisfied and obedient about this and every other thing they did and deliberated, and so we have written them. Now Piero del Pollaiuolo has made the model that we asked him for, which to us seems more beautiful, and more worthy as to its craftsmanship [*più degno d'arte*], and is better liked by Mr. Piero, the said Monsignore's brother, and his whole family, and by us too, and all the citizens of our city who have seen it, than the one by Andrea or any of the others. And for that reason we have asked the said commissioners, if they would, to make some generous arrangement with Andrea, and take the one by Mr. Piero, which would make us very glad and happy. Now we are sending the models to you, as to our protector, because you have full understanding of this sort of thing and everything else, and we are certain you desire the honor of Monsignore and his family, and our city, which being so, we would have you lend your aid and favor to our desire, which is directed only to the honor

* A ducat was worth up to about 7 pounds.

of our city, and the memory of the said Monsignore, always ready for your word and awaiting your reply.

Your servants the overseers of San Jacopo, officials of the Academy, and citizens picked by the council to supervise this work in Pistoia.

Lorenzo de' Medici's Criteria for Paintings

Lorenzo de' Medici (1449–1492), de facto ruler of Florence, is perhaps the person in history most famous for being an art patron, and much has been written about his views and effective guidance of art. It is thus ironic that all this literature does not include his own actual statement on what makes paintings good. It is not a surprise, since the remarks are hidden in a comment on his own sonnets, a justly neglected conventional essay. But the fact that he calls these the complete *requirements makes it more significant that they differ so much from what has often been deduced, or speculated, to be his interest, usually involving neo-Platonic and other symbolically complex imagery. What he asks for does, though, match two other quite different concerns ordinary in the period. First, his three criteria coincide closely with those seen in contracts. In them the patron regularly insists on specific materials, the artist's best craftsmanship, a subject in general terms, and the size—all the concrete demands seen in contracts for other goods too—and on not much else. Of these Lorenzo omits only the size (of course, since he is not speaking of one particular painting). Second, the subjects he lists match those normal in "industrial art" contexts of his time, such as* cassoni *(where the subjects are often land and sea battles), the inlaid wood furniture called* intarsia *(where they are often buildings and other foreshortenings), tapestries (often representing greenery), and decorative fresco painting in houses (often representing dances), all intellectually humble and old-fashioned preferences, and all to the exclusion of choices familiar in the works of leading individual masters in Florence. Original text in the edition of Lorenzo's works,* Opera, *1939, Vol. 1, 68.*

. . . Three things in my judgment are called for for a perfect work of painting, namely, a good support, a wall or wood or cloth or whatever it may be, on which the paint is applied; a master who is very good both in drawing and in color; and, besides this, that the matters painted be, in their own nature, attractive and pleasant to the eyes, for, even if the painting were very good, what is painted might be of a kind that would not be in harmony with the nature of the person who is to see it. For some people take pleasure in merry things such as animals or greenery or dances or similar merrymaking, others would like to see battles, either on land or on the sea, and similar martial wild things, still others landscapes,

buildings, and foreshortenings and proportions of perspective, others some other different thing, and so, if a painting is to please completely, this part is to be added, that the thing which is painted please in itself.

The Rulers of Mantua and Mantegna, Their Painter

Like Mantegna's own letters, the surviving sources on his place in the courtly world are also richer than those on the context of any other artist's life at this time. In this selection we begin with a vivid suggestion of his social position, no longer that of an employed skilled craftsman (as the musician mentioned here is), but of a courtier, able to meet the ruling family on terms of give-and-take and mutual respect, and plied by the young cardinal with his own claims to be a connoisseur, while still subject to being ordered about. Original text in P. Kristeller, Mantegna, *Berlin, 1902, 527.*

Cardinal Francesco Gonzaga to his father the Marquis of Mantua, July 18, 1472.

Most illustrious lord my father, my arrival in Bologna will be, I think, the fifth or sixth of August, where I don't plan to stay more than two days, and to take the waters; where, to have some soothing amusements and keep from falling asleep, as one must in that place, I beg your lordship to be pleased to order that Andrea Mantegna and Malgise come and stay with me all the time. With Andrea I will have amusement showing him some of my cameos and bronze figures and other beautiful antiquities, on which we may study and confer in company. Of Malgise, I will have the pleasure of his singing and playing. . . . Thanks be to God, I feel able to ride, and since I left the Roman air I have been better.

The following letters about the frescoes in the Camera degli Sposi are a recent discovery. They reinforce some older opinions, such as the date 1474 and their rapid rise to fame, which is soon afterwards reflected in the visit by the Duke of Urbino (see Santi). But more in them is new and surprising, beginning with the marquis's critical view of Mantegna's portraits. Contrasting as it does with the always positive statements the three successive marquises made to Mantegna, it evokes the artist's high status as someone important enough so that even the duke held back from offering him criticism, even if this may have been only because he was a prize toy, impossible to duplicate, bringing luster to the court. It is also unparalleled to read that the marquis would even bring up the concept of cutting out some heads from the frescoes for reason of state; perhaps the nearest analogue is the changed head of Portinari in Hans Memling's Last Judgment *of the year 1473.*

Most fascinating is the clear image we gain of why a patron would introduce portraits into his fresco projects, and how he chose them. We see that it was very much like making a list of guests for a reception or for an award, which was likely to annoy those left out. So he hoped to choose the most important (notably including the king, who would see the work); we can infer that he also hoped to tie these people to himself by association. This is the earliest firm case of this type. A similar one soon followed in Florence when Ghirlandaio painted the literary lions of the city in a religious fresco otherwise showing portraits only of the patron family. It is likely that the emperor and king are the only outside portraits in Mantegna's fresco, because otherwise the duke, who was so jealous of their inclusion and angry about being omitted himself, would probably have complained about any other portraits also, and because the same two are reported independently by a local writer in 1521. The two painted heads have now been identified. One was long thought to be Mantegna's self-portrait. This correction should help reduce the amount of indefensible history writing that finds everywhere in Renaissance frescoes the likenesses of the artists and of only those personalities most interesting to us, a habit that began in the sixteenth century and seems to resist all appeals to lack of proof. Still more interesting is the fact that king and emperor were never in Mantua at the same time, proof that the image is not of a specific event there, as usually assumed (in tribute to its powerful reality) but is rather an image of the ducal court in its habitual appearance, as we have seen in Pavia. In fact, an excellent scholar recently denied the accuracy of the identification of king and emperor by the 1521 writer precisely on the ground that the two men were not in Mantua at the same time, because he thought the frescoes must show a specific event. Original texts in Mitteilungen des Kunstistorischen Instituts in Florenz, *Vol. 18, 1974, 230–32.*

The Marquis of Mantua to his treasurer in Venice, March 1, 1474.

. . . We also want you to send 2000 pieces of beaten gold for our chamber in the castle, since we want Andrea Mantegna to get it finished, so that at least when the most serene King of Denmark comes back it will be done.

<p style="text-align:center">* * *</p>

The Marquis' ambassador in Milan, to the Marquis, November 26, 1475.

[He reports a conversation with the Duke of Milan, about his having refused a loan to the King of Denmark.] . . . And then he started on the praises and virtues of the aforesaid king, reading off a notable lecture about him which I will not expound further since I don't think it is necessary. . . . And his lordship ended by remarking that your lordship, in a memorial to the two paltriest men in the world, has had His Im-

perial Majesty and the aforesaid King portrayed in your Chamber, and I infer he is not a bit pleased that your lordship did not have his excellency himself portrayed in it, since your lordship has had such a beautiful chamber made as this one is, about which furthermore everybody here is talking, and saying unanimously, those who have seen it, that it is the most beautiful chamber in the world, and I have had some remarks about it made to me privately. I refer the decision to your lordship's usual prudence. . . .

* * *

The Marquis to the Ambassador in Milan, November 30, 1475.

Zacharia: you wrote me about the speech about the Emperor and the King of Denmark. You can be sure he didn't like the fact that the aforesaid King accomplished something in Italy at his expense. Also, the Emperor is my superior, and the King of Denmark is my brother-in-law, and since they have been seen by so many people as they have been, it would be too great an awkwardness to remove them; they don't hurt anybody by remaining there, whether they like it or not.

Zacharia, we did guess that His Most Illustrious Lordship could have been annoyed that we did not put him in our chamber. To tell the truth, we did think of putting His Sublimity in the worthiest place, but when Andrea Mantegna portrayed him once before, it didn't seem to satisfy him, and we heard he had the sheets of paper burned because he felt he hadn't done him well. And it is true that Andrea is a good master in other things, but in portraits he could have more grace, and doesn't do so well. Therefore we had come to the conclusion that we didn't want to do something he wouldn't like, but we don't wish you to say any more to His Excellency. But if the opportunity should arise in talking, you can tell him, and burn this note.

* * *

The Ambassador in Milan to the Marquis, December 4, 1475.

I have seen what your excellency writes me, of those portraits of the Emperor and the King of Denmark. You should not be worried about it, nor have them removed from where they are, it wasn't said with that aim. I have taken care of what is needful. I am sure it was said with the idea that it would have seemed appropriate that the other might have been portrayed in addition. I understand your lordship's excuse, and if it comes up I'll know what to say.

The following letters have usually been used by scholars with the rather narrow biographical purpose of deciding whether Mantegna painted small figures. But certainly of more interest is the report that artists cannot be told just what to paint, and patrons must be content

with what they do. To be sure, one need not infer literally that the Marquis never could give Mantegna orders; on another occasion he did press him effectively to do a work for another duchess. He may here have been making an excuse when he simply did not want to meet the request. Yet the frequent view of art historians, that painters followed patrons' detailed instructions, is often supported by the basic view that the opposite arrangement could not have been conceived of in this early period. Not only do we have here on record in 1480 the concept of the artist's independence, it must have been a real enough phenomenon, even if it was only an excuse in this case, to work as an excuse. A better-known parallel twenty-five years later involves Mantegna's brother-in-law Giovanni Bellini, who would not paint what a later Marchioness of Mantua wanted because, her agent told her, her idea was not "accommodated to his fancy" and he was "used always to wander at his pleasure in paintings." We have seen still other such documentation, but the present text is the one that asserts this as the norm for the widest range of "recognized masters as a rule." Original text in Gazette des Beaux-Arts, *first series, Vol. 20, 1866, 480.*

The Duchess of Milan to the Marquis of Mantua, from Milan, June 8, 1480.

Counting on your lordship, we send you certain drawings for paintings, which please have executed by your Lord Andrea Mantegna, the famous painter. By Bellinzona B. C.

* * *

The Marquis of Mantua to Her Ladyship the Duchess of Milan, from Mantua, June 20, 1480

Most illustrious. I have received the project for the painting that your excellency sent me, and made every effort with Andrea Mantegna, my painter, to turn it into elegant form. But he tells me it would be more a job for a miniaturist than his kind, because he is not used to painting small figures. In fact he would rather do Our Lady, or something else about two or three feet high, if that might please your most excellent ladyship; if I knew a way to do what your ladyship requests, I would exert myself with the greatest rapidity to satisfy your wish, but, as a rule, these recognized masters have something of the fanciful about them, and it is best to take from them what one can get. So if your excellency is not served as quickly as you had had in mind, I do beg you will excuse me, etc.

The following is perhaps the earliest direct record of including a tour of the famous local artist's studio or work in progress in a visiting

head of state's schedule (as later the Sistine ceiling in progress was visited by a touring duke). That Mantegna first established the pattern shows his great status. No doubt his being also a collector of ancient art helped it to happen—the more so since Lorenzo was a fellow collector. Soon after this Mantegna asked Lorenzo to subsidize him. Original text in P. Kristeller, Mantegna, *Berlin, 1902, 541.*

Francesco Gonzaga to his father the marquis of Mantua, from Mantua, February 23, 1483.

. . . Further, I wish to report to your highness that the Lord Lorenzo de' Medici went to visit the countryside yesterday. And today I accompanied him to mass at San Francesco on foot. From there his lordship directed himself to the house of Andrea Mantegna, where he saw with great pleasure some paintings of the said Andrea, and certain heads in relief, with many other ancient things, which it seems he enjoys very much. Then we came to the court.

Your most illustrious lordship's son and servant Francesco de Gonzaga, with compliments.

The Madonna of Victory Planned

It is rare to have a quite detailed knowledge of the genesis of a major and innovative work of art, and when we do in this case, we find that the work is not a logical outcome of the asserted plan. It seems oddly and deeply out of phase in another way as well, for to us the altarpiece is notable for its modern freedom, that is, for the way in which its space-time dynamics transfigure the old formalities of altarpieces while it yet remains an unmistakable altarpiece. It was so advanced that it served as a model to Correggio, whose work served as a model to the baroque age. Yet the basis of it could not be more involved in tradition, even the kind of folk superstition that we say produces unchanging imagery. Two forces accidentally combined to produce it. First, the Marquis of Mantua won a battle on July 6, 1495, and made a vow to build a church to the Virgin. Second, a certain Daniele Norsa had bought a house in Mantua and, being a Jew, secured the church's permission to remove a Madonna painted on it. When he did, other people became furious, and Norsa was then fined an amount large enough to buy not just a new Madonna, but one by Mantegna. Then the revered hermit Girolamo proposed tearing down Norsa's house and building the marquis's new church on its site. He also presented a program for the altarpiece, based on two identical visions of friends of his. In a second letter (included here) he offers a changed scheme, which Mantegna used, but in a strange way. If the hermit's

mental image, of the Madonna sheltering people under her cloak, was the well-known traditional one—compare Ghirlandaio's fresco of the 1470s—Mantegna oddly altered it to make the cloak so small that it is left without significance, like an appendix, a token cloak under which the marquis is no longer being sheltered, while its sheltering of the boy John the Baptist is theologically unsuitable. It is as if Mantegna included the required cloak only so that he could claim to be abiding by the program, while emphasizing much which was not asked for. An analogy is the anecdote about Ghirlandaio, who formally agreed to include a coat of arms in an altarpiece (begun 1490) in the most honorable place. He did, literally, but it was so small the family could not find it. Original text in P. Kristeller, Mantegna, *Berlin, 1902, 559–60.*

Fra Girolamo Redini to the Marquis of Mantua, in Mantua, August 29, 1495.

Most illustrious prince and excellent lord, my liege lord.

From the Reverend Monsignore your brother I have learned the answer your lordship gave to the Jew, that he had to have the blessed image of the glorious Virgin Mary painted, which he had erased. And I have been very happy to see what his reverend lordship has vigorously done, in fulfilling your excellency's letters. I hope this most holy virgin will be made soon, which will surely be a great comfort to your lordship and the whole city. I wrote a few days ago, in the name also of my colleague Father Don Marcantonio, that, in addition, these houses must be turned into a church, which will be Santa Maria della Vittoria. This has been confirmed by the said Monsignore your brother, in this way: his reverend lordship orders, with the endorsement of your council, that Master Andrea Mantegna make two saints, one on each side of the Madonna, holding her mantle, under which there will be your lordship, armed; these will be Saints George and Michael, and everyone, I most of all, liked the words he added, inspired I believe by God, that these two saints were victorious, one in body and one in soul, and that they, together with the most holy and devout mother of God, your intercessor and sole hope, will give victory to your most illustrious lordship, and finally he said he hoped to see a fine cult grow up in that place. His reverend lordship has already made a pledge to it, and he has commissioned me to write your lordship that the first race will be won by your sick horse which I saw your lordship was himself treating, very attentively, and he promises in your lordship's name that the said race will be dedicated to Saint Mary of Victory. [Further prayers and advice make up the rest of the letter.] Farewell. Your most illustrious lordship's most devoted servant Don Hieronymo the Hermit.

The Madonna of Victory Installed

This is the best record of a painting's being borne in procession when finished, as happened earlier with Duccio's Maestà and others. Writers of the Victorian period and since have read these records as evidence of people's spontaneously appreciating great art in an age of handicrafts and natural living. In this case the event, organized from the top with much self-congratulation, seems more like the celebration today of the opening of a new store. Unique is the report of the costumed figures surrounding the painting, extending its own imagery beyond its frame. Comparable to cases of carved picture frames with figures and of sculptures in front of paintings in shrines, it evokes even better the fundamental aesthetic assumption of the age that what the painting shows is fully real, not different from what is outside the painting. In particular, Mantegna's frequent device of projecting figures forward from the picture space into ours suggests that he designed this pageant. Original text in P. Kristeller, Mantegna, Berlin, 1902, 561.

From Monsignore Sigismondo Gonzaga to his brother the Marquis of Mantua, in Mantua, July 6, 1496.

To my Most Illustrious Sole Lord. Since I continuously remember the harsh and cruel day of the battle, one year ago in Parmigian territory, in which the supreme deity and his glorious mother saved your excellency, after many brave and forceful actions for the death and destruction of the enemy done for her, I thought that today, along with my most illustrious lady, I would make some praiseworthy memorial, in praise of God and his glorious mother. And so we arranged a fine procession, which took place this morning solemnly, with all the orders of monks and priests, in the following manner: all the religious assembled at San Sebastiano, with the greater part of the people, where the image of the glorious virgin which Master Andrea Mantegna has finished was raised up on a great platform, very admirably framed, and above this image was a youth dressed as God the Father, and two prophets were on either side, and at the sides three little angels singing certain lauds, and opposite were the twelve apostles. When it was time, this platform was lifted up, carried by twenty porters, and so this image was carried in procession to San Simone, with such a quantity of people male and female that the like was never seen in Mantua. Here a solemn altar was prepared at the corner of the new chapel, where master Cristoforo Arrivabene celebrated a solemn mass. But first Fra Pietro da Caneto gave a fine speech in Italian to the people, in praise of the glorious virgin, exhorting them to devotion to her, reminding them it was she who had freed your excel-

lency on that identical day from such dangers, and they should all pray to her to preserve you in happiness for the future. And so in truth all did pray, with one voice, a thing from which your lordship should take great comfort, that is from the love and reverence this whole people shows to you, not the least ungrateful for the benefits you are continually giving them. After lunch the image was set in the appointed place, where it was not three hours before some wax images were presented to it, and torches and other ex votos, so I believe that in a short time a great devotion will attach to it, and of all this good your excellency will have been the cause.

<div align="right">Your servant, Sigismondo de Gonzaga</div>

Piero de' Medici Acquires a Cimabue

What the Medici, most famous of collectors, collected was almost all either the product of classical antiquity or contemporary—the latter were acquired not for the sake of collecting so much as for varied functions. This is perhaps the first record of a desire to become the new owner (as against continuing to own what is inherited) of a work of art far removed from the buyer in the cultural context illustrated by its style. It is particularly striking in a period that firmly believed art was improving by growing more naturalistic. Piero got an "Italian primitive," whereas a recent study considers the eighteenth century the period in which a taste for such works first developed. Of course, he was motivated chiefly by interest in the proud history of Florence, an old attitude which at just this date was evolving a special new corollary that Florence's artists were better than those of other cities. Thus in 1490 the first historical plaque in history was installed, and it recorded Giotto as architect of the cathedral; at the same time Manetti was writing a set of lives of eminent past Florentines in which, for the first time, most of those cited were artists. (See p. 195.) Leading Florentine painters at this time, such as Ghirlandaio and Filippino Lippi, also show, in their compositions, a new historicizing allusion to older Florentine works of art. Original text in Rivista d'Arte, *Vol. 3, 1905, 153.*

From the daily record book of the monastery of San Benedetto outside Florence, begun in 1482.

Piero di Lorenzo di Piero di Cosimo di Giovanni di Bicci de' Medici heard that we had in our possession a little panel, painted by the hand of Cimabue, painted on both sides, on one side was a Deposition from the Cross, with the Maries and other saints, on the other side was Christ with one hand on the shoulder of Our Lady and the other on John the Evangelist's. And he sent a message to buy it, whereupon don

Niccolo di Lionardo, prior, gave it to him personally, on November 20, 1490, in the presence of don Paolo Coppini and Brother Panutio, and Galieno the embroiderer. And he showed great pleasure in getting it, and made many offers of everything he could do for us, no less than his ancestors.

From The Medici Inventory

The huge inventory of Lorenzo il Magnifico's estate might seem to be of wide-ranging interest, but when it is inspected, it is easy to see why it has been published only in part and not much used. Its very words are hard to interpret, often obsolete names of objects without any context to help, since they form lists. What is selected here from the published selection includes painting, sculpture, and related objects, some on themes not known in surviving works of the time and unlike our idea of its interests, others recognizable as famous works, some with the artist's name and some not. This is all unlike the inventory of ancient gems and cameos—hundreds of them—which is obviously a "collection." Lorenzo did not collect paintings; they were among the furnishings of a rich house. He was indeed not the great Maecenas of Florentine artists traditionally alleged. And yet, just as both Medici and modern patrons of major architects would have a major role by commissioning buildings for use, which we would not think of calling an "architecture collection," so too the Medici commissioned paintings, a procedure outside our patterns today. Original texts in E. Muentz, Les Collections des Médicis, *1888.*

This book of inventories is copied from another made at the death of the Lord Lorenzo de' Medici; copied December 23, 1512.

One mansion on the corner of Broad Street [Via Larga], parish of San Lorenzo, called the "palace of Cosimo," with its bounds.

. . . In which are the below-named rooms and in them the below-named properties, as shown

. . . In the Great Room next to the Said Porch [*loggia*]

A canvas cloth, 4 feet each away, painted in the French style with the story of two women fighting over a boy and many other figures, 3 florins
A canvas in the French style with a ship and two logs on which it is being rolled, 2 florins

. . . In the Chamber of the Said Hall

A marble pinnacle over the exit of the antechamber, with wooden columns at the sides, and gilded capitals, in it an Our Lady with children on her arm, in half relief, with four angels, that is, two on each side, 23 florins

Two paintings in wood over the fireplace, painted with St. Peter and St. Paul, by the hand of Masaccio, fl. 12

A picture with Italy painted in it, fl. 25

A picture on wood with Spain painted in it, fl. 12

. . . IN THE FIRST CHEST

A tapestry cloth to hang on the wall, 40 feet by 12 high, on it a hunt of the Duke of Burgundy, fl. 100

A tapestry cloth for the wall, 24 feet, figures for a tournament fl. 36

A tapestry cloth with figures and dogs and horses, 20 feet long, 16 feet high, to put on the wall, fl. 30

A tapestry for a backrest, a seat with ancient figures, 28 feet long and 8 feet high, with arms

2 backrests of tapestry and greenery and landscape lined with green cloth, each 26 feet long and 7 high, fl. 70

IN THE OTHER CHEST

2 backrests of tapestry with the story of Narcissus, with chandeliers and family arms, lined with green cloth, old, each 24 feet long

In the large ground-floor bedroom called Lorenzo's Chamber, 6 framed pictures, framed and gilded, above the backrest and the bed, 84 feet long and 7 high, three painted with the Rout of San Romano and one with a battle of Dragons and Lions, and one with the story of Paris, by the hand of Paolo Uccello, and one by the hand of Francesco di Pesello, with a hunt, fl. 300

One large roundel with a frame around it, gilded, painted with our lady and our lord and the magi coming to make offerings, by the hand of Fra Giovanni, fl. 100

One picture painted with the head of St. Sebastian and other figures, and arms and balls, in a tabernacle, by the hand of Squarcione, fl. 10

A picture painted with St. Jerome's Communion, with six little paintings, fl. 10

1 picture painted with the head of the Duke of Urbino with frame around, fl. 10

1 picture painted with the head of Duke Galeazzo by the hand of Piero del Pollaiuolo, fl. 10

. . . IN THE ROOM ABOVE THE STAIRCASE THAT GOES TO THE LOGGIA

A picture on wood painted with the cathedral and San Giovanni

A canvas painted with the Town Hall

The Duke of Milan Has Florentine Painters Recommended to Him

A loose page, found in the Milan archives, is evidently a report by an agent in Florence about 1490 in response to a ducal interest in gaining a painter's services; the duke did try to hire Perugino in 1496–1497. The terms of appraisal are style characterizations, strikingly precise, including one of Botticelli that differs from most modern ones. It is even more notable that, unlike the norm of the nineteenth and twen-

tieth centuries, the artists picked were those whom posterity has continued to rank highest; the same names, other than Ghirlandaio, who had died, recur in a similar list of 1502. This consistency is the usual pattern. Original text in Jahrbuch der preussischen Kunstsammlungen, *Vol. 18, 1897, 165.*

Sandro di Botticelli, a most excellent painter in panel and fresco, his things have a manly air and also have very good organization and complete balance

Filippino di Fra Filippo, very good, pupil of the above, and son of the most remarkable master of his time, his things have a gentler air, I don't think they have as much skill

Perugino, an outstanding master, especially in fresco, his things have an angelic air, very gentle

Domenico di Ghirlandaio, good master in panel and more in fresco, his things have a good air, and he is very expeditious and does a lot of work

All these above-named painters proved themselves in the Sistine Chapel except Filippino, but all of them at the Ospedaletto of Lord Lorenzo, and the choice is almost even.

The Ambassador to Innsbruck Reports on Portraits

A daughter of the Sforza dukes of Milan became the second wife of the Emperor Maximilian (officially called "King of the Romans" because not crowned as emperor). When she went to live in Innsbruck she took along her painter from Milan, Ambrogio de Predis. The rulers of Milan seem to have had an exceptional need for portraits of themselves, as the career of Zanetto Bugatto and other records suggest. Here we see naive concerns much like those people have with today's photographs: an interest in what one's own picture looks like, forming instant opinions of faraway people through their pictures, and other primary significations of images. Original texts in F. Malaguzzi-Valeri, La corte di Lodovico il Moro, *Vol. 3, 1923, 7–8.*

From a report to the Duke of Milan, 1493.

. . . [After dinner the Duchess of Tyrol] came to the Queen dressed in black and gold brocade made in the ancient fashion, very beautifully in the German manner, her hair bound in a ring and down her shoulders, as she had on a previous evening, and said to the Queen she understood her majesty was having a portrait done of her by Johanne Ambrosio Preda to send to the Duchess of Bari,* and she didn't want it sent if she

* That is, to the court of Milan. The Duke of Bari is Ludovico Sforza, il Moro, uncle of the Duke of Milan, regent, and ruler de facto; his Duchess is Beatrice d'Este, sister of Isabella and an equally notable patron.

wasn't well rendered, and Johanne Ambrosio was sent for, and came to draw her, and she had the patience to stay for perhaps two hours until she was drawn, and then she had a portrait done of a lady in waiting of hers, one of the most beautiful she had. . . .

While her excellency was with us, our painter, to her no small pleasure, drew her from life, with one of her ladies, and then she had two drawings brought which the King's Majesty had sent her from Flanders, one of the Queen, drawn from another portrait, the other of his son the Duke of Burgundy. And seeing these, Johanne Ambrosio Preda said he had done a drawing of Your Lordship, which was very beautiful, and when she heard this, it had to be brought, and when she had seen it, it pleased her tremendously, and she said Your Lordship had a serious and lordly countenance. Then since it was evening she took her leave, and when she arrived where the Duke was she told him she had seen Your Lordship's portrait, and he at once sent to have this portrait taken to him, and I Baldasar sent it to him by a cousin of mine. And he showed as much respect on seeing it that it could hardly have been greater.

The Marquis of Mantua Seeks Portrayals of Cities

Sets of cityscapes from this period are visible to us only through such "minor art" forms as woodcut book illustrations and inlaid wood intarsia panels. Vasari reports (Life of Pinturicchio) that in 1484 the pope had a set painted in his new Vatican villa, a "novelty in the Flemish manner" which was much liked, portraying the six great Italian cities: Milan, Genoa, Venice, Florence, Rome, Naples. Slight fragments of this project survive. In this excerpt the Mantuan court is apparently looking for this type of image, first seeking to buy an old view of Venice by Jacopo Bellini, in pen and ink, which his son the painter Gentile thinks has to be brought up to date. He in turn offers another view of San Marco. Such categories of themes may compensate for our habit of seeing this period too much in terms of its religious, figure-centered, and symbol-marked images. Indeed, the city view is not a marginal theme, but fits Alberti's most basic emphasis on the purpose of painting to record the visual field, and Brunelleschi's earliest examples of that, which were Florentine cityscapes. Original text of both the following letters in Archivio storico dell'arte, *Vol. 1, 1888, 276ff.*

An agent in Venice to the Marquis of Mantua, December 23, 1493.

My most illustrious lord: Today I talked to master Gentile Bellini about the portrayal of Venice; he answered it was one his father made, which he offered to give me, and since it is old and so cannot be recog-

nized, it must be touched with the pen, and this will take at least two months. So he asks your excellency to deign to indicate whether he really wants it. If so he will make a start at once, and in case that one is not wanted, you might wait until he sends you by the present messenger the portrayal of San Marco, saying that if it were provided with just a few additions perhaps it would satisfy your need and please your excellency.

Your servant, Antonio Salimbene

By 1497 the marquis was planning a room of cities, and commissioned a Genoa from Gentile and a Paris from his brother Giovanni. When Giovanni declined, the marquis interestingly asked him to paint "what you like" on the panel provided, recalling the previous marquis's remark about Mantegna that we must take from acknowledged masters "what we can get." Giovanni agreed, but added that he would serve him better if he "heard something he fancied"; thus mutual respect prevailed. Later in 1505 the marchioness Isabella d'Este asked Giovanni for a painting, and the Venice agent warned her that her proposal would have to fit the artist's fancy, as he did not like "very specific terms." She then told the artist she would leave to him "the burden of doing the poetic invention." Thus we see these patrons proposing their themes, yet not insisting on them if the painter felt disinclined.

The Marquis of Mantua to Giovanni Bellini, October 4, 1497.

Our right dear and respectable sir, in recent days we sent you by our servant Franceschino a panel on which we wanted you to paint the city of Paris, and since you answer that you had never seen it, we are satisfied, and put it to your judgment that you put on it what you like.

The Duke of Ferrara Finds a New Court Painter

Just as a duke needed the most outstanding head gardener or cook for his comfort and prestige, which is not hard for us to understand, so he had a serious need of the best court painter, and did not merely make a cultural contribution, as his counterpart would today; since we no longer think of art as one of the tools of social situations, the latter need is harder for us to realize. Here the Duke of Ferrara, after Ercole de' Roberti's death, is in luck (or so his agent insists) to be able to get a first-rate painter whom he could arrange to get out of jail. Being jailed was a more widespread experience in Renaissance Italy than it is today; Giovanni dal Ponte was in debtor's prison, but most crimes were of violence, as this one of Boccaccino's probably was, since two years later he murdered his wife for adultery. Unusually unlucky at first was the

sixteenth-century sculptor Leone Leoni, a galley slave until a patron rescued him. Original text in A. Puerari, Boccaccio Boccaccino, *1957, 210.*

An agent in Milan to the Duke of Ferrara, April 1, 1497.

Most illustrious and excellent lord, my honored lord. Although with the greatest difficulty in the world, still, by the grace of our lord God and the good and warm letters your excellency has sent me, I have fought and worked so that I have got Boccaccino the painter out of prison, and I have him in my house, where he will stay for ten or fifteen days to take care of some business of his. And then I will see about sending him to Ferrara, where I think he will gladly come to thank your highness, whom I recommend not to let him leave until you have seen some of his work, because he is reputed one of the best masters in his art in Italy, and I think he is not only as good as Ercole but much better. So that I think your highness, who loves talented men, could not make a better choice in this specialty than him. My compliments,

Antonio Costabili

The Duke's Mistress and Her Portrait by Leonardo da Vinci

Leonardo's "Lady with the Ermine" (National Museum, Cracow) represents Cecilia Gallerani, mistress of the Duke of Milan, when she was about twenty. Since she regards her portrait as an extension of herself rather than a work of art, just as we would with a photograph, she is apparently a bit unwilling to let it be seen, as the powerful duchess commands. The duchess was interested in paintings by great artists, but she was not entirely out of touch with Cecilia's way of thinking either, for long afterwards she arranged with Titian to paint her as she had looked when young. Original text in Archivio storico dell'arte, *Vol. 1, 1888, 181.*

Cecilia Gallerani to Isabella d'Este, Duchess of Mantua, from Milan, April 29, 1498.

Most illustrious dear and honored lady. I have seen what your excellency has written about wanting to see my portrait, and saying I should send it to you. And I would send it more willingly if it looked more like me, and your excellency should not think it is the master's fault, for I do not think he has an equal, but only because this portrait was done when I was not grown up, and I have changed entirely from that appearance, such that nobody seeing it and me together would suppose it was made for me. So I beg your ladyship to accept my good will, for not only the portrait but I too am prepared to do much more to please you, of whom I am the most devoted servant, and my infinite compliments, your excellency's servant, Cecilia Bergamia Visconta.

5

The Clergy
Speaking

Cardinal Dominici on Paintings and Painters

Giovanni Dominici (ca. 1356–1419), one of the great movers and shakers of his age, is best remembered today for a book, The Night Firefly, *that he no doubt regarded as a minor matter; it denounces the study of pagan poetry as a distraction from God. A Florentine orphan, Dominici was inspired by St. Catherine of Siena to be a Dominican monk and became the great supervisor of a new group of monasteries which were particularly strict in observing the rule. They remained a small minority but the leading edge of religious activity; among them was San Domenico in Fiesole, where Fra Angelico entered the order. In church politics, Dominici was the leading spokesman on the Roman pope's side at the end of the great papal schism and at the Council of Constance convened to heal it. His unusual combination of energies is typified by his being the only Dominican in his lifetime to be a cardinal. He also did manuscript illuminating, not unusual for a monk, and thus he is also the one most direct bridge in his time between the high clergy and painting. He did not rank painting very high, considering it useful for small children's religious education. His remarks are most interesting in showing how such an image as "Mary with the Sleeping Child" was understood. That image had earlier, no doubt, symbolized the future death of Christ, and probably continued to do so for some. But Dominici (like all good preachers in making his hearers' experience serve his point) shifted it, in a Renaissance way, to be something identifiable with the observer's everyday life. It becomes not mere genre, however, but shifts from a theological symbol to a moralizing image. Original text in his* Regola del Governo di cura familiare, *1860, 130–33, 182.*

From the *Rule for the Management of Family Care,* 1403.
Part IV [on the management of children]. In the first consideration, which is to bring them up for God . . . you should observe five little rules. . . . The first is to have paintings in the house, of holy little boys or young virgins, in which your child when still in swaddling clothes may delight, as being like himself, and may be seized upon by the like thing, with actions and signs attractive to infancy. And as I say for paintings, so I say of sculptures. The Virgin Mary is good to have, with the child on her arm, and the little bird or the pomegranate in his fist. A good figure would be Jesus suckling, Jesus sleeping on his mother's lap, Jesus standing politely before her, Jesus making a hem and the mother sewing that hem. In the same way he may mirror himself in the holy Baptist, dressed in camel skin, a small boy entering the desert, playing with birds, sucking on the sweet leaves, sleeping on the ground. It would do no harm if he saw Jesus and the Baptist, the little Jesus and the Evangelist grouped together, and the murdered innocents, so that

fear of arms and armed men would come over him. And so too little girls should be brought up in the sight of the eleven thousand virgins, discussing, fighting, and praying. I would like them to see Agnes with the fat lamb, Cecilia crowned with roses, Elizabeth with many roses, Catherine on the wheel, with other figures that would give them love of virginity with their mothers' milk, desire for Christ, hatred of sins, disgust at vanity, shrinking from bad companions, and a beginning, through considering the saints, of contemplating the supreme saint of saints. Therefore you must know that painting of the angels and saints is permitted and ordained, for the mental utility of the lowest. For the middling part of humanity, living creatures are the book . . . but the sacred scriptures are mainly for the most perfect. . . . In the first mirror have your children be mirrored, when they open their eyes, in the second when they can speak, in the third when they are ready for writing. And if you do not wish to, or cannot, make your house into a sort of temple, then, if you have a nurse, have them taken often to church, at a time when there is not a crowd, nor any services are being said. . . . I warn you, if you have paintings in your house for this purpose, avoid frames of gold and silver, lest they become more idolatrous than faithful, since, if they see more candles lit and more hats removed and more kneeling to figures that are gilded and adorned with precious stones than to the old smoky ones, they will only learn to revere gold and jewels, and not the figures, or rather, the truths represented by those figures.

* * *

The community as a whole needs various kinds of labor, such as farmers, woodworkers, masons, carvers, painters, tailors, armorers, weavers, wool workers, money changers, silk workers, merchants, and a thousand different kinds of skills. Let the inclinations of boys be studied, and when they are followed there is a good effect, when the contrary is done, there is only barren fruit, for nature helps training, and training followed against nature is not learned well. One who is disposed to be a wool worker will not be a good barber, and whoever is inclined to carving, or painting, will not be attentive in study. [More examples.]

San Bernardino Preaches about Sienese Paintings

Bernardino of Siena (1380–1444), the greatest revival preacher of his age, was also the key figure in a strict reformist section of the Franciscan order. He was early treated with doubt by church authorities but only six years after his death was canonized as a saint. Many of his sermons were taken down in shorthand. Since their total bulk is vast, it is not surprising that most students of Sienese painting have not known of his comments on such masterpieces as Simone Martini's Annunciation

and Ambrogio Lorenzetti's "Good Government" frescoes, which are actually the earliest literary comments of any kind on these works, such material being sparse in Siena. They show the popular utilization of such works, yet of course the preacher is seizing on well-known objects in his hearer's experience to make his own point. Original texts in his Prediche volgari, *1935, 673, 972.*

Sermon on the Twelve Handmaidens the Virgin Mary Had.

. . . Have you ever seen that Annunciation that is at the Cathedral, at the Altar of S. Ansano, beside the sacristy?* It seems to me surely the most beautiful, the most reverent, the most modest pose you ever saw in an Annunciation. You see she does not gaze at the angel, but sits with that almost frightened pose. She knew well it was an angel, so why should she be disturbed? What would she have done if it had been a man? Take her as an example, girls, of what you should do. Never talk to a man unless your father or mother is present.

<p style="text-align:center">* * *</p>

Sermon on How David Sought for Peace in This World and Could Not Find It.

. . . This peace is such a useful thing! Even this word peace is so sweet, that it gives sweetness to the lips! Look at its opposite, saying war! It's so rough, it has such rudeness, it makes the mouth harsh. Well, you have it painted up in your building, where it is a joy to see peace painted. And thus too it is a darkness to see war painted on the other side.

Saint Antonino on the Ethics of Painting

The Florentine Antonino (1389–1459) joined the strict branch of the Dominicans as a boy, early became an administrator, and moved Cosimo de'Medici to endow a new monastery for his group in Florence. This was San Marco, where Antonino's fellow monk Angelico painted. Then Antonino became archbishop of Florence, outstanding for his austere rejection of pomp and emphasis on giving to the poor. He opposed rich church vessels and church dramas. His organizing sense also produced a Summa Theologica *and many other writings. His puritanism and his sense of system blend in his economic observations, which have been considered by modern observers the earliest articulation of capitalism. In the process of giving instructions to all workers about the ethics of their activities, we see him telling painters to avoid the unnatural and the unhistorical. This modern, Renaissance preference was to him also a more properly religious one (a fact which may puzzle our conventional idea that the most religious art would prefer representations of the super-*

* This is known to have been the location of Simone Martini's altarpiece.

natural and non-naturalistic medieval stylization.) His teaching, being directed to the painters, indicates that they, and not the patrons, were held responsible for deciding the approach to the themes. The images he complained of were not the most common, so he must have looked hard. The terms in which he describes (and objects to) ornament recall such international Gothic works as Gentile da Fabriano's Adoration of the Magi, and imply a preference for a Masaccio-like plainness and accuracy. Original text in Art Bulletin, Vol. 41, 1959, 76–77 (footnote 9).

From *Summa Theologica*, Part 3, Title 8, On the Condition of Merchants and Craftsmen, Chapter 4, Section 11.

. . . Painters more or less reasonably request to be paid the wage of their profession not solely according to the quantity of work, but more according to their industry and their greater expertness in the art. They commit an offense in it, when they create images provoking desire, not through beauty, but through their poses, as of naked women and the like. They are to be reprimanded when they paint things contrary to the faith, when they make an image of the Trinity as one person with three heads, which is monstrous in the nature of things, or, in the Annunciation of the Virgin, a formed little child, that is Jesus, being sent into the womb of the Virgin, as if his body were not derived from the substance of the Virgin, or the little Jesus with a tablet of letters, whereas he did not learn from man. Nor are they to be praised who paint apocryphal tales, such as midwives in the Nativity, or the Virgin's girdle thrown down to Thomas the Apostle during her Assumption because of his doubt,* and the like. To paint curiosities in stories of the saints or in churches, which have no value in stimulating devotion, but laughter and vanity, such as monkeys, or dogs chasing hares, or the like, or vain adornments of clothing, appears superfluous and vain. With these are grouped the illustrators of books, whether with pen or brush, to whom is due the price of their work. And the same commit an offense if they do this on holidays, or when they expect a too high price, and especially when they do not put good materials in their colors, on account of which they quickly fade from the books, or when in order to finish quickly they do not do them carefully, when no agreement has been made for such a price.

Fra Domenico Corella Shows the Church Treasures, 1469

Corella (ca. 1403–1483) was for over sixty years a Dominican monk at Santa Maria Novella in Florence—the regular, not the strict house—and several times was elected head of all the central Italian houses. His

* St. Jerome had already said in the fourth century A.D. that this was apocryphal and therefore not to be preached, and he is endorsed in the *Golden Legend,* the famous thirteenth-century compendium of saints' lives.

biographer (probably his fellow monk Caroli; see below) notes his literary interest and his appointment as city lecturer on Dante, and then adds, "not that he despised holy writ." His two long verse books are a history of Florence and the Theotokon *(Mother of God). Its four books deal with Mary's life, her miracles, and churches in Florence and Rome. The usual report that these describe only churches dedicated to Mary is a sad case of repeating without reading, for, as the samples here show, Corella extends his descriptions so far that he gives a guide book to many, though not all, Florentine churches.*

It is the first such guide that goes beyond architecture to other works of art. He has a distinct taste preference, not for the perspectival and proportionate which we associate with Florence at this time, but for shining and glittering impressions, candles and sunlight. Thus he emphasizes works of art with rich metalwork, including the rarely praised silver altar of the Baptistery, the mosaics there, and also the very new (1468–1469) bronze doors by Luca della Robbia in the cathedral. It sounds more like an early medieval reaction, such as Suger's. Yet under the circumstances it is remarkable how modern Corella is in treating the works of art visually, departing from the then usual guidebook emphasis on miracles of the images or relics.

He is also exceptionally modern in naming the artists. These, apart from his fellow Dominican Angelico, are all the new-wave modern leaders—Luca, Ghiberti, Brunelleschi, and Alberti—the same group cited by Alberti as the best in Della Pittura; *thus we see that the same masters were honored by those of traditional and those of innovative taste, in obvious contrast with more recent periods of critical judgment. The only passage here which is well known (because it provides the attribution) is the one on Angelico's doors for the silver cupboard, the first time that he is called "angelic." The most remarkable section is the long account of the wax images in the church of the Annunziata, otherwise only slightly known from references to a few of them (including the brief description by Filarete, who had donated one.) The powerful effect of clutter may revise our image of Renaissance church interiors, while the objects serve to evoke still another art form of the period, of which no examples have survived. Original text in G. Lami,* Deliciae eruditorum, *Vol. 13, 1742, 84ff.*

Theotokon, from Book III

[At Or San Michele]

> It looks splendid from every side you like,
> Having statues and saints outside,
> Yet inside seems far more beautiful,
> Where the image of God's Holy Mother gleams.

[At the Cathedral, following praise for Brunelleschi, "the second Daedalus of our time"]

> Luca della Robbia, the gold and bronze beater,
> With skill equal to him, composed the splendid doors. . . .

[At the Baptistery]

> The triple gate glows with glittering forms,
> So constructed by the maker's expert hand;
> Lorenzo the noble sculptor made the doors
> Of solid bronze, a work of eternal honor,
> Such as is not believed to have been made
> Ever in the world before, wherefore the name
> Of the clever man is famous everywhere.
> The polychrome floor is roofed by a shining vault,
> Along with waxen gifts there are new banners,
> The silver altar thrives with amazing reverence,
> And the handsome vases with the holy relics,
> The bronze casket that holds Pope John *
> And many things not told of in my verses.

[At the Annunziata]

> In this temple is kept a worthy image
> Of marvelous power, renowned for many miracles. . . .
> Bodies are cured by its aid of many ills
> And every kind of wound is cared for well,
> As the wax figures prove, of many kinds. . . .
> Kings and powerful lords were cured by her,
> And they have placed their distinguished statues
> here.
> Often generals, harshly wounded in war,
> Preserved then by this Virgin's effective aid,
> Have dedicated themselves to her, with their
> horses,
> Giving her gifts appropriate to soldiers.
> These are all the fierce leaders of armies
> Whom we see sitting astride their enormous horses,
> Aged lords besides, and younger ones;
> Another holds back, for the people take bottom
> rank.

* Donatello's tomb of John XXIII, earlier than any of the comments on it which have been known.

This hall has the look of a city, where modeled
 settlers
Live, so many men's images are in it,
And, as in real fights battle lines are drawn
If they are going to be fought in that right order,
The church's lines seem just as tightly packed.
The ships, hanging in the empty air,
The holy mother saved from the ocean waters . . .
For anything that on land or sea may harm
The sacred figure removes, by her assistance. . . .
But though this famous image of God's mother
Was honored by an enormous public, still
The structure of that ancient chapel seemed
Neither suitable nor sufficient for her.
Noting this, Peter, undoubted heir of Cosimo,
His country's splendor, guardian of his house,
Wishing to place her in a worthy setting,
Made this work, fitting for such a Virgin.
For, well-composed throughout of snowy marble,
It outdoes other dwellings in cost and skill.
One space is placed inside the four new columns,
The whole is roofed above by a flat vault
Which antique sculpture drawn by a modern tool
Adorns, and covers with gilded foliage too,
Where many lilies shimmer on green stalks;
Ripe fruit grows red, the Medici family symbols,
The high crown glitters, held by an angel's hand,
Which holy Mary wears on her noble forehead.
The pious Virgin's altar, day and night,
Shines with many lamps, replacing gleaming heaven.
Within this hall a beautiful bowl is placed,*
In its wide mouth holding the holy water,
To it black jasper adds its own enrichment,
And a huge dark marble sphere gives beauty
Which four smaller spheres duly support.
A small bronze figure, the Baptist, completes
 the work,
Whence thronging crowds get the desired atonement. . . .
Of the Virgin's hall I omit to cite the other
Grand treasures that Peter gathered for her.
And for the rich treasures he made new shrines,
That hold the riches, offered spontaneously

* Michelozzo's font; this is a more detailed description than any other of
this lost work.

By kings and famous dukes and powerful tyrants,
Who wished to meet their vows placing them here.
Where there are silver vases, with varied figures,
A panel, painted outside, shelters them inside,
That John the angelic painter painted on the front,
No less in repute than Giotto or Cimabue
Whose fame was bright among the Tuscan cities
As the poet Dante sings in his sweet voice.
He flourished in his many virtues, also,
Mild in his skill, honest in his religion,
So, above other painters, to him deservedly
Was given one grace, of rendering the Virgin,
As the graceful form of the divine Annunciate,
Shows, which is often painted by his hands.

Fra Giovanni Caroli Boasts of His Convent, 1479

Along with Corella, Giovanni Caroli (1428–1503), also of Santa Maria Novella and several times its prior, represents the "silent majority" of regular nonstrict monks; Caroli indeed wrote polemics later against Savonarola. Both he and Corella show that they are no ascetics in their delighted praise of rich, jeweled religious vessels. Caroli, describing his own church and convent in the introduction to a group biography of monks, says its Gothic vaults are the best kind, a view one would not have guessed possible in Florence at this date. He is as surprising in his only reference to paintings, the now famous Spanish Chapel frescoes by Andrea da Firenze (1365–1368), since both work and artist are completely ignored by Ghiberti and other writers of the age, along with the late trecento as a whole. Of course, his unsurprising local patriotism is the stronger force that explains all this. It does not account for his interesting sharp distinction between the frescoes' beauty and their meaning, thus disproving (like some other texts) the belief that this period did not consciously isolate pure beauty in art but always praised art in relation to function. To be sure, the distinction was already traditional in comments on literature, appearing as it does much earlier in Dante's Convivio. Original text in S. Orlandi, Necrologio di S. Maria Novella, *1955, Vol. 2, 395.*

From the *Lives of Some Brothers of the House of S. Maria Novella* Preface, in which The Dignity of the House Is Shown
[After a description of the cloister] . . . And that chapel, as well, which is called the Chapter House, built by the Guidalotti family with outstanding piety and a wonderful love of our religion, is regarded as

actually second to none, not only in the great size of the work, but also in the celebrity of everything about it. It is, first, remarkable in its very special and tall vault, highly praised in the comments and opinions of all craftsmen, and, further, most exceptional in the skills of the painting, on which not only is the eye feasted by its beauty and accomplishment, but also the mind is most forcibly set afire by its most holy meaning, to fervor of devotion.

Friar Felix Schmitt's Tour of Venice, 1483

Travel diaries of Italy in this period are few, but there are many of pilgrimages to the Holy Land. In the present case we are lucky that a group of German pilgrims in 1483 had to wait a month in Venice for a ship, and that their chaplain, the Dominican Friar Felix (1441–1502), kept his diary as faithfully every day as he later did on shipboard— where he is very informative about everything from social psychology to hygiene—and also of course in Palestine. In Venice he visited a different church every morning and afternoon. He was mainly interested in relics but several times stops to discuss works of art, notably very new ones. His mention of the wooden model for the horse of the Colleoni monument, which is often cited in books on Verrocchio, raises more questions than it answers, but two other accounts that have not been considered are more striking.

His is probably the first text on the fame of Venetian glass, just then emerging as something special. It has always been known for com-bining beauty with fragility, as it is here, but at the time Felix wrote the fragility was not yet appreciated. Indeed what Felix describes suggests a slightly later phase of Venetian glass more than the very few preserved specimens of his time.

His violent attack on the pagan intrusions into the ducal tombs is most interesting, since it is not that of a naive person. He enjoyed pagan culture—he elsewhere quotes verses of Ovid on love, but not in this church context. Since he was angry in a Dominican church and was him-self a Dominican, it is hardly to be doubted that he also vented his anger in talking with his fellow Dominicans there, and hence that no satisfying justification was presented to him for the pagan nudities—in short, they did not have a second, Christian, symbolism, unless it was one opaque even to an unusually well-prepared visitor. Although it is sometimes ar-gued today that their presence in a church guarantees a Christian mean-ing, which therefore we must seek to interpret, Friar Felix's reading was really not unusual; the same anger by a priest against pagan images in churches is already on record in the early fourteenth century. In our text, this complaint of his is nicely linked with one against elaborate figured

music—also complained of by Savonarola, in the same sermon in which he objects to paintings of the Virgin drawn from girls. And the image of the ladies coming to church only for the sound of the music would, if quoted alone, more easily be attributed to a much later century than the fifteenth. Original text in the edition of his Evagatorium, *3 vols., 1843–49, Vol. 1, 97; Vol. 2, 395, 424.*

On May 7, the Feast of the Translation of St. Peter Martyr, we sailed outside Venice to Murano . . . we went across to the kilns of the glassmakers, in which art are made very thin glass instruments in many forms; for in the whole world there are no such craftsmen of glass as here. They also make precious crystal vases, and other marvels are seen there.

* * *

On the 14th [of January; on the return journey] we sailed with the traders to the town of Murano, and while they were trading with the glassmakers I entered our convent of St. Peter Martyr. . . . Then I returned to the merchants, and we returned to Venice with the glass purchased; there are not to be found in the world today such precious glass objects as are made there daily, nor such hard-working craftsmen, who from the fragile materials make such elegant vases that gold or silver ones or vases adorned with precious stones hardly surpass them, and if they were solid, like metal vases, their price would be higher than all gold. . . . Only the fragility of these vases makes them cheap and of low reputation, although they are most elegant in appearance, most beautiful to see. For when Emperor Frederick III was in Venice some years ago, and the Doge and Senate offered him a certain remarkable and beautiful glass vase, that he might be pleased because of its appearance, the Emperor, taking it, after having praised the artists' work and admired its beauty considerably, intentionally but as if by accident dropped the vase from his hands on the floor, and it broke into a thousand pieces. But, as if frightened by the breaking, the Emperor said: "Oh, what happened!" and while someone was removing the useless shards, he said: "Well now, how much better gold and silver vases are, whose shards are useful!" From which speech of the Emperor the Venetians, catching on, proffered a gold vase to the Emperor, which he took and never threw to the ground. So we were busy all day cautiously packing the glass vases so they would not be broken by the journey or by motion.

* * *

Appendix: Faithful Description or rather Circumscription of the Most Noble City of the Venetians, which I collected from various descriptions, and added some things I learned orally and many of my own experiences.

The Dominicans have three convents there; the main one is Santi Giovanni e Paolo. . . . Observance of the rule is slight indeed, and it is not reformed, but the brothers live there in a certain pomp of worldly glory, so that on feast days they sing the office of the mass and vespers and compline in figurations, with worldly solemnity, wherefore a crowd of youths and ladies makes its way to these offices, not on account of the divine services but the sound of the melody and singing. They have double organs, and much adornment of the sacristy, beyond moderation. There is also in that church the burial place of many Venetian doges. I have never seen more luxurious tombs and burials, and the tombs of the popes in Rome cannot equal the tombs of the doges of Venice. There are tombs elevated from the ground and set into the walls, and the whole surface of the wall is decorated with varied marble, and sculptures in gold and silver, and ornamented beyond the bounds of propriety. In these tombs the images of Christ, the Blessed Virgin, the apostles and Martyrs, and other saints that one adores, are placed in the middle, as the main figures, but around them are the images of the pagans, Saturn, Janus, Jove, Juno, Minerva, Mars, and Hercules, with the representations of poetic fictions. There I saw in our church next to the door on the right side, in the very rich tomb of a certain doge,* the carved image of Hercules, in that form in which they present him as having fought, but wearing the skin of a lion which he had killed instead of a cloak, and in combat with the hydra, a horrible monster, which had seven heads so that when one was cut off seven more grew in its place. There are also fighters there with their bodies naked, with swords and pikes in their hands, and shields hanging from their necks, and no cuirass or breastplate or helmet, which are real figures of idols. There are naked winged boys, holding tokens of triumph or mourning, and many other such tokens of paganism are placed among the tokens of our redemption, and the simple people think they are images of saints, and revere Hercules, thinking him Samson, and Venus, thinking her Magdalene, and so with others. And they carve sea monsters on the tombs and the arms of the deceased, and verses explaining the deeds of the dead.

Savonarola on Painting

The strict ascetic movement among Dominican monks reached its climax in the famous Girolamo Savonarola (1452–1498), resident of the same Florentine convent of San Marco founded by Antonino. His success as an evangelist swept Florence on to abolish secular government, in

* Pietro Mocenigo (d. 1476); the tomb, by Pietro Lombardo, is on the right from the standpoint of the altar, on the left for one entering the church.

effect, until counterforces crushed him. In his many hundreds of sermons, his darting mind often alludes to painting, partly no doubt from the early influence of his grandfather, Michele Savonarola. Besides the famous condemnation of irreligious art, his sermons also downgrade painting in more intellectually complex ways, using the ideas of its advocates against them: If painting is fine because it imitates nature, then nature is always better; if the birds are deceived by the painted grapes, it is because birds lack sense. Savonarola's remarks are significant not, as with other preachers, because they reflect the culture but on their own account. Other remarks of his are omitted here because they are brief phrases embedded in long discussions of other matters and are hard to extract; those quoted here will give a strong sense of his powerful personality.

From the sermons on the Psalm *Quam bonus,* 1493; original texts in the edition of Prato, 1846, 489, and M. Ferrara, *Savonarola,* 1952, Vol. 2, 46–47.

Art imitates nature as far as it can. I will cite for you as an example the painter and his pupil. What does the pupil look for in the master? I'll tell you. The master draws from his mind an image which his hands trace on paper and it carries the imprint of his idea. The pupil studies the drawing, and tries to imitate it. Little by little, in this way, he appropriates the style of his master. That is how all natural things, and all creatures, have derived from the divine intellect. . . . Come now, we want to imitate God, whom we do not see. How then shall we do it? We will look at the designs, the exemplars, and the images that he has sent forth, that is, we will imitate natural things, as the painter does when he draws the image from the tree or from the man as an exemplar. Note, though, that art cannot imitate nature entirely, even if the artist is perfect, because, even if a painter makes something similar to man in everything, yet it will not have life.

* * *

From *The Simplicity of Christian Life,* 1496; original text in 1959 edition, pp. 61–64.

Nature does all things simply, and has no need of human artifice . . . yet the latter hopes to imitate nature. And since it cannot equal her, we say those things are "art" which artificers do, and they do not actually imitate nature. Thus in everyday speech we say of the painter who wants to proceed with too much artifice, that is, when he shows too much art, that he does not really imitate nature.

[Works of nature are more beautiful than man's artificial works, so the latter try to imitate nature.] If artificers could make their artificial works natural, there is no doubt they would. So we see they try to conceal their art. Orators, and likewise painters, try to conceal art, so that their works

will seem natural. [Children's words please because they are without art; preachers who use art fail, in contrast with inspired apostles.] And though works of art seem to please men, yet if we consider, we find that those please more which imitate nature more. So people praising paintings say: "See, these animals seem to be alive, these flowers seem natural."

* * *

From *Sermons on Amos,* 1496; original texts in 1971 edition, Vol. 1, 149, 309; Vol. 2, 24–25, 274.

[Taverns should be closed to children, especially in Lent.] Aristotle, who was a pagan, says in his *Politics* that figures which are unchaste for children to see should not be painted, because they become lustful when they see them. But what am I to say of you, Christian painters, who make those shameless figures there, which is not proper? Make them no more! You, whose duty it is, should have those figures whitewashed and destroyed which you have in your houses that are painted unchastely, and you would perform a work that would greatly please God and the Virgin Mary.

[God needs no body and no temple.] So these material churches here below are made for you, O Man, although in God's honor, not that the stones or altars are holy, but they are made thus to be of use to you and in honor of God, because when you go into a church you honor God, which is in turn of use to you. You see that saint there in that church, and say; I want to lead a good life and be like him. And this is done for you, and turns out to be of use to you. But when God sees you have no reverence for what is done for you, though in his honor, and that you profane the churches and make them stalls and fill them with filth, then he obliterates all that is done for you.

Have you offered your sacrifices to me, says God, will you see that you are sacrificing to yourself and not to me? Look at the habits of Florence, how the women of Florence have married off their daughters, they put them on show and doll them up so they look like nymphs, and the first thing they take them to the Cathedral. These are your idols, whom you have put in my temple. The images of your Gods are the images and likenesses of the figures you have painted in churches, and then the young men go around saying to this girl and that girl, "That girl is the Magdalene, that other girl is Saint John," because you have the figures in churches painted in the likeness of this woman or that other one, which is ill done and in great dishonor of what is God's. You painters do an ill thing; if you knew what I know and the scandal it produces you would not paint them. You put all the vanities in the churches. Do you believe the Virgin Mary went dressed this way, as you paint her? I tell you she went dressed as a poor woman, simply, and so covered that her face could hardly be seen, and likewise Saint Elizabeth went dressed

simply. You would do well to cancel these figures that are painted so unchastely. You make the Virgin Mary seem dressed like a whore. . . . Look at all the convents. You will find them all filled with the coats of arms of those who have built them. I lift my head to look above that door, I think there is a crucifix, but there is a coat of arms: further on, lift your head, another coat of arms. I put on a vestment, I think there is a painted crucifix on it, it is a coat of arms, and you know they have put coats of arms on the back of vestments, so that when the priest stands at the altar, the arms can be seen well by all the people.

[Sight and the other senses have three objects, particular, general, and incidental.] Incidental is, when you see one thing with your outward sense, imagination gives you another, for instance, I see you here with my eyes, and my imagination tells my mind that you are alive, not that the eye can see life, but because the eye sees the image and color and movements and gives them to the mind; the mind then judges life, though life is not seen, thus if you say: "I see you are alive," but this seeing is called incidental. And that's where I want you.

. . . So the little lamb, when it sees the wolf, instantly gets the idea that it is its enemy, though it had never seen it before, not that the lamb's eyes see the enmity, but this seeing is called incidental, because of the decision which is judging. So, to make a good judgment, one must have a good eye, good judgment, and good imagination, otherwise one could not judge well. For instance, there are certain painters who make figures that appear alive; a person who has good judgment and good imagination judges as soon as he sees this figure that it is dead, not alive, but anyone with a poor eye might be deceived some of the time, and if he saw a figure of a man there a little far off might judge that it was a living man. You see the little bird that does not have a good eye, and sees a scarecrow in the field and thinks it is a live man. . . .

. . . So to judge what is God's, one must have a spiritual eye, and whoever does not have it cannot well see whether he is going the right way or not, and whether his ways are God's or not. But he who has a spiritual eye has a penetrating sight that passes through to the very marrow, and knows if he is going right or not, and judges with penetrating mind full of spiritual light whether it is good, like a person who has a good natural eye and sees the real and the painted grapes, and knows at once which is real and which is false. But the little bird that does not have a good eye sometimes is deceived, and believes the painted grapes are natural.

* * *

From *Sermons on Zachariah;* original text in the edition of 1971, Vol. 2, 412–13; Vol. 3, 34.

Look at natural things; the order of the universe shows you that it

is ordered by some intellect. . . . I will explain this by man-made things. For instance, a man goes into a goldsmith's shop, and sees many silver dishes there and sees the tools for making them. Although he has never seen them before, he instantly has a mental picture that a man has controlled the work, and if he is told tools made it, he says to himself: "Those tools can't do it unless they are controlled," and if he is told: "They are controlled by the hand" he fancies that the hand is controlled by the mind. A master knows what a fault is in an art. . . . A painter knows a defect in a painting and says: "This thing is against order," and knows the fault that is in it. Order comes from the aim, because if there were no aim, there would not be error in the way the thing is made, and so no fault of being against the aim. . . . If a pupil has a print from the painter, which he has to paint, if he does not follow the order of that print the painter says: "You have made a mistake." So too God in his concerns wished to make a print so that whoever falls away from that order is at fault, and will be punished thereafter.

[The congregation is too impatient for God's grace to come.] . . . This time is short. Come now, consider a bit in training. You have a son and want him to learn to paint. The first thing he does, he has to set the goal for himself, that is, to be a master like the one who teaches him, or better; the second thing, to take the model that the master puts before him and keep imitating it little by little; the third thing, to be humble before his master, obey him always, have patience, continuing this process all the way to the end, and if he planned to be a painter to think not about shoes but about painting.

* * *

From *Sermons on Ezekiel,* 1497; original texts in 1955–1956 edition, Vol. 1, 343, 375.

Would you like to see that this of the philosophers was vain knowledge? . . . Would you like to see? They say that every painter paints himself. He does not paint himself as being a man, because he makes images of lions, horses, men, and women that are not himself, but he paints himself as being a painter, that is, according to his concept. And though they may be different fancies and figures of the painters that they paint, yet they are all according to his concept. So too the philosophers, because they were proud, described God in haughty and swollen ways. . . .

You see that when the soul is taken away, the body remains pale and spoiled, and there is no beauty in it any more. And again, you see when a painter makes a figure from life, the live will always be more beautiful than the painted, and he may be a good master in his way, but he cannot give them a certain liveliness that the live has, and art cannot imitate nature in everything. So, since the soul is the cause of the beauty of the body, it must be more beautiful.

6

The Literary People
Speaking

B. Uberto Decembrio Remembers a Boy Painter

The boy here reported on, the leading International Gothic Lombard master Michelino da Besozzo, was younger than the writer (who died in 1427), and so this report has a good claim to be authentic. If it is, one of the better-known mythical stories of the age, about boy geniuses drawing animals, may be closer to real life than is sometimes assumed. Original text in F. Malaguzzi Valeri, Pittori Lombardi, 1902, 207.

From the *Dialogue on Moral Philosophy.*

I knew Michele da Pavia, notable painter of our time, when he was a boy, whom nature had so formed to that art that before he could talk he was drawing birds and very small animal designs, so subtly and accurately that the experts in this art were amazed. Now that he has grown to be a master, his work, I would judge, teaches us that no one is his like.

Gasparino Barzizza on the Education of Apprentice Painters

We are very poorly informed on what apprentice painters did each day; the usual statement that they "ground colors" seems without support (that work was perhaps adult unskilled labor). From quite varied writers (see Savonarola) who are discussing other people's training and citing painters for the sake of comparison, the impression emerges that they constantly made copies—that is, that they were more pupils than odd-job helpers. Original text in Journal of the Warburg and Courtauld Institutes, *Vol. 28, 1965, 183.*

From a letter to Francesco Bicharano, ca. 1420.

[He is making educational recommendations.] I indeed would have done what good painters habitually follow with those who are learning from them: whenever, in fact, something is to be learned from the master, before they have got the theory of painting, they are in the habit of handing them some very good figures and pictures, as models of this craft, and, taught by these, they can progress a bit by themselves.

Leonard Bruni's Rejected Program

No other mere writer ever impressed Florentine merchants as did Leonardo Bruni (1369-1444), who wrote their propaganda correspondence with other states and their city's history. The guild that is here addressed made him an honorary member about the same time, and the city paid for his superb marble tomb (an honor which they promised but did not

give to their generals). Giovanni Rucellai (see p. 110) listed him as one of the four outstanding Florentines of his time, together with Cosimo de' Medici; Cosimo's defeated rival, the even richer merchant Palla Strozzi; and Brunelleschi. Yet his plan for the program of the Baptistery doors by Ghiberti—another work that won unanimous admiration and fame—was rejected. Ghiberti's own report, that he was left free to do it as he would, is probably the key to explaining this surprise. The view that some other unknown humanist's plan must have replaced Bruni's seems based only on the belief that such arrangements were the norm, and yet Bruni's program is actually one of the very few such proposals known, rarer indeed than parallels to Ghiberti's having control. More interesting here is Bruni's statement of the two aesthetic goals required, somewhat like our "form and content." But "form," as in Alberti, is seen in terms of figures. If we compare this with Caroli's statement of the same point, we see that Caroli makes clearer the idea that the two goals were separately conceived, and Bruni's writing skill makes clearer what the definition of each one is. Original text in R. Krautheimer, Lorenzo Ghiberti, *1956, 372–73.*

Letter to the Board of the Merchants Guild, ca. 1425.

Honorable etc. I consider that the twenty scenes on the new door, which you have decided should be of the Old Testament, require two things chiefly, one, that they be brilliant [*illustri*], the other, that they be meaningful. Brilliant I call those that can feast the eye well by their variety of design. Meaningful I call those that have importance worthy of remembrance. Assuming these two things, I have chosen according to my judgment twenty scenes, which I send marked on paper. Whoever designs them will have to be well instructed about each scene, so that he can properly place the persons and actions needed for it, and must be refined [*gentile*] so that he will know how to adorn them well. Besides the twenty scenes, I have noted eight prophets, as you will see on the sheet. I have no doubt that this work as I have designed it for you will turn out very excellent. But I would very much like to get together with the one who is to design it, to get him to pick up every little meaning that the story carries. My compliments to you. Yours, Lionardo d'Arezzo.

How God creates the heaven and stars.	God makes man and woman.	Adam and Eve beside the tree eat the apple.	How they are expelled from paradise by the angel.
Cain kills his brother Abel.	Every kind of animal enters the ark.	Abraham wishes to sacrifice Isaac on God's command.	Isaac blesses Jacob thinking he is Esau.

Joseph's brothers sell him out of envy.	Pharaoh's dream of the 7 cows and 7 ears.	Joseph recognizes his brothers who have come to Egypt for the grain.	Moses sees God in the burning bush.
Moses speaks to Pharaoh and makes miraculous signs.	The sea divided and the people of God passing.	The laws given by God to Moses on the burning mountain as the ram's horn sounds.	Aaron sacrificing on the altar in priest's robes with bells and pomegranates on his robes.
The people of God pass the Jordan and enter the promised land with the ark of the covenant.	David kills Goliath in the presence of Saul.	David made king to the joy of the people.	Solomon judges the question of the child between the two women.
Prophet Samuel Prophet Isaiah	Prophet Nathan Jeremiah	Prophet Elijah Ezekiel	Prophet Elisha Daniel

Bruni Reproves Elaborate Tombs

Humanists are often said to have been more interested in the polishing of Latin style than anything else; it is more accurate to assign their chief interest to the analysis of the ethics of behavior. Here we see Bruni in an undated letter to Poggio conducting such an analysis, using classical references as his evidence, and also engaging in personal abuse of another humanist, which is another common element in their writing. What is not usual is that the motif on which this all turns—the tomb—was a real one, the mausoleum of Bartolommeo Aragazzi, which survives today as the most important sculptural work by Michelozzo. The letter shows us then how such a grand tomb might induce a reaction in a contemporary. Whether it is different from the possible reaction to an imaginary tomb and whether persons other than humanists would have reacted in a similar style are open questions. Original text in the edition of Bruni's letters by L. Mehus, 1741. Vol. 2, Book 6, letter 5, 45–48.

Something worth instantly laughing about happened to me the other day, while I was on the road to Aretine territory, I met panting oxen pulling wagons. In the wagons marble columns were being pulled, and two unfinished statues, and bases and blocks, and architraves, and by chance the wagons were stuck in difficult thickets and couldn't proceed. The drivers were standing around with pickaxes, clearing the way and helping. So I was surprised by the unusualness of the thing, since people

don't normally drive wagons through those woods or bring in marble, and so I came up and asked what was going on, and where such awkward loads were being taken. Then one of the drivers, seeing me, and at the same time wiping the sweat from his face, tired I presume of the labor, and also angry, said: "May the gods damn all poets, those who ever were and those who are to be." Hearing his answer, I said: "What do you have against poets, in what way did they ever do you harm?" "In this way," he said, "that this poet who died recently, well known to be stupid and puffed up with conceit, ordered a marble tomb to be made for himself. For that reason these marbles are being taken to Montepulciano. But I think they never can be got through, considering the difficulty of the roads." And I, wishing to understand more clearly, said "What are you saying, did some poet die at Montepulciano?" "Not there," said he, "but at Rome, but he provided in his will for making his tomb in his native town. And this is his face which you see here, the other is of a relative, whom he ordered to be placed next to him." Then I, basing a conjecture on the death and the native town, had in fact heard that a certain Bartolommeo of Montepulciano had recently died in Rome, and left I don't know how much money. I asked the driver whether he was speaking of him, and he nodded that it was the very same man. "In that case," said I, "why do you curse poets on account of this ass? Do you think he was a poet, who never became acquainted with opinion or learning? He did indeed utterly surpass all men in stupidity and vanity." "I didn't know him when he was living," said he, "and never even heard him mentioned, but his fellow townsmen judge him to be a poet, and if he had left behind just a bit more money, they would have thought him a god. But if he was not a poet, I have no wish to curse poets."

And then I, going away, began to think over the words of the driver, who had called that man stupid and conceited who had ordered a marble tomb built for himself in his native town when he died in Rome. For in fact no one who was confident of his glory ever thought of having a tomb made for himself. He, content with the fame of his praiseworthy works and the distinction of his name, will think himself quite enough approved by posterity on that account. In what way can a tomb, a dumb thing, help a wise man? And what is more vile than for a tomb to be remembered and a life to be passed over in silence? Three emperors are held to have been most eminent in various centuries, Cyrus, Alexander, Caesar. Of whom Cyrus, who was the oldest, by no means sought for a grand tomb, but commanded in his will that no tomb should be built for him, and that he should be buried in the earth, recalling that the earth produces flowers and foods, and brings forth most pleasant and valuable trees, and no finer material for a tomb is to be found; therefore he ordered that his body be buried in the bare ground, wholly without anything of marble or any monument or building. Rightly so, for his

virtues and good deeds assured his lasting memory. [An account of Cyrus's achievements follows.] The same view was held by Caesar and Alexander, of whom, we see, neither thought of making a tomb for himself; I am insulting these great lives, whom I bring as witnesses in rebuking this worthless man. For if the most excellent men have, with praise, avoided this ambitious vanity, how greatly is this pride to be made fun of in this turd of a man? You in your will order marble to be brought to you from far off, do you, a tomb to be made, and statues to be set up for yourself? With what basis, I ask? In your learning, which was nothing, your letters, of which you hardly grasped four? In your life and habits? you who, being of no consequence and full of remarkable stupidity, pursued everything without advice but with rash folly? Then indeed if your conduct does not make you worthy of a statue and a marble tomb, your family does, by its respectability. Born of a father who was a seller of wares in the market square, your grandmother a midwife, your mother a religious fanatic! Or did you think yourself worthy of a statue because of the money buried under ground? That alone was left, as far as anything true is concerned, and after your death when it at length come to light, the pope demanded back that same money, as being abstracted from him illegally. What will you write on your tomb, I wonder, what actions, what deeds will you have inscribed? That your father drove asses and goods around the fairs? That your grandmother helped the mothers giving birth when she took up the infants as they came into the world? That your mother fluttered around churches with her hair down? That you piled up money by stealth? That the pope demanded that money back? That is the sum of your deeds, that is your own and your family's glory, which are such that you, if you knew anything, if you were not carried away by stupidity and rashness when dying, as all through life, would have specified in your will that, just as you had done with the money, so they should hide you underground yourself, lest the vanity and ambition of this your tomb be the cause of laughter and grievance.

Poggio Bracciolini Collects Ancient Sculpture

It is usual to draw a parallel between the new style of Renaissance art and humanistic writing. But that must in part result from the fact that the latter is hardly ever read, and indeed it is largely quite inaccessible, as well as tedious. Humanists in practice show very little interest in art and artists and vice versa, and their paths usually intersect only in the concern of both with classical sculpture, as in this case, which seems to be the only notice of an artist in all the vast correspondence of Poggio Bracciolini. This may serve as a sobering reminder of the small role of the artists in the world of their time. Poggio (1380–1459), one of the

wittiest and most energetic humanists, appears as an early collector of Greek sculpture—collecting of Roman sculpture was no longer remarkable—just as he also sought out manuscripts, his most famous occupation. His attitude toward the works is notably not visual but literary. As we saw with Bruni, humanists' books emphasized not so much study of Latin grammar, often associated with them, as ethical questions. When Poggio begins to consider the ethics of nobility, he moves, with the abruptness of real conversation, from collectors' snobbery to artists' fame, both fresh topics that have in common the question of how to succeed.

Letter to Niccolò Niccoli in Florence, from Rome, September 23 (probably 1430); original text in the edition of his letters, 1832, Vol. 1, 322ff.

I gave some commissions to Master Francesco of Pistoia when he left us, among which the main one was that he should acquire some marble images, even broken ones, or some good head, that he might bring back with him to me. I said there were plenty of them in those parts where he was going. He was quite diligent in executing my orders, for yesterday I got letters written to me by him from Chios, in which he tells me that he has in my name three marble heads, by Polycleitos and Praxiteles, of Juno, Minerva, and Bacchus, which he greatly praises, and he says he will bring them with him to Gaeta. I don't know about the names of the sculptors, Greeks as you know are talkative, and perhaps he faked the names to sell them higher. I would hope that is not so. He also writes that he got these heads from a certain Calorino who recently found about a hundred complete marble statues in a cave, beautiful and of marvelous workmanship. He writes no more, excusing himself because of illness. . . . I at once answered Master Francesco and also Andreolo, who I hear from our Rinuccio is quite well informed, to inquire whether they could get one of these statues, for either a price or a prayer, and be on their toes, and let me know quickly. I wanted you to take part in this discovery. I think his statues are of gods, because of these heads, and were hidden in some sanctuary. He writes that the head of Minerva has a laurel crown, and Bacchus two horns. When they come I will put them in my little study room. Minerva cannot do badly among us, I will place her among my books. Bacchus should feel right, for if he deserves a dwelling anywhere, he can rightly be in my country, in which he is especially honored. We will also give Juno a place. Since she was once the wife of an adulterer, now she will be a mistress. I have something here as well, which will be brought home. Donatello saw it, and praised it very highly. I don't want this letter to include any chatter other than the sculpture, so goodbye, and love me.

* * *

From *A Book on Nobility;* original text in the 1538 edition of his works reprinted 1964, 65–66.

Some time ago, when I had retired from Rome to my own country for a change of air, there came to see me, both on my single request, my very learned friends Niccolò Niccoli and Lorenzo de' Medici,* whom I had wheedled to come there especially by the display of some statues that I had brought from Rome. When they were in the garden, which, with my few curious marbles, I was longing to make famous by the show of some small household stuff, Lorenzo remarked, laughing, as he turned his eyes around: "Our host here has read that it was an old custom among those excellent men of early times to adorn their houses, villas, gardens, court-yards, and study rooms with various images and paintings of their ancestors, indeed with statues, for the fame and ennobling of their lineage, and since images of his progenitors were lacking, he sought to make this place, and himself too, noble with these trifles and bits of marbles, so that because of the novelty of the thing some of his glory might, through these, survive to posterity."

"If he is hungry for that," Niccolò said, "the foundation of nobility is found elsewhere, not in images and fragments of marbles, broken and not to be yearned for in the least by a wise man, but in the mind, that is, we must wrest it from wisdom and virtue, which alone raise men to the praise of nobility."

"That is so," Lorenzo said. "I would regard it as the most suitable for bestowing nobility on men, virtue indeed is considered a divine thing to be yearned for by everyone. Yet we do see nobility being furnished with the aid of paintings and various images, with elegance, riches, and an abundance of property, with public offices above all, and we see virtue in those who are not famous for any other embellishment. And it is hungered and sought after by outstanding talents, for it is well known that the most learned men have devoted much labor and study to buying statues and paintings. . . ."

But Niccolò said: "If those who have statues and paintings in their house obtain nobility, then sculptors and painters would far surpass others in the tokens of nobility, pawnbrokers also. . . ." And Lorenzo: "We rightly do call noble, if you examine the word closely, the sculptors and painters whom their art makes famous and distinguished, and rich too, from things they have continually accomplished in one way or another, and widely known for their great achievements. Therefore, it is right to call noble both him who is outstanding in literary studies and him who is a famous thief, the latter on account of his outstanding punishment. . . . The ancients called noble a person known and notorious for any remarkable thing, and outstanding in any action or skill and famous in the talk of men."

* Brother of Cosimo, granduncle of his famous namesake, il Magnifico.

The Repartee of Donatello and Others

Jokes and comic anecdotes were turned into a great literary form in Florence by Boccaccio's Decameron. *They are the city man's collective expression, showing his superiority over the country bumpkin or getting some revenge on the pompous establishment, which in this age meant the church. The first anecdote, here from a collection by Poggio, probably is much older, reflecting a time in the thirteenth century when crucifixes were as likely to show a live as a dead Christ; later only the latter are usual. The collections of stories have heroes, great talkers who are loved personalities, and Donatello is a preeminent one. In three anecdotes perhaps collected by the humanist Angelo Polizdano (1454–1494) we see Donatello as anticlerical, realistic, and interested in land as an investment, a typical concern of successful career men. The striking preference for Donatello over Ghiberti is unlike earlier opinion (compare Facio) but is consistent with a gradual trend (compare Santi), mainly because most artists tended to lose fame with the passage of time and styles, but Donatello was a great exception. (However, Ghiberti's Doors of Paradise remained famous on their own.) The last item—not by a literary man, but hard to classify—seems to belong with the rest since it again links Donatello to a sharp remark, more authentically. Indeed, modern writers often improve the story by letting Donatello himself call the Paduans frogs. It is also notable in showing that the city fathers in Siena wanted Donatello not in terms of any particular project but because of his high fame; other records of his moving there in fact express the hope that he will "do some very outstanding work in honor of your city" and the cathedral may be "adorned with some one of his works." They were hiring a name, as might happen today, and what he was to do could be taken up later—a status that can helpfully be linked to Rucellai's list of his collection or the record in which Mantegna's patron says that outstanding artists must be thanked for whatever work they will do. Original texts in G. Abrami,* Le facezie dei secoli d'oro, *1944, 32, 48–49, 63–64, and the letter in G. Milanesi,* Documenti per la storia dell'arte senese, *1854, Vol. 2, 299–300.*

From the *Jokes* of Poggio Bracciolini.

From the same village [as a preceding story] some men were sent to Arezzo to buy a wooden crucifix, which was to be put up in their church. And when they went to a man who sold such things, when he realized he was dealing with such completely ignorant louts, the craftsman, so as to get fun out of it, asked when he heard their request whether they wanted the crucifix alive or dead. They took time to think it over, discussed it in private among themselves, and decided they preferred it alive,

because, if that didn't suit their fellow villagers that way, they could kill it in a flash.

* * *

From the "Diary of Poliziano"

The Patriarch sent out a call for Donatello several times, and after many urgings he sent back this answer: "Tell the Patriarch I don't want to go to him, and that I am just as much the Patriarch in my art as he is in his."

There's a saying: "Not for the love of God, but because you need it." This was said by Donatello to a poor man, who asked him for alms for the love of God.

In the time of Donatello, the outstanding sculptor, there was also in Florence another sculptor called Lorenzo di Bartoluccio [Ghiberti] who was a small star beside that sun. Lorenzo had sold some land of his, called Lepricino, from which he was receiving little income. Donatello was asked what was the best thing Lorenzo had ever done, meaning in sculpture; Donatello answered: "Selling Lepricino."

* * *

Letter from the Sienese ambassador in Rome, to the Administrator of the Cathedral Works in Siena, April 14, 1458.

[The main part of the letter recommends an applicant for a job as an accountant.] And give my greetings to the master of the doors, Master Donatello. He is really the right person to bring you great honor, and if only this had been believed by master Mariano I would have brought him from Padua four years ago. For he had a strong feeling about being in Siena, so as not to die among these Paduan frogs as he almost did. Look after him, for he deserves everything good.

Guarino Arranges a Program for Paintings

Polished study of Greek and Latin literature is often thought of as the hallmark of the Renaissance and humanism, and Guarino (1370–1460) is the first major exponent of this trend. He spent his life as a tutor of boys, and his principle that they should chiefly study the classics to become good men began a powerful tradition. He was long tutor to the sons of the Duke of Ferrara, to whom he writes here to explain how the muses should look, offering an approach to painting obviously affected by his specialty. This is the one best text of the century for a "program" of paintings, in which an artist is told not only what to paint but also

details of motifs, gestures, etc., in accordance with the writer's interpretations of the basic meaning of the figures. The paintings described here were destroyed by fire, but a description of 1449 of two of them shows that one followed Guarino's instructions with minor additions—Clio stimulated men to glory by smiling and beckoning—but the other was quite different—Melpomene's chief action was playing a zither. The same varied results are found in other Muses copied from or reflecting these. Many art historical studies interpret paintings by hypothesizing programs similar to this one. They are difficult to judge, not only because of the rarity of evidence for such arrangements, but because the writer in this case invented rather freely, so that reconstructions of what hypothetical similar texts might have said are hardly possible. Original text in Journal of the Warburg and Courtauld Institutes, *Vol. 28, 1965, 201–2.*

To Lionello d'Este, Marquis of Ferrara, November 5, 1447.

When I recently learned, from your highness's letter, of your splendid and really lordly thought of painting the Muses, this plan worthy of a prince was one deserving praise, not being filled with pointless or lascivious evocations. But your pen should have gone further, and the web is stretched further than you expect, for the rule as to the number of the Muses needed working out, many having given various opinions about it. There are those who claim there were perhaps four, those who say five, and those who say nine. Omitting the rest, let us follow these last who say there were nine. In summary, then, it should be understood of them that the Muses are certain concepts and intelligences which, by human studies and industry, have worked out various types of activities and labors, so-called because they seek after everything or else because they are sought after by all, since it is innate in man to wish to know. For *mosthai* in Greek means to investigate, so *mousai* are women who investigate.

Thus Clio, inventor of history and matters involving fame and antiquities, should therefore hold a trumpet in one hand and a book in the other, with a dress woven in various colors and patterns, as we see silk cloth of the old style.

Thalia developed one aspect of agriculture, the planting of fields, as her name shows, which comes from germinating, and so let her hold various sprigs in her hands and her dress be marked with flowers and leaves.

Erato cares for the bonds of matrimony and the duties of proper love; let her hold a youth and a girl on either side, with herself in the middle, and join them by the hands while placing a ring.

Euterpe, the discoverer of pipes, should be gesturing as a teacher to a choir leader holding musical instruments; her face should be of the merriest, as the origin of the word proves.

Melpomene thought out song and the melody of voices, and therefore a book should be in her hands marked with musical notes.

Terpsichore established the rules of dancing and the movements of the feet often used in sacrifices to the gods; she should therefore have boys and girls dancing around her and show the gesture of a director.

Polyhymnia invented the cultivation of fields; she should have short skirts and bowls of seeds, carrying wheat and grapes in her hands.

Urania, since she thought out the rules for astronomy, should contemplate the starry sky over her head while holding an astrolabe.

Calliope, investigator of learning and leader of poetry, who also provides the other arts with a voice, should wear a laurel wreath and have three faces combined, since she expounded the nature of men, demigods, and gods.

I know there will be many who will note other characteristics of the Muses, and to that I will answer with Terence: "There are as many opinions as people." Farewell, lordly prince and pride of the Muses, and I pray as a suppliant that you will look well on the business efforts of my son Manuel.

Two Poets on Pisanello

One brief group of examples will evoke the vast literature of humanist poems praising people, in this case artists; nothing is a better guide to what the most conventional terms of praise were. Although both humanists and the new Renaissance artists cultivated the classical world, it has been noticed that they had little to do with each other, and this poetry tends to praise the less classicizing "international Gothic" artists, who shared a court experience with these writers. This poem honoring Pisanello, the most frequent choice, is unusual since it is by a Florentine, showing that admiration for him was found everywhere, even in the least Gothic and courtly style center. The second poem reports a contest, rare among painters but a favorite humanist subject in other contexts; this contest of portraits is also described by a prose humanist. Original texts in A. Venturi's edition of Le vite scritte da Vasari, *Vol. 1,* Gentile da Fabriano e Pisanello, *1896, 35, 46.*

Lionardo di Pietro Dati (born ca. 1408): "In Praise of Pisano the Painter"

> Our poets gave the palm to Pisanello
> Among the painters; in wit and amazing art
> He equaled nature, copying all, to the nails.
> But though official opinion is sacrosanct
> I clung to my views, and partly was testing their judgment,

But when, Oh Jupiter, I see him bring to light
Our heroes, live, the wing-footed alive,
And every sort of people and wild beasts,
I am struck dumb, I praise Pisanello to the skies,
For having outdone, if it may be said, Prometheus.

"Ulisse on the Outstanding Contest"

As Pisanello, among his famous exploits,
 Was calculating how to contend with nature
 And how he might transform into a painting
 The new high marquis Lionello's features,
Already he had eaten up six months
 So as to give the right form to the figure,
 When scornful fortune, she who robs mankind
 Of all his glories, with her various hurts,
So wrought that from the noble salty shores
 There came Bellini, the excelling painter,
 New Phidias for our unseeing world,
Who made his true appearance come alive
 In the opinion of paternal love,
 Whence he was first, and Pisanello second.

A Scientific Writer on Light and Perception

Giovanni da Fontana was an explorer of many areas, in Padua, the scientific center of the age. (Soon afterwards Corpernicus was a student there.) He was unusual in his involvement with painters, such that he dedicated a (lost) book to Jacopo Bellini. Here too he alludes to similar concerns. In Padua the painter Mantegna, Jacopo's son-in-law, also had similar attitudes, and the image of the figure in the cloud is found in his art, as in Giovanni's scientific reporting. Original text in Arte Veneta, *Vol. 26, 1972, 22–23.*

From the *Tractatus,* 1454.
 . . . A certain very noble science of perspective, which pertains to inquiry into the causes and systems of those things that are seen and felt. . . .
 . . . If there are clouds between us and the sun, that thinner part of them through which the rays come down to us will seem brighter, being imbued with the light of the rays. The thicker part will seem darker, both because of the density and because of the mixture with smoke. . . . Some-

times in such a cloud there seems to be a gap or cleft, and a dark depth, which [at first sight seem] perforations like caves. . . .

. . . Things seen at a distance which partake of more brightness of light, seem nearer than they are, and those that are in blackness seem to be farther than they are. . . .

. . . From this experience with nature the art of painting has derived excellent rules, as I explained with definite rules in a little book dedicated to the outstanding Venetian painter Jacopo Bellini, showing in what ways it should be known how to apply bright and dark colors, with a system such that not only the parts of a single image painted on a surface should seem in relief, but also such that when they are looked at they should be believed to be putting a hand or foot outward, or that they might seem miles away from the men and animals and mountains also placed on the same surface. Indeed the art of painting teaches that near things should be colored with bright colors, the far with dark, and the middle with mixed ones. . . .

[His teacher in 1403 had seen] every day for three days, before the third hour of the morning, in the clouds horsemen and footmen armed with lances and swords attacking. . . .

A Survey of Leading Artists and What Makes Them Leaders

Group biographies were a standard literary form for humanistic writers, reviving the ancient form of Plutarch. When painters and more rarely sculptors are included, though, the writer hesitates and offers excuses, as in the case of Michele Savonarola and here the court writer in Naples, Bartolomeo Facio, whose book is an annex to his official biography of his master, the King of Naples. He tells us that after famous doctors he had meant to go on to private citizens, but "I don't know quite how, our presentation turns to the painters." In explaining what artists should do, he naturally emphasizes human character, which is after all the interest that made him write a group biography; the artists and their subjects are admired on the same basis. Most fifteenth-century lists of the best artists, in such biographies or elsewhere, are devoted to one town. It is natural that an international list should be prepared by an author in Naples, whose artists were undistinguished, and by a writer who had lived in many cities (mostly in north Italy: Verona, Venice, Genoa, briefly in Florence in 1429). In his choice of nonlocal subjects Facio is preceded only by a Roman writer Flavio Biondo, who, around 1450, described all of Italy's towns, and at various places in his book expressed admiration for Gentile da Fabriano, Pisanello, and Donatello, as Facio does here. Later in the century, in the richest nonlocal list, by Giovanni Santi of Urbino, mostly devoted to living artists, the introductory names of older artists are

almost the same, again including the same three; Santi also shares Facio's approval of the two Flemish masters. It thus appears that they may have been the artists most widely considered the masters of the century. Original text in M. Baxandall, Giotto and the Orators, *1971, 163–68.*

From Bartholomeus Facius, *De Viris Illustribus,* 1456.

On Painters

Now let us come to the painters, even though it perhaps would have been more suitable that they should be placed after the poets. In fact, as you know, there is a great kinship of a sort between painters and poets. A painting indeed is nothing but a silent poem. Both have about an equal concern in the invention and the composition of their works. But no painter has been considered superior unless he excelled in representing the qualities of real things. For it is one thing to paint a proud man, another to paint a miser, another to paint an ambitious one, another to paint a prodigal, and so on with the rest. It is as much a matter of importance for a painter as for a poet to work out these characteristics, and the genius and capacity of both is most recognized therein. For if in wishing to represent a miser, one were to liken him to a lion or an eagle, or to a wolf or kite if one wanted a liberal man, he would be going astray, whether he were a painter or a poet. Certainly the prestige of painting has always been great, and not without merit; indeed it is an art of great genius and skill. Hardly any of the manual arts demands more good judgment, since it takes for granted that not only the face and features and contour of the whole body should be expressed, but, much more, the inner feelings and emotions, so that the painting will seem to live and feel, and somehow move and act. Otherwise, it would be like a poem that was beautiful and polished but weary and unmoving. For, as Horace says, it surely "is not enough for a poem to be beautiful, it must also be sweet, so that it may move men's souls and senses whithersoever it will," and so it is right for a painting to be enriched not only by a variety of colors, but much more by a certain life, if I may call it that. And just as with painting, the same is true of carving, casting, and architecture, for it has to be said that all arts derive from painting. Nor can anyone be qualified in these media if the basis of painting is unknown to him. Omitting any longer discussion, let us move on to write of those few painters and sculptors who have been illustrious in our age, and, among their infinite works, of only those of which definite knowledge has come our way.

Gentile da Fabriano

Gentile da Fabriano had a talent able and suited to painting everything. His skill and thoroughness are especially well known in painting buildings. His is that noble panel in Florence, in the church of S. Trinita,

in which are to be seen the Virgin Mary, the infant Jesus in her hands, and the three magi adoring Christ and offering gifts. His is a work in Siena, in the square, the same mother Mary holding the boy Jesus in her lap, like one seeking to cover him with the thin cloth, and John the Baptist, the apostles Peter and Paul, and Christopher holding Christ on his shoulder, with such marvelous skill that it seems that their very bodily movements and gestures are represented. His is a work in Orvieto, in the chief church, the same Virgin and infant Christ in her hands, laughing, to which nothing seems possible to add. He also painted a chapel in Brescia, for Pandolfo Malatesta, for a large fee. In the palace at Venice he also painted a land battle, undertaken and fought by the Venetians for the Pope against the Emperor Frederick's son, which has almost entirely disappeared because of a defect in the wall. In the same city he also painted a whirlwind overturning uprooted trees, and other things of the same kind, whose aspect is such that it induces fear and horror in the beholders. His too is a work in Rome, in the church of St. John Lateran, the story of the said John, and above that story four prophets, represented so that they seem not painted, but imitated in marble. In this work he is said to have surpassed himself, as if he had foreseen his death, and, indeed overtaken by death, he left some things in this work only in the form of a shadow and unfinished. His too is another panel in which Pope Martin and ten cardinals are shown, so that they seem to match nature, in no respect unlike the living people. Of him they say that Rogier van der Weyden, the notable painter of whom we will speak, came into this same church of John the Baptist in the jubilee year, and, caught up with admiration of the work and asking who the artist was, he ranked him ahead of the other Italian painters, piling up much praise. Superior paintings in various places are reported to be his, which I did not write about, since I did not find out enough about them.

Pisanello of Verona

Pisanello is considered to have almost a poet's genius in painting the shapes of things and expressing their feelings. But in painting horses and other animals, in the judgment of experts he surpasses the rest. In Mantua he painted a little room, and much praised panels. In Venice in the Palace he painted the Holy Roman Emperor Frederick Barbarossa and his son, as a suppliant, and besides, a great crowd of attendants dressed in the German fashion, and a priest whose facial expression is as if screwing up his mouth with a finger, and boys laughing about this, with such suavity that it stimulates the observer to amusement. And in Rome he painted in the church of St. John Lateran those things in the story of John the Baptist that Gentile had left unfinished, a work which, however, as I heard from him, was afterwards almost obliterated by the dampness

of the wall. And there are some examples of his genius and skill in painting panels and parchments, in which Jerome praying to Christ on the cross is worthy of veneration because of the gestures and the majesty of his face, and also a hermitage in which there are many kinds of animals which you would say are alive. To painting he added the art of modeling; works of his in lead and bronze are King Alfonso of Aragon, Filippo lord of Milan, and various other rulers of Italy, who were devoted to him on account of the distinction of his art.

On Sculptors

Renzo the Florentine [Lorenzo Ghiberti]

Among the sculptors we have few who are notable among the great quantity, though there are some today whom we consider likely to be outstanding one day. But first I will say a few words about Renzo the Florentine. He is held to be admirable in bronze. He modeled in bronze, on the doors of the church of St. John the Baptist in Florence, first the New Testament and then the Old, so extensive, with such variety, and of indescribable workmanship. His too are in Florence, in the church of Santa Reparata, the tomb of Saint Zenobius in bronze, and in Or San Michele the John the Baptist and Stephen the first Martyr, a work of as great genius as art. Nor is his son Vittorio considered inferior, whose hand and skill are known in the same doors of Saint John. For the works of each harmonize so well among themselves that they seem to be by the same hand.

Donatello the Florentine

Donatello, also a Florentine, excels too by the superiority of his genius and his art; he is very well known, not so much for bronze as for marble, so that he seems to produce living faces, and nearly reach the glory of the ancients. His is the St. Anthony in Padua, and other brilliant representations of saints in the same altarpiece. His is in the same city the distinguished general Gattamelata in bronze, seated on a horse, of marvelous workmanship.

Local Pride in a Fresco by Gentile da Fabriano

Set speeches praising something were common exercises for young writers and were usually empty of content. This one is ordinary in its tone and in the preference of north Italian literary circles for Gentile da Fabriano, but unique in recording the theme and look of a work he did for the tyrant of Brescia, one of his major lost works and the same which

soon afterwards Tura was sent by his lord to study. Its subject (which seems to be recorded only by this forgotten writer and is not reported in the Gentile literature) was a natural favorite for military lords fascinated by the late medieval codes of chivalry and the legends of Arthur and his knights. Gentile's work may well have inspired those of other artists of the region, beginning with Pisanello. Original text in P. Guerrini, Cronache bresciane inedite, *1927, Vol. 5, p. 26.*

From Ubertino Posculo's *Oration on the Praises of Brescia,* 1458.

[The Broletto, or central municipal building] is admired for no work more than for that very famous chapel, in which, just as Phidias's ivory was alive in the temple of Minerva in Athens, so this one shows the live image of St. George, soldier of Christ and martyr, the gleaming eyes of the dragon, the trembling girl, the whinnying horse with its nostrils flaring. These pictures are executed by our painter Gentile with as much art as Phidias or Polycleitos in marble or ivory, or Apelles the painter could produce.

Mantegna's Field Trip to Collect Classical Inscriptions

The humanist collector of inscriptions Felice Feliciano wrote out for his patron, Samuel da Tradate, an official of the court of Mantua, a copy of his biography of the most remarkable of all such collectors, Ciciaco of Ancona, and added at the end this famous account of a boat trip in which Mantegna also took part, in 1464. It is rightly considered the best biographical evidence of Mantegna's passion for Roman remains, but it is much more, mixing up the classical with love of landscape, Christian worship, and a jolly day among friends. This is typical of the way in which, in north Italy, classical interests became absorbed, as an added flavoring, among other things, instead of being an isolated strict system. Sometimes Christian terms are translated into classical ones—the "home of the first pontiff" is the church of St. Peter, and the "most high thunderer," an epithet of Jupiter, is used to refer to the Christian God. But others again are not translated, and the writer's language is similarly casual in structure. Original text in P. Kristeller, Mantegna, Berlin, *1902, 523–24.*

Worth Remembering:

On the IX before the beginning of October, MCCCLXIIII. Starting out together, with Andrea Mantegna the Paduan, incomparable friend, Samuel de Tradate, and myself Feliciano of Verona, for the sake of relaxing our thoughts, we came from a field as lovely as the Tusculan,* by

* After Cicero's writings had made his farm in Tusculum famous, later writers used the adjective to mean any beautiful field.

way of the lake of Garda, to greenswards like heavenly gardens in the most delicious dwelling places of the Muses. We found them not only pleasant and fragrant with red and purple flowers, but also with the leafy branches of orange and lemon trees everywhere, when we gazed at the islands through fields that were overflowing with springs, and adorned with tall old leaf-bearing laurels and fruit trees. There we saw a number of remains of antiquity, and first, on the island of the monks, one with highly ornamental letters on a marble pillar. [Inscriptions then copied.]

Celebration

On the VIII day before the first of October, under the rule of the merry man Samuel de Tradate, the consuls being the distinguished Andrea Mantegna of Padua and John the Antenorean [Paduan], with myself in charge with the bright troop following, through dark laurels taking our ease. Having crowned Samuel with myrtle, periwinkle, ivy, and a variety of leaves, with his own participation, and entering the ancient precincts of St. Dominic, we found a most worthy memorial of Antoninus Pius Germanicus surnamed Sarmaticus. Steering then toward the house of the holy protomartyr,* not far from the said precincts we found in the portico an excellent memorial of Antoninus Pius the God, nephew of Hadrian the God, resident of that region.† Going on then to the house of the first pontiff nearby, we found a huge memorial of Marcus Aurelius the Emperor; all of these are recorded in the present notebooks. I will not omit from what is worthy of record that we found the lodging of Diana the quiver-bearer, which for many reasons we knew could be no other. Having seen all these things, we circled lake Garda, the field of Neptune, in a skiff properly packed with carpets and all kinds of comforts, which we strewed with laurels and other noble leaves, while our ruler Samuel played the zither, and celebrated all the while.

At length, having gloriously crossed over the lake, we sought safe harbor and disembarked. Then entering the temple of the Blessed Virgin on the Garda, and rendering the highest praises to the most high thunderer and his glorious mother, most devoutly, for having illuminated our hearts to assemble together and opened our minds to seek and investigate such outstanding places, and caused us to see such worthy and varied diversions of objects, some of them antiquities, and allowed us such a happy and prosperous day, and given us fortunate sailing and good harbor, and our wished-for conclusion. Especially for seeing such great won-

* St. Stephen, the first Christian martyr.
 † The two inscriptions of Antoninus are of different dates, before and after he had been formally declared a god.

ders of antiquities; anyone of great soul should on just that account take the road to see them.

Etruscan Finds in 1466, Reported by Antonio da Sarzana

Roman remains were so common an object of archeology in the fifteenth century (unlike the fourteenth) that they hardly draw attention. Along with the Greek researches of Ciciaco d'Ancona, we may also look at what was described quite rightly by its recent discoverer as the earliest report of Etruscan finds that is more than a passing allusion. It is indeed visually precise in a way that allows us to see just what sort of works he was studying, when we add our own knowledge of Etruscan forms. And that cannot always be said for the reports of the period about its own art. The text is a letter from an obscure humanist who was employed as a tutor to a boy and was taking him on a tour of Italy, much as was done three hundred years later by British tutors of young lords, often just as archeology-minded. Original text in Art Bulletin, *Vol. 48, 1966, 96.*

From Antonio Ivano da Sarzana, in Volterra, November 7, 1466, to Lodovico.

. . . Another thing, not far from the same hill some tombs were discovered in a certain cave, of which one is marble, whose carved tops represent various effigies of people lying down, and the ancient styles of apparel. But they are very short and narrow, whence we easily deduce that, like urns, they preserved ashes, not bodies. There were also numerous but half-broken clay vases, in the same cave, whose varied appearance pleased me quite a bit. On the top of one marble tomb is carved the image of an elderly matron, with a bracelet, and arm bands painted in light gold. On one front surface of another tomb, a horseman is painted in red pigment, in the early fashion, whom two footmen appear to accompany. One precedes, carrying a shoulder sling, the other follows with a shield. I am of the opinion that these tombs were of one family only, which are now conserved by the diligence of the abbot of San Giusto.

A Poet of Florentine Statistics

The merchant Benedetto Dei of Florence had a twin brother and several uncles who were goldsmiths and so came naturally by his interests in art. His boastful patriotism in favor of Florence is not unusual, but its fabulous density of texture is unique. He was a somewhat unusual

merchant in his boldly adventurous life, traveling to the Near East and working as a spy, though others did so too. Unique are his torrential statistical tables offered in a singsong listing which to us may sound like Thomas Wolfe's Whitmanesque writing. Vast and repetitious, they have in large part remained unpublished, including (surprisingly) the lists of all Florentine painters and sculptors having their own shops in 1470. Can we rely on them? Dei clearly inflates the lists by including long-dead artists (as if he were a machine politician voting the cemetery). But on the other hand, he gives every sign of being, for the same reason, reliable in omitting no one. His efforts to include even those artists whose names he could not remember are one token of this; his inclusion of every artist known from any other source is another. Thus we can tell from him how many painters were at work in Florence and may be able to use his help in matching anonymous works with these names. He is equally informative about other matters, providing economic statistics on trade and the like, of which a few samples aer given here for context. His architectural reports (including the measurements of many elements in the cathedral) call for separate presentation.

From a letter to his brother in Florence, written from France, June 15, 1468: original text in M. Pisani, *Un avventuriero del quattrocento,* 1923, 20.

[He has bought] . . . a great storied painted paper, about twelve feet or so, which had the battle of the mice and the cats, a pleasant thing to see, and a bargain.

* * *

From the *Memorie Istoriche,* 1470; original texts unpublished except for the last; most accessible manuscript a modern transcript in the Warburg Library, London, *carte* 19, 21, 44f., 49.

. . . I was living at the time when they began to make the perspectives in intarsia inlay, and the figures, in such a way as to seem painted, and I was there at the time of the new constructions that are being made for St. John's [festival procession], which to any outsider would seem made by magic arts. I was there at such a time as to have seen new-made and set up the doors of St. John's in Florence [the Baptistery] which are of gilded bronze, in relief, and storied in a hundred thousand ways, in very beautiful style.

. . . Florence has [the wool guild and others and] every perfection in handicraft, such as building, carving marble and stone, such as bronze figures in relief, and it has perspective in wood, and has gold and silver thread, and has fustians and other coarse cloths. . . .

PAINTERS IN THE CITY OF FLORENCE, 1470.
A shop of Fra Filippo of the Carmelite Order, Florentine
of Master Masaccio, Florentine
of Fra Giovanni, Florentine [Fra Angelico]
of Master Masolino, Florentine
of Master del Pollaiuolo, Florentine
of Master Bicci, Florentine
of Master Andrea Verrocchio, Florentine
of Master Benozzo del Sellaio, Florentine
of Master Neri di Bicci, Florentine
of Master Alesso Baldovinetti, Florentine
of Sandro Botticelli, Florentine
of Master Domenico di Michelino, Florentine
of Master Giovanni di Francesco, Florentine
of Master Antonio di Boldro, Florentine
of Jacopo di Forzere, Florentine
of Master Appolonio, Florentine
of Master Lorenzo di Pigniaro, Florentine
of Master called or nicknamed lo Scheggia, Florentine
of Master Marco del Buono, Florentine
of Master Massaio of the Animals, Florentine
of Master Antonio Zoppo, Florentine
of Master Lippo, Florentine
of Master Giovanni da S. Stefano, Florentine
of Master Rossello, Florentine
of Master and Friar Diamante, Florentine
of Master Piero del Massaio, Florentine
of Master Riccardo delle Nostre Donne, Florentine
of Master Piero son of Master Francesco, Florentine
of Master Cosimo son of Master Biagio, Florentine
of Master Lessandro da Pistoia, Florentine

SCULPTORS OF BRONZE, MARBLE, AND STONE IN FLORENCE, YEAR 1470.
Filippo di ser Brunelleschi, king of the world
Donatello, sculptor of bronze and marble
Lorenzo di Bartoluccio of the San Giovanni doors
Luca della Robbia, great master
Michelozzo, architect and sculptor of everything
Agostino, sculptor of bronze and marble
Andrea called Verrocchio of the ball [on the top of the cathedral]
Bernardo Ciuffagnio, sculptor of everything
Vittorio son of Lorenzo son of Bartoluccio, sculptor
Ottaviano, sculptor of bronze and marble
Antonio, son of Mrs. Apolonia, sculptor
Pagni who does the Nunziata, sculptor
Andrea della Robbia, sculptor of everything
Alessandro of the Piazza of the Frescobaldi
Agnolo at the Piazza of S. Trinita
The master next to the Bartolini [family's house] of the Borgo
The master who lives in the Piazza of S. Croce

The master who lives by the Soderini at the foot of the bridge
The master who lives at San Pier Maggiore at the arch
The master who lives next to Strozzo Strozzi
The master who lives at the Tornabuoni's, at the piazza
The master who lives at San Michele Berteldi
The master who lives at San Lorenzo, by the Medici

* * *

The following original text in *Revue des Arts,* Vol. 3, 1953, 149.

... Masters of Perspective in Florence, all Florentines, in 1470
Antonio Manetti
Giuliano da Maiano
Giovanni da Gaiole at the Nunziata
Francione da Fondamente
[Ten more names]

Note that the above were the masters of Italy, in the time of Benedetto Dei, in the year 1470.

* * *

From the *Cronica,* 1472; original text in G. Pagnini, *Della Decima,* 1967 reprint, 275–77.

... Florence the fair has 270 shops of the wool guild within the city between Via Maggio and in San Martino and the Vigna and the via del Palagio and at the Peliciai and at S. Procolo and the Porta Rossa and at the Guild of Druggists and at the Ferravecchi and in the Fondaccio and at S. Felicita in the Piazza and in Borgo San Jacopo, who make cloths for Rome, for Florence, for Sicily, for the Marches, for Naples, for Turkey, for Constantinople, for Pera, for Adrianople, for Bursa, for Chios in 1471, as is well known to the Genoese and Ragusans, and other merchants. Florence the fair has 83 lordly shops of the Silk Guild [similar details] ... and 33 banks [likewise] ... and 84 shops of woodworkers, in inlay and carving, and 54 shops for stone, dressed and rough, and masters of carving and relief and half relief and foliage, inside and outside the city, in all perfection, and 70 shops of butchers in the city, and 8 poulterers [similar details]. Florence the fair has 39 shops of goldbeaters and silver filigree, and expert masters of wax images the equal of the world, and if you make a comparison in these two arts, and take Venice and take Genoa and take Milan and take Lucca, for these four cities make silver filigree, and in wax images I would have you take Bruges and London and Germany and France and Spain and Hungary and Italy, any city at all or that ever was in the world, you won't find and can't find masters of wax images equal to these, who are in the city of Florence today, and the Nunziata [church known for wax images] shows it to everyone. Florence the fair has 44 shops of goldsmiths and silversmiths. ...

A Humanist Asserts That the Moderns Can Equal the Ancients

In this longstanding quarrel, the Florentine Alamanno Rinuccini seems to have been the first to introduce painters to illustrate his side. In so doing, he provides a list of the Florentines he admired. The list was rapidly followed by other similar lists by Florentine writers of the next few decades (Landino, Manetti, Landucci, Verino), all of whom, however, were making patriotic boasts about Florence. Rinuccini does not do that here and so can include in his list the nonnative Domenico Veneziano, omitted by the most chauvinistic of the other writers; yet his layman's knowledge of painting is limited enough to restrict him to painters active in his city. (Thus he omits Piero della Francesca, who worked for the same duke to whom he was dedicating this letter; this is one of many signs that Piero was not very famous in his day.) All these lists echo the much earlier one of five artists plus Alberti, available since 1435 in Alberti's dedicatory introduction to his book on painting. At this later time his six names are regularly repeated and a few others added. The latter vary, but the lists make a consensus visible, which shows that these masters of the beginning of the century were now looked back to as a classic group. Original text in E. H. Gombrich, Norm and Form, *1966, 139–40.*

From the letter of dedication to the Duke of Urbino of the translation into Latin of the *Life of Apollonius of Tyana* by Philostratus, 1472.

[Some say that the superiority of the past reveals our time as without honor, industry, or study.] To me, on the other hand, it is sometimes permissible to take pleasure that it befell me to be born in this age, which has borne almost innumerable men excellent in various arts and disciplines, whom I consider comparable with the ancients. Specifically, proceeding from the lesser so that we may at length come to the greater, the painters who have flourished in our age have led the arts of painting and sculpture, adorned already by the genius of Cimabue, Giotto, and Taddeo Gaddi previously, to so much greatness and goodness, that they can deservedly be compared with the ancients. Close to our own age, Masaccio in painting expressed the likeness of everything in nature so well that we seemed to see the things themselves with our eyes, and not images of the things. And what more skilled than the paintings of Domenico Veneziano, what more to be admired than the panels of Fra Filippo, more rich than the images of Giovanni, of the Dominican order [Fra Angelico]? They are all considered different among themselves in their variety, yet very alike in excellence and goodness. As to sculptors, although I could cite many who might have been regarded as the best if they had happened to be born a little earlier, at this time Donatello by himself excelled them

185

all, so that he would be listed almost alone in this category. Luca della Robbia, though, and Lorenzo di Bartolo, were not to be dismissed, as the brilliant works executed by them testify.

Architecture . . . Brunelleschi and Alberti. . . .

Images from Innermost Philosophy

The important book by the humanist Valturius on military tech-nology is, in the usual way, obsequious to his patron, the lord of Rimini. It is nonetheless good evidence in its comments on the ruler's remarkable new church of San Francesco, better known as the Tempio Malatestiano. The writer's point that the sculpture has special appeal to learned people corresponds to the riddle-like effect that this decoration suggests today. And just as no other sculpture of the period has that look, so too this text is unique in the period. Mysteries, abstruse symbolisms, and second levels of meaning are sometimes claimed to be the norms of the period, but no comparable texts support that view or the view that works with appar-ently commonplace themes have arcane meanings. Such readings seem justified in the special case of these images which clearly are unclear (a genre commoner in the following century in emblems). Original text in A. Warburg. Gesammelte Schriften, *1932, 12.*

From *De Re Militari,* 1472.

. . . The very broad walls in particular, built from imported marble in very many high arches, which are clothed with stone panels, on which are to be seen very beautiful carved images, the whole comprising the holy fathers, the four virtues, the signs of the zodiac, the movable stars, the sibyls and muses and very many other very noble things, which can attract experts who admire literary study and who are almost wholly detached from the ordinary, not only through the very brilliant craftsmanship of stonecutter and sculptor, but also through knowledge of the forms, in de-signs picked by you, who are the most keen and indubitably the most brilliant prince of this century, from the innermost secrets of philosophy.

A Trompe l'Oeil Still-life Painting

A minor poet living in Venice, a pupil of Guarino's, Raffaello Zoven-zonio, wrote complimentary epigrams to Giovanni Bellini and others giving them conventional praise for the illusion of life created in their figures. This written praise of still life seems to precede by a generation any other records of independent still-life painting. Original text in Carmina illustrium poetarum italorum *Vol. 2, 1726, 479, apparently its only publication.*

To the painter M. Claudius of Bologna [Marco Zoppo].

> The fruits which Hercules handed to the Hesperides
> Your painted panel gave to me, O Zoppo
> They deceived your own daughter, Mark, and no wonder,
> Such fruits would draw Phidias's hand to them.

Indecision about Commissioning a Portrait from Tura

Here, as before in the case of Pisanello, painting in this period becomes a theme of poetry usually in a courtly, late Gothic, and secular context. The poems about Pisanello are familiar in books about him (perhaps as a replacement for the gaps in his biography). The following poem does not appear in books on Tura and may well describe an imaginary project. But the poet is a better poet, even if he is forgotten today, like most Renaissance writers in Latin, and his style resembles the painter's in its use of classical ornament in a mannered, witty way. Original text in the edition of 1513.

From Tito Vespasiano Strozzi, *Eroticon*, Book 4.

> Look at troubled Helen, novel cares consume her,
> She would be painted, Cosimo, by your hand, expertly,
> Of course so she may turn out famous in the future,
> And her name remain bright through exceptional art.
> But while she debates on what season suits such serious
> Business, and what clothes to wear, a year disappears.
> Spring is praised indeed, but summer's called more suitable,
> Now autumn pleases and now winter is endorsed.
> Now, wrapped up, she wants her hair painted with some
> covering,
> Now again she yearns for her tresses to be bare.
> And while the silly girl shifts the day and different forms of
> dress,
> She drags out what she wants in long delays forever.
> What *do* you want, what *are* you arranging, fool? Afraid
> perhaps
> This fickleness of yours may become well known to
> everyone?
> Since your body's imperfections are so great and numerous,
> Do you require to have a painter of your looks?
> For if worry about a fresh image bothers you,
> And you would be gazed on by rough posterity,

The published poems that people read about you,
 These preserve your manners and your picture too.
These can bring pallor to you as you read them,
 Even if youthful modesty flees a shameless face.
Maybe by my art, transmitted through the ages,
 You will be the second Thais of a later time.

A Rhetorician Admires Inlaid Wood

Often as a training exercise in this period a writer composed a piece in elaborate praise of something. What is unusual about the following example is that it was published, and that it is about works of art. The repeated admiration for the virtuosity and naturalism of the work no doubt represents a naive, yet educated, normal reaction in the period, easy for us to understand when looking at the same objects, yet today often questioned as the right response. Thus, even though the images are in churches, we see that these bird cages, fruit bowls, and so on did not convey religious lessons or symbols to such an observer but could be appreciated in this simpler visual way. This is the first detailed description of the art form intarsia, *inlaid wood pictures commonly seen in such furniture as choir stalls. The writer prefaces this by the second example (Michele Savonarola's being the first) of an honor roll of non-Florentine artists, the first to include the more modern artists. The inclusion of the sculptors, less known to us, reflects a taste natural in a classicist like this writer. Original text in the edition of 1491 (?) and an equally rare reprint of 1829; elsewhere only excerpts of a few sentences from it.*

From Matteo Colacio of Sicily, *De Verbo*, 1491(?)
Letter to the most learned Antonio the Sicilian, most worthy rector of the University of Padua, about 1476.

So far as I can determine in my slight judgment, I would hold that the moderns are less than the ancients in all skills. To be sure, the art of painting, which they call the perspective art, is still pure among us. I would say we are outdone by them in this as well, but only in the number of talents, not in their talent. Our ancestors had innumerable skilled practitioners in this art, our age has very few. Of those whom I know, it has Antonello the Sicilian, whose painting at Venice in the temple of San Cassiano is to be seen with admiration, the Bellini, Venetians whose excellent works I love especially, Andrea Mantegna the Paduan, famous for much work, and it has sculptors too, Pietro Lombardo and his sons who are rising in their father's art, the Veronese Antonio Rizzo, very famous in sculpture and architecture, and Bellano the Paduan. I would dare compare all these with antiquity. I do not see how they could

imitate nature more closely. But of all these and other things of the same kind, we may speak on another occasion. . . . Let us now praise the talent of those who built the seats in the temple of St. Antonio at Padua, in what they call the choir. Seeing these images a few days ago, I was so overwhelmed by their remarkable craftsmanship that I could not keep silent, as far as my talent and skill may go, noting that writers have not praised them to the skies.

<div align="center">*　*　*</div>

Letter to the brothers Cristofano and Lorenzo and to Pietro Antonio, son-in-law of Lorenzo, the Italian Parrhasiuses, the Italian Phidiases, the Italian Apelleses!*

Freed finally from the cares of teaching, I go to take the waters for relaxation. Entering Padua, I begin to wander through the city like those eager for the sights . . . having heard of the fame of the temple of St. Antonio, I hurry there. Entering, I gaze through the temple, but without admiration. I see things great in quantity, not quality.† Then I come to the choir stalls of the brothers; here I first mount the step, turn my gaze hither and thither, and am almost struck dumb with admiration, for I seem never to have seen anything of greater genius. Everything seems real to me, I cannot believe it is feigned. I come closer, and run my hands over them all, then, stepping back, look at everything carefully. To begin with things known to me from every day, the books seem truer to me than the true. Some on top of others, scattered by accident or carelessness, some closed, some newly bound and difficult to close. Wax candles with the last flame still in them, in well-turned wooden sconces, one straight, another twisted, some more and some less, another intermediate. Elsewhere smoke clouds spreading from chimneys, peaches rolling out of baskets, a zither protruding from a narrow niche; nearby, a barred bird cage, put together with marvelous ingenuity, with the wooden ring most beautifully fitted around each end and the middle, matching in size, color, and convexity; outside, the cylinder tied with a bronze rod, inside a bowl of food and a red ball hanging for the bird to play with. . . . Palaces, churches, towers with bells, with the shadows of open windows, with vaults rising and steps, openings allowing the space inside to be seen. Mountains too, most natural, so that one could not say what ought to be added or subtracted, they seem covered with grass or stones or vari-colored terrain, though they are bare of all greenery. . . . But what of the images of those saints! Their curly, rough beards, their hands, the articula-

* Names of Greek artists mentioned with the highest praise in classical writings.

† This "tourist" was not impressed by the sculpture of Donatello in the choir. That may illustrate his aesthetic naivete, but it may also simply mean that he was writing his exercise only about the stalls.

tion of the figures, the nails? The clothing, the sinuous folds, the shadows? . . . Then near the angel Gabriel and Mary, you admire branches with such leaves and fruit that nature does not produce truer. And this is to be admired too, that the faded color of their leaves makes it seem that they were just taken from the tree the day before. Who would deny that the square footstool really was placed to support the feet of the mother of mercy? Who could be sated of admiring that silk veil stretched over a chalice, both for the color and for the fineness of the weave, all in folds of purple, and for those sinuous folds produced by the inequality of the falling ends? . . . What a mind, what a genius! What eloquence would be required to adorn it with appropriate praises! But why give words more time, when with them I never can equal your mastery? So be it, one must admit defeat by your skill. It is truly easier and truer for you to imitate nature by feigning than for us to express this in words. . . . This work seems not yours but nature's, it had shadows longer and shorter, thicker and thinner. Enough, from wood you could extract anything that could have been got from colors, even with the greatest difficulty.

A Humanist Praises a Cassone Painter

Those humanists who wrote praises of Pisanello never did so for the Florentine artists who, then as now, were recognized as the innovators of the Renaissance. Although we group the latter and the humanists together as founders of the new age, the humanist writers were consistently more attracted to more old-fashioned art. This attitude was evident not only in courtly towns but also in Florence, where, when we do find a poem of praise, it lauds a humble furniture painter, whose classical subject matter rather than artistic style attracted the writer. This poem was discovered by E. H. Gombrich and made it possible for him to name Apollonio as the artist of many chest fronts (cassoni) painted for Florentine families, a type of painting previously anonymous. Original text in E. H. Gombrich, Norm and Form, *1966, 26–27.*

Ugolino Verino, "On the Noteworthy Painter Apollonio"

> In former times Homer sang how the walls
> Of Phoebus' Troy were burnt by the Greek pyres,
> Eloquent Virgil's great work as well
> Proclaimed the Greek cheats and Troy's destruction,
> But surely the Tuscan Apelles, Apollonius,
> Now has painted Troy burning better for us!
> Painting the flight of Aeneas and the anger
> Of evil Juno, the tossed rafts, with such skill,

And Neptune's threats, as he shoots through the tall seas,
 And checks the waves, turned from the swift winds,
Painted how Aeneas, with faithful Achates beside him,
 Entered the Phoenician woman's city, disguised,
And his departure, and wretched Dido's funeral,
 The painted panel shows by Apollonio's hand.

Landino on Florentine Painting and Sculpture

The industrious writer Cristoforo Landino wrote a notable dialogue debating whether the active or comtemplative life is better, translated Pliny's Natural History *into Italian, and prepared a long-standard edition of Dante's* Divine Comedy. *The introduction to the latter glorifies Florence through its great men, including its artists. Landino's list no doubt reflects standard taste, like that of the less well-known Rinuccini a little earlier, and standard matters of concern like three-dimensionality and the simple and the elaborate. He was influenced by Alberti, whom he admired immensely. These remarks were read more than any others on these artists in the century. Original text in* Burlington Magazine, *Vol. 95, 1953, 267–70.*

From Landino's preface to Dante, 1481.

. . . There remains painting, which was never slightly esteemed among the ancients; the Egyptians wrote that painting was their invention. [Ancient painters, as reported by Pliny.] . . . There was Giotto, the Florentine, contemporary of Dante. . . . Masaccio was a first-rate imitator of nature, presented great depth of relief without any lapses, good in composing and simple without elaboration, because he devoted himself solely to the imitation of reality and to relief in figures; he was certainly as good a master of perspective as anyone of those times, and of great facility in his work, being very young, as he died at twenty-six. Fra Filippo was graceful and elaborate and skillful in the highest degree, he was strong in composition and in variety, in coloring, in depth, in ornaments of all sorts, either taken from life or made up. Andreino [Castagno] was a great draftsman, and great in depth, he loved difficulties in craftsmanship and foreshortening, lively and alert and facile in execution. Paolo Uccello, good composer and varied, great master of animals and landscapes, skillful in foreshortening, because he understood perspective well. Fra Giovanni Angelico was graceful and devout and very elaborate, with great facility. Pesello was particularly strong in animals, more than the others. Pesellino followed Gentile, and was excellent in composing small paintings. Filippo son of the lawyer Brunellesco, the architect, was also strong in painting and sculpture, he understood perspective especially

well, and some assert that he was its discoverer or inventor, and in both the arts there are excellent things made by him. Donato, the sculptor, is to be counted with the ancients, marvelous in composition and variety, alert and with great liveliness in the arranging and placing of the figures, which all seem to be in motion. He was a great imitator of the ancients and understood a lot about perspective. Desiderio, very great and delicate and charming and of the highest grace, and he polished his pieces highly, and if untimely death had not seized him in his early years, every expert in that art hoped he would have reached the peak of perfection. Lorenzo di Bartoluccio is famous for the bronze doors of the Baptistery. There remain perfect works by Antonio Rosso [Rossellino] and of his brother Bernardo, a noble architect.

The Best Florentine Artists in 1488

While Landino listed the best Florentine artists of the period just past, Ugolino Verino—in a passage in a long poem—dwells mainly on those then living. So had Giovanni Santi, but not from a Florentine standpoint. Verino is another local patriot, though he is drawn to this subject not because of the usual motivation of patriotism but from the observation that an ancient Greek poet had praised Greek painters, and he wants to follow the example. We have already seen his poem about Apollonio and his paintings on themes from Greek poetry. The following lines are often quoted piecemeal in the biography of each artist, but they are more interesting when read together. Like Santi, and unlike similar nineteenth-century writers, Verino shows secure taste in choosing artists in his own culture. He lists no painter whom we would deem unworthy of inclusion, except perhaps Piero Pollaiuolo (these writers do have a weakness for relatives of famous artists: see Facio's inclusion of Vittorio Ghiberti). The only other painter he might have mentioned but does not is Ghirlandaio. For sculptors he turns to two of a previous generation, already deceased, perhaps because he considered, reasonably enough, that at the moment Florence was poorer in sculptors, and only thus could he obtain a balance. Original text in H. Horne, Botticelli, *1908, 306.*

From Ugolino Verino, *On Giving Praise to the City of Florence.*

> But now if [the Greek poet] were to see all the
> painters of this age,
> How Greece would have sung their praises, when
> Florence bore as a parent, in one century,
> These whom I choose to equal with the Greeks.
> There are the two brothers, Pollaiuolo by name,

One a painter, the other a good sculptor,
Antonio casts his breathing faces in bronze,
And models vigorous images from soft clay.
Nor is our Verrocchio less than Phidias, and he
Surpasses the Greek in one respect, for he both
 casts and paints.
What Donato was as a sculptor in our city
The vigorous stones can testify for his name,
Nor was Theban Scopas or Praxiteles greater
Than Desiderio was in marble that seems to breathe.
And Sandro [Botticelli] I would not deem un-
 worthy to be equated
With Apelles, his name is known everywhere.
Zeuxis of Heraclea, however you may have
 painted well, you fall,
Vinci of Tuscany is hardly less than you in skill.
Nor shall I omit you, Filippo, memorable
 offspring of a painter [Lippi]
Worthy to hold the first place.

Making Fun of the Venetian Masters

What may seem missing in writing of this period is attacks on artists for poor work. Indeed it is true that formal literature tends to praise. It is in the subliterary culture of dialect or ribald writers that we find the extreme opposite, violent attacks which no doubt had a personal rather than an aesthetic stimulus. Popular poetry is an active, if little documented, part of the writing of the age, but rarely refers to art. However, the Paduan poet Strazzola in the 1490s seems to have conducted a vendetta against several painters, particularly a certain unknown Ombrone. He also had bad things to say about Gentile Bellini, and his worst insult to Carpaccio was to call him Bellini's pupil. Original text in Giornale storico della letteratura italiana, *Vol. 26, 1895, 47–48, 49–50, 53–54.*

What Gentile Bellini's Canvas Said

I'm called by everyone the giantess,
That the painter Gentile Bellini made,
He would have made me even bigger still,
If he had not been halted by reproof.
Everybody who sees me so ill painted
Cannot restrain himself from laughing at me

In anger, and those with training look and pass,
Judging me as if I were a worn-out shoe,
But it is the sublime and excellent hand
Of Giovanni his brother, here nearby,
That wounds me far more than all those tongues,
I am called the frightful foolish picture,
About which people mutter as they go,
As if I were some disagreeable schemer,
 O high and mighty Jove
Explain to this fool what's wrong with me,
For he should be called pedant among painters.

The Painting of Hands

Two painted hands upon a sheet of parchment
I saw the other day. To take it further,
They looked to me like gloves of otter skin
From which the fur had rubbed off from much use.
And what infuriates me more about it
Is thinking that bystanders say about it,
That they were made by one of the most outstanding
Painters that ever have been known to man.
And I couldn't restrain myself from saying,
"Was there in the world ever an ox
That couldn't paint at least better than he can!"
It's not Ombron, who was so entirely stupid
That he wound up painting two melons, sort of,
Thinking to act the architect, the madman.
 So your Carpaccio, then,
O my dear highness Contarini sir,
Seems a true pupil of Gentile Bellini.

The Image of Christ by Ombrone

I am a Christ that has abjured God,
Having a form of a bedeviled man.
The ignorant Ombron painted me here,
And couldn't have done it with more piety.
The perspective has made my features evil,
Being misunderstood on every side,
He measured the vanishing point falsely,
So I don't have a member that is mine.
So those who see me laugh and do not pray,
Making game of my ill-formed effigy,
Which wipes out reverence among the people.

To punish what these people do to me
I shall make him who does not know true art
Cry "Mercy, Lord, upon me, for I lost
 My time and hours in talk
And not in doing" wherefore then Bellini
Will make me more human, more divine.

Manetti's Lives of Florentine Artists

Antonio Manetti (1435–1497) translated a fourteenth-century group biography of notable Florentines by Filippo Villani and then added himself the biographies of "fourteen notable men from 1400 on." The momentous change in his supplement is that, of the fourteen, the majority are artists (the seven printed here plus the architect Brunelleschi); thus Manetti's work foreshadows the lives of the artists by Vasari in 1550. Like Landino and others, he concentrates on the now awesome reputations of the artists of the early part of the century. Unlike them, but like Ghiberti, he mainly lists the artists' works. His are often the earliest records of these works and so are of unique value to us in identifying them. Many of them survive, probably at least partly because they too had begun to be revered as classics. This reverence is apparent in the 1490s also in such Florentine artists as Ghirlandaio, Giuliano da Sangallo, and Benedetto da Maiano, who reworked and revived compositions of the same masters. Original text in Burlington Magazine, *Vol. 99, 1957, 330–36.*

From *XIV Outstanding Men in Florence from 1400 on* (written between 1494 and 1497).

Donatello, master sculptor, made many things in bronze and marble, in Florence and elsewhere, in Florence in the bell tower of the Cathedral, toward the square, in the tabernacles outside Or San Michele, [the figures of] St. George, St. Peter, and St. Mark, marvelous works, and so too in many other places, at Prato, at Siena, at Padua, and in many other places.

Lorenzo di Bartolo, superior sculptor, made the bronze doors of San Giovanni of Florence, that is, those in the front opposite the Cathedral, and also the one to the north, and the bronze tomb of San Zenobio which is in the Cathedral, and other figures of bronze in the tabernacles of Or San Michele and elsewhere.

Masaccio, painter, an amazing man, painted in Florence and elsewhere, he died at about 27. [Marginal addition: on December 15 1472 his brother, Lo Scheggia, told me he was born on St. Thomas Day in 1401, which is December 21.] He made in Florence in the Carmine a St. Paul between the chapel of the Serragli, where the Crucifix is, and the chapel

with the story of St. Jerome painted in it, a wonderful figure. He painted in the Brancacci chapel various scenes, the best of those there, it is painted by three masters, all good, but he is wonderful. He painted in the same church, in the cloister, over the door where you go into the church, in monochrome, a scene wonderful in construction to every expert, where he shows the Carmine square, with many figures, and he made things also in other places in Florence, and for private persons, and in Pisa and Rome and elsewhere, considered the best painter of whom there is knowledge up to his time.

Frate Giovanni, called of Fiesole because he was a monk at San Domenico, a wonderful master of painting, painted in St. Mark the high altarpiece, the chapter house of the first cloister, with Christ on the cross with the thieves on the sides and many saints, and other things, many in the same church, especially in the monks' living area. He painted a panel in S. Egidio, the church of the hospital of S. Maria Nuova, of a Coronation of our Lady, one at S. Maria degli Angeli of the Last Judgment, almost the entire silver tabernacle in the SS. Annunziata, the church of the Servites, and many other private things in Florence and elsewhere, small devotional works and others, and an altarpiece in the sacristy of S. Trinita of a Deposition of Christ from the Cross. And in Rome he did many beautiful things and died there. Since he was a monk he never painted for money, and if he got anything it was all for the convent. He is buried in Rome in S. Maria della Minerva, in a worthy spot. He never left his church duties to paint, and was of holy life. He was from the Mugello by birth.

Frate Filippo of the Carmine, a wonderful master of painting, did a chapel in the chief church of Prato, that is, the main chapel. He did two altarpieces in the monastery of the Murate, of Florence, the one of the high altar and the one of St. Jerome, one in the sacristy of S. Spirito, one of the Annunciate Virgin in San Lorenzo, in the chapel of the board of works, one in the main chapel of S. Ambrogio, and many others. And finally a chapel in Spoleto, where he died and where he was buried with much honor.

Paolo Uccello, master of painting, painted the flood in the cloister of S. Maria Novella, and the scene under it, and the first two scenes, the upper and the lower one, when you come down the steps into the cloister entering it from the church, and many other things in S. Trinita and elsewhere.

Luca, who was called Della Robbia, master sculptor of casts and marble and clay, and he was the first who discovered how to glaze figures. He did many things, but in the Cathedral in Florence may be seen by him three marvelous works together, the bronze door of the sacristy on the north side, the balustrade above, where the organs are, and above the doors of the sacristies, that is, both of them, the glazed figures, or rather,

figures of glazed clay, with the Resurrection of Christ and the Ascension. He did many other things for the city and elsewhere. A good man and of respectable life and great intelligence.

How Mantegna Knew How to Present an Allegory

The humanist Battista Fiera (1469–1538) was a friend of Mantegna and served as a witness of his will. In his dialogue on Justice, written shortly after 1489, he has as a main theme the many varieties of defini-tions and uses this story of Mantegna to make the problem vivid. The story is probably true, since Mantegna had painted a Justice for the pope. It is of interest to us to see that here: (1) the patron asks for an allegory but offers no specific instructions on how to paint it, and (2) when the painter is conscientious, he will then ask advice of literary experts. Al-berti's advice to the painter—to cultivate literary men for their help with inventions—is consistent with this pattern of behavior and suggests that seeking advice may have been common practice. It would make the room for maneuver on the painter's part larger than is sometimes thought. Original text De Justicia Pingenda, *1957.*

From *On Painting Justice.*

[Asked what Justice is, Mantegna answers] I established Justice when painting, in a certain way. He who can do everything ordered it. Since I am the sort of painter who pays particular attention even to the last touches, and had always heard various things about Justice itself, I therefore thought the philosophers ought to be consulted. [He receives many irreconcilable suggestions].

A Visit to a Fresco Cycle

The Campo Santo in Pisa remains famous today as the site of great fresco cycles of the fourteenth and fifteenth centuries. It was also the theme of a doggerel poem, written in or around 1487, which is perhaps the earliest existing guidebook-type presentation of an assembly of works of art produced after ancient times. We can observe a way in which a contemporary comments on such paintings (not excluding that other approaches also were used). His comments turn out to be very similar to those a modern tour guide might make to a listener who is an art tourist, not a pilgrim. Sometimes he narrates the Bible stories told, and their morals, but without any second symbolic levels of theology; sometimes he admires the artist's cleverness, other times the charm of a detail. It also seems to be the earliest definite record, partially preceded in Viterbo in

1469, of portraits of important local people being included as spectators in a religious fresco. This device was apparently first practiced about 1460 (simultaneously by Fra Filippo Lippi, Piero della Francesca, and Benozzo Gozzoli). The literary background for the poem is evidently in the tradition of poems describing imaginary paintings in castles, which may also sometimes have been real ones, though that is not usually thought. The poem speaks of the Gozzoli frescoes, which were completed in 1484, so the writer's reaction is that of a contemporary spectator. But the response to the much older frescoes of the Triumph of Death is of equal interest. Original text in I. Supino, Il Camposanto di Pisa, 1896, 301ff.

Michelangelo di Cristofano da Volterra, trumpet player in Pisa, *The Wonderful and Unparalleled Beauties and Enrichments of the Cemetery of Pisa,* selections from some of the 64 eight-line stanzas.

> Mount Parnassus I do not invoke,
> The Nine Sisters I do not invoke,
> But turn only to that fount and spring
> Which is in Heaven, above the highest stars,
> And so I pray Christ's mother in this case
> Will help to make my verses beautiful,
> And so may my little work proceed
> About the glorious worthy cemetery.

[He briefly reports the measurements of the building, the cathedral and the baptistery adjacent, the Campo Santo's doors, tabernacles, and roof, then the frescoes with stories of San Ranieri, Saints Efiso and Potito, Job, the Hermits, Hell, the Judgment.]

> Passing on further then, we can see Death,
> And how it hunts young people with a will,
> And flees the old, who loudly call upon it,
> Leaving them bereft along the way,
> And many sick, who would prefer that fate,
> And it presents to them its violent acts,
> And in that place we see emperors and popes,
> And every one of them cut off by death.

[The Crucifixion, Resurrection, and Ascension.]

> And all of these narrations, as they are told,
> Stefano, Taddeo Gaddi, Bonamico,
> These three have done the work entirely,

In times past and very long ago,
Pupils of Giotto, if you'll pay attention,
They were all three, as I have told you plainly,
And each a master and an excellent painter,
And you can see that, testing it yourself.

[The second part begins with God holding the world in his arms, and the
Old Testament stories up to Cain.]

Then after that starts off the modern story,
Painted by the Florentine Benozzo,
It is the Old Testament, quite plainly,
In all these, and it never had been done
In a way that would meet whatever tests,
And this man topped all challenges and methods
That can be set for painting, first of all
For being placed there so remarkably.

[General admiration of the figures and buildings.]

The ancient and the modern and all others,
The people here will certainly amaze you,
And there are animals of every type,
And also birds besides, I am not lying,
In every action, as my talk informs you,
All very numerous before your face,
Then also splendid landscape, greenery,
Nor ever did you see a painting like it.
For there are birds, flying above the trees,
Such as you would believe they were alive,
And there are many who have been before,
As my explaining fully will inform you.
Noah you see, along with all his helpers. . . .
And then you see the great tale of Nimrod,
How he had the tower of Babel made,
And how the masters lost their memory,
So that he did not get the tower finished.
Master Giovan Francesco with great honor
Is there portrayed, and also all his brothers,
And seem alive, as I allege is certain,
Who were the sons of the great lord Roberto*. . . .

* Roberto da Sanseverino was an important military-political figure in
central Italy. Vasari, who always looked for portrait figures in such frescoes,
gave a different and presumably incorrect name for these.

And then there is the destruction of Sodom,
How that city was destroyed by fire
Because of the great and unchaste sin,
With four other towns, as scripture tells us:
Italy should watch out, and note my speech,
About that judgment, which can quickly come,
For in Heaven I seem to sense already
That Christ no longer can put up with this. . . .

[The stories of Jacob and Esau, Jacob and Rachel, Moses and Joshua, Saul; the Queen of Sheba comes to visit Solomon.]

. . . with many youths, so natural
That man is glorified just by the sight,
They all come together, those and those,
And visit together, very haughty,
Laden with precious jewels and with gold,
No one has ever seen a richer work. . . .

[The windows are pointed out, and one last stanza notes that the pope has granted an indulgence to visitors.]

7

Diarists
and Chroniclers

The Sienese Chronicle and the City Fountain

Private diaries of current events in town, the nearest equivalent in the period to our newspapers, concentrated on wars and politics, but sometimes a new civic building is mentioned. Reference to a work of art is rare, as it would be on a front page today, and is a clue that the work was probably of more than artistic importance and that its production involved the public and officialdom. It is even more exceptional for the artist to be named. Contemporary with this record in Siena of Jacopo della Quercia's fountain, called the Fonte Gaia, Ghiberti's Baptistery doors were recorded by Florentine chroniclers, but much more briefly than this. Original text in P. Bacci, Francesco da Valdambrino, *1936, 301–4.*

1416: It was decided to tear down the fountain of the square [*campo*] of Siena, and redo it in marble, carved with figures and other decorations. And so it was torn down, and two basins were placed beside it, which filled up with water for whoever wanted some, and a fence was built around the construction, so that people would not get in the way of those who were building. . . . Then it was arranged for the said water to go through a conduit to the base of the City Hall, and a column was placed there, carved with figures spouting water, and at the foot was a basin into which the water fell, and there were also some of those spouting figures outside the basin. The fountain of the square had begun to be built, and was torn down and being made higher.

1419: The fountain of the Square was finished, with figures of marble and other handsome decorations, as can be seen, with much abundance of water. These figures were made by master Jacomo son of Master Pietro della Quercia of Siena, and he composed the fountain and made all the figures and other carvings, and they can be seen. Master Francesco di Valdambrino of Siena also made one of the said figures, and master Sano of Siena built the fountain all round, in the year 1419.

Marco Rustichi Sees the Sights of Pisa, 1425

Art tourism—travel to enjoy man's works for their beauty rather than their function—seems to reappear first (after antiquity) in Florence and to begin with architecture, for reasons that should be further explored. A Florentine chronicler in 1310 boasted of such foreign visitors. In 1423 another one described the city's buildings in aesthetic terms, and about 1440 the goldsmith Marco Rustichi started to make a series of drawings of them. Earlier the same Marco, who kept a diary while on a pilgrimage to the Holy Land, had started making entries in it as soon as he left town, on his first stop at the port of Pisa. Most of his remarks are

also on buildings, but they extend in fascinating ways to images of city views and traffic patterns, as well as to works of art. This is perhaps the first post-classical record—excluding passing phrases in religiously oriented writings about Rome—of an "out-of-towner's" pleasure in the particular works of art of a city. It is also remarkable for its positive views toward earlier art, even more than Ghiberti expressed in the same generation. It praises the pulpit by Giovanni Pisano (which Ghiberti merely includes in a list), and refers briefly to the pulpit by Nicola Pisano and the thirteenth-century mosaics (which Ghiberti does not even list). Even the twelfth-century bronze doors of Bonannus receive an appreciative mention, and nowhere do we find the comment "good considering the times," which the Renaissance usually made on this older art. Original text in I. Supino, Arte Pisana, *1904, 315–16.*

From the *Demonstration of the Trip or Journey to the Holy Sepulchre and to Mount Sinai*

We arrived in the city of Pisa. . . . [He discusses its history and legends; moral reflections.] The city is a marvel to see, with its beauties and enrichments, and well peopled, in it are beautiful churches and beautiful hospitals and beautiful mansions and houses and gardens, and through the middle flows the river Arno. . . .

And there is the main church, called the Cathedral. . . . [He describes its architecture] and inside it is worked throughout with mosaics, storied with beautiful figures . . . and the doors of the church are of metal, with certain figures cut in relief, and there is in the church a certain pulpit entirely of marble, instead of columns it is all figures, carved with beautiful scenes in relief, the whole New Testament, which is the most beautiful work of this kind ever seen in the world.

And opposite the Cathedral there is the tribune [Baptistery] of St. John the Baptist, with a beautiful marble pulpit. . . . [He describes the Campo Santo and the rest of the city.]

Chronicle of the New Dominican Convent of San Marco, Florence

Though monks kept better records than most people, it is rare luck that a chronicle survives for the beginnings of the most remarkable convent of fifteenth-century Florence, in a sixteenth-century copy which appears to be faithful. The author was the doubtless well-informed Friar Giuliano Lapaccini, who was its prior in 1444 and from 1448 to 1453. We must read between the lines of this strictly official version of events. To make possible the settling in Florence of the new reformed group of Dominicans, earlier established in Fiesole with the help of Cardinal Dominici, it was necessary to oust the previous occupants of San Marco, the Silvestrine monks. They were not willing to leave, and this effort

failed several times, until Pope Eugene IV, present in Florence as a refugee, acceded to the request of Cosimo de' Medici. Cosimo was the de facto ruler of Florence, a friend of the reformed Dominicans, and paid most of the rebuilding costs. It was explained that the Silvestrines had become corrupt morally. Although our chronicler tells us that the family holding the rights to the main chapel of the church (a matter of great prestige to any family) gave it back to the new monks, who in turn gave it to Cosimo, who then made a money gift to the old owner, we have little trouble in seeing a forced sale to the most powerful family. Before we become too angry at the Dominicans, we need to take into account that they really were a great ethical force in the culture—Savonarola was one of the monks in this convent later—and the Silvestrines were not. As they took the powerful Medici as an ally in their good cause, so do modern proponents of an ideal often gratefully accept alliances with less than ideal partners, without compunction.

Elsewhere in the chronicle, the removal of the older family's altarpiece, to be replaced by a new one for the Medici with their special saints, documents a "remodeling" most unusual when the discarded work was only thirty-eight years old. It is still to be seen in the small town church to which it was then sent—bearing an inscription of gratitude to the Medici, not to its official donors, the monks—and can be fascinatingly compared with its replacement. The painter of the new altarpiece and almost everything else was of course the community's own great artist, Fra Angelico, and it is a further irony to see him cited, between the water supply and the garden, as one of its great assets. The list here is the fundamental document of his work in the convent, but the chronicler gave almost equal attention to the chapel by the old-fashioned Bicci di Lorenzo. Original text in Archivio storico italiano, *Vol. 71, 1913, 12–16.*

From the Chronicle of San Marco.

[After the Dominicans had obtained the old church and the attached convent of the Silvestrine monks.] Thus in the year of our Lord 1438, a certain Florentine citizen called Mariotto de' Banchi, who, according to papers he showed, had the sole right over the main chapel or tribune . . . renounced all his rights in the said chapel, and gave it to the chapter or convent of San Marco, brother Cyprian above-mentioned being prior, out of a sense of piety, freely, spontaneously, and gratis, so that it could be enlarged in structure, as is on record in a public document in the hand of a certain Ser Giovanni del Colle, notary in Florence.

The aforesaid chapter and convent then conveyed and donated the said chapel to the aforesaid citizens the brothers Cosimo and Lorenzo [de'Medici] who, recognizing the liberality of the said Mariotto, freely conveyed and gave to him five hundred gold ducats. And so they began to repair and rebuild the said chapel. . . .

At the same time, brother Cyprian still being prior, the painting of

the high altar, which was large and beautiful, adorned with many figures and worth about two hundred ducats, was given by the monks to the convent of our order in Cortona, the aforesaid brother Cyprian being especially active in this, on which he had the Medici arms and the names of the said Medici placed, nor was the painting which is now on the high altar yet finished.

[1439 and after] . . . And note that certain special distinctions are to be seen in the building, among which the highest place belongs to the library . . . the second distinction belongs to the reciprocity and dovetailing arrangement of the dwelling areas . . . and to this contribute the many walls in logical places, both for providing water for the use of the brothers and for collecting the rainwater.

The third distinction is to be found in the paintings. For the altarpiece of the high altar, the figures of the chapter house and of the first cloister, and of all the upper cells, and of the Crucified in the Refectory, are all painted by a certain brother of the order of preachers and of the convent of Fiesole who was held to be the finest master in the art of painting in Italy, who was called brother Giovanni di Pietro of Mugello, a man of complete modesty and religious life.

The fourth distinction is the garden. . . . The fifth distinction is the delightfulness of the dwelling areas both above and below; the convent always seems to smile upon all who enter.

. . . In the year of our lord 1442 in January, on the solemn feast of the Epiphany, though the convent was not completely built, the church was consecrated, by order of our sacred lord Pope Eugene IV, by a certain cardinal bishop of Saint Marcellus, named Nicholas, called Cardinal Capuano, to whose solemn mass came the aforesaid supreme pontiff with the whole college of cardinals and a great multitude of bishops and prelates of the church of God, and a whole crowd of people, and the high altar was consecrated by the said cardinal in honor of saints Mark the evangelist and Cosmas and Damian, and there was also consecrated the altar of the chapel next to the choir, which is called of the Martini, painted throughout with the history of our Lady the Virgin Mary, and it was named in honor of the Assumption of the same Lady, and so too the whole chapel is named, and it was consecrated by a bishop who is a member of our order. . . .

Ciriaco d'Ancona in Search of Greek Antiquities

Ciriaco (ca. 1391–ca. 1455) after traveling on business to the Balkans for several years, developed an intense passion for Greek relics and became an eccentric antiquary. On numerous trips he kept diaries of his finds, in a not quite classical Latin, which he then eagerly transmitted

to humanists in Italy. Of his original notebooks only the diary of 1447–
1448 remains; the rest have been reconstructed from many copies, and
the process is not yet complete. It is rare for him to describe sculpture, as
he does in that diary, for inscriptions were his real specialty. Yet the
enthusiasm suggests how many people felt. At this time Roman finds were
commonplace, and usually limited to coins, gems, and sarcophagi; it was
the sensational finds of the following century along with a genuinely
Roman taste among artists that afterwards transformed matters. In a
passage from an Italian travel diary of Ciriaco's, we see one of the rare
contacts between artists and scholars.

Letter from a ship off Crete, November 1445: original text in *Proceedings*
of the British Academy, Vol. 45, 1959, 39–40.

. . . Also, I report something really remarkable to you, that diligent
captain Giovanni Delfino had shown me many coins and precious gems,
and when I spent the whole night with him in his quarters he showed me,
among other relics of the same kind, a noble incised crystal seal, the size
of a thumb, with the image of Alexander of Macedon, bust length, hel-
meted, by the marvelously skillful hand of Eutyches, in high relief. And
for adornment of the shining helmet there are two ram's horns on the
forehead, the undoubted symbols of his father Jupiter Ammon, but with
twisted horns, and at the peak a tiara seems to support those swift hunt-
ing Molossian hounds, on both sides, and under the helmet is the deli-
cate prince, with the greatest beauty of art, with curls on both sides,
dressed in a thin cloth traveling costume, with elaborate designs at the
top, appearing to have moved his right hand, so that he is bare to the
elbow, with the costume chastely held out from the edge of the chest.
The face, with an admirable gesture and royal appearance, sharply di-
rects its glance, and seeks to show living features in the gleaming stone,
and heroic lordliness. When you hold the thick part of the gem to the
light, where the breathing limbs are seen gleaming in their solid corp-
oreality, in shining glassy transparent shadow with marvelous beauty, we
learn the master of this exceptional object from the ancient Greek letters
inscribed on it at the top.

* * *

From the Ciriaco diaries, 1433 (?); original text in E. Muentz, *Les Col-*
lections des Medicis, 1888, 3.

[When in Florence] in the meantime, along with Carlo Marsuppini,
having seen his choice library, with the ancient coins and images, they
saw the representations of the priest of Lupercal carved by Pyrogoteles
out of an agate gem on a seal, and of Mercury with his winged sandals in
a bronze image, and many precious objects of the same type, belonging to
very rich Cosimo, and at the noble sculptors', Donatello's and Lorenzo's,

a good many old things, and new ones produced by them, images of bronze and marble. . . .

* * *

From the Ciriaco diaries, 1448; original text in *Miscellanea Cerrini*, 1910, 228.

On March 23, the day before Easter, we revisited Nauplia, and with great pleasure saw our good friends again . . . and on the next day, in case any relics survived to the present time of the destroyed city of the Myceneans, we first observed many things in the Argive plain, notable monuments, and among the better ones not a few very beautiful reliefs of images in white marble, formerly from the very ancient temple of Juno, among the more remarkable works of Polycleitos, as may be believed, later transferred by Christians to be an ornament for the church of our religion, on whose first, semi-destroyed stone, the most outstanding one, we found this ancient epigram in Latin [text follows].

Michele Savonarola on the Fine Men of Padua

Michele (ca. 1385–1464) was a physician as well as a writer on many subjects. After moving away from Padua in 1440, he wrote a little book in 1447 expressing his love for his city. In praising its outstanding men, he wonders whether he is justified in including painters, since they are too manual and not theoretical enough. (Earlier he had worried about placing doctors after lawyers and historians after poets, for similar reasons.) He finally decides to include them at the end, because they can be considered mathematicians. We thus learn that the new interest in perspective was motivated not only by scientific concern with real space, but also helped to give artists the higher social status they were seeking, as we know from records usually noticed separately. It did so by linking them with theoretical enquiry, not merely handicraft. The resulting group biography of painters is the earliest anywhere outside Florence, appropriate when we recall that at this date Padua had begun to be influenced by the new Florentine Renaissance art in the work of visitors like Donatello and several painters. The Paduan list of artists differs by including visitors, not only natives. We learn, in another passage, why Michele was tempted to include the painters. It explains that he was an admirer of painting, and also gives an unexpected insight into the role of Padua as a training center. The fact that young artists went for training to a center far from their homes (as if to a university) runs against the usual notion that apprenticeship to a master in one's city own was the norm. Here the allusion is no doubt to the school of Squarcione, a significant

stage in the shift toward the art school. Original text in L. Muratori, editor, Rerum Italicarum Scriptores, *Vol. 24, 1902, pp. 44, 50.*

From *On the Lordly Adornments of the Royal City of Padua,* 1447.

. . . I turn at last to the glorious skilled craftsmen, and the men illustrious in their art, whose knowledge is not remote from philosophy, and is the application of the mathematical arts. These are the painters, to whom it is given to know the outlines of the figures and the projections of the rays; as their knowledge of perspective is famous, so too it may be demonstrated by them as practitioners.

In this category our city had two who were famous, Guariento and Giusto. Their fame is exceedingly bright still, because of their marvelous and wonderful pictures. Guariento painted with his own hand, in magnificent fashion, the overwhelming and very grand room of the most serene Venetian state, which is called the Great Hall, in a wonderful way. Having a close look at it is regarded with such eagerness that on Ascension day, when admission is open to all, there is no hour of the day when it is not filled with an innumerable crowd of men of various countries. So fine is the delightful appearance of the admirable figures, and the admirable matter of the merely painted impression, that no one wants to leave.

Then Giusto painted the very large space that the Paduans call the Baptistery. For in this place, on a holy day when the Paduan clergy are assembled, baptism is done and the little children are baptized. And the charming appearance of the figures, composed with great art, is such that for those who come in it is disagreeable to leave. It shows the Old and New Testaments, with the greatest richness.

And since mention has been made of illustrious and famous men, and outsiders are found in addition to local men, I thought to add to these painters those illustrious and famous ones whose glorious fame has flourished in great part through the works they left in our city. And first of all I will speak of Giotto the Florentine, who was the first who rendered figures modern, in a marvelous way, after the old mosaics. His leadership in art was such that he is considered the king of all the others absolutely. With his own hand he painted the splendid big chapel of the noble Scrovegni [the Arena chapel] for a great price, where the images of the New and Old Testament seem living. He also decorated the Chapter House of St. Anthony, with the result that there is much attendance at these places, to see the painted figures. And the dignity of the city so impressed him that he spent a large part of his life in it, so that he might live forever through the glorious figures that he thus left in the city.

We give second place to Jacopo Avanzo of Bologna, who adorned the admirable chapel of the noble Lupi family as if with living figures. The third to Altichiero of Verona, who skillfully decorated the little

church of St. George, of the Lupi family, near the large temple of St. Anthony. And finally we give no little honor to Stefano of Verona, who illustrated a chapel with extraordinary miracles of our glorious Anthony, with figures that are as if moving, in a wonderful way. These, the illustrious men in their art, adorned our glorious city with their paintings, and it was made a more famous school of painters.

. . . Thus our city owes very much to the university. Nor do I belittle the university [*studium*] of painting; it provides a particular embellishment for our city, as it is to be associated with the study of letters and the cultivated arts more than the other arts are, as it is a part of perspective, which deals with the projections of rays. And this is a part of philosophy. Giotto in his glorious paintings, beautiful and of astonishing quantity, that prince of painters, lived in our city, as did four others of whom mention was made above. And painters flock from every part of Italy to see them, and youths come, eager for this study, that they may become better informed and then return home. I will not omit an amusing incident. An industrious youth from Naples came to Padua to absorb and learn this art, and when I asked him a bit about his studies, which I love, he answered after much else that the fame of our city would never have spread any farther than the Venetian lagoon if the illustrious painters named had not illuminated the glorious fame of the study of painting. To whom I, smiling, replied, Then you put it in great peril, for you put it in the hands of fools, who, if they liked, might destroy their figures by breaking them up, and by this destruction destroy that fame just as they are the cause of it.

Playing Cards for the Duke of Milan

Several sets of painted and engraved tarot cards survive from north Italy in this period, despite the exceptional likelihood of loss of such objects. They play a marked role in the oeuvre of several painters and are striking to us because the pictorial imagery is so unlike what we regard as usual in this period. This text from the biography of a duke helps to clarify how they came into being. We have met the author, rewarded for this book with a medal. Original text in L. Muratori, editor, Rerum italicacum scriptores, *Vol. 20, Part 1, 1928, 323–24.*

From the Life of Filippo Maria Visconti, Duke of Milan, by P. C. Decembrio.

Filippo Maria from youth was in the habit of playing games of various kinds. Sometimes he exercised with the spear, sometimes with the ball, but chiefly played that type of game which uses painted images, to which he was so immensely attracted that he bought a whole set of them

for 1500 gold pieces, the person responsible being primarily his secretary
Mariano of Tortona, who arranged for the images of gods, and figures of
animals and birds dependent on them, with the greatest intelligence.

Niccolò della Tuccia's Portrait Intrudes in Sacred Images

*Every town had a chronicler or two, many with individual quirky
interests. In retelling events of Viterbo, the chronicler Niccolò della Tuc-
cia (who had started his book in 1434) shows a unique interest in a
phenomenon not otherwise reported so early, though common—the way
in which traditional religious narrative paintings came to include specific
portraits of contemporary worthies. (See the slightly later report by
Michelangelo di Cristoforo.) This phenomenon fascinated scholars of
later ages, when they looked for authentic portraits of famous characters
in history and claimed to find authentic features of those persons; this
temptation is still strongly with us. Niccolò's concern with it in his own
case is so strong as to show us two stages. The first is the transformation
of the traditional "Madonna of Mercy" votive image. This had shown
the Virgin spreading her cloak wide, giving refuge under it to kneeling
devotees, who represented all the people of the world. Artists often
showed this by painting equal numbers of men on one side and women
on the other, and by putting them in the costumes of different social
groups, clergy, kings, etc. In Niccolò's case, instead, the people protected
are the specific individuals who ordered the painting, and, like the large
majority of true portraits of the period, are all male. The phenomenon
of a votive image ordered by a committee of public officeholders, honor-
ing the current members, was already old. Here reality goes further, in-
cluding the committee's servants, anticipating later types like "Cardinal
so-and-so with his secretary" or Rembrandt's* Syndics of the Cloth Hall*.
Niccolò's second stage is the well-known case of a fresco of a saint's life,
which includes portraits in the crowd of spectators. This seems to have
first appeared just about 1460 in works of several artists (Gozzoli, Lippi,
Piero della Francesca) and is first recorded here. An unexpected point is
that it was the artist's own idea. Original text in* Cronache e statuti della
citta di Viterbo*, 1872, 67, 97.*

From the *Chronicle*

When 1458 came, I, Niccolò della Tuccia, the writer of the chron-
icle, was made one of the city council, an office that came to me by votes
in the ballot box, and the office was vacated at New Years. And, so that
anyone so wishing may know and recognize what I look like, I will make
mention here that in the said council term, in January and February, we
had a figure of Our Lady made for the altar of the chapel of the honor-

able councilors, in a panel, in which we were all painted from life, according to our functions. In it there are, under the mantle of the blessed figure, seven persons on each side. Thus on the right the Virgin's prime supporter was Mr. Pier Filippo de Marturellis, of Spoleto, lieutenant and governor for the Holy See, with a red cap and blue gown brocaded with gold. A serving man painted behind him was called Ursino, son of lawyer Pandolfo di Caponi of Urbino, with a red cap, with flaps on it, on his head. The four priors on that side, the one just below the lieutenant was called Battistino di Piovicca of the St. Peter's Gate, the one behind him, dressed in sky-blue with a big hat, was called Pietro Antonio della Sterparella di Pianscarlano, and the one below Battistino was called Valentino della Pagnotta, and lived near the fountain of S. Lorenzo. The one beneath Pietro Antonio behind Valentino was called Stefano di Santoro, shoemaker, and lived in the Piazza near San Silvestro. Battistino was a gentleman, Pietro Antonio and Valentino were working men.

On the other side of Our Lady the person opposite the governor was Jacopo Oliveiri di Catalogna, priest, spiritual treasurer for the Holy See. The youth behind him was called Arcagnolo di Sconciliati of Viterbo. The one below the treasurer, with a red cap and a blue-green robe, was Pacifico di Nardo, druggist, and lived near the crossroads of San Niccolò della Vascella, and the one behind Pacifico was called Battista del Pecaraio, leather tanner, and lived opposite the church of S. Silio. The one below the said Battista was called Petruccio alla Silia di Malutto, silk worker, and lived in the Piazza of San Faustino. The one nearest the left foot of the Virgin, with a big red hat and peacock cloak, was taken from the appearance of me, Niccolò above-named. And so, let anyone who wants to know such things give thought to this panel, and my business was being a merchant, and I lived near the gate of San Mattia della Botte, in a house with a courtyard and a small fountain, which courtyard and fountain and stairhead above it I the above-said Niccolò had rebuilt. The little boy behind Battista was called Giovanni di Giovanni di Picca, nephew of master Valentino painter of the said painting, and the one behind is Pierantonio son of Bartolomeo del Rossolino. . . . I have made a record of the figures thus made, not out of pride or vainglory, but only in case any of my successors wishes to see me, he can remember me better thus, and my soul may be commended to him, and likewise the writer for those who will read this book, which has been copied out by me.

* * *

1469, between April 18 and October 30

. . . The aforesaid Nardo [Mazzatosta] had an honorable chapel built with his own money in the church of S. Maria della Verità, where there is an image of Our Lady, and painted and adorned by the hand of master Lorenzo, son of Jacopo di Pietro Paulo of Viterbo, dwelling near the little gate that goes to the church of the Trinity in the San

Faustino valley. In the chapel painted and decorated there is, among the other figures, the story of the most glorious mother, and this story is on the left hand when you enter that chapel, where it is seen that this glorious Virgin receives a ring from Joseph, where there are many youths drawn from life. Among these, on the side where the glorious Virgin stands, certain women are painted, of varying types, and behind these women is one dressed in black, in the guise of a widow, and behind there the said master Lorenzo wished to paint me, and draw me from life, and so he did. Where you will see a man of advanced age, sixty-eight and a half years old, or thereabouts, dressed in blue-green, and with a cloak and a round hat and black hose. And this is made in my likeness, done on April 26, 1469. And those persons who will want to read my writings and know me, come to see that place. The other figures are made in the likeness of others, whom at present I do not record.

Pope Pius II Describes a Procession and Its Adornments

Trained as a humanist, Enea Silvio Piccolomini (1405–1464) was always active as a writer and when he became Pope Pius II recorded his own reign in a form between a diary and a biography; it is still the only autobiography by a pope and is decidedly flattering to its subject. Grand staged events play a large role in it, as do the pope's travels and his reception. It is worth underlining that works of art and artists play virtually no role in this very long work, or in his other works, despite his involvement both with the furtherance of religion and with culti- vated refinement. This is a warning against our tendency to think that Renaissance people, especially leaders of society, spent their time with the works of art which we find the most interesting product of their age. In 1462, Pius was in Viterbo, and a grand procession was organized for the Feast of Corpus Christi; his description is one of the most detailed and vivid we have of these temporary art forms. Among other fascinations it shows the tendency to blend paintings and posed groups of actors on the same level of reality, and also the completely unsystematic, meaning- less relation between one display and the next; each person did just what he wanted. Since it is hard to imagine that any such displays were more official or more expensive than this one, this randomness of the series may never have been superseded in the period. Original text in the very rare edition of 1584 only; accessible in translations, including an English one, Smith College Studies in History, *Vol. 35, 1951, 55ff.*

From *The Commentaries*, Book VIII.

. . . Meanwhile, since the solemn feast of the most holy Body and Blood of Christ was near [June 17], which every year is observed in the Christian world with the greatest devotion of the faithful, the Pope gave

orders that it should be carried out with the greatest reverence possible, and exceptional honors. For this purpose he gave orders first of all to clear the street that crosses the town from the Castle to the Cathedral, which was filled up with many objects, and disfigured with wooden porticoes. . . .

Then the Cardinals were invited to choose each a part of the street to cover and adorn with cloths. The rest was divided between bishops and officials of the curia. . . . The Pope had a marvelous tabernacle constructed, with curtains of various colors, hanging from beams erected then and there by many ropes. Behind these he built an altar, adorned with tapestries, hanging on both sides, and placed on it many marvelous works of art, which naturally drew the gaze of the spectators. There was also the vestibule . . . and nearby a room with a divan covered with purple, and ancient tales woven in silk, wool, and gold, and portraits of illustrious men, and various figures of wild beasts.

Many arches of flowering branches were built over the street . . . in the middle, opposite the tabernacle, a triumphal arch was raised, with the figures of the cardinal virtues, and windblown flags with the insignia of the pope, kings, and cardinals; the walls were covered with varicolored carpets or flowers. The Pope celebrated vespers [on the eve of the feast] in the tabernacle . . . the sun was still high, and its rays, penetrating the woolen curtains, gave it all the colors of the rainbow, and transformed it into a heavenly seat and the dwelling of the All Highest, while the singers intoned sweet hymns like angels, and the lights, placed with marvelous art, seemed the stars of heaven. . . .

The following day at dawn, the Pope coming out of the castle with the Cardinals . . . took the Sacred Host from that altar and proceeded toward the Cathedral. Many people had come from neighboring places, either drawn by the promised indulgences or to enjoy the spectacle. The piazza and the street were packed. . . . When the part decorated by the Pope was passed, that of the Cardinal of Rouen began, then that of the Cardinal of Coutances and him of Albret, who, according to the custom of their cities, adorned the walls of the houses with the cloths called arrases, and constructed altars rich with gold and silver objects and with much incense burning. Then came the houses decorated by the Referendarii; under an altar which they built high up, they had placed a youth representing the Savior, who was sweating blood, and from a wound in his breast was filling a cup with the blood that brings salvation to the soul, and they placed there winged children, who were singing epic or elegiac verse composed by poets not without merit.

Then came the Cardinal of San Sisto, who, as befitted his churchly dignity, represented Our Savior's Last Supper, seeking to reproduce the Savior with his Disciples and the institution of the Sacrament in memory of the passion and perpetual defense of the human race against diabolical

temptation, and St. Thomas Aquinas in the act of dispensing the solemn Sacrament of the Eucharist.* Right after him, the Cardinal of Mantua adorned a long stretch of road with famous stories, which very skilled weavers had represented on very rich cloths. To these succeeded the Cardinal of Porto, in whose section a huge dragon and many monsters of malign spirits seemed to give off horrible threats, but as the Pope went by an armed soldier dressed like the Archangel Michael cut off the beast's head and all the demons fell down, barking the while. The sky was covered as if by a cloud, with a reddish cloth, and on the wall was stretched leather stamped with gold flowers in the Spanish style . . . [more altars with singers] Then began the part adorned by the vice-chancellor, which extended seventy-four steps. A rich purple curtain enclosed statues, and living scenes of stories, a decorated chamber, and a precious bed, and a fountain which spouted not only water but also excellent wines through various pipes. When the Pope approached, two boys came forward singing as sweetly as angels. . . . [Figures dressed as five kings first bar the Pope, then bow to him; trumpets and other instruments play.] While the Pope passes, a wild man leading a lion, with which he often fights, comes before him. On the whole piazza around the fountain there was a high and rich canopy of precious cloths . . . insignia of Pope Calixtus and the Borgia who had been prefect of the city; at the sides hung tapestries, very rich both in material and in the skill of the workmanship, which blocked the view and delighted the mind, not only of the ignorant crowd, but of connoisseurs too. At the exit a triumphal arch was built like a fortress, occupied by armed soldiers, who, imitating thunder with bronze bombards, struck terror into the passers-by. The Cardinal of Santa Susanna [had a flowered fountain which spouted wine, a perfumed altar, statues which sang, and a choir with instruments, all under a sky-colored cloth].

Niccolò, cardinal of Teano . . . was allotted the piazza where the magistrates' houses are. He covered this with a white and blue cloth and decorated it with tapestries on all sides, then he raised a row of arches covered with green ivy and many kinds of flowers, and above every column was seated a boy representing an angel. There were eighteen boys who, like angels in their faces, voices, and costumes, sang sweet songs in turn, as they had been assigned. In the middle of the square he reconstructed the tomb of Christ, the model of the one in which Our Life, in the Lord, slept for us. Around soldiers lay in deep sleep, as if dead, and angels stood watchful, to prevent the tomb of the Heavenly Bridegroom from being violated.

* The Cardinal of San Sisto, a Dominican, a very rare case in this century of a monk becoming a cardinal, here pays homage to the great Dominican St. Thomas, the theologian most associated with the liturgy of the Eucharist, and in the process produces an atypically churchly section of the display.

Gentile Bellini's Trip to Constantinople

Of special interest in this account is the picture of Sultan Moham-
med II, the imposing figure who had conquered Constantinople in 1453
and was to die two years after these events. Reference to paintings of
sexual themes is not found in any other documents of the period.
Original texts in L. Thuasne, Gentile Bellini et Sultan Mohemmet II,
1888. 67–68.

From the *Summaries of Venetian History,* by Marino Sanudo, August 1,
1479.

There came an ambassador from the Turkish Ruler, a Jew, with
letters. He writes the City Council to send a good painter, and invites the
Doge to go and attend the wedding of his son. He was answered thank-
ing him, and was sent Gentile Bellini, the best of painters, who went with
the East-bound Galleys, and the Council paid the expenses, and it left
September 3.

<p style="text-align:center">* * *</p>

From the *Turkish History 1429–1513,* by G. M. Angiolello and others.

Sultan Mehmet was a clever man, he loved talent and had people
read to him. He was very cruel. He loved gardens and took pleasure in
paintings, and therefore wrote the Illustrious City Council that it should
send him a painter. And Master Gentile Bellini, most expert in the art,
was sent, whom he received cordially. He wanted him to make a drawing
of Venice, and he drew many people, and so became welcome to the
ruler. And when the Ruler wanted to see someone who was said to be a
handsome man, he had him drawn by the said Gentile Bellini, and then
saw him. . . .

Several beautiful paintings were made by the said Gentile Bellini,
especially sexual themes, in some beautiful works, so that he had a great
quantity of them in the seraglio. And when his son Lord Bajazet suc-
ceeded him, he had them all sold at the bazaar, and they were bought by
our [Venetian] merchants. And Bajazet said that his father was the
master, and did not believe in Mohammed, and in effect it was so. . . .

Luca Landucci on the Passing Scene in Florence

The druggist Luca Landucci, (ca. 1436–1519) is one of many Floren-
tine small businessmen who kept a notebook of interesting things which
happened in town. Most of his accounts are political and military; quite
a few report new buildings. In the years before 1500, just three refer to
painting and sculpture, and all are quoted here. He is often graphic, as in

his later account of installing Michelangelo's David, *but he is also un-
sophisticated. Works of art enter his awareness only as public shows or
because of their prices. Luca as a philistine may serve to cure our tempta-
tion to think all Florentines of the Renaissance understood their art.
Like many chroniclers, he begins with a summary of how things were at
the time when he began writing. It is interesting that his list of famous
Florentines is, like Manetti's, dominated by artists. Yet it is also notable
that his statement about Donatello is incorrect; the work mentioned is
actually by Bernardo Rossellino. By a normal pattern, a very conspicuous
work, the Bruni tomb, was attributed to the most famous artist; the false
report serves as a warning against treating near-contemporary attribu-
tions as reliable. Original text in the edition of 1883, reprint 1969, pp.
2–3, 60, 114.*

From the *Diaries.*

In the neighborhood of 1450, notable Florentines included [the
scientist Paolo Toscanelli, Cosimo de' Medici] Donatello, a sculptor, who
made the tomb of Master Lionardo d'Arezzo which is in Santa Croce.
Then Rossellino became notable, a tiny little man but big in sculpture,
he made that tomb of the Cardinal which is in San Miniato, in that
chapel on the left [an organist, a singer]. Master Andreino degli Im-
piccati [i.e., Castagno] painter, Master Domenico da Vinegia, painter, and
Master Antonio and Piero his brother called del Pollaiuolo, goldsmiths,
sculptors, and painters, became notable. . . .

December 22, 1490, the chapel of S. Maria Novella, the main chapel,
was unveiled. Domenico del Grillandaio had painted it, and Giovanni
Tornabuoni had it painted, and he made the wood choir going all round
the chapel, and the painting alone cost 1000 gold florins.

. . . And on 11th [of August, 1495] all day, at Or San Michele, they
sold Piero de' Medici's things at auction, bed covers of velvet, gold em-
broideries, many and various items of painting, pictures and many fine
things, to show how in such matters fortune is fleeting, etc.

Niccolò dell' Arca's Strange Personality

*A chronicle of Bologna was kept by the Dominican monk Fra
Girolamo Borselli (1432–1497), who introduced this sketch of Niccolò
dell'Arca under the year 1494, as an obituary. Since Niccolò had worked
for years in this monk's own church, on the tomb of St. Dominic, the
comments are direct observations, not merely statements about a town
celebrity. This is perhaps the earliest psychological profile of an artist.
(Hence it was reported, as an introductory example, in a chapter on
"Florentine Eccentrics of the Sixteenth Century" in a book on the per-*

ceived character of artists.) However, it was not rare at this time for profiles of eccentric citizens of other professions to be written, and thus it is clear that at the time artists were not thought of as a more eccentric group than others (if anything, they were considered less so.) Rather, we see artists participating in the general growing consciousness of individuality. This paragraph is also notable in that all the sculptures mentioned survive, just as in the case of Ghiberti's autobiography, suggesting a much more favorable ratio of survival than the one often assumed which allows for a majority of works to have been lost. Original text in C. Gnudi, Niccolò dell'Arca, 1942, 67.*

From the *Chronicle.*

Nicholas, who came from the province of Dalmatia, but was brought up in Bologna from his youth, a man most accomplished in the art of carving and making figures, both in clay and marble, died in misery, and was buried in the church of the Celestines. He executed the marble tomb of the Blessed Dominic, the figure of the Blessed Virgin Mary which is set in the front wall of the palace of the lords councilors. He did not want to train any pupil, nor to teach anyone. He was fanciful and uncivilized in his ways, and was so rough that he drove everybody off. Most of the time he was in want even of necessities, but he was thickheaded, and wouldn't accept the advice of his friends. He had a wife of the Boaterii family, and one son and one daughter, and left a marble figure of St. John the Baptist to be sold for five hundred golden ducats. On his tomb this epitaph is written: He who gave life to stones, and formed breathing images with his chisel, now, O Nicholas, Praxiteles, Phidias, Polycleitos adore thee and wonder at your hands.

Botticelli, His Brother, and Savonarola

Botticelli lived with his brother Simone Filipepi, who was a chronicler, and a devotee of the preacher Savonarola (see excerpts from his sermons on pages 155–159). Here Simone records an incident a year after Savonarola was burned to death, after being convicted of disobedience to the Pope. Doffo Spini had been a leader of the anti-Savonarola party or mob. This is the only contemporary record even suggesting how Botticelli reacted to the event. It is often said that he was a Savonarolan too, but the only evidence usually mentioned is the later statement by Vasari (not to be taken as certain) and either one or two of his paintings where Savonarolan imagery can be found (in which the patrons' wishes may have been primary). Against that is the fact that during the years of

* R. and M. Wittkower, *Born under Saturn*, 1963, 68.

Savonarola's power Botticelli maintained close ties with his old patron,
Lorenzo de' Medici the younger, who at various times was either neutral
or anti-Savonarolan. This text suggests that he was sympathetic but not
a partisan. Original text in H. Horne, Botticelli, *1908, 362.*

From the *Chronicle.*

 I will here copy out a memorandum I made on November 2, 1499.
About the third hour after sunset, my brother Alessandro di Mariano
Filipepi [Botticelli], one of the good painters our city has had in these
times, in my presence, being in the house by the fire, told me how that
same day in his shop he had been in conversation with Doffo Spini about
the fall of Fra Girolamo [Savonarola]. And, in sum, because he knew that
the said Doffo had been one of the leaders of those who had always put
the question to him, Sandro asked him to tell him the simple truth, what
sins they had found in Fra Girolamo, to make him deserve such a vile
death, whereupon Doffo answered him, "Sandro, I'll tell you the truth,
we never found any venial sin in him, let alone mortal." Then Sandro
said to him, "Then why did you make him die so vilely?" He answered,
"It wasn't me, but Benozzo Federighi who was the cause, and if he hadn't
had that prophet and his companion killed, but had sent them back to
San Marco, the people would have taken us and cut us to pieces, the
matter had gone so far that we decided they must die to save us." Then
other things were said between them, which need not be repeated.

Index

(with the collaboration of Priscilla Bain Smith)

Aaron, 165
Abbiategrasso, 123
Abel, 86, 164
Abraham, 87, 164
Adam, 86, 102, 164
Adimari, Guglielmo, 26
Aeneas, 57, 190, 191
Agnes, St., 146
Agnolo of Piazza of S. Trinita, 183
Agostino, sculptor, 183
Alberti, Leon Battista, 6, 40, 51, 88, 102, 110, 112, 140, 149, 164, 185, 186, 191
Alexander the Great, 59, 67, 102, 166, 167, 207
Alessandra di Giovanni, Mrs., 45
Alessandro of the Piazza of the Frescobaldi, 183
Alfonso, King of Naples, 178
Altichiero, 209
Ambrogio of Milan, 99
Ambrose, St., 86
Ancona, 179
Andrea da Firenze, 152
Andrea Pisano, 82
Angelico, Fra, 5, 99, 138, 145, 147, 149, 152, 183, 185, 191, 196, 205, 206
Angiolello, G. M., 216
Anjou, Duke of, 82
Anthony, St., 28, 88, 89, 178
Antigonus, 64
Antonello da Messina, 99, 188
Antoniazzo Romano, 15, 16, 17
Antonino, St., 147, 155
Antoninus Pius, Emperor, 102, 180
Antonio, son of Mrs. Apolonia, 183
Antonio of Sarzana, 181
Antwerp, 110
Apelles, 70, 71, 74, 75, 94, 102, 179, 189, 190, 193
Apollonio di Giovanni, 183, 190, 191, 192
Aragazzi, Bartolommeo, 165, 166
Aragon, 178
Arca, Niccolò dell', 217
Ardizoni, Simone di, 11
Arezzo, 21, 170
Aristophanes, 33
Aristotle, 157
Asclepiodorus, 75

Assisi, San Francesco, 77, 78
Assisi, S. Maria degli Angeli, 77, 85
Athena, 63
Athens, 90, 179
Aulis, 59
Avanzo, Jacopo, 209
Avignon, 81

Bacchus, 13, 168
Badia a Settimo, 79
Bajazet, 216
Baldovinetti, Alesso, 183
Banchi, Mariotto de', 205
Barbarigo, Girolamo, 123
Barna, 82
Bartolo d'Antonio, stone carver, 30
Bartolomeo, administrator, 27
Barzizza, Gasparino, 163
Bellano, 188
Bellini, Anna, 36
Bellini, Gentile, 12, 23, 36, 99, 140, 141, 191, 193, 194, 216
Bellini, Giovanni, 99, 132, 141, 174, 186, 188, 194, 195
Bellini, Jacopo, 23, 24, 25, 28, 29, 35, 36, 140, 174, 175
Bellini, Niccolò, 29, 36
Bembo, Bonifacio, 124, 125, 126
Benjamin, 87
Benvenuti, Romano dei, judge, 24
Bernard, St., 43
Bernardino of Siena, 146
Bernardo, son of lawyer Silvester, 24, 25
Berri, Duke of, 107
Bicci, Master, 183
Bicci di Lorenzo, 205
Bicharano, Francesco, 163
Biondo, Flavio, 175
Boaterii family, 218
Boccaccio, 170
Boccaccino, 141
Boldro, Antonio, 183
Bologna, 4, 9, 76, 79, 129, 187, 209, 217, 218
Bologna, San Petronio (Church), 36
Bologna, San Procolo, 37
Bona of Savoy, 122

Bonamico, 79, 198
Bonannus of Pisa, 204
Borghesi, Jacopo di, 39
Borgia family, 215
Botticelli, 51, 99, 138, 139, 183, 193, 218, 219
Boucicaut Master, 107
Bracciano, 16, 18
Bracciolini, Poggio, 165, 167, 168, 170
Bragadin, Donato, 29
Bramante, 101
Bregno, Andrea, 99
Brescia, 22, 41, 42, 123, 177, 178
Brescia, Broletto, 179
Bruges, 98, 110, 117, 184
Brunelleschi, 29, 51 52, 84, 88, 140, 149, 150, 164, 183, 186, 191, 195
Brunelleschi, Filippo, 88
Bruni, Leonardo, 163, 164, 165, 168, 217
Bucephalos, 67
Bugatto, Zanetto, 120, 121, 122, 125, 139
Buglioni, Betto, 46
Burgundy, Duke of, 121, 138, 140

Caesar, 89, 100, 166, 167
Cain, 86, 164, 199
Calixtus III, Pope, 215
Calorino, 168
Calvi, Galeazzo, 36, 37
Cardinal Capuano, 206
Cardinals, 214–215
Caroli, Fra Giovanni, 117, 149, 152, 164
Carpaccio, 12, 193, 194
Castagno, Andrea dal, 99, 112, 191, 217
Castor and Pollux, 63
Catherine of Alexandria, St., 37, 39, 81, 146
Catherine of Siena, St., 145
Cavalcanti, Andrea di Lazzero, 30
Cavallini, Pietro, 79, 91
Cecilia, St., 146
Certaldo, 101
Charlemagne, 44
Chellini, Dr. Giovanni, 116, 117
Chios, 168, 184
Christopher, St., 177
Cicero, 179
Cimabue, 21, 76, 90, 102, 136, 152, 185
Ciriaco d'Ancona, 6, 179, 181, 206, 207, 208
Ciuffagni, Bernardo, 183
Colacio, Matteo, 188
Colle, Giovanni del, 205
Colle, Simone da, 84
Colleoni, Bartolommeo, 40, 153
Cologne, 82
Comus, 14
Consandulus, Salutius, 123

Constantine, Emperor, 76, 78
Constantino, 126
Constantinople, 184, 216
Copernicus, 174
Corella, Fra Domenico, 148, 149, 152
Cori, Domenico de', 3, 23, 107
Correggio, 133
Corte, Johanne Pietro da, 124
Cortona, 82, 206
Cosmas and Damian, Sts., 206
Cossa, Francesco del, 9, 123
Crédi, Lorenzo di, 40, 41, 47
Cremona, 125, 126
Cremona, Carlo da, 124
Crete, 207
Crivelli, Taddeo, 36, 37, 38
Crotona, temple of Lucina, 72
Cyclops, 57
Cyprian, Brother, 205, 206
Cyrus, 166, 167

Daedalus, 150
Dalmatia, 218
Daniel, 165
Dante, 43, 78, 80, 149, 152, 191
Darius, 102
Dati, Leonardo, 85
Dati, Leonardo di Pietro, 173
Datini, Francesco, 108
David, 87, 165
Decembrio, B. Uberto, 163
Decembrio, Pier Candido, 109, 210
Dei, Benedetto, 181, 182, 184
Delfino, Giovanni, 207
Desiderio da Settignano, 30, 99, 112, 192, 193
Diamante, Fra, 183
Diana, 69, 180
Dido, 69, 191
Domenico di Michelino, 183
Domenico Veneziano, 4, 5, 99, 112, 185, 217
Dominic, St., 37, 180, 217, 218
Dominici, Cardinal Giovanni, 145–146
Donatello, 25, 26, 27, 30, 52, 88, 89, 99, 107, 116, 117, 150, 168, 170, 171, 175, 178, 183, 185, 189, 192, 193, 195, 207, 217
Duccio, 82, 135

Efiso, St., 198
Egypt, 87, 165
Elijah, 165
Elisha, 165
Elizabeth, St., 146, 157
Elizabeth, Mrs., 43, 44, 45
England, 15

Epicurus, 83
Ercole, 99
Esau, 87, 164, 200
Este, Beatrice d', 139
Este, Isabella d', 14, 15, 139, 141, 142
Etruria, 76, 77, 79, 181
Eugene IV, Pope, 85, 205, 206
Eupompus, 97
Evander, 56
Eve, 86, 164
Eyck, Jan van, 98

Facio, Bartolommeo, 95, 123, 170, 175, 176, 192
Facchino, silversmith, 114
Faustina, 14
Federighi, Benozzo, 219
Federigo of Naples, 46
Feliciano, Felice, 179
Ferrara, 4, 5, 9, 10, 33, 109, 123, 172
Ferrara, Palazzo Schifanoia, 9
Ferrara, Dukes of, 9, 10, 109, 123, 141, 142, 171, 173, 174
Ferucci, Bartolomeo, 115
Fideli, Stefano de, 124
Fiera, Battista, 197
Fiesole, 145, 196, 204, 206
Fiesole, San Domenico, 145, 196
Filarete, Antonio, 27, 88, 89, 90, 149
Filipepi, Simone, 218
Filippo, Duke of Milan, 109, 178
Filippo di ser Giovanni, priest, 115, 116
Finiguerra, Maso, 112
Fioravante, 4
Fiore, Jacobello del, 28
Florence, 3–5, 7–9, 18, 23, 25–27, 29, 35, 40–43, 51, 77–79, 81, 84, 85, 89, 95, 101, 107, 108, 111–113, 126, 128, 130, 136, 138, 140, 147–149, 152, 157, 168, 171, 175, 176, 178, 181–185, 192, 195, 196, 203–205, 207, 208, 216
Florence: Annunziata, 149, 150, 183, 184, 196; S. Ambrogio, 41, 196; Badia, 35, 47, 77; Baptistry, 3, 25, 47, 82, 86, 126, 138, 149, 150, 164, 178, 182, 192, 195; Bartolini house, 183; San Benedetto, monastery, 136; Carmine, Brancacci Chapel, 125, 195, 196; Campanile, 82; Castellaccio, 45, 46; S. Cristoforo, 26; S. Croce, 47, 76, 217; Corso degli Adimari, 26; S. Egidio, 196; S. Felicita, 184; S. Giorgio, 77; S. Lorenzo, 27, 35, 88, 89, 137, 184, 196; S. Marco, 147, 155, 196, 204, 205, 219; S. Maria degli Angeli, 85, 196; S. Maria degli Ughi, 24; S. Maria del Fiore, 88, 117, 150, 157, 195, 196; S. Maria Novella, 29, 79, 111, 148, 152, 196, 217; S. Maria

Novella, Spanish Chapel, 152; S. Maria Nuova, 196; S. Martino, 184; Medici Chapel, 8; S. Miniato, 217; Murate, 196; Ognissanti, 26; Or San Michele, 79, 86, 89, 107, 149, 178, 195, 217; Palazzo di Parte Guelfa, 77; Palazzo del Podesta, 77; Palazzo Strozzi, 112, 117; Pazzi Corner, 45; Piazza S. Croce, 183; Piazza Frescobaldi, 183; Piazza della Signoria, 35; Piazza of S. Trinita, 183; S. Pier Maggiore, 184; S. Piero Scheraggio, 35; Porta Rossa, 184; S. Procolo, 81, 184; S. Reparata, 77, 82, 178; Servi Church, 45, 80; Soderini house, 184; S. Spirito, 5, 25, 78, 196; Tornabuoni house, 184; S. Trinita, 24, 176, 196; Via dei Balestrieri, 45; Via Larga, 137; Via Maggio, 184; Via del Proconsolo, 30 Via del Palagio, 184; Via San Gallo, 45; Via de' Servi, 45, 117; Via di Ventura, 45
Fontana, Giovanni da, 174
Foppa, Vincenzo, 22, 41, 125, 126
Forzere, Jacopo di, 183
Francesca, Piero della, 91, 95, 99, 185, 198, 211
Francesco da Valdambrino, 203
Francesco of Pistoia, 168
Francione, 184
Francis, St., 37, 78, 89
Frederick III, Emperor, 22, 39, 154, 177
Fruosino, 110

Gaddi, Taddeo, 78, 184, 198
Gadio, Bartolomeo, 124
Gaeta, 168
Gaiole, Giovanni da, 184
Galen, 72
Gallerani, Cecilia, 142
Ganymede, 63
Garda, Lake, 180
Gasperino, Gregorio da, 33
Gattamelata, 89, 178
Gellius, Aulus, 56
Genoa, 140, 141, 175, 184
Gentile da Fabriano, 23, 24, 99, 123, 148, 175–179
George, St., 89, 123, 134, 179, 195
George of Germany, 39
Geremia, Cristoforo, 118, 119
Gerini, Niccolo, 108, 109
Ghiberti, Lorenzo, 3, 25, 30, 52, 75, 76, 100, 107, 112, 149, 150, 152, 164, 170, 171, 178, 183, 186, 192, 195, 203, 204, 207, 218
Ghiberti, Vittorio, 99, 178, 183, 192
Ghirlandaio, Domenico, 99, 130, 134, 136, 139, 192, 195, 217
Giancristoforo Romano, 15, 16

Giotto, 47, 65, 75–78, 82, 90, 91, 102, 111, 136, 152, 185, 191, 199, 209, 210
Giovanni di Bertino, 112
Giovanni di Francesco, 183
Giovanni da Maiano, 44, 45
Giovanni of Padua, 180
Giovanni dal Ponte, 141
Giovanni da S. Stefano, painter, 183
Giovanni da Siena, 4
Giuliano, son of Andrea, 3
Giuliano di Nofri, 30
Giulio Romano, 122
Giusto d'Andrea, 100
Goliath, 87, 165
Gonzaga, Francesco, Marquis of Mantua, 14, 15, 129, 133
Gonzaga, Lodovico, Marquis of Mantua, 10–12, 16, 118–120, 129, 130–132, 134, 140
Gonzaga, Monsignor Sigismondo, 134–136
Goro, 3
Gozzoli, Benozzo, 8, 9, 101, 110, 198, 199, 211
Greece, 79, 90
Gregory, St., 44
Guariento, 209
Guarino da Verona, 171, 172, 186
Gubbio, 24
Guidalotti family, 152
Gusmin, 82
Guzon, 34

Hadrian, Emperor, 102, 180
Ham, 87
Hannibal, 89
Helen, 63, 187
Henry Fearless of Germany, scribe, 36, 37
Heraclea, 193
Herod, 85
Hercules, 56, 155, 187
Hesperides, 187
Holbein, Hans, 121
Homer, 66, 71, 190
Horace, 176
Hyacinth, 85

Innsbruck, 139
Isaac, 84, 87, 164
Isabella of Milan, 122
Isaiah, 165

Jacob, 87, 164, 200
James, St., 32, 37, 79, 116
Janus, 155
Jeremiah, 165
Jericho, 87
Jerome, St., 43, 116, 138, 148, 178, 196

Job, 198
John the Baptist, 37, 47, 82, 85, 134, 145, 177, 218
John the Evangelist, 37, 39, 47, 136, 145, 157
John XXIII, Pope, 25, 150
Jordan, River, 87, 165
Joseph, 165, 213
Joseph, St., 39, 87
Joshua, 87, 200
Jove, 59, 63, 71, 194
Juno, 155, 168, 190, 208
Jupiter, 174, 179, 194, 207

Lamberti, Niccolò, 84
Landino, Cristoforo, 44, 185, 191, 192, 195
Landucci, Luca, 185, 216–217
Lapaccini, Giuliano, 204
Lapo, lawyer, 108, 109
Lawrence, St., 35, 37
Lendinara, Cristofano da, 189
Lendinara, Lorenzo da, 189
Leonard, St., 35
Leonardo da Vinci, 15, 43, 51, 99, 142, 193
Leoni, Leone, 142
Lepricino, 171
Lessandro da Pistoia, 183
Lippi, Filippino, 99, 139
Lippi, Fra Filippo, 5, 7, 8, 52, 99, 112, 125, 136, 139, 183, 185, 191, 193, 196, 198, 211
Lippo, Master, 183
Livy, 44
Lombardo, Pietro, 155, 188
London, 182, 184
Lorenzetti, Ambrogio, 80, 81, 147
Lorenzo di Pigniaro, painter, 183
Lorenzo da Viterbo, 212, 213
Lucca, 184
Lucian, 70
Lucy, St., 37
Lupi family, 209, 210

Maecenas, 137
Maiano, Benedetto da, 42–45, 195
Maiano, Giuliano da, 43–45, 112, 184
Malatesta family of Pesaro, 84
Malatesta, Pandolfo, 177
Malgise, musician, 129
Mammas, St., 116
Manetti, Antonio, 136, 184, 185, 195, 217
Mantegna, Andrea, 10–14, 31, 32, 94–96, 100, 110, 120, 122, 125, 129–135, 141, 170, 174, 179, 180, 188, 197
Mantegna, Francesco, 14–16
Mantua, 10, 11, 14, 15, 94, 118, 119, 122, 129, 130, 132–134, 177, 179; Camera degli

Mantua (*cont.*)
 Sposi, 129; San Francesco, 133; Santa
 Maria della Vittoria, 134, San Sebasti-
 ano, 135; San Simone, 135
Marcantonio, Father, 134
Marchesi, Pietro da, 124, 125
Marco del Buono, 183
Marcus Aurelius, 180
Mariano of Tortona, 211
Marius, trophies of, 102
Mark, St., 12, 195
Mars, 63
Marsuppini, Carlo, 207
Martelli, Bartolommeo, 7
Martelli, Roberto, 8
Martin V, Pope, 83, 85, 177
Martini, Simone, 81, 146
Martino di Bartolomeo, 21, 22
Mary Magdalene, St., 37, 39, 77, 155, 157
Masaccio, 25, 51, 52, 99, 138, 148, 183, 185,
 191, 195
Maso, 78
Masolino, 183
Massa, 81
Massaio, Piero del, 183
Massaio of the Animals, 183
Matteo di Giovanni, 38–40
Matthew, St., 85
Maximilian, Emperor, 139
Medici family, 34, 100, 101, 110, 136–137,
 151, 184, 205, 206
Medici, Cosimo, 5, 7, 137, 147, 151, 164,
 169, 205, 207, 217
Medici, Piero, 5, 8, 18, 136, 151, 217
Medici, Giovanni, 7, 110
Medici, Lorenzo, il Magnifico, 110, 118,
 126, 128, 133, 137, 138, 169
Medici, Lorenzo di Pierfrancesco, 169, 205,
 219
Melchior da Lampugnano, 124
Meleager, 63
Melozzo da Forlì, 99
Memling, Hans, 129
Memmi, Lippo, 81
Menabuoi, Giusto de', 209
Mercury, 207
Michael, St., 7, 89, 134, 215
Michelangelo, 15, 21, 31, 117, 217
Michelangelo di Cristofano da Volterra,
 198, 211
Michelino da Besozzo, 163
Michelozzo, 25, 26, 151, 165, 183
Milan, 11, 16, 41, 88, 95, 101, 121, 122, 124,
 130–132, 138–140, 142, 177, 184; Castle,
 124; Duchess, 120; Duke, 89, 90, 120–
 124, 126, 138–139, 142, 210
Milano, Pietro da, 32
Milo, 63
Minerva, 155, 168, 179

Mino da Fiesole, 34, 35
Mocenigo, Pietro, 155
Mohammed II, Sultan, 216
Montepulciano, 166
Moses, 87, 165, 200
Mugello, 196, 206
Murano, 154; Convent of St. Peter Martyr,
 154
Muses, 71, 172–173, 198

Naples, 7, 46, 77, 112, 114, 140, 175, 184,
 210; Castel dell 'Ovo, 77; King, 7, 175
Narcissus, 59, 110, 138
Nardo di Cione, 80
Nathan, 165
Nauplia, 208
Neptune, 180, 191
Neri di Bicci, 30, 31, 100, 101, 183
Nero, 85
Neroccio, 42
Neroni, Dietsalvi, 34, 35
Nestor, 63
Niccoli, Niccolò, 168, 169
Niccolò d' Arezzo, 84
Niccolò di Lionardo, prior, 137
Nimrod, 199
Noah, 86
Norsa, Daniele, 133
Novara, 11

Obizzi, Ludovico degli, 85
Ombrone, 193, 194
Orcagna, 79
Orsa, mother of Donatello, 26
Orsini, 18
Orsini, Cardinal, 112
Orsini, Virginio, 16, 17
Orvieto, 177
Ospedaletto, 139
Ostia, 17
Ottaviano, sculptor, 183
Ovetari, Imperatrice da, 32
Ovid, 153

Padua, 31–34, 77, 171, 174, 178, 180, 189,
 195, 208–210; S. Antonio, 77, 78, 85, 189,
 210; Chapter House, 209; Arena Chapel,
 77, 209; Baptistry, 209; Eremitani, Ovi-
 tari Chapel, 31; Great Hall, 209; Ora-
 tory of St. George, 210; University, 188
Pagno di Lapo, 27, 183
Palestine, 153
Palvini, Bastiano, 44
Parenti, Marco, 112, 113
Parrhasius, 189

Paris, 138, 140, 141
Pasti, Matteo de', 6
Paul, St., 37, 46, 79, 89, 138, 177
Pavia, 123, 124, 126, 130; Castle, 122, 126;
 St. James, 126; Count, 123
Perseus, 102
Perugia, 4, 5, 82, 111; Castle of Braccio, 4
Perugino, 99, 138, 139
Pesaro, 83, 84
Pesellino, 99, 116, 191
Pesello, Francesco di, 138, 191
Peter, St., 37, 79, 81, 139, 177, 195
Petrarch, 6, 88
Petronio, San, 37
Phaeton, 72
Pharaoh, 87, 165
Phidias, 59, 71, 174, 179, 187, 189, 193, 218
Philip, St., 37
Philostratus, 185
Phoebus, 102, 190
Piero, painter, 108
Piero, priest, 114–116
Piero, son of Master Francesco, painter,
 183
Pietro Antonio, woodworker, 189
Pinzino, Master, guide, 103
Pisa, 46, 79, 82, 196–198, 203, 204; Abbey
 of San Frediano, 46, 47; Baptistry, 82,
 84, 204; Campo Santo, 79, 197, 204;
 Cathedral, 204; Santa Maria a Ponte, 82;
 San Paolo a Ripa d' Arno, 79
Pisanello, 9, 99, 109, 173–175, 177, 179, 187,
 190
Pisano, Giovanni, 82, 204
Pisano, Nicola, 82, 204
Pistoia, 18, 82, 114, 116, 126–128, 168; S.
 Jacopo, 127, 128; Society of the Most
 Holy Trinity, 114–116
Pius II, Pope, 213–215
Pizzolo, Niccolò, 32
Pliny, 59, 97, 191
Plutarch, 59, 175
Poggio a Caiano, 18
Poliziano, Angelo, 70, 171
Pollaiuolo, Antonio del, 17, 18, 102, 112,
 183, 193, 217
Pollaiuolo, Piero del, 126, 127, 138, 192,
 217
Pollaiuolo, Simone, 47
Polyclitus, 85, 168, 179, 208, 218
Polyphemus, 57
Pontormo, 16
Portinari, Tommaso, 129
Posculo, Ubertino, 179
Potito, St., 198
Prato, 108, 156, 195, 196; San Niccolo, 109
Praxiteles, 59, 102, 168, 193, 218
Predis, Ambrogio de, 139, 140
Prisciano, Pellegrino de, 9

Prometheus, 174
Protogenes, 74
Ptolemy, 81
Pyrgoteles, 85, 207

Quercia, Jacopo della, 4, 25, 26, 84, 99, 203
Quintillian, 59

Rachel, 200
Ranieri, San, 198
Raphael, 94
Redini, Girolamo, hermit, 133, 134
René, King, 100
Riccardo delle Nostre Donne, 183
Rimini, 6, 186; Tempio Malatestiano (S.
 Francesco), 186
Rinuccini, Alamanno, 185, 191
Rizzo, Antonio, 99, 188
Robbia, Andrea della, 183
Robbia, Luca della, 149, 150, 183, 186, 196
Robert, King of Naples, 77
Roberti, Ercole de', 99, 141
Rome, 12, 13, 17, 18, 31, 55, 63, 76, 77, 79,
 100–102, 111, 112, 118, 120, 140, 149,
 155, 166, 168, 169, 171, 177, 184, 196;
 S. Agnese, 112; S. Cecelia, 79; S. Co-
 stanza, 111, 112; S. Crisogono, 79; S.
 Francesco, 79; St. John Lateran, 111, 177;
 S. Maria Maggiore, 111; S. Maria Sopra
 Minerva, 77, 196; S. Maria in Trastevere,
 79; Monte Giordano, 112; S. Paolo, 79,
 111; St. Peter's, 77, 79, 91, 111, 179;
 Vatican Palace, Belvedere, 13; Sistine
 Chapel, 88, 133, 139
Rosselli, Cosimo, 31, 43, 44, 47
Rossellino, Antonio, 30, 99, 192
Rossellino, Bernardo, 192, 217
Rossello, Master, 183
Rossore, St., 26
Rucellai family, 30
Rucellai, Fra Andrea, 30
Rucellai, Giovanni, 107, 110, 111, 164, 170
Rustichi, Giovan Francesco, 45
Rustichi, Marco, 203

Salimbene, Antonio, 141
Salmon, Pierre, 107
Salviati, tomb, 47
Samuel, 165
Samson, 110, 155
Sangallo, Giuliano da, 195
San Gimignano, 82; S. Agostino, 101
Sano of Siena, builder, 203
Sanseverino family, 199
Santa Croce, Cardinal of, 102

Santi, Giovanni, 94, 95, 129, 170, 175, 176, 192
Sanudo, Marino, 216
Saturn, 155
Saul, 87, 165, 200
Savona, 102
Savonarola, Girolamo, 152, 154–156, 163, 205, 218, 219
Savonarola, Michele, 34, 156, 175, 188, 208
Scheggia, lo, painter, 183, 195
Schmitt, Friar Felix, 153
Scipio, 100
Scopas, 102, 193
Scotti, Gottardo de, 124
Scrovegni family, 209
Sebastian, St., 46, 138
Sellaio, Benozzo del, 183
Serrestori, Giovanni, 47
Sforza, Galeazzo Maria, 122, 123, 138
Sforza, Ludovico, 139
Sforza, Ludovico il Moro, 139
Siena, 3, 4, 22, 23, 25–27, 29, 34, 38–42, 80–82, 84, 102, 107, 145–147, 170–171, 195, 203; Baptistry, 85; Cathedral, 25, 27, 81, 82, 102, 147; Altar of S. Ansano, 147; Works, 171; S. Domenico, 38, 39; Fonte Gaia, 203; Hospital of La Scala, 81; Loggia of St. Paul, 4; Palazzo Pubblico, 21, 22, 81, 203; Porta Romana, 81; Society of St. Barbara, 38
Signorelli, Luca, 52, 99
Sixtus IV, Pope, 17, 18, 36, 102
Sodom, 200
Solomon, 87, 164, 200
Spini, Doffo, 218, 219
Spinello Aretino, 21, 22
Spoleto, 196, 212
Squarcione, Francesco, 33, 34, 138, 208
Stefano, painter, 78, 198
Stefano of Verona, 210
Stephen, St., 37, 86, 178, 180
Strazzola, 193
Strozzi family, 80
Strozzi, Alessandra, 112, 117
Strozzi, Filippo, 112, 113
Strozzi, Giovanni, bronze caster, 26
Strozzi, Lorenzo, 111, 117
Strozzi, Palla, 164
Strozzi, Tito Vespasiano, 187
Suger, Abbot, 149
Sylvester, St., 37, 78
Sylvester, Pope, 76

Tasso, Leonardo di Chementi del, 45
Terence, 173
Theophrastus, 83
Thomas, St., the Apostle, 148

Thomas, St., Aquinas, 78, 215
Ticcia, Giovanni del, 30
Timanthes, 57
Titian, 142
Tornabuoni, Giovanni, 217
Toscanelli, Paolo, 217
Tournai, 121
Tradate, Samuel da, 179, 180
Troy, 190
Tuccia, Niccolò della, 211
Tura, Cosimo, 32, 33, 123, 179, 187
Turini, Giovanni, 3, 26
Tusculum, 179
Tyrol, Duchess of, 139

Uccello, Paolo, 4, 31, 99, 112, 138, 191, 196
Ulisse, poet, 174
Urbino, 94, 95, 212
Urbino, Duke of, 94–96, 100, 129, 138, 185

Valdambrino, Francesco da, 3, 84, 203
Valori, Bartolomeo, 85
Valturius, 186
Vasari, Giorgio, 7, 76, 140, 195, 199, 218
Vecchietta, painter, 99
Venice, 6, 12, 16, 28, 29, 36, 40, 41, 90, 91, 95, 130, 140, 141, 153–155, 175, 177, 184, 188, 216; S. Cassiano, 188; S. Geminiamo parish, 29; SS. Giovanni e Paolo, 29, 155; S. Marcilian parish, 40; St. Mark's, 91, 140, 141; S. Maria dell'Orto, 40
Venus, 63, 155
Verino, Ugolino, 185, 190, 192
Verona, 11, 32, 175, 209, 210
Verrocchio, Andrea del, 40, 99, 102, 112, 126, 127, 153, 183, 193
Verrocchio, Michele del, 40
Verrocchio, Tommaso del, 41
Vespignano, 76
Vigevano, 122, 124
Villani, Filippo, 195
Virgil, 57, 69, 190
Vitruvius, 63, 69, 97
Viterbo, 197, 211, 213; Cathedral, 214
Volterra, 81, 181; San Giusto, 181

Weyden, Rogier van der, 98, 120, 121, 177

Zaynario, Jacopino, painter, 126
Zeno, St., 116
Zenobio, weaver, 41
Zenobius, St., 86, 178
Zeuxis, 59, 66, 72, 94, 193
Zoan Andrea, 10, 11
Zohane, Antonio, court fool, 122
Zoppo, Antonio, 183
Zoppo, Marco, 187
Zovenzonio, Raffaello, poet, 186

Italian Art, 1400-1500

SOURCES AND DOCUMENTS

Creighton E. Gilbert, the Jacob Gould Schurman Professor of the History of Art, Cornell University

Writings about art from the Early Renaissance period make up the principal contents, all expressly translated by the author from the original Latin, Italian, or French. Many of these documents have never been translated before. Introductions precede each text, and the author has tried to convey the equivalent of the originals in usability for the reader.

PRENTICE-HALL
SOURCES AND DOCUMENTS IN THE HISTORY OF ART SERIES

H. W. Janson, New York University, Series Editor

AMERICAN ART, 1700–1960
John W. McCoubrey, University of Pennsylvania

IMPRESSIONISM AND POST-IMPRESSIONISM, 1874–1904
Linda Nochlin, Vassar College

ITALIAN ART, 1400–1500
Creighton E. Gilbert, Cornell University

ITALY AND SPAIN, 1600–1750
Robert Enggass, Pennsylvania State University;
Jonathan Brown, Princeton University

NEOCLASSICISM AND ROMANTICISM, 1750–1850
Volume I: Enlightenment/Revolution
Volume II: Restoration/The Twilight of Humanism
Lorenz Eitner, Stanford University

REALISM AND TRADITION IN ART, 1848–1900
Linda Nochlin, Vassar College

0-13-507947-0